The
Floating
World

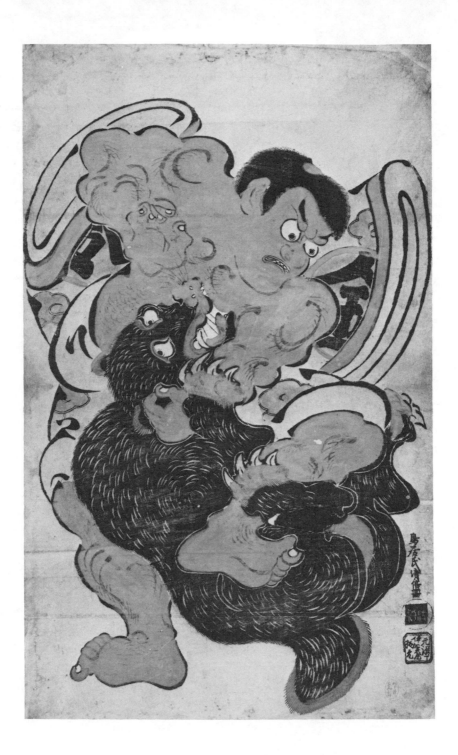

The Floating World

James A. Michener

with commentary by
Howard A. Link

University of Hawaii Press
Honolulu

© 1954 James A. Michener
© 1983 University of Hawaii Press
All rights reserved
Originally published by Random House, Inc.
Library of Congress Catalog Card Number 54-7812
ISBN 0-8248-0873-8
Manufactured in the United States of America
88 87 86 85 84 5 4 3 2

Grateful acknowledgment is made for the following: Quotation from Faubion Bowers' *Japanese Theatre* by permission of Hermitage House, New York; from Henry P. Bowie's *On the Laws of Japanese Painting* reprinted through permission of Dover Publications, Inc., New York; from Arthur Davison Ficke's *Chats on Japanese Prints* by permission of Ernest Benn Limited, London; from Frederick William Gookin's *Katsukawa Shunsho* by permission of The Art Institute of Chicago; from Judson D. Metzgar's *Adventures in Japanese Prints* (Dawson's Book Shop, Los Angeles) by permission of the author; from Hans Alexander Mueller's *How I Make Woodcuts and Wood Engravings* by permission of the author and American Artists Group, New York; from A. L. Sadler's *The Maker of Modern Japan* by permission of George Allen & Unwin, Ltd., London; from Waldmar von Seidlitz' *A History of Japanese Color Prints* by permission of William Heinemann, Ltd., London.

FRONTIS
Title: Kintoki Wrestling with a Black Bear
Location: The James A. Michener Collection, Honolulu Academy of Arts.
Size: 55.1 x 31.9 cm. *Publisher:* Moto-hama-chō Iga-ya hammoto. *Date:* Ca. 1700.
Signature and Seal: Torii Uji Kyomasu zu, Kiyomasu.
Technical: Handcolored kakemono-e.
Commentary: This powerful design of Kintoki wrestling with a black bear, one of the finest Torii-style prints in existence and the only recorded impression, can be dated on the basis of style, signature, technical matters, and the use of vivid tan to around 1700. The print, along with others dated 1697, 1701, and 1704, defines Torii Kiyomasu's early style and suggests that Kiyomasu was a mature, active artist during the early years of Kiyonobu's career.

Contents

Illustrations

James A. Michener:
Author, Connoisseur, Collector, and Museum Patron

Whentheic American novelist James A. Michener was a boy in Pennsylvania, he came upon an article on Central Asia in the *National Geographic* magazine and made a vow to visit Asia someday. The result of Michener's dream was a lifelong interest in the Orient that took him to most of the Asian countries. His fascination took literary form with the books, *The Voice of Asia* (1951), *The Bridges at Toko-Ri* (1953), *Sayonara* (1954), and *The Floating World* (1955)—the last a lively, well-written account detailing the history of ukiyo-e.

The Floating World embodies Michener's continuing interest in pictorial art, as well as his great love of the Japanese print. He once remarked on the book and his own ukiyo-e collection: "It was from my account of Utamaro's haunting woman, 'Hana-ogi,' that I was able to afford most of my prints . . . so in a very real sense she can be called the patron saint of this collection, except that the word saint is one which hardly applies to this remarkable woman."

Propelled by the instant success of *The Floating World*, Michener was soon recognized as a leading authority on the Japanese print—so much so that Mrs. Georgia Forman of Buffalo, New York, gave her small but choice collection of prints to him upon her death. This was shortly followed by the fortuitous opportunity to purchase the Charles H. Chandler Collection of Evanston, Illinois. Assembled in the 1910s when choice specimens were still available in great numbers, Chandler's collection boasted over 4,500 prints, half by the poetic landscapist Hiroshige, and the remainder by a number of other ukiyo-e masters, mostly of the full-color printing era. While Chandler's passion for Hiroshige resulted in a collection of unparalleled depth it lacked balance, and many artists, particularly those of the primitive period, were totally overlooked. It remained for James Michener, therefore, to fill in the important gaps and refine the exist-

ing assemblage. Indeed, the Chandler acquisition was not the end but rather the beginning of Michener's search.

In the grand tradition of his contemporaries, Popper, Grabhorn, Gale, and Scheiwe, Michener systematically began to add almost a thousand exceptional works, including prints of the primitive period by Kiyonobu I, Kiyomasu I, Kiyohiro, Kiyoshige, and Kiyomitsu I, not to mention the superb Kaigetsudō courtesan portrait formerly in the Morse Collection. Whenever possible, Michener balanced and shaped. Important prints by Harunobu, Kiyonaga, and Utamaro were sought to enhance the already fine grouping gathered by Chandler. Secondary artists were not overlooked; prints by Hokkei, Hokuju, Eishō, Eishi, Shunchō, Toyoharu, Kitao Masanobu, Shun'ei, Bunchō, and Harushige, to mention only a few, were acquired to provide additional representation. Michener also conceived a plan that would not duplicate or rival any known holdings: "Gather into one small collection representative examples of the exquisite work of the past plus the thundering vitality of the present," the latter reflecting Michener's keen interest and appreciation of the modern school of Japanese printmaking.

By 1959 Michener had gathered into one place an exceptional survey of the Japanese print numbering 5,400 prints, books, and album leaves and had written his third book on ukiyo-e, covering highlights from his collection as it existed in 1957. His ample commentary carries the history of the art over three centuries and is supplemented by authoritative notes by Richard Lane, whose initial research on the collection provided the foundation for all subsequent studies.

In the course of all this activity, it was by no mere chance that the Honolulu Academy of Arts became involved. Michener at that time was a resident of Honolulu, doing research for his now famous book *Hawaii*. Already convinced that museums are "adornments of our civilization" he developed a special affinity for the academy which has continued to the present day. Michener found a museum free from "gimmicks" and from the catering for sensation that now disfigures many other institutions in the West. He found instead an academy for those who like to wander around in peace and contemplate works of art and who when they have had their fill can go into some of the courtyards and look at the goldfish in the pool. He found the museum rather like a private home, where the pleasure principle is enshrined.

James A. Michener x

Such was the aim of its founder, Mrs. Charles M. Cooke, Sr. She came from a family of missionaries who had entered commerce in the islands and prospered. Her Puritan background in no way hampered her love of art any more than it did that of many nineteenth-century New Englanders. Her spirit is reflected in the building, which was designed by Bertram Goohue and Hardie Phillip in the 1920s—a typical expression of that eclecticism, which is such a feature of American late nineteenth-century culture. Michener appreciated the balance between East and West which is a major feature of the academy's collection. Michener's other great passion in art is Sienese painting, a subject that he ranks close to his love for ukiyo-e.

The fact that Michener had a quick visual grasp of art style and could go with knowledge from Oriental to Western galleries in a matter of minutes meant that much could be learned about the affinities between two different cultures: to see a Kamakura Jizō shortly after looking at a great baroque sculpture made him keenly aware of the aesthetic relations between East and West.

In 1959, Robert P. Griffing, Jr. was director of the academy and Marvell A. Hart was keeper of collections. Both shared Michener's passion for prints and in recognition of this, and the academy's unique qualities, he placed the collection in the museum's care on permanent loan. Over the years since then, more than half of the Michener Collection has been presented to the academy in annual increments, and the donor has graciously signified his intention to transfer title of all the remainder in the course of time.

What the academy acquired from James A. Michener was the result of over half a century of painstaking search, first by Chandler and then by Michener. Prints from most of the illustrious collectors of the past, moreover, found their way into the assemblage. To study the provenance of each individual print is to review much of the history of ukiyo-e collecting itself. The notable Japanese pioneers of the late nineteenth-century, Wakai and Hayashi, are represented in numbers. The great Parisian connoisseurs, whose early recognition and writings on the intrinsic beauty and technical excellence of ukiyo-e actually preceded any acknowledgement in Japan, are also here. Prints from the late nineteenth-century collections of Gonse, Manzi, Haviland, Jacquin, Rouart, Vignier, Koechlin, and Vever recall pioneer interest. The strength of the German collections is to be found in several prints from the famed collector Frau Straus-

Negbaur; former holdings of Jaeckel and Von Heymel are also present. English activity is represented by some superb prints from Bateson and Kingston Baker. And, of course, examples from most of the great American collections are here. It was in the early 1900s, some twenty years prior to the formation of the Matsukata Collection, now in the Tokyo National Museum, that American connoisseurs became interested in ukiyo-e. Prints from the collections of Fenollosa, Happer, Morse, Wright, Ficke, Gookin, Chandler, Field, Ainsworth, Metzgar, Mansfield, May, Schraubstadter, Ledoux, and Grabhorn recall much of the history of ukiyo-e collecting in America.

It is the Michener Collection, along with a number of prints from Mrs. Cooke, the founder of the museum, and the study collection of ukiyo-e illustrated books, that prompted establishment in 1970 of the academy's Ukiyo-e Center, with permanent galleries, first at Spalding House, the museum's former extension for Asian decorative arts, and now at the main museum.

In 1970 I came to Honolulu to join the staff of the academy as the first keeper of the new Ukiyo-e Center. It is no small coincidence that I should have gravitated to the Michener Collection in Hawaii. Many years earlier I too had read *The Floating World* and had been deeply impressed with Michener's enthusiasms and love of the Japanese print. In fact, it was Michener's account of the Torii masters that led me to explore the subject anew and to subsequently make some refinements to our present knowledge.

Over the years, a range of mini-exhibitions have been presented to the Honolulu community, which has close ties to Japan and its culture. More recently, two internationally acclaimed traveling shows were mounted: *Utamaro and Hiroshige* (1976–1977), organized in cooperation with the Japan Ukiyo-e Society, and my own *Theatrical Prints of the Torii Masters* (1977–1978), a loan exhibition done jointly with the Riccar Art Museum, Tokyo, and the first major exhibition in the West to deal with these neglected artists.

The James A. Michener Collection remains a living collection in other ways, for Michener has continued to support its growth and refinement through the academy's curatorial staff. Major acquisitions of the works by Kiyonobu I, Kiyomasu I, Kiyonaga, Sugimura, Shun'ei, Toyokuni, Utamaro, Hokusai, Hiroshige, and Kuniyoshi have added immeasurably to the collection's documentation. For example, Kiyomasu's "Kintoki Wrestling with a Black Bear" (frontis)

—formerly part of the Vever Collection and known only in this impression—is one of the finest and earliest examples of Kiyomasu's expressive style to survive. Its acquisition, made possible through Michener, is the capstone to a search that he had embarked upon many years ago and one in which I am proud to have played a part. Other prints, such as the left hand sheet of a rare kakemono diptych and attributed by some to Sugimura (67), dates to the formative period of tan-e prints in the 1670s and adds real knowledge to our growing understanding of the early technical development of ukiyo-e. It should be added that the contemporary print masters of today have not been neglected; additional funding has been provided to assure the continued development of the collection in this vital area.

In writing of a past age Michener succeeded in conveying something of ukiyo-e artists in a society now long dead knowing that the glimpse would never be clearer than in the art left behind. Dr. Narazaki Muneshige observed in the words of his English adaptor and ukiyo-e critic, C. H. Mitchell: "A great deal of the essential flavor of the Edo merchant culture is conveyed in ukiyo-e. . . . This flavor can be interpreted in larger terms as an expression of some of the most significant characteristics of the Japanese people and perhaps in a still broader sense as an expression of certain human values which prevail all over the world and at all times." These sentiments echo James A. Michener's own commitment to these "magnificent scraps of paper" as not only works of art but as testaments to the human spirit.

An Explanation

It is the ambition of this book to accomplish four things. *First*, it tries to provide an account of the life and death of an art. The birth of this art is witnessed. Analyses are made of the causes for its periodic strength and weakness. An attempt is made to say why it died.

We Americans need to acquaint ourselves with the logical processes that govern both the life of an art and the vitality of other social forms. For the art discussed in this book need not have died, yet its death clearly proves the inevitable end of any social expression that consistently makes grievous and sometimes willful mistakes.

Second, this book tries to identify the relationship of certain great individual figures to the ebb and flow of a total art. Time and again, as the art seems about to expire from enervation, some violently original man will save it. But the tragic day will come when no such original mind leaps into the breach, and the art will perish.

We Americans need to remind ourselves, in an age when it has become popular sport to ridicule or persecute any original thought, that only by the contributions of such cleansing and motivating intellect can any social organism be kept alive. With all our wonderful machines we have yet to create even a tenth-rate substitute for an original mind.

Third, this book tries to explain what happens to an art when a powerful and practical civil government begins to regulate all aspects of that art. We shall watch such a government, benign and extraordinarily wise, as it begins to build its strait jacket for art: what colors may be used, what unpatriotic subject matter must be excluded, what immoral material must be stopped. We shall see this government exhort its artists to produce only those subjects which glorify the history of the nation. And we shall clearly see that those laws hastened the death of the art.

We Americans need to be reminded that a man with the mind of a mouse can lay down completely reasonable laws to govern the artistic process or any other social process. An idiot can propose such laws and make them sound logical. But of course, the social process thus regimented will always wither.

I must postpone stating the fourth objective of this book until I have explained why I chose to write about Japanese prints.

I started this book twenty-three years ago when I was a student in Siena and laid plans to write about the unique art of that exquisite Italian hilltop city, for the art of Siena was almost ideal to my purpose. It was a confined art, so that its motives and problems could be studied under pressure, as it were. It was largely unfamiliar to Americans, so it could be approached without worrying about too many preconceptions in the mind of the reader. It contained an endlessly repeated iconography, which encouraged sequential study. It was a lovely art, one truly meriting wider acquaintance. And most significant of all, it illustrated the importance of fresh minds; it was born in the greatness of Duccio, flourished in the vigor of Matteo di Giovanni, and perished when no strong new minds appeared. It was, I thought, the perfect art from which to develop the ideas that were germinating in my mind.

Later I was to find that the Japanese print was more appropriate in every way. It, too, rose and flourished and died in a clearly defined historical period. Its subject matter was strange to Americans and therefore uncluttered with preconceptions. It had an endlessly repeated iconography. In addition it had special attributes which made it ideal for my purposes.

For one thing, it was a more artistic art than Sienese painting, in that it included at least six artists notably superior to any produced by Siena, excepting only Duccio, and for the most part they were men directly and vitally concerned with the innermost problems of art.

Also, the Japanese print, both in time (roughly 1660–1860) and in spirit, is closer to the modern mind than the Sienese easel painting, for in the former will be found a fuller reference to modern life than that provided by the exquisite gold-leaf work of Siena. For better or worse, the last two hundred years have witnessed the irresistible upthrusting of great masses of people from what used to be called the lower social orders. Had this not occurred and had medieval habits of thought persisted, the art of Siena would have been ideal for study.

But it has occurred and the Japanese print, more than any other art form in the world excepting American popular songs from Tin Pan Alley, reflects that occurrence.

Furthermore, the Japanese print is fun. It comprises one of the most totally delightful art forms ever devised. Its colors are varied, its subject matter witty, its allurement infinite.

Fourth, this book endeavors to bring home to the American people the stunning fact that our museums contain the world's finest collection of Japanese prints. I do not mean the finest collection outside of Japan. I mean in all the world, Japan included. The two stupendous collections in the Boston Museum of Fine Arts and the Art Institute of Chicago are incomparable, while the smaller collection in the Metropolitan Museum of Art in New York compares favorably with all but the greatest Japanese collections. Through the curious chances of history, which will be described later, America is the curator of one of the world's loveliest arts.

I can therefore use only one word to describe our lack of attention to the amazing riches we have stumbled upon. It is shocking. We have hoarded these prints for nearly half a century and in spite of the work of a pitifully few devoted public servants, the prints remain today ill housed, poorly catalogued, unknown to the public and ignored by scholars.

Here we possess almost a monopoly of one of Asia's rarest and most instructive arts and we have done nothing with it, although it provides an almost unequaled avenue into major aspects of Asian culture, and Asia comprises the major land and population segment of the world.

Belatedly work is being done, and it is of excellent quality, what little there is of it, but for the most part America has hoarded its massive collections in secrecy. I am perplexed as to why this has been, for the prints have always been available for study.

In fact, one of the real joys of studying Japanese prints in America is that almost always they have been owned by such delightful people. The great collectors have traditionally welcomed connoisseurs, and now that most of the massive private collections have passed into museums, the same spirit prevails there. It has been a great privilege for me to go into the Boston museum to meet Robert T. Paine, Jr., the Assistant Curator, or Kojiro Tomita, Curator of the Asiatic Department. In Chicago it is pleasant to see the overpowering riches with Margaret Gentles, a devoted scholar with a sense of humor. Carl

Zigrosser in Philadelphia is an erudite and charming guide, and at the Freer in Washington Phillip Stern knows both the language and the art of Japan. Although the Metropolitan Museum in New York houses its prints far from the Asian section, the European specialists who have to exhibit them to visitors could not be more courteous and generous of their time, so that after one has plagued genial A. Hyatt Mayor years on end to see the Japanese prints, in which he has no special interest, one feels almost obligated, out of common decency, to ask for a couple of Dürers, which are his specialty.

One point must be made clear. Without a knowledge of the Japanese language no one can make original contributions to the study of prints. I lack such knowledge, but I have been fortunate to know and work with most of the leading Japanese scholars in this field. Seiichiro Takahashi helped me on the economics of the art. Ichitaro Kondo provided much guidance. Kiyoshi Shibui unlocked both his extraordinary collection and his knowledge of the Genroku period. Tetsu Takahashi spent long hours helping me prepare Chapter 20. Teruji Yoshida provided expert advice on all kabuki prints. Muneyoshi Yanagi explained Otsu-e, and Shigeo Sorimachi spent many hours discussing and exhibiting books. Koshiro Onchi and Un-ichi Hiratsuka, gifted modern artists, taught me how they made prints.

Two profound students of ukiyo-e were especially generous in both time and ideas. Toyohisa Adachi is a witty, skilled young man who makes excellent copies of ukiyo-e using classic procedures. From long hours in his shop I learned techniques. Shizuya Fujikake is the beloved dean of ukiyo-e scholars and I spent encouraging mornings in his Tokyo garden home under the framed sign: "To be a scholar requires silence." At our first meeting this splendid man said he would enjoy telling me all he knew. I wish I had learned even a fragment.

Working with the men named above was the richest intellectual experience of my life and although the errors in this book derive from the fact that I didn't always understand what they told me, the truth in these pages is due to their help. I hope something of the love they have for their subject shows through my writing.

For I must stress that Japanese prints are a joy. They will gladden the mind and quicken the eye, and we Americans are very lucky that we own so many of them, for in the long history of man's persistent attempts to create beauty, these prints represent one of the gratifying successes.

The Floating World

1

In the Village of Otsu

In the year 1666, when London lay dying of the plague and New York, having ousted the Dutch, was settling down to English rule, a vigorous procession set forth from the ancient Japanese city of Kyoto. At the head four men hurried back and forth shouting, "Bow down! Bow down!" Two stout servants followed bearing tall staffs, heavily plumed on top, while behind them strode a number of unusual warriors. Bare kneed, they wore leggings and loose sandals. Over plain gray garments they wore colorful coats from which protruded two carefully arranged swords which had been thrust into the heavy belts that encircled their waists. Each man wore a big circular straw hat which remained steady as he marched, swords jutting out fore and aft and his shoulders moving in that exaggerated manner known as "cutting the air." The faces of these warriors were solemn and preoccupied, for they were samurai (those who serve) and under Japanese law were entitled to cut down with their terrible swords any commoner who offended them in any way. Should the commoner die, which usually happened, no trial was held, for the right of "cutting down" was ancient and kept the samurai's spirit both warlike and pure.

Behind these grim stocky men came nearly a hundred others, some lugging huge boxes of bedding, some with portable shrines, still others with tents, for this procession would march many days across mountains and up the coast until it reached the new capital city of Edo,† later to be known as Tokyo. Each item of cargo was stamped with the bright crest of the solemn man who rode hunched up, knees to chin, in a palanquin slung upon the shoulders of four strong men who

† There are two ways of spelling this word: Edo and Yedo. This also applies to all names beginning with E, as Eishi, Yeishi. The Y has been avoided in this book because it invites completely misleading pronunciation. The city is usually pronounced Eddo.

3

would lug it step by step more than three hundred miles. Behind the palanquin which bore this silent daimyo (great name), one of the feudal barons of Japan, came dozens of other servants, some with very tall pikes tipped with banners, others leading horses, some with boxes of gifts for Edo. At the rear, six samurai cut the air with their arrogant shoulders while one servant carried aloft the warning plume and two handymen scurried about crying a last warning, "Bow down!" lest any commoner rise from the dusty road too soon and meet the sword of an offended samurai.

When the procession left ancient Kyoto each man had been dressed in his finest to impress that rare old city with the wealth of his daimyo master, but some seven miles east of the city lay the unpretentious junction village of Otsu on the shore of beautiful Lake Biwa, and here the cavalcade was permitted to change into more comfortable gear for the murderous hike to Edo.

Now, as the procession approached Otsu, it headed through a group of low mountains and the warning runners hurried into the inconspicuous village of Oiwake, strung out in two single lines of houses on either side of the mountain pass. "Bow down!" shouted the runners as the train moved through the village and on to the equally unpretentious village of Otani, from which the daimyo, pulling aside the curtains of his palanquin, could see Otsu dead ahead and beyond it the majestic blue of Lake Biwa. The entire procession hurried forward to reach the first day's camping ground and comfort.

When the samurai left Oiwake, which should be considered merely as a suburb of more important Otsu, the townspeople rose, dusted themselves off and watched the impressive daimyo train weave down the hill to the lakeside. It must not be thought that these peasants and merchants and rowdy housewives were overawed by the swaggering samurai. Custom demanded this kneeling in the dust but one did it automatically, joking under his breath, for although the samurai had free right to slash and cut for even the most minor offense, they rarely exercised this privilege and a kind of easy truce prevailed.

As the crowd resumed activity, it became obvious that most of the people who jammed Oiwake that day were either pilgrims to the Buddhist temple of Mii nearby or sightseers for the renowned eight famous views of Lake Biwa, scenes borrowed from China, where the eight most delectable sights in nature had long ago been defined. The vast pine at Karasaki was such a view, especially if seen in the

rain, the daring bridge at Seta in sunset, and evening snow upon Mount Hira (61).†

But before these travelers proceeded to their inspection of the famous views they stopped at an open shop from which hung a signboard containing a painting of a Buddhist god. Inside were small stacks of paintings, each roughly two feet high by ten inches wide. They depicted various scenes in Buddhist faith and were notable for the dark earthy color of the paper on which they appeared and for the freedom and verve with which the colors had been applied.

These were Otsu-e (Otsu pictures) and since they have a peculiar fascination for anyone interested in either the woodblock prints of Japan or the nature of folk art anywhere in the world, they must be inspected carefully.

Originally dealing only with religious subjects, they may have been painted as early as 1624 but specific written records do not antedate 1660; however, since books of that time speak of the pictures as if they had existed for many years, some date like 1630 might represent the beginning. Although religious, they sprang from neither temple nor priest but from common street-side painters; they were connected in no way with any formal school of art; they were unsigned; they never appeared anywhere except in the Otsu villages; they were purchased only by the poor; there is no record that a daimyo's train ever stopped for any; and all the early examples were sold with imitation frames painted on in ink and with two cheap sticks of wood pasted at top and bottom to mimic the expensive hanging pictures of the rich.

They were produced in a special way. Two or sometimes four sheets of brownish paper were pasted together and then smeared with a light clay which stained the paper an attractive color. Working very rapidly with any pigments available, the artist then quickly splashed on lighter colors, creating a general outline of the holy subject. A head would be a more-or-less round blob of white. A hand would be a rectangular smear of the same color. A foot might be square. The speed with which the artist worked is hard to believe but a picture rarely took more than eight minutes "and it would have been less except that the first paint had to dry." This drying was important, for after the general areas had been laid out, the artist took a smaller brush containing either dark brown or black and with lightning strokes out-

† A number within parentheses is used to indicate the corresponding print in this book.

lined the head, smacked on the features, drew some jagged lines for fingers, other rough swirls for the feet and called the picture done.

The origins of this slap-dash art are unknown, but about 1705 Chikamatsu Monzaemon,† Japan's leading dramatist, wrote a purely fictional play which launched the rumor that a wholly imaginary painter Tosa no Matabei Mitsuoki had fled to Otsu in disgrace and in his declining years had taught certain rural youths to paint in classic manner, which in time degenerated into Otsu-e. The name concocted by Chikamatsu resembles Michelangelo Velasquez Cézanne and how any intelligent critic could have been taken in by such broad foolery is difficult to understand, but the legend has never died and in 1953 a major publishing firm in Kyoto issued two sets of Otsu-e copies as "satirical pictures by Matabei." Without belaboring a ridiculous issue, it can be stated categorically that Matabei, a superior painter whom we shall meet later, had nothing to do with Otsu-e; neither did Tosa Mitsuoki; Matahei, supposed son of the former, never worked in the village; and Domo no Matahei was the stuttering hero of a fine and moving play but never a living person. Otsu-e was purely a folk art.

By 1690 several shops produced these popular pictures, entire families doing the work piecemeal. The less skilled members prepared the paper, the more skilled did the human figures, while older members pasted on the make-believe sticks. It is recorded that some especially rapid workmen kept two brushes in their painting hand, one for big basic daubs, the other for finishing outlines. From pin pricks still visible in many paintings it is certain that round faces and halos were laid out with the compass and before long this led to the one technical advance that Otsu-e discovered in more than two hundred years. Someone cut a satisfactory woodblock to represent a human head which could be stamped on the paper and painted around. In time each shop acquired one such head, sometimes stamping it up to twelve times on a single picture and it is amazing how, by varying the tilt of this common woodblock and the colors which later surrounded it, quite distinct portraits were achieved. Until the trick is pointed out one usually fails to detect it.

People who bought Otsu-e did so for two reasons: to decorate their otherwise meager homes and in obedience to religious superstition.

† Japanese names are given throughout the text and appendix in Japanese style, family name first. In the preface modern Japanese names were given in the western style now generally used.

One of the prints, if hung upside down, was guaranteed to prevent babies from crying after midnight. Another kept off robbers, but there was one very serious use to which these religious pictures were put. In 1638 some thirty-seven thousand Christian converts who had been hiding out in various remote areas, the government having banned their religion, were finally herded into one remote spot and slaughtered. This occurred at just about the time Otsu-e were becoming popular and thereafter it was deemed prudent for all houses in the area to contain at least one clear picture of Buddha, and many Otsu-e that have come down to us were used as charms, not against imaginary devils but against government inspectors checking upon religious conformity. Doubtless the rise of the art was related to this custom.

But starting sometime after 1680 the pictures became less religious, imitation frames were dropped and the first of nearly a hundred satirical lay themes appeared By 1709, when a book was published concerning Otsu-e, more than half its forty-two illustrations were nonreligious. Their place was taken by humorous comment on life at hand. One of the most popular subjects poked fun at the pompous standard bearer of the daimyo's procession, whom commoners despised for being arrogant while lacking real authority. As these new subjects are mentioned, reference will be made to woodblock prints containing similar content, but it must be understood that only one hand-painted Otsu-e appears in this book as number 24. The rest are woodblock prints and bear no relation to Otsu-e except a common subject matter. The pompous servant can be seen with his standard in print 8 as he starts a journey across Nihonbashi Bridge, the center of Edo. He appears in thousands of Otsu-e to provide malicious pleasure to the commoners whom he pushed around.

Another favorite became the signboard for all Otsu-e shops, a devil beating a drum in ridicule of the persistent alms-collecting monks like those in print 19. This taunting of authority also occurred in pictures of famous gang leaders who had resisted the oppressive government and given hope to the common people, like the rugged heroes of prints 41 and 42.

In time, however, Otsu-e lost their vital edge and became highly moralistic, with sententious verses written across the face of each painting. Now the pictures were used to teach the young and the most famous shows the devil taking a bath with the warning, "Many a man washes his body but not his mind." New subjects appeared,

like the wild hero Goro sharpening his arrow (30). The effeminate young men of nearby Kyoto were ridiculed (31). The samisen-playing young dandy was lampooned (2). Three of the most delightful single Otsu-e that have come down to us depict the young monk hiding his head under a basket as he tours the city playing a flute (19); the young woman under an umbrella, who will become almost a trade mark of fine woodblock prints (12); and the tall stately courtesan who will appear on hundreds of prints (5).

It is impossible to say, regarding this common use of subject matter, who copied whom, but it seems unlikely that Otsu-e ever created much of a stir in sophisticated Edo, where the prints were made, whereas the prints must have trickled down to Otsu, which was after all on the main highway. We know, however, that Otsu-e frequently provided subject matter for plays and dances which reached Edo with terrific impact and we know that prints were derived from such spectacles. The safest conclusion is that during this period there was consistent cross-fertilization of artistic ideas, spurred by a very popular and vital theatre. All we can be sure of is that Otsu-e and woodblock prints used many common motifs.

There has always been argument about the artistic merit of Otsu-e, and Japanese scholars, trained in Chinese classicism, have settled their portion of the argument by ignoring Otsu-e completely. European writers have done the same. American collectors have generally refused to admit that one must study Otsu-e before he can understand prints fully, and in English there is only one satisfactory account of this curious art, and that a translation.

Critics who have bothered to inspect Otsu-e have usually derided this gaudy poor man's art. Three poems of the early eighteenth century sum up what literary men of the time thought: "Even children learning penmanship can draw as well as the Otsu painters." "This sad painter makes his Chinese heroine look no better than a girl in Otsu-e." "I tried to draw a portrait of my mother, but it came out looking no better than a devil from Otsu." It remained for a poet of first rank to sum up the criticism: "A swallow flew overhead and aimed his droppings on the Otsu-e below."

I shall be forgiven, I hope, if I disagree with such comments. Otsu-e are lively, colorful, dramatic and immensely decorative. Non-academic they are, but in their saucy freedom they show a sweep of line and a command of movement that are commendable. Their color

is especially appropriate. They are not great art, but they constitute a huge storehouse of artistic ideas. I am positive that one of these days living artists will return to this wealth of thematic material the way exploring children ransack an attic. The richness of decorative idea in Otsu-e is untouched; if they had been French in origin, or Bavarian, an entire school of design would have been built up about them and sooner or later that will occur in Japan. But I am not content to say merely that these laughing old pictures are archaic treasure houses of quaint values. A few have the quality of notable art, specifically the monk in his basket hat, a delightful scene with two doves on a branch of flowers, and print 24. Other taste would find other Otsu-e paintings of high merit.

By 1807 and probably at least twenty years earlier there happened to Otsu-e what seems to happen to all folk art: it crystallized into set forms. This time the crystallization occurred in an unprecedented way and must be considered in any philosophical discussion of wood-block prints. A street song called "Otsu-e Bushi" became extraordinarily popular—it remained so for more than ninety years—its jingles consisting of the names of the ten most popular Otsu-e subjects. So persuasive was this song that people stopped buying other subjects, which had to be discontinued, for pilgrims to Otsu feared that if a subject was not named in the song it could not be authentic.

Why these particular ten were chosen is incomprehensible. No common thread has been detected and the only likely guess is that during the nearly two centuries of Otsu-e's existence, these ten had been found to be especially lucky. Each probably had a hidden folk significance that escapes us now. The unlikely ten were: the god of long life with a ladder propped against his enormous forehead up which another god climbs to shave his hair; the god of thunder pulling up his drum from the sea; a blind man attacked by a mongrel dog; a monkey fishing for a catfish with a slippery gourd; the daimyo's pompous servant; the legendary hero Goro and his arrow. Three deserve special mention. The devil beating a drum has already been noted as the traditional sign of an Otsu-e shop, the fiercer the better. The two most popular subjects in this last stage of the art were a young hunter with a falcon on his wrist and a girl dancing with a bunch of wisteria flowers held over one shoulder, a subject which later became the basis for one of Japan's finest dances. The tenth was the favorite of children and appears as print 24, where it is described.

What sense can be made from such a jumbled list? These ten became enshrined. They appeared in books, in songs, in dances and are today as perplexing as when they triumphed over ninety other subjects equally good. In a study of Japanese woodblock prints they are important because in the following respects they resemble prints.

Otsu-e were cheap and were produced in thousands of copies by artists not of the classical schools. They were bought by commoners, were considered expendable and were not recognized as art until some time after the death of the movement. One of their major functions was to poke fun at established authority, but they were basically conservative and their purchasers were too. The old subjects, the old style of delineation, the old lucky manner of dress were demanded. During more than 120 years the rugged rascal shown in print 24 changed little and the people who bought him changed not much more.

Otsu-e and woodblock prints were similar in another respect: they were essentially folk art, even though prints had additional significant qualities, and the destiny of folk art is to crystallize. It has to be conservative for it is created by unphilosophical minds relying upon pragmatic sanctions. At times it seems to possess a teleology which drives it irresistibly to standardization, and it is quite possible that the devastating song "Otsu-e Bushi" merely recorded a crystallization that had already taken place.

Now for the differences. The fundamental distinction between Otsu-e and woodblock prints is that the latter were produced by individual men who sometimes had great genius and who always had separate personalities, whereas the Otsu-e men lacked individual styles and even names, relying in Yanagi's magnificent phrase upon "the long experience of the neighborhood." The history of prints conversely is the proud record of contributions made by gifted men who relied upon their own genius and not that of a common society. Without these sometimes explosive talents woodblocks would have crystallized into their own peculiar set of ten acceptable subjects and would have served some trivial utility as good luck charms; but that could not happen, because whenever crystallization threatened, some extraordinary man with new vision stumbled and banged and elbowed his way into the field and totally disrupted the art, making stultification impossible.

I find the history of such eruptions of the human spirit exciting. That here they occurred in an art which was of itself rich and beautiful makes

the account even more rewarding. We have started our discussion of prints with this look at Otsu-e because it is important to keep in mind that inherently the nature of any art, particularly a folk art, is to become hidebound, to settle upon a few approved themes presented in one or two sanctioned styles.

Each of the artists to be discussed from here on was tempted, invited, cajoled and as we shall see sometimes even ordered to keep going along the same old way. But these men we are now to meet were not hack artisans in the village of Otsu, slapping color onto squares of paper in accordance with rules set down two hundred years earlier. These men were artists and that makes quite a difference.

2

The Land and the People

The Japanese print coincides generally with the powerful Tokugawa dictatorship which governed Japan from 1603 to 1867, and since print making more than most arts depended upon unique social and economic conditions it is essential to understand what they were.

As with all nations, Japan developed her traditions partly in response to geographical limitations, a major factor being that the islands are small and the land crowded. The four principal islands have less territory than California and the main island of Honshu, which alone produced prints, is only slightly larger than Utah.

The islands lie in roughly the same latitude as the United States (Japan 46N to 30N; U.S. 49N to 25N) and have a more gentle climate, due to the Japanese counterpart of the Gulf Stream: the Black Stream which hugs the coast as it moves warmly northward at the rate of ten miles a day. Cities at the latitude of Philadelphia sometimes show plum blossoms in January.

The surface of Japan is more mountainous than that of any other major nation on earth, less than fourteen percent of its area being tillable. Only the most careful agricultural practices permit more than a few people to inhabit the islands.

Mountains have inhibited road building and prevented travel. During the entire period under discussion there was no good road that ran from one end of Honshu to the other nor did any cross the island, and even in 1954 the same could be said regarding paved roads. It is remarkable that even yet there is no paved road between Tokyo and Kyoto. Such terrain made inevitable the partition of Japan into small manageable areas and the development of feudalism as the logical form of government.

The extent to which the system depended upon rice is difficult to believe. Lacking coal and iron, having insufficient timber, voluntarily excluded from world trade and retarded in undergoing the industrial revolution, the nation existed on rice. Its culture was suited to the Japanese climate, except in the north, where growing rice is an obstinate perversion. It even constituted the money system, so that a man was known by the amount of rice to which he was entitled each year. Thus, of the twenty-eight million koku† normally produced, the Tokugawa dictators reserved eight million for themselves and carefully apportioned the rest. A leading daimyo might be entitled to a million koku; a minor samurai might get only thirty. The efficacy of every economic law was judged by one criterion: did it produce more rice? Peasants were kept tied to the land to produce rice. Daimyo were exhorted to produce more rice. And the geography of Japan, which provided slopes onto which water could be led by gravity, abetted the system. There is no close parallel in history to Japan's fanatical dependence upon rice.

The people who inhabited the islands in 1603 were pretty much like those of other islands lying off the shores of a great continent. An enormous number of racial strands had gone into their construction: the original and shadowy inhabitants; the hairy Ainu of the north; stragglers from Siberia; early settlers from some region near India; many families from China and Korea; heavy immigration from Malaya; and a good many South Sea islanders who introduced a fish culture and island architecture. Those are merely the main strands, for in few cities of the world today can one see so many radically different facial types as in a northern Japanese town, where color ranges from almost pure white to Eskimo red and contours from the round to the oblong.

Yet the myth persists that Japan contains the world's most homogeneous population. Two facts support this belief. The nature of Japanese society has always been such that differences are ruthlessly eliminated; and during the years 1600 to 1920, when other major nations were exchanging population rapidly, Japan received none. Therefore if one accepts as his starting point the population held by the islands in 1600, it is correct to say that the population is remarkably homogeneous; but if one goes back to the mixed antecedents of those on hand in 1600, the phrase is meaningless.

It is also misleading to try to identify any inherent psychological qualities which differentiate Japanese from other human beings. They

† A koku is about five bushels and varied in value from seven to fifteen dollars.

neither think differently nor have different physical needs or capacities for emotion. Physiologically their minds and nervous systems operate like those of all other human beings. But upon this fundamental human structure are overlaid numerous unique and commanding cultural habits and this book attempts to identify some of them. For example, I suppose that few Americans appreciate how fanatically we accept two of our own cultural assumptions—chosen at random from many which determine our habits—that a man's word must be even better than his bond and that a man's deepest social obligation is to the future of his children. Advertisements, stories, sermons and even the structure of our economic life are founded upon such commonly held principles. In Japan life is organized about other unchallengeable assumptions: for example, that a man is more deeply bound by loyalty to superiors than by love for his own family; and that for a man to die in support of his superior is not only honorable but desirable. These are cultural phenomena and are not inheritable. If an American infant were to be reared within Japanese social pressures, he would acculturate himself with them.†

There are of course physiological differences which mark Japanese from other national groups. The islanders are short, of a slightly yellowish cast though many are largely white or Malayan brown, and have eyes that bear the Mongolian fold, an extra layer of skin held taut in the upper eyelid. A simple operation costing about five dollars is frequently performed to drop the fold, whereupon the eye looks entirely western. It is probably futile to claim that most Japanese eyes are not slanted—especially in a work on Japanese prints, whose artists adopted the pleasing convention that they were—but actually most eyes look pretty much like those in prints 4 and 23. Even the shortness of the Japanese is deceptive, for one of the most constant surprises in Japan is entering a dining room with a group of noticeably short people, only to find that when seated the Japanese are exactly as tall as you. The differential is only in the legs. About the only generalization I could accept about the Japanese is that they all have black hair.

Throughout the Tokugawa period the people of Japan were divided

† It is even dangerous to put too much stock in cultural differences. Today, in victory, Americans write astonishing nonsense about stupid and drugged Japanese suicide pilots who dived their planes at American ships when defeat of Japan seemed imminent; but we forget the way our nation reacted in the early days—when our defeat seemed at hand—to the incredible bravery of heroic Colin Kelly, who had dived his plane at a Japanese ship.

into five classes: the lords, the samurai, the farmers, the artisans and far at the bottom of the list, almost beneath contempt, the merchants. There has also always been an Eta class of untouchables, wholly beyond the pale.

The first class consisted of about 150 noble families of no political importance attached to the Emperor's court in Kyoto and about 300 daimyo families of great importance responsible to the Tokugawa shogun (barbarian-subduing generalissimo) who lived in Edo. The daimyo were divided into the hereditary vassals who had actively supported the Tokugawa rise to power and whose lands lay closer to Edo, and the outside lords who had either resisted or been indifferent to the Tokugawas. The history of this period is marked by the fear the Tokugawas had that these outside lords might one day revolt, a justifiable apprehension since that is what happened in 1867. Nevertheless, for an unprecedented 264 years of peaceful rule the adroit Tokugawas held the daimyos at bay by several clever devices: the feudal lords were encouraged to spend more than they got so there could never be a surplus for munitions; they were forced to underwrite enormous public works; and whenever a daimyo was absent from Edo he had to leave his family behind as hostages. Furthermore, within the first half century of Tokugawa rule, most daimyos were shifted into new territory, which kept them off balance. Nevertheless, in their own territories they had the power of life and death.

The samurai can be considered analogous to the petty knights of England in feudal days, except that their loyalty was to a particular daimyo rather than to the Tokugawa. They were often nominated on the field of battle for conspicuous service to their daimyo and enjoyed hereditary status. Since they were warriors, one of the persistent problems of the extended peace was finding something for them to do; it was never solved and the samurai constituted a drain on the economy, an undigested element in society, and an unprepared, incompetent military force when the west finally threatened Japan. Yet contrarily, in the awakened regime that followed the Tokugawa, it was these same useless samurai who sprang into positions of leadership, who opened factories, wrote books and became the backbone of the nation. Theirs was the tragedy of the Tokugawa age, for had they been creatively utilized they could have fortified the state and preserved the system. Two subgroups of samurai were important. First were the hatamoto (banner knights) who were in all respects samurai but who owed their allegiance not to a

daimyo but to the Tokugawas. They lived mainly in Edo and were an arrogant, ugly, ruthless gang of ruffians whom commoners hated, regular samurai envied and national leaders feared. The ronin (wave men) were samurai whose daimyo had been deposed or forced to commit hara-kiri (belly cutting) for offences against the state. These unfortunate men were turned loose with no lord, no home, no job and no rice allowance to become wanderers or brigands. Several contradictions arise when one endeavors to understand the samurai. They were entitled to cut commoners down at will; yet the reiterated precept of the shogun was that a wise man did not draw his sword. They were commanded never to be seen in public without two swords (8) and failure to obey this rule could entail banishment or harakiri; yet the shogun taught that a man who had to draw a sword in anger had already lost the argument. They were one of the most dedicated military groups in history; yet for more than two hundred years they fought no war. Loyalty to their lord was the high religion of their lives; yet Japanese history abounds in instances where samurai betrayed their side or murdered their lord. The entire system was promulgated to protect the Tokugawa dictatorship; yet when the time of ultimate crisis came "there was but one case among the daimyo of unbroken allegiance to the government (Aizu)."† And although manly virtues were extolled, homosexualism among the samurai was common.

Farmers, as might be expected in a rice economy, were sentimentally revered as the foundation of Japan—"One farmer is worth two samurai" —and economically persecuted worse than animals. A policy was actually formulated whereby at the harvest "the farmer should be left just enough rice so that he neither lives nor dies." There were numerous instances in which all a farmer's crop was taken and he left to starve. Farmers were constantly exhorted to live frugally, buy nothing, never eat rice but live on coarser grains, never to ape city ways. "Farmers should always instruct their children never to abandon the plough under any circumstances. They can apprentice sons of weak constitution to various trades in town, but once they have put them to trade, they should not bring them home again, lest their urban habits and manners should affect good rural customs and traditions.‡ The ideal farmer was defined as one

† Itani Zenichi: "The Economic Causes of the Meiji Restoration," pages 191–207 of *The Transaction of the Asiatic Society of Japan*, Second Series, Vol. XVII, Tokyo, December, 1938, page 204.

‡ Honjo Eijuro: *Economic Theory and History of Japan in the Tokugawa Period*. Tokyo: Maruzen Co. Ltd., 1943, page 101.

who avoided marriage with city women, divorced his wife immediately if she showed a fancy to go wandering, paid no attention to the money value of his rice, and who lived only one degree above the starvation minimum.

Noticeably below the farmer in social position, and far above him economically, were the artisans, some of the most beautifully skilled workmen produced by any pre-industrial society. In weaving, sword-making, cloisonné, pottery, carpentry and lacquer work these men were extraordinary. They belonged to guilds and commanded the respect due their brilliant talents, but they were consigned to a class out of which it was almost impossible for them to climb.

It is difficult to describe or explain the contempt in which merchants were held. Possibly it arose from philosophical speculation about the state in which each class had an obvious job: rulers ruled; samurai fought; farmers grew rice; and artisans made things. But what did the merchant contribute? He was universally held to be a parasite, a corrupter of morals through his ostentation, a leech sucking economic blood from the samurai and a coward who would not fight in war. The most severe restrictions, both economic and social, hedged him in and numerous attempts were made to exterminate him altogether; yet he prospered and the history of both Tokugawa Japan and its prints is a reflection of his rise to power. Relentlessly, from 1603 to 1867, he gained ever more power. By peaceful penetration he overthrew the samurai and bought their titles which in previous ages could have been won only through valor. He made Japan over in his image and there are few chapters in world history more thrilling than the relentless rise of the Tokugawa merchant over almost every conceivable handicap.

In 1603 the total population of Japan was probably about twenty million. In 1726 a reliable census was taken and showed about twenty-eight million, which soon rose to thirty. Then, for more than a hundred and thirty years the figure remained stationary† until the end of feudalism permitted an increased food supply and released enormous national energies, whereupon population rose to its present eighty-eight million. Thus the entire period of print making was one of suspended growth, an age of wait-and-see in which the only substantial activity was undertaken by those classes of the population represented so often in prints. Taking the population as thirty million, we know that the noble and samurai

† Contrary to common belief, this growth pattern was not unique to Japan; a similar pattern was followed in India, Indonesia, Burma.

class comprised about two million people (hatamoto eighty thousand; ronin about sixty thousand at any one time); we can hazard a fairly good guess that farmers numbered about twenty-one million, artisans five million and merchants about two million, each of these major categories including women and children.

The Tokugawa system of government had much to commend it. Order was maintained. Justice was prompt, reasonably consistent and firm. A dedicated officialdom served with some intelligence and the welfare of Japan seems to have been considered at all times. The weaknesses of the system were those inevitable in dictatorship. Beheading, burning alive and crucifixion were used to keep the nation in line. Ruthless control of thought was practiced and it is difficult to believe that during this entire period there was not available to the general public one history of Japan, one work on economics, nor any kind of speculation on anything. Excellent books were compiled in all these fields, but were reserved for only a few of the top daimyo. Again and again one finds this comment applied to scholarly manuscripts which have come down to us: "This work was not published but was circulated secretly." The nature of the dictatorship, which began as a military one and imperceptibly shifted to a civilian bureaucracy, is indicated in one famous decree: Any law which had been in existence for fifty years could not be altered, even though faulty. Magistrates responsible for the execution of law were advised not to inform the population of what the laws were lest speculation be aroused. The Tokugawas were committed to a rice economy that could not support the nation, to a rigid social system that could not escape deterioration and to an intellectual strangulation that stifled growth.

After the first few years, the dictatorship was operated not by a single individual but by the bakufu (curtain government), the military command headquarters, a self-perpetuating committee of extremely conservative men. That they gave Japan effective government cannot be denied; that they totally failed to comprehend what was happening to the nation is equally obvious. Three special points are noteworthy. First, the bakufu kept the imperial family penned up in Kyoto as the symbol of their rule and scrupulously preserved the convention of governing in the Emperor's name. Like a farmer, the Emperor was allowed enough rice to exist on but not enough really to live, and it is one of the morbid fascinations of history to watch the Tokugawas carefully keeping alive the Emperor who would ultimately be the rallying point for their final

destruction. Second, it is true that from 1637 on the bakufu ruthlessly excluded foreign influence from Japan—an act apparently brought on by fear of the civil disruption which might be caused by Christian converts, all of whom were executed—but what is often overlooked is that prior to 1637 Japan had traded and traveled widely and seemed about to enter a vigorous program of imperialism. Also, during the long blackout of foreign influence one port was kept open for the Dutch at Nagasaki, through which foreign books were smuggled in really surprising number. Almost every surreptitious philosopher, medical student or economist of this period secretly learned Dutch, and the influence of Dutch thought upon subsequent Japanese history is incalculable. Third, the bakufu hated prints as the symbol of the rising merchant class. Prints were held to be corrupting, anti-classical, anti-samurai and a diversion which must be considered an incitement to disrespect and possibly riot. No definitive list has yet been compiled of all bakufu decrees directed against prints but I have found about two dozen typical laws; but just as the bakufu were impotent to eradicate the merchants so were they incompetent to halt the merchants' art.

What happened to Japan under bakufu rule should be obvious. Restrictive legislation prevented industrial growth and repressive legislation inhibited the growth of incentives which would have spurred rice production. Literally, the nation began to starve and a constant feature of the age was rice riots, invariably put down with cruel retaliation. Infanticide became common as a means of controlling population: "Only one boy is kept, the rest destroyed. If two or three be preserved the parents are ridiculed for cowardice."† Samurai began converting their rice allocations into money, a transaction on which merchants made handsome commissions besides gaining control of the rice for speculation, and slowly Japan shifted from a rice economy to a money economy. A travesty developed whereby the bakufu continued to govern Japan as if the old samurai-dominated order existed, whereas actually power was passing steadily into the hands of the most despised element of society, the merchant. By 1730 most samurai had either innocently lost ownership of their feudatory lands or had connivingly traded them in for ready cash. Now, with landless samurai abundant, merchants had to become money lenders and their rates were murderous. A

† Chikuzan Nakai, economic historian, describing conditions as he saw them at the end of the eighteenth century. Quoted in Itani, op. cit., page 207. His remarks apply especially to samurai families.

petition has been preserved which details the lamentable plight of the samurai who needed a loan: he first had to buy the merchant frequent dinners to smooth the way; then he had to pay ten percent of the loan in interest subtracted at the start; gratitude money was extra; and if the loan ran beyond four months, as most did, additional interest at the rate of thirty percent was added. (It is probable that interest and fees totaled about fifty percent annually.) The wealth of Japan was being siphoned off into the pockets of merchants and no one in the bakufu discovered an effective way to stop it.

Punitive measures, taken after the event, were experimented with and consisted of four logical steps. To rescue the samurai from their crushing burden of interest, debtors' holidays were periodically declared. These wiped out all samurai indebtedness to merchants but interest on new loans soon recouped the losses. Next, when merchants gained too great control of the currency it was ruthlessly debased, which decimated their profits but which speeded up business and brought them even greater riches in the new currency. The third step was outright confiscation of up to fifty percent of all capital holdings, a move highly recommended by contemporary writers: "The bakufu must order rich people in the cities to donate one half of the property which they have accumulated for years. No one will criticize this step as unjust."† But since the stolen money was promptly put back into circulation, the merchants just as promptly got control of it once more. So finally the bakufu resorted to a desperation measure: excessively rich merchants were thrown into jail and all their property confiscated. But of course others took their place.

Such repression bred in merchants a desperation and daring that is a mark of Tokugawa Japan. Their theatre became violent, passionate, their literature picaresque, and their prints bombastic and richly seductive. They held in their hands the future of Japan and from about 1765 on they appear to have realized this fact. When the great days of decision came one hundred years later, few merchants bothered to take the field against Tokugawa armies. They stayed home and financed the Emperor. Theirs was the ultimate triumph.‡

† From contemporary sources (1853) as reported in Honjo, *op. cit.*, page 207.
‡ Feudalism is generally held to have ended in Japan in 1867 with the overthrow of the Tokugawa dictatorship. This was about three hundred years later than the decline of the system in England, roughly contemporary with the change in Russia, and about fifty years ahead of Mexico. The pattern of change—the relentless and largely peaceful rise of a merchant class which allied itself with the interests of a hereditary monarchy as opposed to landed barons—closely resembled England's experience.

3

The Sovereign Line

HISHIKAWA MORONOBU

The first Japanese woodblock artist of any stature was a giant. He not only pioneered a completely new art form; some think the art never produced finer work than when he, with skill and dramatic force, produced his first bold prints.

The accomplishments of Moronobu were these. He established the visual patterns of an art. He made this art so Japanese in style and content—as contrasted to Chinese classicism—that all who followed in the field had to remain Japanese. He offered his art to the maximum number of people for the least amount of money. He poured into it a dramatic content that has never been surpassed in the graphic arts of any other nation. And he possessed a powerful yet fluid draftsmanship, a singing line, that is one of the finest accomplishments of Japanese art. Had he done nothing but exhibit this sovereign line he would have been immortal. That he accomplished so much more indicates his unusual stature.

In four respects he was the typical woodblock artist. He came from an ordinary background, his father being an embroiderer. He was self-taught. He understood the characteristics of all major Japanese schools of painting and was proficient in at least two. And he was an Edo man. He knew its canals and alleys, its sweep of park, its amusement centers and the day-to-day work of its roistering poor. Arriving in the city from the north as a young man, within ten years he wrote the first illustrated guide, supplying the teeming sketches too (8). He called himself "The Sparrow of Edo," a busy, prying fellow who jumped about inspecting all manifestations of city life. Witty, lusty, joyous, Moronobu was the typical man of Edo.

First he trained himself to be a skilled painter, studying the three cur-

2 1

rent schools, Kano, Tosa and genre. The first was markedly Chinese in character and although originally stressing black-and-white painting, had lately developed a brilliant palette including much gold leaf. It emphasized landscape and depended upon the patronage of the shoguns, who lived in Edo.

The Tosa school was patronized by the hereditary Emperor, in those days a man of no significance, who kept his palace in Kyoto, where he was virtually a prisoner. The Tosa school derived from Japanese tradition but in Moronobu's time had become ingrown and lacking in vitality. It stressed figure painting and narratives related to literary classics.

The genre school was of recent formation though of ancient derivation. At first it drew its members surreptitiously from the two historic systems but gradually there were open defections to its ranks. Even so, most of its paintings were unsigned. Most appear to have been done by Kano artists as a relief from the tediousness of their official Chinese-type work. These genre paintings were decidedly Japanese, depicting the common people in a multitude of vivid endeavors. Two at least of the genre paintings are masterpieces; the Hikone screen, which shows varied scenes against a gold-leaf ground, and a panel called simply "Yuna" (Bathhouse Girls). Six hussies are shown standing together in naturalistic and appealing style. Their costumes are vividly differentiated and suggested by means of a spare, beautiful line. This picture, probably of Kano origin, summarizes what the artists of that school accomplished when they slipped over to genre painting.

Moronobu inclined toward this new school but never altogether lost his Kano ability to use black and white with maximum effect, whereas his unprecedented command of human figures in moments of emotional stress probably derived from long study of the more dramatic content in Tosa art. Thus he was a distillation of important aspects of the three best Japanese schools.

His extant paintings are neither numerous nor especially outstanding. Most popular is the panel with mottled-gold background showing a girl walking to the left, her head turned back over her far shoulder. Her kimono is an attractive dull red ornamented with flowers and a sash of green and gold. The draftsmanship is excellent and the posture of the girl's body, bent at knee and head twisted, is most appealing.

Of quite different magnitude are the two six-panel screens owned by the Freer Gallery in Washington. They show the festivities of Edo on a warm spring day in the park. Eight boating parties are on the lake;

lovely women in palanquins chat with neighbors; there are processions and picnics and parties in the pavilions; and cherry blossoms fill the air. In these screens he approached greatness.

From these and other works we can deduce certain characteristics of Moronobu the painter. He was an average draftsman, a satisfactory designer and he had a pleasing color sense. He enjoyed introducing many human figures, each drawn individualistically, against landscape backgrounds, in which he excelled. The story content of his art was high. For example, in the Freer screens no matter where you look, you find yourself drawn into one of the eighty-odd separate groups of people. You are teased into guessing what they are talking about, what animates them. In this respect alone Moronobu is a fine painter, but it is doubtful if he could ever have achieved major status, for in a later chapter we shall meet certain Japanese painters who did and we shall perhaps be surprised at the quality of their genius, for it is little known in America. Moronobu would have had to be content with secondary status except that he stumbled upon a new function of art which Japan needed in that age and which was suited to his skills. The technique on which his fame was built—carving woodblocks and printing from them—was known in China at least as early as 750, in Korea by the year 1250 and in Europe by 1350. In Japan primitive prints like the one on page 25 had probably been made as early as 900 by monks who cut religious designs in wood which they then stamped on thin paper in sheets of six to one hundred impressions which were later cut apart and sold to pilgrims. Some uncut sheets have come down to us, so this is not conjecture.

In China, Korea and Japan it had also long been the practice to publish books by cutting them onto blocks from which copies were struck. Many years before Gutenberg, Koreans found it simpler to cut movable characters which could be reused instead of full pages; so throughout Asia there were skilled woodcutters. It was inevitable that occasionally publishers would introduce into their books not only text but rude illustrations as well. By the year 1600 this was commonplace in China and well known in Japan. It is also possible but not proved that Japanese artists studied Jesuit religious engravings introduced by European missionaries prior to 1610.

In no remote sense can Moronobu be said to have invented any technique. So far as we know, he added not a single scientific improvement to the printing process already in being. What he did was to adapt this

process to four felt needs of the common people: illustrated books in which pictures rather than text predominated; big illustrated albums in which there was no text at all; big single sheets which surrendered all pretext to being part of a book; and single sheets colored by hand to provide cheap substitutes for the paintings purchased by the rich. It was from the latter two innovations that the Japanese print developed.

Moronobu's books are unlike anything in western art. They are bold, tumultuous things in vigorous black-and-white design. They give the impression of an artist run wild, filling innumerable pages with drama and story. They include more than 150 volumes, each filled with writhing line and jet-black masses. Their subject matter covers all Japanese history, most of its literature, heroes from China, lives of poets, the seventy-eight major occupations of the Japanese countryside, landscape, principles of gardening and guidebooks. It was mainly through these vibrant books that the force of Moronobu was felt in Edo (8).

His albums are larger in size than the books, more impressive in artistry and fewer in number. Stitched at the right-hand edge, these big pages were usually folded down the middle of their 11 x 16 inch pages, but today of course their single sheets have become so valuable that all have been taken apart. The most famous album was *Yoshiwara no Tei* (Scenes from the Yoshiwara), which showed people who could not afford night life that went on in the gay quarter of Edo (9). Obviously

1 THE GOD BISHAMON

Unknown Buddhist Artist

Location: Museum of Fine Arts, Boston.
Size: Paper on which it appears 7¾ x 5. *Date:* 1162.
Iconography: In international Buddhism, pagoda in left hand indicates the conservation of all Buddha's teachings to protect Buddhistic doctrine. Sword in right hand represents the defense of the faith. In Japan, Bishamon is also one of the Seven Gods of Good Luck, so designated in 1624.
Technical: Figure carved on wood then inked and stamped on large sheets of paper, six figures appearing together for cutting apart later. Then thirty or forty sheets of six were stored inside the body of a religious statue, the back of each sheet containing the following words written in sumi (black ink): March 7, Second Year of Oho (1162). They were discovered within the statue in this century by the Kyoto artist Hashimoto Kansetsu.

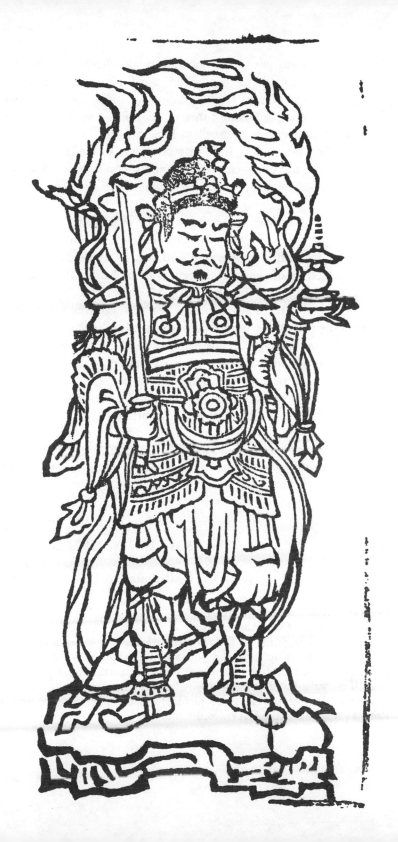

these album pages paved the way for single sheets, which promptly monopolized the field. Various artists issued albums in the Moronobu style and at least seven of these find a place among the major works of the Japanese print, but none surpasses *Yoshiwara no Tei*. This album contains not only dozens of excellent human figures, and an unsurpassed record of the Yoshiwara; it is also a masterpiece of landscape drawing as well as one of the best genre achievements, for it goes both into the open countryside and into the kitchen where fish are being cut up for supper.

Moronobu's happiest innovation was the single-sheet print, whereby poorer people were not required to buy complete albums. Unfortunately he signed none of these single sheets, so that today we cannot positively identify which he did and which were done by his many immediate followers. The print opposite is probably Moronobu's, although one Japanese critic doubts it. In any event the reader should take pains to fix in his mind the size of the original of this print. It is suggested that he find a sheet of rough brown wrapping paper and cut from it a panel 23 x 12½ inches which will indicate how impressive these prints must have been when first issued, plus some idea of the kind of paper used.

Moronobu's next innovation was inevitable, for he added dashes of color to liven up the big prints, most often tan (orange-red lead), whence the name tan-e (tan pictures), with occasional additions of citron-yellow and olive-gray (25). It is important to observe however that this gratuitous addition of color rarely improved the print. So

2 WAKASHU WITH SAMISEN

Attributed to Hishikawa Moronobu

Location: Museum of Fine Arts, Boston.
Size: 23 x 12½. *Date:* About 1685.
Kabuki: This rare print has for years been known as the portrait of a yujo (courtesan) but is actually the portrait of a wakashu (effeminate young man) as can be seen from the sword and the small shaved portion of the head. This wakashu plays as his dainty friends dance on stage.
Technical: Ichimai-e (one-sheet picture). Used expressly of early work. Print 25 was one of the first colored ichimai-e.

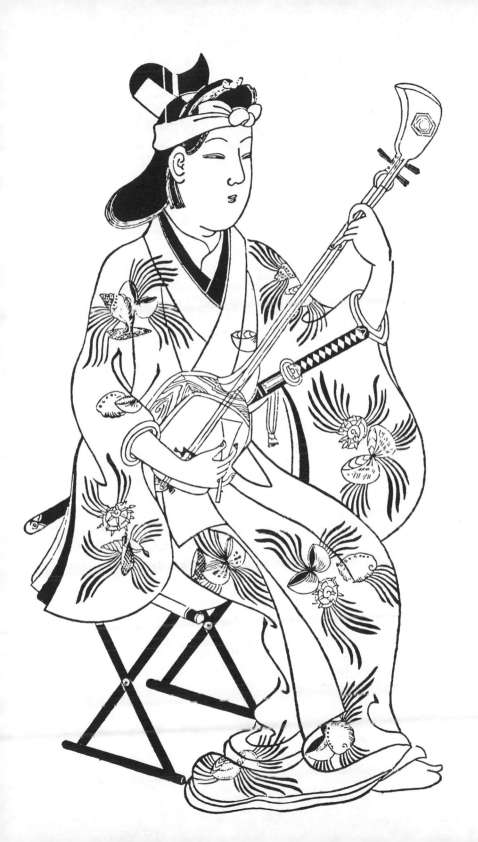

vigorous were the black-and-white designs that color was unnecessary, and indeed frequently a handicap.

Of the four illustrations cited, prints 8 and 9 are indisputably Moronobu's and 2 and 25 are either his or so close to his manner as to permit certain generalizations about his work. However, in the comments that follow reference is made only to signed work. Moronobu was a master of line and it was usually rough and bold. Especially in his figures of women with swirling kimonos (9) does he allow this strong line full sway, achieving a rhythm more powerful than sensuous. Fortunately America is rich in good copies of his books and album sheets, and from his *Iwaki Ezukusihi*, (Rock-Tree Picture Book, 1683), students can trace the obvious derivation of his strong line from Kano models.

But in that same book at the twenty-first double spread appears a most un-Kano type of picture: a bald-headed young monk in white looks over his shoulder at a haughty woman who moves off followed by her reluctant serving maid, who stares back at the monk, obviously attracted by his handsome appearance. It is impossible to look at this print without wondering what has transpired between the monk and the woman, what role the maid played, what will happen next. This ability to infuse a picture with maximum drama occurs in *Yoshiwara no Tei* and it is interesting to speculate upon the interrelationships of the people who inhabit print 9.

One of his special abilities is that of evoking historical scenes. I realize that this is not a primary function of art but it is an excellent asset if one is going to be a book illustrator. It would have been exciting to have filled the first portion of this book with his vivid pageantry of Japanese history: old Kumagai, one of the tragic figures of all history, about to slay young Atsumori, whose death will haunt him forever and provide Japan's noblest drama, in which Kumagai sacrifices his own son instead; Yoshitsune fighting Benkei on the bridge; tough Watanabe afraid of neither man nor devil, ripping off the arm of the latter at the Rashomon; the dedicated son Soga no Goro,† who will appear many times in this book, fighting Asahina, the man who conquered hell; Nasu no Yoichi shooting away the rivet of a distant fan to prove his skill. These and hundreds of other evocative compositions show why Moronobu delighted and awakened the people of Edo. He was their Plutarch.

† Such Japanese names are analogous to John of Gaunt and are read Goro of the Sogas.

In his historical series is one print that has been widely praised but which I once considered a lesser work. It illustrates the legend which was to become source material for one of Japan's most lyrical and poignant dramas: *Matsukaze*, which tells how this young fisherwoman and her helper befriend the imperial councillor Yukihira during his exile in their village (37). Moronobu shows Yukihira, his exile ended, about to depart for the capital and saying farewell to the two fisherwomen. I did not like the print because the background is cluttered, the women do not stand clear and Yukihira is placed so high on the page that his hat, which is an important feature of the design, is imprudently cut off. There are other weaknesses too, but now looking at the print afresh I realize what a mistake I made. Here is grief. Here are two fisherwomen who know that the man they both love is about to disappear forever. Here is a real man about to leave a scene of happiness to which he can never return. Great as is the drama *Matsukaze*, this print is greater and I regret its absence. Fortunately, it has often been reproduced and is available in many books.

Moronobu's weaknesses are always as obvious as in this print. His cluttered backgrounds obscure the main emphasis (8). His line, while strong, lacks the poetic sweep that later artists will achieve. Some critics have held that this was because his wood carvers could not keep up with him, whereas later artists had the advantage of superior artisans to help them. A study of his known paintings does not confirm this. His colored prints lack evidence of the sure color sense developed by many of his immediate successors, but here the critics are probably right when they suggest that he probably colored very few if any of his own prints. The fact that the color in print 25 is so good is one of the reasons why the attribution of that work to Moronobu has been questioned, but this may have been one time when he did the work himself. The design of few Moronobu prints is altogether pleasing. It seems as if his tremendous vitality of line and ebullience prevented him from keeping the various parts of his prints related. This is true of his single figures as well as his larger groups, especially when the background is not bare. Even the pages of *Yoshiwara no Tei* exhibit this weakness.

But his faults, although they prevent him from just claim to the elevated rank some writers would accord him, are trivial compared to his vital strength. He is, above all other woodblock artists, a pristine genius. He is closer to the wood, nearer to the big chunks of paper.

He is a man of the morning light, of outdoor spaces and laughter. His brush is charged with fire as well as ink.

The art he pioneered is called ukiyo-e. Debate upon this word fills many pages but the following facts now seem agreed upon. Two different Chinese characters have been used to represent *uki*—and they mean respectively *float* and *grief*, but in the age of ukiyo-e the latter usage seems to have been long since dead. Only one character was used for *-yo* and it means *world*. Therefore *ukiyo*, before it acquired artistic meaning, was a religious word carrying strong Buddhist overtones: the sad, floating, evanescent, grief-stricken world. The prefix *e*, as we have seen, means *picture*, so that *ukiyo-e* means literally a picture, possibly religious in import, of the evanescent world. A less appropriate title for the kinds of pictures we shall meet in this book would be difficult to devise.

The explanation is this: by the time ukiyo-e was adopted as the name for an art tradition it had undergone many transformations, had lost its Buddhist connotations and had come to mean just the contrary of grief-stricken or religious evanescence. Ukiyo now referred to something like the modern mode, the passing scene, the floating world of pleasure. In this vague sense it is appropriate and Moronobu's work epitomizes the word. But if it is difficult to define the word, it is impossible to say what it refers to.

Ukiyo-e cannot mean the same as genre, whose main principles developed long before the word became current and whose essence is a rugged realism. Furthermore, in the latter days of ukiyo-e its two most gifted practitioners, Hokusai and Hiroshige, worked mainly in landscape and not genre.

Ukiyo-e cannot refer to woodblock prints exclusively for three reasons. First, during the decades when the principles of ukiyo-e were being established, there were no prints. Second, even after prints appeared there continued to be a clearly defined ukiyo-e school of painters, some of whom like Miyagawa Choshun and Kaigetsudo Ando produced no prints. Third, almost all woodblock men were also good painters in the ukiyo-e tradition and several, in their later years, ceased making prints and retired to the more respectable occupation of ukiyo-e painter.

Ukiyo-e has sometimes been defined in terms of the cheapness of its prints and their availability to the common people, and this was certainly a major characteristic but such definition does not include

ukiyo-e paintings, which were expensive and which so far as we know were never sold to common people of low income. They were considered important, brought a good price and often found their way into upper-class homes.

Other proposed definitions of this contrary word have been suggested, but each can be punctured. One can only conclude that it has no precise meaning and is most inadequate for defining anything. But in common usage it refers to paintings or woodblock prints, particularly the latter, depicting scenes of everyday life, particularly those relating to beautiful women and actors. In short, no one can define the word, but everyone knows what it means: pictures of the floating world.

It is necessary to point out that Iwasa Matabei, who didn't invent Otsu-e, didn't invent ukiyo-e either, although many books claim he did and will probably continue to do so. How this second part of the Matabei legend became established is as difficult to rationalize as the Otsu-e segment. Partly it stems from Chikamatsu's play and its fictional painter, partly from many careless attributions to Matabei of anonymous ukiyo-e paintings; but when the man's proved work is studied it betrays no relation to ukiyo-e at all. He did no genre painting. His characters never appear in contemporary dress, and he is shown to be a gifted painter who experimented modestly in color but not in line or content. Of course he designed no prints. There is however one shred of support for Matabei's claim. We know that other painters of like reputation executed ukiyo-e work but refused to sign it; perhaps he did the same. But even this reasoning is destroyed when one recalls that in the signed work of such surreptitious workers who have now been identified there are some visible signs of a nascent ukiyo-e style. In Matabei there are none.

Furthermore, we need not really search beyond Moronobu for the founder of the print section of this earthy, pleasing school. That he had antecedents is granted, for ukiyo-e as painting antedates him by a hundred years. That some of them were of great talent is proved by the Hikone screen and the picture of the six yuna, but none of them bulk large. Moronobu, on the other hand, loomed out of Edo like a giant and the stamp of his massive hand was to be visible upon the prints of Japan until they perished sometime around 1860. Few arts can be so positively traced to one man. Few started with such magnificent vitality.

4

The City and the Stage

When Ieyasu, before he became the first Tokugawa shogun, was given as his feudal fief the broad and empty lands of eastern Japan, he selected as his daimyo's capital not the ancient town of Kamakura, which had once been capital of all Japan, but the completely insignificant crossroads of Edo, a village of one hundred houses, whose lonely countryside was described by a contemporary poet as follows: "The wide plain of Musashi has no hills at all where the moon sets, sweeping o'er a sea of grass." Most of what later became a glittering world capital, Tokyo, was marsh; much that was to house the glory of Japan was under water.

In 1603 when the Tokugawas gained control of Japan, this trivial village of Edo became the capital of the nation and a transformation occurred that is still difficult to believe. On a small hill a castle was rebuilt. A larger hill was completely leveled, the earth being hauled into the marshes to make new land. Scooping out enormous moats provided additional earth for building more land. All Japan sent stone to face the moat and artisans to build the city, which fortunately had burned down in 1602 so that a whole new start could be made.

Shortly the general aspect of Edo was determined: the shogunal castle within the vast moat; residential areas near modern Kanda and the Yasukuni Shrine; a business area near Nihonbashi (Japan Bridge); a big park at Ueno; a commoner's paradise of shops and temples and entertainment at Asakusa; and outside the city limits the gay quarters of the Yoshiwara. Even then many parts of modern Tokyo remained under water to be reclaimed year by year. In twenty years the population was a hundred and fifty thousand, by 1700 more than half a million and by 1787 well over a million and a quarter.

Throughout this entire period daimyo and samurai occupied about two-thirds of Edo, even the minor daimyo owning two or three major residences while the great outside daimyo often had as many as six separate palaces with huge gardens and wooded retreats. Other spacious areas were reserved for shrines and temples, while the despised merchants never occupied more than one tenth of the city. But the area they did concentrate in became a focal point of Japanese life. It centered upon the Nihonbashi (8) and included the muddy land between the Sumida River and the shogun's castle grounds. Here in time developed the business and banking heart of the nation. As early as 1650 the powerful department stores that still grace Tokyo were launched and in 1673 the most powerful of all, the Mitsukoshi, was in operation, but under a different name. Rice warehouses lined the river, theatres occupied a glamorous street of their own and ukiyo-e publishers dotted the area. Along the canal the city jail sprawled and every kind of commercial activity crowded the narrow alleys of what was to become Chuo-ku (central ward). It was properly called the belly of Japan, for here rice was ultimately controlled; but it was also the intellect and possibly the heart of the islands, for here books were circulated. Specifically, the great majority of ukiyo-e artists lived in this confined area, published their prints here and sold them in shops near the Nihonbashi.

The relationship between ancient Kyoto and brash young Edo must be kept in mind.† Kyoto was a classic city, copied after the orderly lines of an antique Chinese metropolis; Edo was an unplanned collection of autonomous communities connected by winding footpaths widened into streets. Kyoto was conservative; Edo was bright and brash, it being said that no man was a true native of Edo if he kept a coin in his pocket overnight. Kyoto preserved old ideas, old conventions, including the desiccated Emperor; Edo was the innovator and housed the more virile shogun. Kyoto was the source of most fine workmanship and exported enormous quantities of fine wares, books and genteel courtesans to the rich new city of the east; Edo was the producer mainly of quantity goods of mediocre quality. For example, many Edo leaders sought Kyoto wives, and the wives insisted upon Kyoto dresses and tableware, one going so far as to demand Kyoto

† It is impossible to convince visitors to Japan that Kyoto lies almost due west of Tokyo, less than a degree of latitude between them. Everyone believes the older city is far to the south, and even though I have lived in each, I still unconsciously write "south to Kyoto."

water for her ink stone, Edo water being too rough for really fine writing. Rivalry between the two cities never ceased and once when a Kyoto bell was about to be dedicated bearing the florid inscription, "In the east it greets the pale moon, and in the west bids farewell to the setting sun," shogunate officials halted proceedings on grounds that Edo was denigrated. Kyoto men took quiet pleasure from their conviction that Edo was nouveau riche, while Edo men composed ditties about the western city that are quite unprintable.†

Social life in Edo was divided sharply into three categories. First came the somnolent yet invigorating pageantry of court and daimyo circles. Tea ceremonies, games of identifying incense and stately ritual marked this life. At the bottom of Edo life came the tea houses of the general populace, open-air places for gossip where one could waste a day over a dish of dumplings. In between these extremes the rising class of merchants built themselves a fascinating social life to which men could gain entrance either by wealth or talent. It is this world, slowly emerging as the very soul of Edo, that is memoralized by Japan today in much the way that Ben Jonson's Mermaid Tavern and Doctor Johnson's coffee houses are sighed after by English-speaking people.

Three quite different citizens of Edo recall the flavor of the age. Fukai Shidoken was a young man of such brilliant capacity that he was sent to become a Buddhist monk. Learning his lessons rapidly he caught the attention of the authorities and was placed in charge of the beginners; but his behavior with them was so scandalous that he was kicked out of the priesthood. Then began the long years of his life as a beggar. Dressed in priest's garments and tonsured, he saw a good deal of Japan and picked up hundreds of stories, so that one day while watching the crowds at Asakusa in Edo the thought occurred to him that he had at his disposal a ready way to earn a living. Accordingly, he set himself up at a wooden table under a huge tree and here he told with wonderful mimicry the boisterous folk stories of Japan, larded heavily with obscenity. He became enormously popular and had carved for his use a huge wooden phallus with which he hammered the table to emphasize exciting passages. Many delightful prints have come down to us showing this disreputable priest, toothless,

† During World War II the United States adopted the time-honored attitudes. Ancient Kyoto, with more than 1,100 temples and shrines, was never bombed and survived the war untouched, one of the most treasured museum cities on earth. Tokyo of course was almost totally destroyed and is now rebuilt into a splendid metropolis.

grinning, about to beat the table with his gavel. One famous large print by Toyonobu shows him at his heyday when he owned a little house which he used as a theatre, roaring out his hilarious stories. He sold love potions, horoscopes, ready-written letters and anything else to make a mon (old coin equivalent to about one cent today), but he seems never to have earned enough to slake his monumental thirst. In 1763, when he was over eighty, friends published a book to help pay for the sake (rice wine) he consumed each day.

Just as Shidoken was passing from the Edo scene an amazing fellow entered the city from Sendai to the north. Dohei was a huckster who sold rice jelly. Dressed in wildly conspicuous clothing, he roamed Edo streets hawking jelly and chanting songs which he seems to have made up and which captured Edo imaginations. It is recorded that children followed him through the streets, singing along with him, and some of his ditties exist today in children's games: "In Sendai, in Sendai by the building of the big bridge I caught a mouse. I shaved her forehead, bound up her hair and sent her out to sell cakes. Then at once the cat ate her up as well as the box of cakes. A second time I shall send no mouse to sell my cakes." It is said that when Dohei sold his jelly in one part of Edo, other neighborhoods protested and sent to know when he would visit them. To increase his reputation he printed his songs from woodblocks and some of them have survived in that form, suggesting other reasons why he may have been so popular:

> *Hearest thou, maiden?*
> *For my supper*
> *I need no wheat-meal dumplings.*
> *What I need is thee . . .*
> > *Sansho no se,*
> > *Dohei, Dohei, Dohei.*†

And when Dohei was about to leave the streets of Edo, his lilting minstrelsy echoing long after his departure, one of the most extraordinary men in Edo history appeared. Tanikaze (Valley Wind), a chronicle states, "was the greatest wrestler who ever lived and for him we can find no parallel in our history." When born in 1751 to a poor

† The beautiful portrait of O-Sen (6) is taken from a contemporary book celebrating Dohei.

farmer in the north of Japan, he weighed thirteen pounds and at age seven he was eating twenty-five times as much rice as a man. At nine he frightened villagers by his strength and was soon spotted by a wrestling manager who happened to pass by. Tanikaze traveled to Edo, where he was a sensation. Standing a little over six feet tall and weighing 365 pounds before he got heavy, he won 183 out of his first 220 matches and was proclaimed a grand champion. Then he accomplished something almost impossible in Japanese wrestling, where an opponent has nearly four dozen tricks by which to throw even the greatest wrestler off balance in one lucky thrust. He won sixty-three straight matches. At this time his portrait appeared in many ukiyo-e prints (52) and he dominated Edo conversation as no athlete has since. Like many men, he was fortunate in having a heroic opponent, Onogawa, who was almost as good as he. They met twenty-one times, before the shogun, in major cities and at special matches, and Onogawa won twice, but each match was historical. So astounded were the people of Edo when Onogawa finally defeated the giant champion that a rumor was quickly circulated: Onogawa had met Tanikaze that morning at the warehouse of a rice merchant and had challenged him to a rice-lifting contest. Tanikaze, insulted, had hefted away with all his energies while Onogawa made believe so that when the wrestling match occurred Onogawa won easily. Dozens of similar folk tales are still told about the monster: a wily merchant displayed a bag of rice casually on the ground and bet passersby that none could lift it, but they didn't know that a stake had been driven deep into the ground and the rice bag tied to it. Tanikaze, of course, ripped up bag, ropes and stake. Again, a poverty-stricken wrestler of no ability had only one virtue: he loved his father and suffered mightily for him. So struck was Tanikaze by this filial devotion that he allowed the poor wrestler to throw him and win a huge prize, with which he opened a shop for his father. There were many wrestlers in Edo, and ukiyo-e artists did massive portraits of them. But none equaled Tanikaze.

Even more than wrestling, however, the people of Edo loved the theatre. At dawn each day, along a narrow street not far from the Nihonbashi, huge mournful drums would be beat for nearly an hour, calling the citizens of Edo to the theatres. Outside, on brilliant big panels of wood, posters identifying the plays and players lured the customers as daylight broke. Tickets were not expensive, especially since a performance lasted about twelve hours, from dawn to dusk.

Inside the theatre (30) plays of extreme violence, wild emotion and the most graceful pantomime were presented by actors whose fame rivaled that of either Tanikaze or Shidoken. This was the kabuki (song-dance skill) theatre of Japan, one of the most vigorous and colorful ever developed and just about as vital today as it was in 1700.

It is not an especially old theatrical art, having been started in 1586 by a dancing girl who appears to have learned simple religious dances at Japan's oldest shrine at Izumo, where all the gods of Japan spend the month of October. Leaving Izumo, she came to Kyoto, where it was the custom to have gentle entertainment on improvised platforms along the dry river bed in summer. O-Kuni delighted the staid people of Kyoto, for starting with a demure temple dance she suddenly burst into a most erotic performance, enlivened it with comedy, new dance steps and unexpected music. So complete was her success that imitators launched professional troupes comprised of attractive young women who conducted another business after hours. In time these troupes became such a public scandal that the government had to abolish them as offenses against national morality.

So what had been called Onna Kabuki (Women's Kabuki) was abruptly transformed into Wakashu Kabuki (Young Men's), where gross immorality of a different type flourished until the young men also were driven off the stage (31). It was then that kabuki discovered its permanent characteristic and allocated all roles to adult men of mature reputation and responsibility. By 1664 a complete play in more than one act was performed and soon thereafter the powerful classic repertory of kabuki was being assembled.

Kabuki derived from many ancient and often peculiarly Japanese sources,† chief of which were ancient religious dances, mask dances largely imported from the mainland of Asia and strong, rough earthy dances from the countryside of Japan. By the fifteenth century these largely formless dances had been combined into the stately and powerful noh (the ideograph for this word means skill, faculty, power; it has come to mean a lyric drama). Many of these poetic plays have been translated into English (37). With the noh drama we are approaching kabuki, especially when one considers the rollicking farce interludes used to relieve the austere quality of the noh. These boisterous amusements were often lifted with little change into kabuki, where they have

† An excellent account of these beginnings is found in Fauhion Bowers· *Japanese Theatre*. New York, 1952. Since kabuki and ukiyo-e are so interrelated, anyone interested in pursuing a study of prints should inspect this book.

thrived. Thus by 1586, when O-Kuni launched her improvised performances along the river bottom of Kyoto, a sophisticated art form combining pantomime, music and high comedy was available. Kabuki could have grown directly from these honorable antecedents.

But nothing in Japanese art is as simple as that, so while the sensitive noh drama waits to be utilized we must double back to consider other antecedents. As early as the thirteenth century, narratives of heroic or passionate action became common throughout Japan and were recited with much effect by professional chanters. In time one love story excelled all others, the tragedy of Yoshitsune and Princess Joruri (page 120), so that the account of her suicide became the generic name for such narratives: joruri, in which the deeply moving dramas of Japanese life were remembered.

The path from joruri to kabuki—it being obvious that the bloody and moving subject matter of joruri was just what kabuki needed—was an unpredictable one. In Osaka a puppeteer joined forces with a joruri chanter and a skilled master of the samisen (a banjo-like musical instrument introduced to Japan from Okinawa in 1560; it is usually pronounced shamisen). The result was one of those happy artistic inventions which captivates a society. Puppets were ideal for acting out the grandiose stories of joruri. Big dolls (7) were manipulated by three men, one in full dress and two in black wearing masks which made them—for all except the literal minded—invisible. Slowly and with an unforgettable awkward grace the dolls moved back and forth across a narrow stage while samisens played and chanters bellowed and whispered and roared and simpered. Dramatically the effect was deeply powerful and soon some of the most skilled writers produced by Japan were composing important dramas for the dolls.

Chikamatsu Monzaemon (1653–1725) was the first of these excellent playwrights. He produced more than a hundred plays, including twenty-four domestic dramas of real merit. Spurred by his inspiration, the puppeteers of Osaka created a theatre which for vitality, color and impassioned drama has been excelled only in the days of Aeschylus and Shakespeare. Chikamatsu was fortunate in having at his disposal magnificent dolls able to imitate almost any human action, good musicians and frenetic chanters whose command of the human voice remains legendary. Other fine dramatists followed Chikamatsu, including the gifted Ki no Kaion, who told the story of the girl who burned down Edo for love, which figures so often in these pages (27).

Now everything was available to kabuki: the classic grandeur of noh, the comedy of farce interludes, the vigor of rural dancing, the samisen from Okinawa, the dramatic use of the human voice as practiced by joruri chanters and the fine plays developed in the puppet theatre. Most of all—and this is what has kept kabuki alive—there was an acting tradition ready for adoption. It was the tradition of the manipulated doll, and the secret of kabuki acting is that the original presentation of most of the great roles took place in puppet theatres, so that when these roles were adapted to the kabuki stage, the actors were inspired to imitate not life but puppetry. As Bowers says so happily, "However much the public liked to see puppets acts as humans, they were more delighted to see actors perform as puppets." On its own, kabuki added the most dazzling costuming ever brought into any theatre, skilled stagecraft and a theatre stage so big that complete houses could be built upon it, so tricky that ghosts could rise out of the floor or the floor itself turn upon a vast circle and disappear.

The people of Edo loved this theatre. They were fortunate in that a group of actors commensurate with the stage and the grandeur of the plays developed. Five of these superlative men are still remembered in Japan. Nakamura Shichisaburo (10) represented the hero of the softer domestic dramas. He appears in many prints, where his handsome deportment illustrates his basic acting principle: that he should look as well from the rear or side as from in front, and that he should perpetually give the illusion of a man acting. Ichikawa Danjuro I was quite the contrary. A bombastic, original and fiery man with tremendous voice, he literally filled the stage with his violence and tore scenery apart. He wrote many plays for himself, which means that he invented some trivial business upon which he could hang a ranting display, often screaming words that had no meaning but that did have exciting, rounded syllables. Many of his plays descended from a popular type of joruri invented some years before his arrival as a great actor. They were called Kimpira joruri and related the fabulous doings of Kimpira, the Japanese Hercules. Together, the styles of Shichisaburo and Danjuro were to exist in kabuki for 250 years, as they do today, and when one has seen either style for long, the other comes as refreshing antidote.

Danjuro II (11, 29) was one of the most popular kabuki actors, a thoroughly rounded performer who apparently could do everything well, but even so he never attained the almost ridiculous popularity

enjoyed for a few years by Sanogawa Ichimatsu, whose story is briefly told with prints 31, 33, 34. Danjuro V, the last of this notable quintet, is fully covered in prints 41–46.†

The plays that developed for kabuki alone, in contrast to the masterpieces written for the puppets, were likely to be an odd lot. Playwrights were pathetic hacks whose major job was to smack boards together to indicate climaxes, and we know that if an actor had a speciality such as playing the samisen particularly well, the playwright would be ordered to whip up a play in which the star could exhibit his musicianship (35). Plagiarism became so common that the word lost its meaning, but most confusing was the trick of taking a contemporary event and rewriting it so that both it and its characters became part of one of the kabuki worlds. This confusing habit can best be explained by reference to the Soga world.

Altogether there are more than three hundred plays dealing with the Soga brothers and their revenge upon the man who killed their father when they were mere children of five and three. For sixteen years they plotted revenge but repeatedly they failed, for their adversary was a grown man with a powerful position in government who suspected they might try to kill him.

Finally, on May 28, 1193, on a dark night heavy with rain they slipped past the guards and crept into their enemy's lodge. Shaking him from his slumbers, they formally announced themselves as sons of the man he had murdered and slashed off his head. Then, instead of trying to escape, they stepped out into the rain and began to shout news of their revenge. Immediately they were surrounded by guards and the older brother was killed. The younger, having fought his way

† The complex kabuki system of training and naming actors is illustrated by Ichikawa Danjuro V. He was born in 1741 to Matsumoto Shichizo and was called Umemaru, but upon making his stage debut at age four he became Matsumoto Kozo. In 1754 his father assumed the august name of Danjuro IV and he became Matsumoto Koshiro III. In 1770 his distinguished father, feeling his vigor lag, surrendered the name Danjuro to his son, who became the Fifth, the father taking the name his son had graduated from, Matsumoto Koshiro, but the Second. In 1772 the father surrendered Koshiro and took still another famous name controlled by the family, Ichikawa Ebizo II. In 1778 the father died and Danjuro V became the head of the family. In 1791 he felt himself slipping and turned the famous name over to his son, assuming the lesser name of Ichikawa Ebizo III. When he retired in 1796 he took the honorary name Shichizaemon, and when he died he was referred to only by his Buddhist posthumous name Kwanyo Johon Daiyu Hosshi. In addition he used three different names for writing poetry, Omegawa, Hakuyen and Hanamichi no Tsurane. And when he appeared on stage the people of Edo shouted none of these names but a cryptic nickname, Naritaya.

free, was trapped some days later by a spy dressed as an old woman. He was executed.

Memory of the youthful heroes became the focus of a cult, and warriors swore "devotion to the Soga brothers." Naturally, details of their revenge became confused and enlarged so that today even so simple a thing as their ages can no longer be determined, ten books giving eight different versions. But invariably in January theatres present some part of the Soga story to remind Japan of filial piety, and Juro (29) and Goro (32) act out their revenge.

Dramatic though this history is, it would not warrant the construction of three hundred plays except that kabuki audiences became so fascinated by the story that whenever a contemporary incident of roughly similar nature occurred, it was recast into the mold of the Soga revenge and offered as a new play. For example, in 1701, during the Genroku period, two brothers killed a villain who had murdered their father. Instantly they were hailed as the Genroku Soga and a play reporting their exploits was imperative (58). Naturally, it was thrown into the Soga world. To the western mind, jamming varied dramatic material into the procrustean bed of one world or another weakens the effect of something worthy of standing on its own, but to the Japanese theatre patron the result is warmly gratifying. There comes a sigh of relief and recognition when late in a play the hero turns out to be one of the Soga boys after all. Synopses of kabuki plays are peppered with such phrases as "who is none other than Soga no Juro," or "in reality Soga no Goro."

A patient Japanese who had lived in the United States explained it thus: "Suppose the great dramatic story in America was the friendship of Washington and Lafayette. There would be a dozen plays. *The Generals at Valley Forge. The Generals at Yorktown. The Generals at Trenton.* Then you come to the War of 1812 and Washington is dead. But who saves New Orleans? On the stage it's General Jackson but at the end of the play the audience discovers it was really Washington and Lafayette. Who fights the Indians? Who builds the Union Pacific railroad? In the Civil War who were Abraham Lincoln and Robert E. Lee? None other than Washington and Lafayette. And so it would go right down to World War I where the meeting of Pershing and Foch would take on unbearable excitement when the audience found out that it was really Washington and Lafayette!"

Of the theatres it is necessary only to report three curious facts. Gentlewomen were not supposed to attend kabuki, but the fascination of handsome actors was irresistible and most of the famous scandals revolved about noble women who surreptitiously slipped into theatres to become involved with actors. Theatres burned down with monotonous regularity, the two leading houses each having burned completely in March 1760, October 1761, April 1766, April 1772, January 1781 and October 1783. This meant that rebuilding kept the companies constantly bankrupt and a system was devised whereby each theatre had an alternative name, so that when debts exceeded manageable proportions the company simply went out of business and opened shortly under a new name, keeping that until hopelessly engulfed, whereupon the old one would be resumed for a fresh start.

There was another section of Edo given over to pleasure, the notorious Yoshiwara (originally Rush Moor, but later another character was used for Yoshi, meaning joyful or fortunate), assembled in 1617 by an enterprising businessman who memorialized the government as follows: First, Kyoto has a pleasure quarter, as do all big cities, and for Edo not to have one makes the capital look bad. Second, unorganized prostitution is detrimental to public morals and diminishes real estate values. Third, at present citizens of Edo patronize these places and get drunk and sometimes stay three or four days, which is a disgrace, for in an organized district they would be thrown out at dawn. Fourth, police find it difficult to check on scattered areas, so kidnapping of little girls is common. Finally, should the government allow me to build one big district, my associates could spy upon any doubtful characters who might be enemies of the state and report them to the authorities.

The petition was so reasonable and promised such assistance to the government that approval was forthcoming, resulting in the world's largest and best organized district. In 1657 the original Yoshiwara burned down completely, along with most of Edo, whereupon the district was moved to its present location, where it has existed with no great change for early three hundred years.† At the height of ukiyo-e's history, when the greatest artists issued series after series depicting the wonders of the Yoshiwara, the district consisted of 153 separate houses, 3,289 courtesans and 394 tea rooms.

† The fires which periodically ravaged Edo usually reached the Yoshiwara, which in 220 years burned completely eleven times and almost completely sixteen other times.

The mood of the Yoshiwara was one of cherry blossoms. Down the central Nakanocho flowering trees were kept in tubs and along the high fences that lined the moat blossoming branches peeped. At the O-mon (great gate), where a sworn guard stood twenty-four hours a day to prevent escape, the view of flowers was constant. And along the narrow streets, for the Yoshiwara was constructed like a small city, as dusk fell some of the most beautiful women in Japan took their places behind bars, sitting in little cages so that visitors could inspect them (9).

Journeying out to the Yoshiwara from the center of Edo took about two hours and price lists for the trip have survived: "From Nihonbashi to the gate of the Yoshiwara, ordinary horse, 200 mon. Ditto, but with a white horse richly caparisoned and two footmen singing the Komurobushi song in clear voices, 348 mon." Costs at the Yoshiwara were very high, which primarily explains why merchants were welcome and samurai were not. One had to tip at least eight different servants, could arrange for meeting one of the girls only through the services of a tea room and in self-respect had to throw around a good deal of extra money, it being customary not to expect change. The most beautiful girls were known as keisei (those who wreck castles) because to attend them frequently would ruin even the richest man. A novel by Ihara Saikaku, a contemporary of Chikamatsu the playwright, tells succinctly what happened to men who surrendered to the castle-wreckers: "A man who had inherited a fortune from a thrifty father increased it greatly by practicing still greater thriftiness. One day, on returning home from a funeral, he picked up a sealed letter. He opened it to find a message from a client to a courtesan enclosing a gold coin. As, from the letter, the woman appeared to be in a very miserable state, he went to the trouble of calling upon her in the gay quarters in order to give her the money. She was, however, too ill for him to see, and he, once in the place, felt reluctant to leave immediately. So he decided to take as much pleasure as that piece of money would cover. The experience so delighted him that he was led into a life of debauchery and ended with squandering his entire fortune."

Certain amenities were rigorously followed in the Yoshiwara. Visitors treated the girls with deference. A completely stilted dialect was developed in the district, many of the phrases later passing into polite usage. And no man was permitted to wear his swords into the houses, for it was known that girls imprisoned within the moats would grab

for anything with which they might commit suicide. The Yoshiwara had many evil aspects but none worse than its methods of conscripting inmates. Judges could sentence girls to the district. Parents could sell daughters. Husbands could sell wives. Rascals could kidnap children or adopt orphans. The whole range of human evil was represented in this system, compounded by the fact that once inside the walls, escape was physically impossible and economically improbable, since from the day of her arrival a girl was presented with one paper after another to sign, all methodically legal, which committed her to pay interest charges at thirty to forty percent on petty loans that would last out her life.

Of course there were poetic and tender moments too. The Yoshiwara was marked by some of the most beautiful pageantry in Asia to which Edo families and their children would come as if to a picnic. Then too, each year some dashing young man would fall desperately in love with a courtesan and either spirit her away, which was extraordinarily difficult, or buy her, which was expensive. And finally, there was within the Yoshiwara the fellowship of the finest intellects of the age. Not only were some of the girls superbly gifted (54), not only were books circulated there more widely than in the rest of Japan, but the men whose thought was modifying national life made the Yoshiwara their Bohemia. For them little money was needed. They lounged in tea rooms, fell in love with girls who came to see them at the end of work, and talked. They proposed new ways to write poetry, and did so. They discussed novels that ought to be written, and wrote them. Many of the artists represented here brought to the Yoshiwara both their sketchbooks and their hearts, improving each inside the great gate. And the political philosophers of the age, unable to publish their speculations or perfect them in a parliament, met here to ponder the future of Japan.

A little while ago in Tokyo I was called to an early morning meeting with the president of one of Japan's finest universities, his professor of religion and his professor of Chinese philosophy. The men were late and when they arrived laughing, the professor of religion explained, "We were out last night. To the Yoshiwara." When my jaw dropped a bit he added, "Not the girls. The tea houses and a lot of talk. For generations men like us have done most of our serious talking in the Yoshiwara."

5

The Dramatic Vision

TORII KIYONOBU I · TORII KIYOMASU I ·
TORII KIYONOBU II · TORII KIYOMASU II

Three mysteries of considerable magnitude obscure the study of ukiyo-e. The first, which we now meet, is totally bewildering. The second is tantalizing and the third is one of the most profound problems in the entire field of art. Taken together, these three mysteries are matched only by the shadowy question of Greek painting. We know that in Athens a major art once flourished, and we even know the names of some of the artists such as Apelles, but we possess not a single painting to study. We must depend only upon vague oral and written traditions that this masterful art did indeed once prosper.

The mystery we are about to attack is rather the reverse. We have in our possession a collection of work clearly signed and containing some of ukiyo-e's greatest masterpieces. But we cannot be sure who created it.

The work consists of nine distinct types of art, including famous books, dazzling black-and-white single figures, exquisite pictures of birds, arresting landscapes and above all, tremendous big pictures in furious line and striking color which show scenes from stage plays. This is the work of the early Torii masters, the professional sign painters for the Edo theatres. It is really not very important to know who created these powerful and contorted works. It is enough to know that taken together they comprise one of the most dramatic visions of the external world ever contrived. Their underlying basic concept is theatrical. Even the exquisite bird pictures show eagles and hawks about to tear lesser creatures apart. Everywhere there is dramatic power which leads one to believe that their creators must have been

very good sign painters. Often their wild, tremendous designs can be caught across a room, yet as we shall see their work is not merely fustian, for it also contains great statuesque beauty, tender poetry and those intimate qualities that can result only from the closest observation of human beings and their natural surroundings.

Tradition distributes this remarkable body of work among four theoretical artists—Kiyonobu I, Kiyomasu I, Kiyonobu II and Kiyomasu II—who flourished from about 1687, when striking work was produced by someone calling himself Kiyonobu, to 1763, when a man of very little talent calling himself Kiyomasu died. It must be understood that the designations I and II have been created by critics and were not used by the artists themselves, who signed only the names Kiyonobu and Kiyomasu. Trouble arises from the fact that on some prints both names appear (27) and the German critic Rumpf claims there is one print, the first copy of which is signed Kiyonobu; the second copy is signed Kiyomasu.

Without plunging into the total confusion that surrounds this problem, it is sufficient to state that some critics have claimed there were only two artists who used the names indiscriminately; others claim there were six. And no matter what theory we settle on, we cannot be sure what the relationships were between the artists we have selected. For instance, it is not known whether Kiyomasu I, a really great and gifted artist, was the son, son-in-law, adopted son or brother of Kiyonobu I. In fact, it is seriously proposed that he was actually Kiyonobu himself, under a different name.

It would be fruitless here to review the speculation that confuses this unusual mélange of written history, oral tradition and known facts derived from the prints themselves. Let us approach the problem in a way not attempted before. Let us see what works these men left.

First, there are about a dozen striking prints, dating from about 1695 to 1715, which consist of big, powerful black-and-white portraits of women, young men and occasionally actors. These people fill their prints and stand in majestic dignity, sweeping their gaily decorated kimonos about them (3). The black line of these prints is both strong and vital. It swirls in great designs and seems to have a life of its own. Occasionally the kimono is decorated with Chinese written characters; in such cases the relationship between calligraphy and Japanese art is clearly seen, for the vital sweep and swirl of beautiful

handwriting is picked up and translated into forms of great visual beauty. Faces are customarily drawn with a finer line and sometimes are overwhelmed by the more rugged drapery. The human figures are well proportioned, stately, satisfactory to the eye, handsomely posed. Invariably they are placed on the empty page with uncanny taste and judgment so that they seem to be about to spring into motion. These massive black-and-white Torii prints constitute one of the glories of ukiyo-e and their statuesque grandeur remains in the mind long after the more delicate prints of a later age are forgotten. Fortunately, several copies of each subject often exist, and American museums have their share. They are among the art treasures of the world. They are signed either Kiyonobu or Kiyomasu, those with the latter name tending to be more graceful and poetic, those with the former more powerful and architectural. There are no disappointing subjects in this vital series. There are none where the essential beauty of black and white is lost. Critics find in these prints justification for almost any theory. Supporters of the idea that one man drew them all point to the admitted similarity of pose and essential style, while those who prefer to think there were both a Kiyonobu and a Kiyomasu find to their satisfaction that two distinct artistic personalities can be detected. This much is agreed upon: the prints were early work and although clearly in the Moronobu tradition were not slavishly dependent upon him; powerful original ideas were added, and the type of print thus devised remained popular for at least twenty years. The reason for their issue seems to have been three-fold. Those depicting actors served both as advertisements and as cherished mementoes of theatre going. They were probably purchased by men and women alike. Those depicting famous courtesans of the time were probably commissioned either by the houses in which these girls worked or by their principal patrons. In either case they were a form of public advertising. The remaining pictures of effeminate young men were likely to have been commissioned by wealthy older men. In any event, these bold and striking prints became a feature of Edo life, bespeaking the strong and heady pleasures newly available in the young city.

Second, there are more than a dozen powerful prints dated between 1698 and 1712 which are almost identical with the above but colored by hand in swashbuckling orange-red, yellow and a subdued olive-green (27). In general they tend to be slightly more complex in design than the uncolored prints, possibly because they came later, and sometimes

the contorted poses are less satisfying. Nevertheless, each print exhibits the same powerful drawing, the swirling line and the uncanny placement. Curiously, it is the addition of color which keeps these imposing prints from reaching the stature of the plain black and whites. Rarely does it enhance the design as color should, nor is it of itself beautiful as color sometimes is, nor does it accentuate the interest of the figure. An exception, and there are several, would be the unsigned print formerly in the Ledoux collection and now in the Metropolitan in which Monaka, a public beauty, reads a poem beginning, "Life is full of trouble, but the plum blossoms by the window. . . ." In this fine print the design is preserved because the kimono is predominantly black, so that when orange-red and yellow are added a most satisfying design results. These prints are often unsigned; sometimes they bear the name of either Kiyonobu or Kiyomasu; occasionally they are signed Kiyonobu and sealed Kiyomasu, or vice versa. Those attributed to Kiyomasu are usually better designed and more pleasingly colored, but this is only because the grandeur of Kiyonobu's actually superior black-and-white basic design is so strong that it fights against the unnecessary color, which, if it were removed, would leave a print entirely satisfying in black and white. But the entire destiny of ukiyo-e from the day it was born in a Moronobu black-and-white book design was inevitably toward full color, so that even though it was this color gone sour which hastened the death of the art, nevertheless color was the relentless future and one must conclude that Kiyomasu's experiments (if indeed there was a Kiyomasu distinct from Kiyonobu) were a step toward the ultimate fulfillment of the art. One need not

3 COURTESAN

Torii Kiyomasu I

Location: Art Institute, Chicago. *Publisher:* Nakajimaya.
Signed: Torii Kiyomasu. *Size:* 22¾ x 12½. *Date:* About 1711–1716.
Translation: Right seal: Kiyomasu. *Left seal:* Publisher Nakajimaya at Sakaecho.
Technical: Sumizuri-e (ink-printed picture). Sumi is a Chinese ink erroneuosly known in the west as India ink. Printed from one block with no additional color. Ichimae-e.

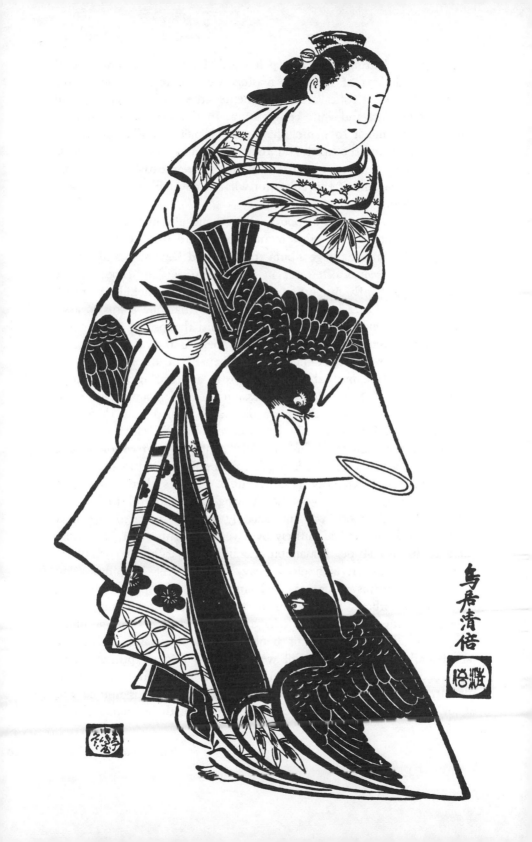

call this first halting color a step forward, for with the obscuring of the grand designs of the early masters we lose forever one of the world's honest artistic accomplishments: the surging power and grandeur of black-and-white composition. In the later days of ukiyo-e there will be much to praise, there will be pictures of extraordinary delicacy to warm the heart and they would not have been possible without color. But one who has seen the greatest early prints refuses to cheer the advent of this color, for what it covered up was rare and fine and clean.

Third, there is a series of books, albums and album sheets in black and white which are of great merit. These date from 1687 to 1758. Especially fine are the large album sheets signed Kiyomasu and depicting theatrical scenes often set in impressionistic landscapes. These sheets are excellently proportioned, filled with loving detail and handsomely drawn. There is a delicacy about them that one learns to associate with Kiyomasu's signature and an unusual sense of placing the human characters, usually several in number, so that they appear to be involved in some real moment of conflict. Especially notable is the use of architecture, invariably impressionistic, as a setting for argument or love or fury. They yield an impression of what Japanese life must have been like in early Tokugawa days and immediately thereafter. It would be pleasant to describe half a dozen of these delectable prints, for they are of high merit, but we must confine our attention to one magnificent album, *Keisei Ehon* (Picture Book of Courtesans, 1700) containing the portraits of famous public beauties then working in the Yoshiwara. So fresh was the drawing, so wonderful the artistic concept that the book was immediately sold out, pirated the next year and later plagiarized entirely by a very powerful artist just beginning to hit his stride, Masanobu. Each of the eighteen portraits is a masterpiece drawn with clean heavy line, perfect in composition and most judicious in use of black and white. The paper used was unusually absorbent, resulting in an inky line that fairly sings as it vibrates on the creamy page. Perhaps some accident of time accounts for the subtle quality of this book. Possibly the pages were once accidentally dampened. For all we know the original printer might have been disappointed in the curious results, for an unusual amount of burr shows on the inky line. At any rate, the book is unique and a joy to hold. The long-dead courtesans, each with her name clearly

inscribed for the guidance of wealthy strangers visiting the Yoshiwara for the first time, seem to live and move with the soft, sinuous ink.

Fourth, there is a group of very large prints, excellently colored by hand, showing scenes of violent action on the kabuki stage. They date between 1698 and 1718. A few depict grandiose historical or mythological events but all are absolutely breathtaking, a shattering contorted cramming of dramatic fury onto a flat sheet of paper. These are unsurpassed in all of ukiyo-e and unfortunately America possesses few of them. The Boston example (26) depicts the swirling housecleaning dance which Kyoto and Osaka actors traditionally performed when first appearing upon the Edo stage. The finest example of this type is not owned by our major museums: Kiyomasu's gigantic portrait of Danjuro II in the role of Watonai, one of Soga no Goro's fanciful incarnations. In frenzy he roots up a bamboo grove and stands before us superbly drawn, leaping into the air with left leg extended while his naked belly, distorted face and straining arms are painted a fiery red, cracked and crackled by time. This print is a perfect representation of violence, in which the powerful drawing and the brutal color combine for maximum effect. Boston owns a Kiyomasu of this type (28) but it falls short of the dazzling Danjuro rooting up the bamboo grove. The Philadelphia Kiyonobu (11), its pigments now badly faded, shows how little this great draftsman needed color. This scene from *Narukami* is one of Kiyonobu's greatest accomplishments, combining as it does dramatic strength, fine drawing and a sense of poetic charm. But again America lacks the top masterpiece of this quieter style. Few prints in the entire range of ukiyo-e excel Kiyonobu's stately portrait of the famous actor Nakamura Shichisaburo in his role of a public letter writer accosting a handsome woman as she passes his open-air writing stand. The background of this print resembles print 11 in feeling but is better done. It presents an impressionistic collection of symbols relating to the sensationally popular actor who claimed that he conducted himself on stage so that he would present a beautiful picture from any angle. This time even the color harmonies are ingratiating and it is to be regretted that no copy of this superb print has so far found its way into one of our big public collections, but since both this and bold Kiyomasu's portrait of Danjuro rooting up bamboos are known to have been in Europe at the turn of this century, perhaps they may still turn up. Print 10

and its accompanying original woodblock are of extraordinary interest in that the block dates back to 1699, the paper to about 1710, but the actual print only to 1905, when a trial proof was struck off on antique paper, there being no known prints from this important block. The tall actor is the same Shichisaburo in a role he wrote for himself describing a young man who lost the world for love of a courtesan— *Keisei Asamagatake* (The Courtesan of Mount Asama). Both print and block show Kiyonobu's powerful early style. In comparing all known prints of this type one finds little difference between those signed Kiyonobu and those attributed to Kiyomasu. They are all exciting, well designed, daring in conception, wise in use of color and evocative of great scenes within the theatre or in Japanese history. The finest of them are as good as the early black and whites, and with them color captures the single-sheet print so securely that going back to a simpler form is never again possible. Rarely has a new art form leaped into the middle of the world with such a furious bang. If color had to drive out the old black-and-white masterpieces, this was the way to do it.

Fifth, there is a voluminous series of prints roughly 13 x 5⅝ inches (hoso-e size, but often called actor-print size) issued between 1707 and 1745. They are hand colored and after 1724 are frequently enriched by gold dust and lacquer,† although lacquer was known as early as 1714. So far as we know, both Kiyonobus and both Kiyomasus issued many of these prints, and they are the only ones of which this can be said. This series contains some of the most boring art ever created by the ukiyo-e artists and occasionally some of the best (29). The disasters are always signed Kiyomasu and customarily consist of one actor standing and one seated. Lacquer, which in the hands of certain fine artists we shall meet later could be used to enhance delicate colors, is here piled with a heavy brush on areas of solid black, so that the result is a kind of meaningless and cracked mirror smashed into the center of the print, reflecting light and destroying any illusion of beauty. Furthermore, the drawing is poor, the design cluttered and the color harmony nauseous. The difference between a Kiyomasu black and white (3) and a Kiyomasu lacquer print sprinkled with gauche and meaningless gold dust is truly the difference between Giotto and Sir Edward Burne-Jones. How a serious art critic could

† Such prints are known as Urushi-e (lacquer pictures). Ink or pigment was often thickened by cheap glue to obtain the glossy effect associated with expensive lacquer.

compose a theory which required one artist named Kiyomasu to create in his youth the superb early prints we have been describing and then to degenerate into the dreadful junk now under discussion might seem beyond comprehension. But many critics, including even the perspicacious Laurence Binyon, have insisted there was only one Kiyomasu; and when one knows the full history of ukiyo-e such reliance upon the total artistic disintegration of an artist is quite possible. In our study of Toyokuni we shall find an artist who in his youth was as great as the early Kiyomasu, but who certainly degenerated into something as poor as the late Kiyomasu; and the history of his disruption is well authenticated. But fortunately we are not here witnessing such a decline. Recent studies make it fairly clear that there were two Kiyomasus, one a very fine artist and one a drudge. The actor prints signed Kiyonobu are always exciting and sometimes very fine (29). Presumably they were by Kiyonobu II, whoever he was, but Boston possesses two stunning prints which were certainly by Kiyonobu I. They merit the most careful attention, for they round out the picture we are acquiring of this titanic early artist and they show him at a subdued, poetic level of extraordinary beauty. The first print (Museum number 11.13165) shows swashbuckling Danjuro II in a scene from one of Chikamatsu's most popular plays, *Kokusenya the Pirate*, a wild flight of fancy.† Danjuro's pirate is as bouncy and raffish an item as ukiyo-e can offer. In a pirate's costume sewn purely from cloth of the imagination, the great actor leers through lacquer and speckled gold in a completely winning way. The second print (Museum number 11.13175) is the finer. No print of this period in America is in better preservation or lovelier color. To see how fine a lacquer print could be, one must see this example. The coloring is so perfect that one is instantly reminded of the oral tradition that Kiyonobu kept in his employ a very old woman expert in mixing and applying colors to his prints. If this is indeed an example of her handiwork, she was most skilled.

Sixth, there is a smaller collection of actor prints in the 13 x 5⅝ format which come at the very end of the Kiyonobu-Kiyomasu reign, from 1742 to 1758, when the activity of Kiyomasu II ceased. These

† Any historical novelist seeking a majestic plot should investigate the real Kokusenya. Known in China as Sciko and in the west as Coxinga, this fabulous pirate was the son of a Chinese adventurer and a Japanese mother. Around 1650 he daringly controlled the China coast, Formosa and islands south of Japan and terrorized Asia from Singapore to Manila.

prints are usually in two colors, rose-red and apple-green and they are not colored by hand, being printed entirely from blocks, a technique that will be discussed later. Signed either Kiyonobu or Kiyomasu, they are the final prints bearing these distinguished names and some of them are delightful. It seems likely that the same Kiyomasu who produced the flood of dismal gold-dust and lacquer prints was responsible for many of these attractive prints. If so, here is an interesting example of a man's doing much better work when he found a medium to which he was suited. These prints are also important in that they raise a question which helps in the solution of the Kiyonobu mystery: is it likely that these delicate and often effeminate two-color prints signed Kiyonobu could have been done by the roaring giant responsible for the early kabuki scenes signed Kiyonobu?

Seventh, there is a distinguished series of prints signed Kiyomasu depicting birds. They are traditionally dated about 1710. They appear to be early; they are most handsome, faithful to nature and dramatic. Eagles and crows destroy smaller prey. Deep-set eyes look down from gaunt pine trees, and pinions sometimes seem like javelins. It is unlikely that more than one man created these and it is significant that our Kiyomasu (3) shows two crows drawn in much the pattern of these fine prints.

Eighth, there are extant several distinguished paintings, 1697 to 1727, on either silk or paper signed Kiyonobu. They are early, not obviously related to the style of the prints, fresh in color and of a ukiyo-e rather than a classical content.

Ninth, several theatrical signboards remain, attributed to Kiyonobu. They date from 1720 to 1725 and are violent in action, broad in execution and totally commercial. Yet they show the vigor of this school of sign painters and explain why they were so popular in Edo. A large painting in this style can be seen in the Freer Gallery.

Now what can be said of the individual artists that made up this school? We know that Kiyonobu's father was a second-rate actor of women's roles in Osaka as early as 1670. He played under the name of Torii Shoshichi and possibly eked out a living by painting signboards as well. At any rate, in 1687 he decided to try his luck as an actor in Edo, where he assumed the name of Nakamura Jugoro, the first part of which he appropriated from one of the most distinguished lines of Japanese actors. With this auspicious beginning he switched to men's roles and attempted hero parts, but the sophisticated Edo

playgoers were bored so he took a third name, Torii Kiyomoto, and made a good living as sign painter for the theatres of the city, dying in that job sometime after 1702. He designed no prints.

When he sought new fortunes in Edo in 1687 he brought along his twenty-three-year-old second son Shobei, who had been born in 1664. Promptly, and not later than 1687, this Shobei began to issue books, prints and theatrical signboards under the name Torii Kiyonobu. He died, and all critics now agree on this fact, on August 11, 1729. He was the first official Torii, the first official sign painter, the great artist of whom we have been speaking.

What happened next is unknown and speculation is too confusing to relate here. Briefly, critics are tending toward a theory with the following general characteristics. Torii Kiyonobu I had at least four sons, the eldest of which was extraordinarily precocious. He became Kiyomasu I and died at twenty-two, having first issued all of the early Kiyomasu prints we have been praising. Kiyonobu I's third son then assumed the name Kiyomasu, which he kept until his father's death in 1729 (some say until his father's retirement in 1727), whereupon he dropped the name Kiyomasu and took the more important name Kiyonobu, becoming the moderately gifted artist we know as Kiyonobu II. This left the fourth son of the original Kiyonobu I free to assume the name Kiyomasu, and he became the inept artist in gold dust and lacquer known to history as Kiyomasu II. (There is a likelihood that this fourth son had been adopted as a ready-made husband for Kiyonobu's daughter.) This theory, complex as it is and calling for two Kiyonobus and three Kiyomasus, harmonizes with the easily detected stylistic changes in the work of this fascinating school. But perhaps before this book sees print, new researches will refine or even revolutionize our present answers to the mystery of the early Torii masters.

What will not be revised is the fact that in Torii Kiyonobu I Japan produced a powerful artist. It is true that he was not so inventive as certain men who came later. Nor was he so universal in spirit as the amazing man who preceded him, Moronobu; his human figures were more static and less graceful than Moronobu's; his line was usually less controlled, his plastic sense less developed. At times he even appears at a disadvantage when compared to Kiyomasu I, whose total concept of art seems to have been more poetic. But in force, in grand design and in dramatic power Kiyonobu I was a great artist.

The violent swirl of his bold black lines has not been surpassed. The daring creation of huge color patterns was his. No artist disposed his symbols upon a flat rectangle of white paper more effectively than he. And though he must be judged deficient in the utmost reaches of artistic invention, he nevertheless did devise the tradition of presenting actors' portraits in vigorous action, a convention which was to account for at least thirty-five percent of all subsequent ukiyo-e production. He also had such a titanic force that dozens of later artists borrowed from him and he thus became responsible for one of the two main life-springs of ukiyo-e, the second of which we shall discuss next. The vitality of Kiyonobu was not to perish until the art itself died.

6

The Floating World

Of Nishikawa Sukenobu,† the book illustrator, it is difficult to speak with restraint. Not only was he a perfect artist like Mozart, Keats or Watteau; he also created some of the most exquisite drawings ever produced, figures which can be immediately appreciated by any taste. It takes time and knowledge to love the work of Moronobu or Kiyonobu. Instinctively and at first glance one accepts the sweet-faced beauties which Sukenobu drew in such abundance.

In all, he produced more than one hundred books in at least three hundred volumes, each with an average of fifteen double-page drawings. Some of his books give the impression of hasty execution but there is not a poor one in the lot and at least a dozen are superb. He is unusual in that his greatest work came after he was fifty and increased in power until he reached seventy. Neither his style nor his execution deteriorated and his intellectual capacity seemed to increase.

Born in 1671, just as Moronobu was beginning to set Edo afire, Sukenobu lived all his life in the twin cities of the west, Kyoto the ancient capital and Osaka the industrial center. From the former he derived an education in Chinese learning, a foundation in classical painting and the indefinable Kyoto love of quiet beauty. In the latter city he found good publishers and a prosperous market. He never worked in Edo, probably never visited the city but certainly knew the work of Moronobu, whose books influenced him considerably.

His own books were famous during his lifetime and continued so for generations after his death. Many were reprinted; others were

† In Japanese pronunciation the letter *u* when in conjunction with *s* or *k* is practically silent. Thus: S'kenobu, Kiyomas', Hok'sai, Sharak', Kaigets'do, Hirats'ka. Of course the *u* has to be sounded in names like Toyokuni and Kuniyoshi. Japanese has no accent: Ske-no-bu.

pirated; all served as hunting grounds for succeeding ukiyo-e artists in search of a theme. He issued a few single sheets of no importance and many excellent paintings, which caused a contemporary to exclaim, "In ukiyo-e Hanabusa Itcho is good. There are men like Okumura Masanobu, Torii Kiyonobu, Hanegawa Chincho and Kaigetsudo, but the master in painting is Nishikawa Sukenobu. He is the saint of ukiyo-e."

A typical Sukenobu book is *Ehon Tokiwagusa* (Picture Book of the Pine Tree), published in Osaka in 1720, when the artist was forty-nine. It was issued in three separate volumes, as were most books of that time, each being about 10 x 7½ inches, covered with a brownish heavy paper and sewn together with silk thread at the spine, as explained at print 12.

Naturally, each volume read from what we would call back to front and each contained a foreword by Sukenobu of three pages in carved Chinese characters, but since these books were intended for largely uneducated commoners, words which might give them difficulty in Chinese style were accompanied by Japanese alphabet explanations and hints in smaller print, as can be seen on print 38. The first page of each volume contained a drawing of one of the three symbols of longevity: pine, bamboo, plum, the second of which is judged one of Sukenobu's greatest works. It is impossible to explain why a simple drawing of a bamboo clump has captivated so many judges, but it has.

As in most Sukenobu books, this one consists of pictures of women, volume one showing court ladies, volume two middle-class women and the last a parade of courtesans. To give some indication of the wealth of Sukenobu's imagination and at the same time to suggest the repetition to which he was addicted, several pictures in this book must be described.

Vol 1, No. 5. The poetess Ono no Komachi (13, 18, 53 C, 54) in court dress stands sensuously in the middle of an excellent landscape in which the branches of a weeping willow complement the flowing lines of her body. This fine design illustrates three facets of Japanese art: the ancient convention whereby formalized layers of mist (suyari) as seen in prints 47–49, represent the passage of time; the competence of almost all ukiyo-e artists in depicting landscape, which is contrary to the general belief that ukiyo-e landscape was unknown before the age of Hokusai; the joy ukiyo-e artists found in recasting classical events into contemporary form.

Vol. 1, No. 11. The poetess Uba walks beneath flowering branches with four companions, three of whom are dressed in heavily brocaded costumes and with shawls covering their heads. Far left stands a typical Sukenobu figure, a maid with a package. No drawing could be finer than this, for with economy of line the artist has suggested an older woman, a little stooped, a little tired.

Vol. 1, No. 15. One of Sukenobu's greatest compositions, it shows on the right two gaily dressed women out to view cherry blossoms, while trailing them on the left-hand page is another superb presentation of a maid followed by a barelegged workman. It would be difficult to praise this print too highly.

Vol. 2, No. 2. Five women strolling along a river bank. The movement is winsome, the drawing superb, and the representation of the river done so as to complement the movement of the figures.

Vol. 2, No. 6. Five women viewing wisteria blossoms. One is quite old and excellently drawn, while the fifth is a young servant with her back turned to the spectator in Sukenobu's finest style.

Vol. 3, No. 1. Two courtesans on parade accompanied by two girls and a servant with umbrella. Here again is one of Sukenobu's finest compositions. The five figures are crowded toward the center of the two pages, but so skillful is the intertwining of their costumes that the effect is brilliant.

Vol. 3, No. 4. Four courtesans idling away an afternoon under an oak. The drawing of the two on the left-hand page is astonishing in its combination of extreme simplicity, effectiveness and beauty.

Vol. 3, No. 9. Perhaps Sukenobu's most widely reproduced subject, this double spread shows two courtesans, one bare to the waist, fixing their hair before easel mirrors. Through open doors a sketchy view of a garden can be seen. A most happy composition, a most lovely piece of drawing but inappropriate for selection as Sukenobu's masterpiece for it is completely soft, whereas much of his greatest work is strong.

Vol. 3, No. 16. Four courtesans, each wonderfully drawn, sitting in the garden of their house on a late autumn afternoon, looking at chrysanthemums while one plays a samisen and another writes a letter. Here the full bitter boredom of life in the green houses is shown. This is a tender, evocative drawing, brilliantly composed and unforgettable. The figure of the samisen player, back to viewer, is one of the artist's best.

From these random pictures some of the characteristics of Sukenobu

can be deduced. He was partial to processional pictures and was never surpassed in this form, popular as it became with later artists. His happiest results were obtained with five figures, whose relationships were carefully worked out. He was master of foreshortening, loved a solitary figure off to one side, drew the nude with great skill, liked to pose his women so they filled the foregrounds of his pictures and used as a trademark the figure of a maid, back to viewer, drawn with a simplicity that baffles competition.

Comparison with Kiyonobu is inevitable. Sukenobu was a magnificent artist and it was fortunate that in the development of ukiyo-e his vision of beauty was destined to serve as the counterpart to Kiyonobu's dramatic fury. Together these two men, each derived from the basic strength of Moronobu, account for practically every vital force in ukiyo-e down to the arrival of the great landscapists in the final days of the art.

Kiyonobu was forceful; Sukenobu was graceful. Kiyonobu depended upon violent line, crashing color, overpowering design; Sukenobu never raised his voice but influenced most subsequent artists with his sure, clean line, his purity of black and white and his subtle, sometimes casual design. Kiyonobu dragged the ukiyo-e artists into the theatres and the brothels and kept them there for more than a hundred years; Sukenobu showed them married women viewing cherry blossoms along peaceful country lanes. Kiyonobu was the thundering merchant from Edo; Sukenobu was the learned Kyoto scholar. His forte was gentle observation plus the most gracious execution. Japanese cherish the women of Sukenobu because the artist who drew them loved them.

It would be incorrect to conclude that Kiyonobu represented Japanese culture and Sukenobu Chinese, for the latter was contemptuous of his contemporaries who did not dedicate themselves to Japanese subject matter and signed one of his books Yamato-eshi (painter of Japan). He also excoriated Japanese painters who clung to Chinese styles: "That is certainly a miserable heart which trusts in a foreign country for its own home land. It is a matter of deep sadness that one cannot see where to find the beauty of his native manners and customs."

True to his own preachments, Sukenobu applied himself to life in Japan as it was lived in his age. In his books one finds the floating world. Every aspect of society is treated and it is safe to say that no other nation of the world, prior to photography, owns so complete

a record of one of its periods of greatness as Sukenobu's report on life in feudal Japan. Imagine what we would give for a similar record of Periclean Athens or Shakespearean England.

Four of his greatest books should be mentioned, for each is available in America. His masterpiece, according to western taste, is *Hyakunin Joro Shina-Sadame* (Studies of One Hundred Women, 1723). This magnificent record of Japanese life merits full description of each page but the chief prints are well known and readily available in reproduction. There is the brilliant widow of the shogun in mourning black, preferred by most western critics as his finest processional. Then come the four powerful scenes of peasant women at work: stone sellers guiding handsome horses through the streets of Kyoto, firewood sellers, cotton-gin workers and the sweating women laboriously threshing rice. The latter is my favorite Sukenobu and I refrain from reproducing it only because it can be found in many other books. Finally there is one print not widely recognized as the perfect thing it is. The fourteenth double spread of the second volume shows a picture of two women attendants at a bathhouse. The older is to the left and slightly higher on the page; the younger, carrying a stave, stands with her back to the viewer. The drawing of these two figures and the subtle manner in which the line of one complements the other show Sukenobu at his unpretentious best. Again, I would have reproduced this admirable page if I could have found a copy that was not grease-thumbed; but this book was one of the best loved ever published. Almost every copy is heavily marked by fingers and many in American museums have had most of the good pages half worn away by previous owners who pored over these handsome and gracious scenes.

Ehon Tamakazura (Picture Book of the Vine of Jewels, 1736) is represented by the admirable procession in the rain reproduced in print 12. This book also illustrates the complete irrelevancy of Japanese titles, for unless one wanted to go into an exegesis many paragraphs long he could not even begin to explain the ordinary fanciful title.

Ehon Asakayama (Picture Book of Mount Asaka, 1739) probably presents Sukenobu in his most ingratiating style. Large figures fill pages usually devoid of background. Some of his most seductive beauties appear in this book, including the widely reproduced picture of a girl naked to the waist fixing her hair. The charm of this drawing is universal yet the sweetness of the girl's beauty does not destroy the sharp and perfect line with which the body is composed. My favorite appears on

the facing page, a perfect Sukenobu. It is interesting that from time to time subsequent publishers have experimented with issuing single sheets of Sukenobu's finest book illustrations in colored form as they might have appeared had the artist lived sixty years later when color printing had been perfected. Such prints are offensive and prove that Sukenobu did not need color. His drawing and design were so admirable that the mind needs no further crutches to help it visualize what the artist intended.

At seventy-one this prolific man produced what Japanese consider his greatest work. *Ehon Yamato Hiji* (Picture Book of Things Japanese, 1742) is in ten volumes and constitutes a history of Japan, not as we use the word history but as a patriotic account of ancient heroes, myths and folklore. Here is recorded the scandal of the poet Noin Hoshi, who composed a glowing poem about his heroic journey to the far north, then sat in his open window for days getting sunburnt so that his friends would think he had taken the trip. Here also is a picture illustrating an incident in the life of the classic painter Sesshu, who as a boy was tied to a porch, but drew with his big toe pictures of rats so realistic that his captor set him free in astonishment. We also meet the resourceful woman caught alone in her house by burglars whom she frightens away by breaking up the furniture so they will think there is a party going on. And there is the deeply moving story of old Komachi (13).

As we have seen, honest histories of Japan were forbidden, so the public had to rely on such mélanges of hero worship, myth and filial piety as books like Sukenobu's could provide. It is surprising therefore to find that the average edition was not much over nine hundred copies. Some were rushed on porters' backs to Edo, where they were widely disseminated. Others must have trickled to the southern islands but most were absorbed in Kyoto and Osaka. That so many exist today is a measure of

4 PAGE FROM *EHON ASAKAYAMA*

(Picture Book of Mount Asaka)
Nishikawa Sukenobu

Location: Author. *Also:* New York and New York Public Library.
Book Signed: Nishikawa Sukenobu. *Date:* 1739.
Publisher: Kikuya Kihei of Kyoto. *Size:* 10¾ x 7⅛. Original figure one inch taller than this reproduction.

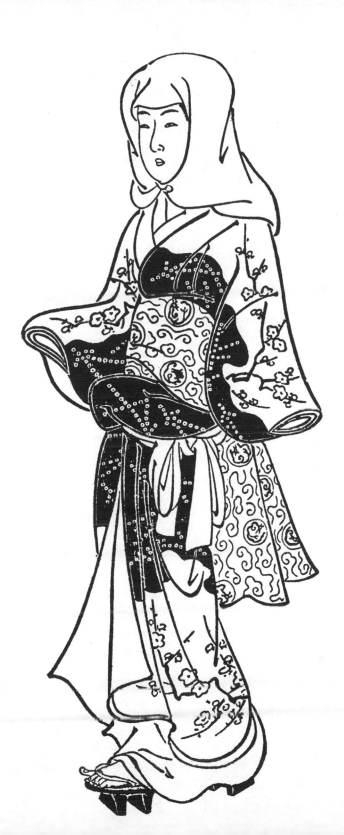

the affection in which they were held, for in these thin folded pages the people of Japan saw themselves for the first time.

Of all the artists I have met in ukiyo-e, I have been most surprised by Sukenobu, of whom I had never heard a word spoken in western art centers. It would be rewarding to devote all the reproductions in this book to his alluring work but even then the richness of the man and his subtle beauty would not be fully represented. I could wish anyone interested in the simplicity of art no better luck than to spend an hour or two with some of his books. They are available, often grease stained, in major museums and are wonderfully rewarding.

Sukenobu was no giant like Kiyonobu. He never mastered color, never experimented beyond his own small world of Kyoto sunshine. But he was an authentic artist. He had his own vision. He had a penetrating eye for form and design, and he could hold an ink-charged brush as securely as any man who ever lived. His quiet beauty was to reappear in ukiyo-e prints as long as the art lived, for he was one of the two sources of the Japanese print. His grace and Kiyonobu's power, springing alike from Moronobu, activated the art.

7

The Function of the Symbol

When Matsuki Kihachiro, the Japanese expert, visited Louis Ledoux in New York to see the latter's small but unequaled selection of ukiyo-e masterpieces, the Japanese connoisseur asked, "Might we begin with your Kaigetsudo picture?"

Without commenting Ledoux produced a crystal and lovely print, possibly the Kaigetsudo Doshin (5) which was once in his collection. Mr. Matsuki studied it and said, "Perfection! You are so fortunate to own a verified Kaigetsudo."

Without comment Ledoux placed a second Kaigetsudo on the easel, one like the Anchi (14). This time Matsuki sucked in his breath enviously and whispered, "You have two of these famous prints?"

Then Ledoux showed a third print, one of his Kaigetsudo Dohans (15) and Matsuki could say nothing, but when Ledoux proceeded to show two more Dohans and still another Anchi the Japanese expert became actually ill and stared at Ledoux as if to protest: "Why should six Kaigetsudo be in the hands of one man, and he not a Japanese?" Then he laughed and confided, "I'm not up to seeing any more prints today. I'm overwhelmed."

Only thirty-nine of these great classic prints exist and they constitute the second tantalizing mystery of ukiyo-e, for it is not known who designed them. As in the case of the Kiyonobu-Kiyomasu confusion, each print is clearly signed by one of the three names given above, Doshin, Anchi, Dohan, but what these names mean no one can say. Curiously, as explained at print 14, we do not even know how the names should be pronounced and Doshin, for example, is only a guess.

Consider also the three unchallenged signatures on the Kaigetsudo prints offered in this book. Each can be read "Nippon Gigwa Kaigetsu

Matsuyo Doshin (Anchi or Dohan, as the case may be) zu." Translated this means, "Japanese for-fun-only picture. Kaigetsu Doshin, the last leaf, drew this." In each instance the circular seal repeats the artist's name, Doshin for example, while the eggplant seal on 14 and the shield on 5 indicate the publisher. The square seal below is that of a former owner, one Takeuchi, while the faintly discernible round seal in the lower left corner of 5 and 15 is of some unidentified earlier owner.

With so much authentic knowledge at hand it would seem easy to determine who these artists were, and the following thory has been proposed. Between the years 1704–1716 a gifted painter named Kaigetsudo Ando, who did no prints, created a new fashion for solid, round-faced girls standing in imposing positions, wearing heavily decorated kimonos, all executed on silk or paper with the heaviest of brush strokes. Three of his students transferred this idea to woodblock prints, copying the big figures, the handsome round faces and the heavy brush work. Because these prints depicted only professional beauties from the Yoshiwara and bore no relation to classical Chinese art, they were signed "Japanese for-fun-only picture." And since the woodblock designers were obviously inferior in status to the silk-and-pigment painter, the former deferentially signed their pictures "the last leaf of Kaigetsu" meaning "the follower of, or pupil of, Kaigetsudo."

Unfortunately this simple explanation cannot be reconciled to other stubborn facts and for the present we cannot say who created these prints. The twenty-two subjects are too similar, the signatures are too nearly identical and the artistic conventions such as the way heads and

5 COURTESAN

Kaigetsudo Doshin

Location: Metropolitan Museum of Art, New York. *Size:* 23½ x 12½.
Signed: Nippon Gigwa Kaigetsu Matsuyo Doshin zu (Japanese for-fun-only picture. Kaigetsu Doshin, the last leaf, drew this). *Publisher:* Nakaya of Toriabura-cho. *Date:* 1714c.
Translation: Square seal: Doshin. *Indented circular seal:* Publisher's trademark. *Small square seal:* Takeuchi no in (Seal of Takeuchi), a former owner.
Technical: Sumizuri-e. Printed from one block. Uncolored.

The Function of the Symbol 66

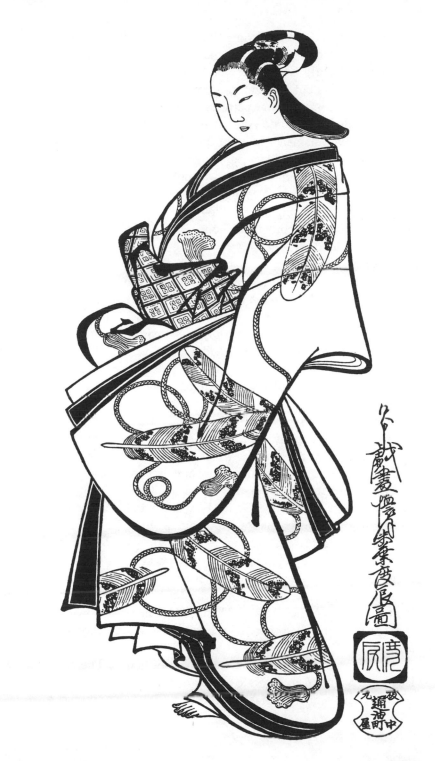

ears are drawn are too absolutely identical to permit the easy assumption that five different men painted the pictures and drew the woodblock prints. (There is a fifth Kaigetsudo, Doshu or Norihide, whose signature appears on paintings but not, so far, on prints.)

In addition there are several perplexing paintings signed Kaigetsudo Dohan and sealed Kaigetsudo Ando, which might indicate that we are here dealing with one man who used five different names. As we shall see in a moment he did use two different alternatives for Ando so that four additional names would not be without precedent. Normally one would ridicule a theory which required the use of seven different nom de plumes but before doing so one should consult the appendix where Hokusai's astonishing record is laid out. It is traditionally reasonable that Kaigetsudo used seven names.

Why he did so requires a dramatic new theory. There is rumor that long before the great Kaigetsudo prints were issued there lived in Edo a shadowy painter called only Kaigetsudo, who is supposed to have worked in 1615. Nothing is known of him, no second name, no pictures or written records of any kind. But only if he existed could the phrase *last leaf* as used by Doshin, Anchi and Dohan mean *follower of*, for Japanese artists frequently select some long dead master to serve as spiritual sponsor. But it is doubtful if there ever was such a painter, so the phrase *last leaf* must mean something else.

It is proposed that Kaigetsudo Ando, of whom there are many records, at some time called himself Anchi and Doshin and Dohan to confuse the authorities. Accounts exist in which he called himself Ankei and Anshi for some devious personal reason, and it is well known that he was a central figure in Edo's outstanding scandal.

Ando lived in Asakusa, Edo's Coney Island, where he became friendly with a neighboring rice merchant with whom, in 1714, he tried to corner the rice market and make a fortune. In pursuit of this objective Ando sought the help of Lady Eshima, highly placed at court. As a present, he designed for her a scroll of erotic pictures and followed this up by arranging to smuggle her into a kabuki theater, which was of course forbidden to a woman of her station. Then, to seal her support of the rice scheme, Ando introduced her to a handsome actor, who promptly seduced her.

The scandal rocked Edo. The corner in rice exploded. The actor and the lady were banished to separate exiles. And it is said that Ando was fined heavily and sent in disgrace to the tiny island of Oshima, where

he served until 1716. His name was tarnished so that when he slipped back into Edo life he used four different aliases which he signed to his stunning prints and fine silk paintings.

Regrettably, this romantic theory can be riddled. For example, critics insist they can detect differences between the work of Dohan and Anchi. Calligraphic experts say they can easily spot five different handwritings. And there is a persistent rumor that Ando died in exile and so could not have done the prints; but his faithful students carried on his style, his signature and his name out of devotion to a man who was wronged.

Whoever created these thirty-nine majestic prints somehow produced one of the most powerful symbols in world art. For the Kaigetsudo courtesan, standing motionless in her heavy robes, swathed in great black lines, has become a symbol of ukiyo-e. The mere outline of one of those heavy, silent figures on a poster immediately identifies the subject with Tokugawa Japan. In creating this unforgettable design, the Kaigetsudo artist, or artists, joined the ranks of those lucky men in world history who have been able to identify their periods permanently by some instantly recognized symbol.

The fin de siècle lithographs of Lautrec define his age. Nobody could have drawn the posters but he, in no city but Paris, at no other period in history. A Watteau lute player in velvet knee breeches symbolizes his period. So do an angel by Fra Angelico, a cedar by Van Gogh or an Amsterdam beggar by Rembrandt. These persistent symbols, capriciously elected by the public, seem to satisfy some craving for identifying marks by which to summarize a concept too large to be fully comprehended. Frequently such symbols are poor art, like the Madonnas of Sano di Pietro which identify Siena or the horse-and-sleigh of Currier and Ives which recalls nineteenth-century America, but regardless of merit these chance symbols live while superior art which fails to represent anything dies.

It is one of the jobs of art to create imperishable symbols. Consider the role played by certain persistent artistic symbols in religion, or the pyramids in a national culture, or the Statue of Liberty, as a rallying point for quite abstract concepts. Generally speaking, the better the art, the more meaningful its persistent symbols; poor art produces only clichés. Sentimental or junky symbols which persist long in human memory merely signify that the art which threw them forth was of a low grade, or perhaps that the better arts of the period didn't do their job. For the human mind must cling to something which it accepts as

the summation of an age and if no inspired artist provides a worthy symbol, the people will cling to junk.

Ukiyo-e created three master symbols: the majestic courtesan of Kaigetsudo, the lovely woman's head of Utamaro and the contorted face of a Sharaku actor. These are memorable and worthy symbols but incontestably the finest—as symbol—is the Kaigetsudo woman, clutching her kimono in lonely grandeur. Collectors around the world pay homage to this woman as the spirit of ukiyo-e.

She is more. She is also the summation of Japan's attitude toward feminine beauty. The profoundest ideal of what a Japanese woman should look like is this plump, round-faced beauty of grave demeanor. Even more than the willowy figures which will dominate ukiyo-e eighty years later, this Kaigetsudo woman persists. A writer of that age said, "The popular face of our time is round and pink." An artistic symbol to be of continuing validity must represent the essential quality of its own age; great symbols also relate to things deep and permanent. The Kaigetsudo print does this.

Every male visitor to Japan progresses through a three-part indoctrination. First he is astonished and relieved to find that many beautiful Japanese girls look pretty much like pretty girls in New York or Paris. He feels at ease. Second he begins to recognize the more typical Japanese face with broad cheek bones and delicate chin. He now feels at home. Third, after he has come to know Japan well he suddenly awakens to the fact that the really beautiful Japanese women have the round-faced, masklike quality of the statuesque Kaigetsudo woman. He is now thinking like a Japanese and it's high time he went back home.

What is the difference between the Kaigetsudo courtesan and the beauties of Kiyonobu and Kiyomasu? The Kaigetsudo print is more harmoniously composed; individual lines are more subordinated to total design and the resulting air of repose bespeaks something deeply cherished in the Japanese heart.

What is the difference between a Kaigetsudo print and a Sukenobu? The former represents an ideal figure in timeless space, a majestic and towering creature living in the mind only. Sukenobu invariably shows us real little girls and patient housewives who live down the street.

But the biggest difference is that both Kiyonobu and Sukenobu set in motion artistic currents which took ukiyo-e far beyond anything they themselves either accomplished or envisioned. Their impact on their art was truly revolutionary. The Kaigetsudo artists projected nothing. No

school grew up about them. No followers developed their ideas into glowing subsequent prints. No renaissance of the Kaigetsudo ideal ever developed. All they did was create one of the most powerful symbols ever devised. That massive woman, that overpowering black line, that sensation of terrible loneliness and complete satisfaction . . . that is what the Kaigetsudo artists accomplished.

Who they were we cannot yet say, but we are fortunate in America in possessing so many of their prints. Both Boston and the Metropolitan, which now owns the six glorious prints from the Ledoux collection, can show admirable examples of these big prints and Chicago has several fine copies, including some with hand coloring for comparative study.

Today the prints, for all practical purposes, are priceless, for there are none in circulation, yet envious collectors around the world often torment themselves by recalling how ten of the choicest Kaigetsudos were discovered. A Tokyo dealer in 1884 was rummaging through a batch of prints in a competitor's shop and that night he dutifully recorded the day's business: "Found ten prints by Kaigetsudo for one yen, sixty-five sen the lot."†

† It has been traditionally stated that these ten prints, now worth around twenty-five thousand dollars, sold for seventy cents; a more accurate equivalent would be about two dollars and sixty cents.

8

The Role of the Inventor

OKUMURA MASANOBU · NISHIMURA SHIGENAGA
ISHIKAWA TOYONOBU
TORII KIYOHIRO · TORII KIYOMITSU

It is very difficult to keep an art alive. The entire tendency is toward crystallization, conservatism and imprisonment in style once vital but now grown sterile. For unless an art is constantly cross-fertilized by new concepts it ceases to grow and must by definition wither and die.

Greek architecture, the sonnet, string quartets and the informal essay died when old vitality went out and was replaced by nothing powerfully new.† Consideration of these and dozens of other similar examples makes one mournful when contemplating any social organization which tries to perpetuate itself by deifying old custom and ignoring or outlawing new.

Perhaps the most remarkable illustration of this sad but on the whole clean and reassuring death of desiccated art forms is found in Sienese painting. Here indeed was one of Europe's most poetic schools. None was ever launched by a more powerful progenitor than Duccio, whose ideas must have seemed at the time vital enough to inseminate successors for ten generations. Strong new men like Matteo di Giovanni added life but soon the crystallization set in. No ideas sufficiently acerb to cleanse away the encrustations of gold-leaf and stultified subject matter appeared, and the art perished.

In ukiyo-e it must have seemed that with four such distinguished

† One is struck by certain similarities between the fate of ukiyo-e in Japan and the state of poetry in America. Each was once a popular art enjoying wide acceptance. Each became sterile and died for lack of vital new ideas. Belatedly, when the necessary cross-fertilization had occurred, the reborn art found that it had lost its audience and had to be content with an esoteric existence, which nevertheless gave promise of vital resurgence and possibly a renewed general acceptance.

progenitors as Moronobu, Kiyonobu, Sukenobu and Kaigetsudo a suf-
ficiently vital start had been made to carry the art through many
decades. This was far from the case. Ukiyo-e was essentially a people's
art and therefore the prey of fashion. A print two months old could fail
to sell because of some radical shift in coiffure, and charts have been
assembled whereby an expert can merely look at a woman's headdress
and state when the print was issued.

Ukiyo-e, more than most arts, was susceptible to suicide. Great Moro-
nobu's figures were outmoded as soon as issued. It is a matter of sad
record that artists who followed Kiyonobu I became the very sort of con-
servatives who kill an art, and they nearly killed ukiyo-e. The few who
attempted to follow Kaigetsudo soon quit for their work was totally
archaic. Only Sukenobu passed along vital ideas, and even his threatened
to degenerate into mere prettiness.

It is possible that a wise man, using the best of these four great initia-
tors, might have kept ukiyo-e alive, but such eclectic judgment is most
difficult to find, for eclecticism usually focuses upon the meretricious
and the facile, ignoring power, and thus defeats itself. What is needed is
not eclecticism but explosive genius, some man of colossal self-assurance
who will leap into the middle of a stagnant art, stir it up wildly, revital-
ize some of the old forms, kick others out and set a whole new genera-
tion into vigorous movement. Such a man was Okumura Masanobu.

This vainglorious, avaricious, mendacious and vastly gifted little man
has generally been credited with at least thirteen technical innovations
that saved ukiyo-e. He is supposed to have invented the use of lacquer
to attain brilliant effects and gold dust to provide sparkle (32). He
pioneered the mica background which was to account for the later
prints which dazzled Europe (53 B, 58). He certainly was the first ex-
perimenter with European perspective and produced several important
prints in this form (30), passing the idea on to others who specialized
in it. He was the first to issue three related prints in the form of an un-
cut triptych (36) which could be sold together to rich people or cut
apart for the poor. He also invented the tall upright picture (32) and
the pillar print which became so popular in decorating middle-class
houses (31, 47–9). He went far back into Chinese art history and re-
vived the process of ink rubbings, although of course he worked out a
better system than the Chinese had used (16). There are claims that he
perfected the use of tan on prints, that he was the first to use embossing
and that he pioneered in the development of landscape. Finally, he is

supposed to have invented the one brilliant idea which foretold the future—printing everything from blocks and dispensing with hand work —and to have chosen the two wonderfully happy colors, rose-red and apple-green, which when scattered judiciously upon a print uncannily suggested a complete spectrum (35, 37).

In addition he was a shrewd businessman, publishing his own pictures and making money from a stable of lesser artists. He is credited with having put the print business on a solid commercial basis and he probably launched the movement to take the peddling of prints off the streets, where they were hawked by runners, bringing them into an established shop. He advertised blatantly across the face of his own prints, threatening, cajoling, bragging: "The genuine brush of the Japanese painter Okumura Masanobu. Torishio Street picture wholesale shop. Saffron pictures and illustrated books for sale. My authentic bottle-gourd seal is enclosed. Okumura." Across the face of other prints he boasted of having originated pillar prints, lacquer prints and perspective drawings. Again he would blazon down the side of some print the charge that crooks were pirating his drawings and would beg patrons to come exclusively to his respectable shop on Torishio Street.

He was indefatigable, for in addition to his daring innovations he also illustrated more than 140 books, the first at age twelve. At thirteeen he astonished Edo with a magnificent guide to the most popular courtesans of the city, a publication which he put through five subsequent editions while still in his teens. At seventeen he is supposed to have rewritten for the near illiterate Japan's great classic novel, *The Tale of Genji*, which he illustrated and published in seventeen volumes. He was also a popular poet and issued several albums of large black-and-white prints that are heavenly.

He was largely self-taught, which is a euphemism for the obvious fact that he plagiarized openly from the very best sources. One of his albums is taken directly from Moronobu's *Yoshiwara no Tei*. He copied line for line Kiyonobu's great *Keisei Ehon* album and appears to have sold more copies of it than Kiyonobu did of the original. He tried his hand, successfully, at the Kaigetsudo style but promptly abandoned it for Sukenobu, who influenced him deeply and well. His worst pictures seem to have mimicked Kiyomasu II, but it may have been the other way around, and he certainly copied Kiyonobu II's best work. Up to the age of forty this cyclonic man smashed and slashed his way all over the

place, an inspired eclectic who looked as if he might never quite find his niche.

Then, in one of those miracles that enliven art, he suddenly began to produce with furious energy some of the noblest prints in ukiyo-e, and of course Masanobu-like, in several completely different styles. The first is represented by print 32. Note the bigness of this print, the spacious drawing and brilliant color. In this form he produced nearly two dozen works that have been hailed as masterpieces, so magnificent in concept and execution are they. One of the best is his portait of flamboyant actor Sanogawa Ichimatsu (who appears also in prints 31, 33, 34) as a puppeteer dressed in a checkered kimono inset with scenes from *Genji*. An undergarment of brilliant orange and gold shows against an olive-brown. Ichimatsu holds high above his head the delicate wooden figure of a young girl on her way to either an elopement or a suicide. Swept above in fine flowing characters is the love poem: "Struggling along the road, then at last Matsuyama . . . O, how the evening showers fell!" This print, and the dozens like it, could not have been designed by Kiyonobu for the figure is too human, the drapery too relaxed and the color too subdued and harmonious. Nor could it have been done by Kaigetsudo, for there is no aloofness, no cold beauty or thundering line engulfing the human form. In these great prints Masanobu is notable for the way in which he fits a living human being onto the fragile paper. Women hurry to appointments through the wind; actors dance in joy; and young girls play. Yet in each the placement is exact and the observation of human life warm and rich.

It is therefore difficult to believe that the master who created this hand-colored grandeur voluntarily abandoned it and turned to the benizuri-e print,† where he brought forth cameos of the most superb tenderness. No print of this period existing today surpasses print 35, whose color and condition are perfect and whose representation of the gay arsonist, Yaoya O-Shichi, is so appealing.

Masanobu has, appropriately, left several self-portraits, the finest being the one in Chicago which presents a cocky little fellow wearing heavy glasses, mustache, goatee and beret as he sits on his haunches finishing up some incredible writing on a public wall in which he proclaims how good he is and how improper it would be for him to hold back any of

† *Benizuri-e* means *beni-printed picture*, beni being a rose-red vegetable color which was traditionally accompanied by an apple-green, although in the last stage of beni-zurie other colors like yellow and a fugitive blue were added (38).

his work from his adoring public. He looks self-satisfied, happy, assured of his artistic competence. He reminds one of Rubens, a tremendous lover of life, a gargantuan appetite and a corking good businessman. Even in death he had a sublime sense of the appropriate, for he died in 1764, just as multi-colored prints were coming into existence to save the art whose first threat of death had been staved off by his personal brilliance.

Unfortunately, some of his claims cannot be supported and many innovations attributed to him were probably the work of men less addicted to personal advertising. Let us consider them one by one. He was undoubtedly plagiarized, as the three remarkable prints 31, 33, and 34 prove. But it is ironic for him to complain in view of what he did to Moronobu's and Kiyonobu's great albums. In other instances it is difficult to guess who plagiarized whom, but Masanobu certainly was not averse to lifting a good design if he thought he could improve upon it. Almost invariably he did.

It is unlikely that he pioneered the use of lacquer, Kiyonobu's Boston masterpieces possibly being prior to Masanobu's claim, but it is certain that no one, not even Kiyonobu, ever issued finer lacquer prints than his best, say the portrait of Onoe Kikugoro dancing a Soga role in which the harmony of brilliant color is enhanced by lacquer and represents the apex of this technique.

He seems to have invented the use of gold dust, triptychs, pillar prints, mica grounds and ishizuri-e (stone-printed picture). It is doubtful that he invented embossing, and even if he did it assumed no importance until later artists perfected the device (40). On the other hand, he did much effective landscape work in single prints; but most of his predecessors had also produced excellent nature studies in their books and Kiyomasu, at least, issued single prints with telling impressionistic landscape backgrounds.

This leaves the greatest invention of all, the one that set ukiyo-e free —the use of two-color printing from multiple blocks. This process had been known in China since 1627 and in Edo since 1730, when the actor Danjuro II (29, 30) issued a small book memorializing his famous father. Luminaries of Edo contributed poems and a well-known painter added illustrations which were cut onto woodblocks. The last four, which showed rural scenes, have become famous, for they were printed in full color from blocks, the first publicly issued color prints in Japanese history. They appear within pale brick-red circles 5½ inches across. The

first shows the corner of a house and uses pale green, yellow and red for the seal. The second shows a nobleman in a field contemplating his mistress and uses green, yellow, blue and red. The third presents flowers in two shades of green, yellow, brown and red. The last, utilizing three shades of gray, pale brown and red, shows a tree trunk, a grasshopper and a bundle of faggots. The register, color and general attractiveness of these casual prints is so pleasing that one is perplexed as to why eleven years passed without any further use of this device—and then only in two colors. It would be twenty-five years before the complexity of this earliest example would be matched. A perfect copy of this rare book reached the New York Public Library in 1953 and demonstrates that when Japanese workmen decided to emulate their Chinese teachers they were prepared to go infinite distances beyond anything the Chinese had envisioned or accomplished.

Sometime soon after 1740 prints were issued in Edo which abandoned the old idea of hand coloring and applied, by means of two additional blocks, the colors beni and green. Perfect registry of the two colors was made possible by the invention of kento (aim), the cut guide lines which are shown in 63 B. Prior to kento one corner of the woodblock was left uncut to support the paper (10 A) but it provided no assurance of registry should additional colors be wanted.

Credit for inventing kento has been given in turn to four different individuals. First, it is claimed that a leading fan manufacturer discovered the technique while looking for a way to bolster sales. Second, a bookseller who wanted to get into the profitable fan business invented the device as a way to make a big initial splash. Third, the chief printer for an outfit that sold street guides of Edo turned the trick well before 1740 as a way of adding yellow lines to his maps. Fourth, and this is most likely, Okumura Masanobu, always a cagey publisher, heard of the map maker's clever device for insuring registry and borrowed it for the production of his own prints.

Neither is it known who chose that incredibly lucky combination of beni and green from whose juxtaposition so much poetic beauty was to be created. It seems likely that the combination goes far back into history, long before Masanobu's birth, for it was known in Japan by 1635 and had been used long before that in Chinese erotic books. At any rate, Masanobu revived the use and it is unlikely that two more appropriate colors could have been selected. It is astonishing however to think that a period of about twenty-four years passed during which artists largely

restricted themselves to these two colors. But from them, plus jet-black ink and creamy-white paper, they produced color harmonies and implications of other colors which bewilder the eye, and for this perfection of technique Masanobu was responsible.

We can reject all the technical claims made for this wiry little man. We can deflate the pompous advertisements he spread across his prints, but we cannot deny that he was the most vital single force ever to hit ukiyo-e. When he arrived it was ready to become a second Otsu-e, with everything formalized, with subjects and style established. He kicked the art wide open and upon his precepts it lived for a good sixty years.

Into his orbit were drawn four gifted men. Of them Nishimura Shigenaga was the most angular, the most self-contained and in natural force the strongest. He was a tight painter, awkward in line and somber in color, yet he commanded such a powerful sense of rugged design that his finest prints bespeak a modernity that the prettier work of his contemporaries missed. He composed several prints showing groups of people on balconies drawn in European perspective, and these demonstrate the deep, pervasive poetry of suspended conversation at dusk. In many of his prints nature is featured and his gardens seem very real, with gnarled trees and angular rocks. He painted some of the finest lacquer prints, one of which is extraordinarily lovely, with a courtesan smoking a long pipe on a porch as she watches the evening moon rise across a river. His solitary quality is best demonstrated in one large religious print, unusual in ukiyo-e history, in which he depicts all the creatures of earth and heaven lamenting the death of Buddha. His elephants, lions, tigers and peacocks remind one of Henri Rousseau and evoke the same powerful imagery.

At times he copied Masanobu (33) but some critics claim he invented both benizuri-e and the later three-colored print, which these critics say Masanobu copied from him. His experiments in perspective work are more pleasing than Masanobu's because more varied in subject matter, but in selecting colors he was uninspired and it is unlikely that he could have stumbled upon those glorious combinations which mark Masanobu's best work.

Apart from his prints, Shigenaga is warmly regarded because he was one of the greatest art teachers in history, resembling in many ways Squarcione in north Italy. His pupils included many of the later masters of ukiyo-e, each of whom went far beyond his teacher. Their names are listed in the appendix and constitute an imposing array, each of whom

went out of his way to acknowledge his schooling at the hand of this awkward and powerful man.

Early in my study of ukiyo-e I was advised by a Japanese expert, "Whenever you find a print which is clearly a masterpiece but whose artist you do not know, call it a Toyonobu." The advice was good, for considering all ukiyo-e artists, Ishikawa Toyonobu probably painted a higher percentage of superior prints than any other except Utamaro. In his work there are not the dull passages that fill the lesser prints of artists inherently better than he.

Toyonobu is recorded in history as a man of memorable charm. Handsome, adroit, skilled, he married well and got a good tavern along with his wife. There he played host and it is said of him that never once did he consort with the courtesans of the Yoshiwara. He was an industrious artist, one of those fortunate men who perform right up to the limit of their talents.

With Toyonobu it is talent and not genius. His most delightful prints never quite match Masanobu's in fire; his most intriguing color harmonies never seem to have the brilliance that Masanobu commanded. His human figures, though they could not be better posed or drawn, seem a little arty. And his composition, applauded wherever students analyze it, is obvious. The fact is that Toyonobu pioneered nothing, and although he challenged Masanobu in the two-color print he added little to this curious and lovely form. Many critics have called Toyonobu one of the greatest masters of ukiyo-e. He was not that. He was one of the most successful.

He started his artistic life as Nishimura Shigenobu, under which name he did many strong lacquer prints, reminiscent of Shigenaga, who must have been his teacher. For two centuries critics considered this shadowy Shigenobu a young artist of great promise who died prematurely. At the same time there was speculation as to why so fine a painter as Toyonobu did no work before the age of thirty-two, when he suddenly burst upon Edo as one of the most accomplished and graceful of all the print makers. Belatedly we have discovered a simple answer to the two problems: Shigenobu and Toyonobu were the same man.

The early prints bearing Toyonobu's name are generally big, tall sheets, sometimes very narrow, exquisitely colored by hand, sometimes with lacquer added. Customarily they represent a man or woman moving majestically off the page with a grace and rhythm unequaled (34). There is hardly a single Toyonobu of this style that is not a stately,

poetic thing and when the hand-applied colors are in good condition, as they often are, there is a masterly beauty in these big prints.

However it is the prints from the next period that account for Toyonobu's fame. Taking the beni-and-green combination as his specialty, he composed a series of big rectangular prints which seem to contain upward of a dozen colors. Two such prints show the actors Kikugoro and Kiyosaburo as musicians. In the first they stroll off to the right in a manner most reminiscent of Masanobu's masterpiece (35) and in the second they are seated on a bench. They are huge prints, masterfully designed and finely colored. His uncut triptych (36) shows what he could accomplish with these two colors.

He pioneered only once, but in a field so unexpected that he merits considerable praise. Of all Japanese artists, ukiyo-e or classic, he undertook the most comprehensive experiments with the nude. His work is good and not the aborted self-conscious distortion which his countrymen produced under the invariable title, "Woman Getting out of Bath." Toyonobu's nudes are well studied and carefully drawn and although there is not sufficient space to speculate on why Japanese culture frowned on the nude, it is to be regretted that followers of Toyonobu did not proceed with his experiments. Then perhaps the autumnal days of ukiyo-e might have had a subject matter that could have carried the art forward and away from the flamboyant kimonos, the kabuki costumes and the historical armor that finally swamped the art. But to stress the nude was not traditional and Toyonobu's trail blazing in this field went to naught. Had his lead been followed he might justly be considered one of the greatest masters.

Of Torii Kiyohiro we know almost nothing. His birth and death were unrecorded. We know nothing of his parentage, his real name, his teacher or his working habits. He is a shadowy figure but one of the most widely loved artists of the school.

Working almost exclusively in beni and green, he produced a rare series of poetic prints. They are subtly drawn, awkwardly composed and delicately colored. In each there is a faraway quality that immediately communicates itself to the viewer, so that his prints have been appreciated in all countries and by all tastes. They are exceedingly winsome, and America's great collections contain excellent examples, for he has been especially popular here.

His prints fall into two general groups, small panels like print 37 and large sheets, the latter being the more striking. In one, Japan's Don

Juan, the poet Narihira, elopes with a young girl, but the representation is like no other of this subject, for Narihira is a most handsome young man and he carries his girl piggy-back through a field of exquisite flowers while about his head twines a poem of many mixed meanings: "To carry a girl on the back is a heavy load indeed," which can also be translated "A man is a fool to marry."

In most Kiyohiro prints the general design is both cluttered and ineffective, for he seems to have been one of the few ukiyo-e artists, along with Kiyomasu II, who lacked the sense of space distribution that is so marked a feature of this school, a weakness he demonstrates in print 37. In view of this central inability to design a print that sets the mind at rest, it is remarkable that Kiyohiro should have been so highly praised by so many critics. The secret is that his complete winsomeness, his naïveté and his poetic conception of life seduce the critical mind, so that his prints often seem finer than they really are.

In raw strength Torii Kiyomitsu resembles Shigenaga the way Torii Kiyohiro in poetic quality resembles Toyonobu. In most of his prints Kiyomitsu made no conscious attempt to attain quick beauty or obvious allure. His figures were strong and angular. His color was rich rather than pretty, and his composition dominant rather than cluttered.

He excelled in three kinds of prints, the small panel in two or three colors, the very tall and thin pillar print in which he did a few striking nudes after the Toyonobu manner, and large rectangular prints in which all his merits seem to flourish (38). He did a few hand-colored prints, many beni and green, an equal number of three-color prints and is said to have pioneered one of the happiest color combinations of ukiyo-e, rose, green, blue and bright yellow. He also was among the first to overprint two different colors to achieve a third and also created some very fine full-color prints. He thus bridges most of the major forms of ukiyo-e and is a solid, strong artist.

He has never been noticeably popular, however, for he neither innovated successful new subject matter nor did he establish any one successful style noted for its beauty. His benizuri-e are monotonous, featuring the branch of a tree, identical from print to print, jutting out and framing some actor's likeness. His angular figures do not attract and his color, while pure and right, does not invite. For these reasons Kiyomitsu has often been minimized, but in some prints he approaches perfection.

One, which merits special mention in the study of ukiyo-e, seems not

to be available in American collections. This is regrettable, for in Japan no other print has been recut more often, no other provides so many versions from which to choose as Kiyomitsu's very big horizontal print in many colors of the main gate of the Yoshiwara, showing the night procession of beauties, the young men of Edo, the older poets and philosophers, the little stalls where the girls entertain, the children and the older women who arrange meetings, and in the distance a temple with birds flying south. I regret that I could not reproduce this deeply loved print, for in its methodical reporting it summarizes much of Edo life and a great deal of Kiyomitsu.

Both Kiyohiro and Kiyomitsu were members of the Torii clan, the latter probably by birth and the former possibly by adoption. This means that they were trained to be sign painters and Kiyomitsu at least followed that profession, bearing the cherished title Torii III.† And it is as a Torii that Kiyomitsu now interests us, for he demonstrates the lack of inventiveness characteristic of the Torii school at this period. He shows clearly that if the old precepts of Kiyonobu and Kiyomasu alone had dominated ukiyo-e, the art would have foundered and died. In place of new ideas the Torii offered crystallized actors' poses. Instead of new design there were atrophied tree branches forming time-honored patterns. In lieu of color that sprang from the subject matter there was a highly perfected checkerboard of arbitrary tints. And instead of human beings carefully studied there were archaic dummies. So that no matter how much pleasure one finds in the hard, confined work of Kiyomitsu, there is also the tragedy of seeing the sterile end of a powerful Torii art. And it is this tendency toward sterility, detectable to greater or less degree in each of the men who surrounded Masanobu—Shigenaga, Toyonobu, Kiyohiro, Kiyomitsu—that makes Masanobu himself so important an artist.

It is regrettable that all ukiyo-e artists through Kiyomitsu have been lumped together under an extraordinarily inappropriate designation: primitives. The subtle line of Sukenobu is labeled primitive. The forceful and impeccable space dispositions of Kiyonobu are primitive. The haunting figures of Moronobu, the great statues of Kaigetsudo and the infinitely knowing work of Masanobu are supposed to be primitive. Even if one accords this condescending word its most favorable connotations—force, original power, strong color, simple forms, telling subject

† The first was Kiyonobu; the second Kiyomasu, the fourth Kiyonaga, after which the quality of the Torii line died away. But even today there remain painters in Tokyo entitled to the proud name.

matter—its use in ukiyo-e is totally misleading. These artists were no more primitive than Cézanne or Picasso. They were inheritors of a sophisticated and learned tradition. Most were trained for periods of six to eight years and the work of each shows that even if he did elect the bright colors of ukiyo-e and the common subject matter of Edo streets, he also knew the classical forms. In fact, as we shall see in Chapter 14, even the brilliant coloring of ukiyo-e, derived from classical schools.

Primitive these prints are not. The word was coined by print sellers who thus had an easy label which would attract European buyers and promote high prices. It was forgivable for merchants to invent such a trick; it was uncritical, misleading and somewhat fraudulent for historians of ukiyo-e to accept it. There are a few primitive pre-Moronobu woodblock prints, crude awkward things resembling very much the pre-Cimabue paintings of Italy. The word should be reserved for them; for if Okumura Masanobu is a primitive then so are Ludwig van Beethoven and Peter Paul Rubens.†

I cannot leave these early artists without reporting that many men who have spent a lifetime studying ukiyo-e reserve their affection for these early prints. An assembly of work by these great artists is positively satisfying and although I am aware that we have not yet mentioned the famous names of ukiyo-e—Harunobu, Kiyonaga, Utamaro, Sharaku, Hokusai, Hiroshige—men whose work set Europe afire, if we were back in the exciting years of the nineteenth century when prints were sold by the stack, I must confess that I would pick the lot through and take nothing later than Kiyomitsu, leaving the more popular and perhaps greater names for others. In the work of early men like Kiyonobu and Masanobu I would be close to the well springs of art: the rude line, the strong color and the massive design. I am convinced that in years to come Americans will grow proud of our unparalled heritage of these early prints.

† Objection to *primitive* arises from the contradictory connotations acquired by the word in recent years. In the phrase "the Flemish primitives" the word merely means *early*, for the Flemish primitive painters belonged to carefully supervised guilds which demanded long apprenticeship. In the phrase "that authentic primitive, Grandma Moses" the word obviously means an untutored, brilliant amateur ignorant alike of perspective and palette. The latter connotation has usurped the field and is inapplicable to ukiyo-e. Of course, most writers who apply the word *primitive* to early ukiyo-e intend the original connotation, but unfortunately that meaning has been engulfed.

9

The Exquisite Vision

SUZUKI HARUNOBU

*N*o major artist was ever influenced more profoundly by a technical improvement in his field than Harunobu, whose entire artistic life was altered by the invention of an improved system whereby as many as thirty different colors could be applied to one print with assured registry. As we have seen, there is much argument as to who devised this new use of kento marks and when, but in 1764 Harunobu experimented with it and in 1765 issued about one hundred magnificently colored prints in the course of which he perfected the technique to a point beyond which it never progressed.

Prior to this spectacular burst of energy, Harunobu had been a mediocre artist. As early as 1754 he had issued prints which looked like Kiyonobu II but which soon shifted to Toyonobu and then to Kiyomitsu. Later in life, when he dominated ukiyo-e, he boasted that he had never drawn actors—"I am a Japanese artist. Why should I draw portraits of this vulgar herd?"—forgetting that as a struggling young man he had drawn many actors, but without distinction.

He was forty years old when the lightning of full color struck and five brief years later he was dead. In that time he issued more than 600 prints (his total catalogued output exceeds 700; prints now lost probably totaled another 200) and among them were at least 150 truly delightful works. More people around the world instinctively appreciate a Harunobu than any other ukiyo-e print; indeed, his finest are probably the most widely accepted graphic prints produced by any society.

A brief description of two popular masterpieces will explain why. The first shows a young girl in a delicately striped blue-and-white kimono standing at the edge of a porch and looking out upon a lake where

iris grow. At the corner of the porch a flower pot contains beautiful red blooms whose soft color is repeated in a wisp of the girl's under kimono and in her comb. The charm of this print is fourfold: the woman is adorable and as her kimono slips from her shoulder she seems the essence of desire; the lake is invitingly suggested by white wavelets that dance across the palest possible blue; the flowers and the girl stand in a slight breeze which lends the entire print movement; and the colors are perfection. They are not only proper each to its own mission but they harmonize admirably. It is difficult to imagine how anyone could dislike this print.

The second shows a young girl seated by a waterfall, gathering a bouquet of many-hued asterlike flowers. Of itself the design of the print is delectable, with the flowers bending down to mimic the flowing lines of the girl's body, with a wanton stream tumbling over a falls and with the near shore and the sky establishing a fine balance. But it is the color of the print which allures the eye, for the girl is clothed in soft purple, the ground on which she sits is a most excellent yellow-brown and the entire sky is rosy-pink. This must sound awful; it looks fine.

One could continue describing Harunobu's happy prints until a hundred had been identified but it would all add up to this: adorable young girls never past their teens, dreamlike landscapes, heavenly flowers, and some of the most perfect color harmonies attained in art. Many critics have called these prints exquisite. Others, bewitched, have claimed that ukiyo-e ended with Harunobu and that all subsequent prints were a sad retreat from his original vision. But of late a more practical group of critics have extolled him: commercial men who find that his prints make perfect Christmas cards. One print in particular known as "Heron and Crow" in which a man in black escorts a girl in white through a snow storm under a yellow umbrella is both Harunobu's masterpiece and the most popular Christmas card of recent years.

Now there is nothing wrong with art that accidentally makes a fine greeting card but when prints sometimes seem to have been devised for that purpose alone, certain questions insidiously creep into the mind and the more one studies Harunobu the more difficult it is to ignore those questions.

Can a man's art be founded exclusively upon cloying pictures of girls in their teens? Two famous prints come to mind. In the first,

one of the evilest witches of Japanese legend enters a wood at midnight to hammer forty-eight spikes into the portrait of her enemy. To suggest this infuriated beldame Harunobu offers a sweet child of six-teen standing with poetic grace in a dreamy fairy land. In the second print the poetess Ono no Komachi is shown in her decrepit old age (13) begging by the road. In order to portray age, Harunobu uses a girl of seventeen instead of his usual model of two or three years younger. One can study Harunobu endlessly and find only that insipid, childish face. It appears not only on girls and old women; it also appears on men. One Japanese critic who adored Harunobu confessed the only fault he had ever found: "In love scenes I can never tell which is the man and which the girl. That's bad."

Can a man's art be founded primarily on thefts from other artists? Harunobu was one of the least original of the ukiyo-e artists. Sukenobu provided fifteen to twenty percent of his themes and without the work of this fine book illustrator serving as a quarry to be mined, it is uncer-tain what Harunobu would have become; but whereas Sukenobu's women run the full gamut of human experience Harunobu borrowed only the cloyingly sweet. Masanobu was also used frequently and a list of dozens of designs lifted from him is easy to compile, the most notable being that of the nymph Kinko Senjo riding across waves on the back of a carp. Koetsu, whom we shall meet later, provided designs from his ceramics and Kiyomitsu originally did the fine print used in this book (39). Most memorable however are the many prints which Harunobu borrowed from himself, returning again and again to some fortunate success which he would redraw slightly and issue as a new print. All artists borrow, in ukiyo-e more than elsewhere, but they usually do so when young. Harunobu was in his forties when he did his.

Can a ukiyo-e artist be considered first rate if he is defective in the design of his prints? No matter how highly one praises Harunobu's line and color, in his utilization of space upon a flat surface he was weak. His greatest prints, those so far mentioned, escape this criticism but most of the others do not. They lack a focusing point, a clearly under-stood relation between their diverse parts, and their backgrounds are badly cluttered. The worst examples of this failing are unpleasant and merit no further comment since their failure is obvious, but certain prints which have been highly praised for other reasons also show this defect. One Japanese critic has hailed as "one of the best color prints ever produced in Japan" Harunobu's famous picture of one young girl

standing on the shoulders of another to pick blossoms from a branch hanging over a gray brick wall. The scene is pretty, the girls enchanting and the conceit gentle, but the design is weak. The top of the wall cuts off one's girl's head, the picture is badly cramped at the top, and the kimonos of the two girls clash both in color and in drawing. The other shows a young man playing a Japanese drum while a closed book lies on the floor at his knees. In color and drawing this print is superb but it is positively annoying to look at because the background is badly chopped in design and color so that the eye can find no resting place.

There are grave defects in the work of Harunobu but because his prints are beguiling and easily understood he has suffered from a smothering adulation and his sometimes tedious procession of teen-age girls has been likened to the angels that decorate Renaissance art; he has been termed the Fra Angelico of Japan. The complete absurdity of this comparison will be made clear in Chapter 20, but for the present let me insist that it is misleading. An analogy to Pisanello would be more appropriate.

Such is the summary of the adverse criticism that Harunobu has always deserved but which sentimentality has kept from him. Now let us see what his solid attributes were.

He was the first to employ full color and although one may argue that any ukiyo-e artist who had stumbled upon the devices available to Harunobu would have produced just as good color harmonies, I do not think this is true. In the late days of ukiyo-e, color ran wild and helped kill the art. If Harunobu had elected colors like those the art would have died sooner. Fortunately, this subtle and glorious colorist exercised admirable taste and established a palette that is one of the glories of Asiatic art.

He was also a daring innovator. Not content with the colors he found at hand, he was willing to experiment with rosy-pink skies, kelly-green for earth, a positively jet-black for night skies, a blue of his own manufacture for sunny skies and an opaque brown which produced very happy results. He also pioneered the loveliest single color in ukiyo-e, a gray (made of ink, white lead and ground mica) that lends beauty to any print upon which it appears. I have sometimes been struck quite silent by the magic effect he obtains with this color in a print showing an old poverty-stricken Chinese sage—represented by a courtesan in her teens—reading by snow light at a window in

a solid gray wall overhung with bamboo branches laden with snow. In his later years when his designs were very weak his colors weakened too—that is, they became more violent and clashing—but what the interrelationships were between these two degenerations or which caused the other is debatable; in his early prints of simple design and great flat areas of color he was supreme.

He also pioneered in the extensive use of embossing (also called gauffrage or blind printing) although he did not invent the technique, which had been used in early lacquer prints to define the areas to be lacquered. No one approached Harunobu in his creative use of this simple device whereby a block with no ink is used to raise certain portions of the print into effective patterns. He used it variously: kimono designs, snow banks, horizon lines, birds in flight, waves or as a substitute for portions of the key block. His effects were happiest when embossing was used sparingly in connection with colors to suggest cloth; but actually embossing is a perversion of the basic idea of ukiyo-e in which flatness is essential to the artistic concept. There-- fore when overdone it is distasteful and later artists used it sparingly. In the prints here reproduced embossing is used in 39 (snowy branches on first kimono); 40 (white kimono); 43 (kimono sleeve); and 53 A, B, C (edge of the rolled paper at bottom center). It is used in the original way to define the lacquered area in the headdress of 57.

If Harunobu copied, he copied the best. Without him the wonders of Sukenobu might not have gained wide circulation and he performed an even greater service to ukiyo-e by introducing Chinese influences when they were needed to cross-fertilize Japanese concepts.

As early as 750, Chinese artists had done good work with wood-blocks and by 1330 had developed two-color printing and embossing, samples of which reached Japan. By 1590 full polychrome printing, though with poor registry, was known. It was in 1627 that the first volume of a book destined to have lasting effects in Asia was published. Assembled by the artist Ku Yueh-tsung (also spelled Hu Cheng-yen) it was named for his fanciful home *Ten Bamboo Studio* and was an instruction book for artists. Completed in 1633, copies soon found their way to Japan, where years later it was republished. The book is notable for its color work copied from classical Chinese painters and reproduced by fine woodblocks.

It was not this book which influenced Harunobu but one like it whose fame was even greater, *Mustard Seed Garden*, named after the

residence of its general editor, Li Yu, whose son-in-law commissioned the painter Wang An-chieh to produce a series of pictures which could serve as an art course. Publication was slow, consuming the years 1679–1701, with an inadequate last volume appearing in 1818, which must be something of a record.

Reasons for the delay were explained by Editor Li: "One who works with brush on paper cannot engrave on wooden blocks, and one who engraves wooden blocks cannot produce those light, clear, delicate tones in shading and coloring on paper. Thus we hesitated, feeling as if our hands were bound, and the work brought to a standstill. . . . Thus, having inquired after good hands for eighteen years, we at last found the right men. . . . Occasionally, what one who uses the brush is unable to attain, one who handles the knife will do; and what one who handles the knife is unable to give, one who uses the brush will accomplish. Classified according to the order in which they are to be used, to give the right colors for certain pictures, scores of printing blocks reach a height of more than a foot when piled. As for the work on the blocks, distinguishing between lighter or heavier applications, and after scores of trials, it took hours for the printing of some of the pictures. Thus each picture, when done, not only causes the connoisseur to clap his hands in excitement, but also causes good painters to express their approval profusely."

One good artist who expressed his approval was Harunobu, who sometime before 1764 saw these volumes, then more than fifty years old and well known in Japan. From *Mustard Seed Garden* Harunobu obtained much of his sure color sense, most of his instruction regarding flowers and some of his ability to create mood. Cut off like other plebeian ukiyo-e artists from formal instruction in Japanese classical schools, Harunobu was lucky to find in this Chinese masterwork the ideas he needed to perfect his style. Blending the lessons from *Mustard Seed Garden* with those learned from the benizuri-e masters, he was soon offering Edo prints requiring ten different blocks in a rainbow of colors never dreamed of by the Chinese.

But it is not his technical experiments that have made Harunobu the darling of ukiyo-e. He created a private artistic world of his own, a feat which few can accomplish and only those who have tried can appreciate. It is a world of spring and rippling waterfalls and flowers and young girls perpetually beautiful. No fears intrude, no age, no withered grass, no hurt or anger. No artist ever portrayed so black a

night as Harunobu uses but he always illuminates it so that the living world under the jet-black sky is a little brighter than noonday. It is a universe of dreams created by a man approaching fifty. Consistently beautiful, magnificently colored with the pigments of youth that most of us forget, it is the world of one man's vision. Most of all it is recollection of how entrancingly beautiful girls can be, how like the reeds at the river's bank or the birds in spring, how very like the lazy wind that comes across the lake on a summer's day. Life must assume hundreds of aspects which an artist could legitimately preempt for his private world. Harunobu alone chose the aspect which is forever fair.

It seems intrusive to inject scholarship into such a world, but two perplexing questions persist. The first involves an astonishing young man called Harushige, a pupil who admitted in a book of memoirs long after Harunobu's death that he made his early income by forging prints in his master's style. What disturbs collectors is his contention that prints containing embossed designs were his, for they constitute some of the most sought-after Harunobus. The truth will never be known but of three things we can be certain: Harunobu was more counterfeited than any other ukiyo-e artist because the market for his prints has always been larger; the confessed faker Harushige went on to become one of Japan's outstanding intellects under the name of Shiba Kokan and introduced much European learning into Japan including engraving, perspective painting, Dutch technical skills and many scientific theories; and finally, the prints which Harushige openly signed with his own name aren't very good so that doubt must be cast on his ability to have counterfeited Harunobu very extensively without detection.

The second problem concerns print 39, which is clearly by Harunobu but just as clearly signed by another amateur artist, Kyosen. It is one of eight prints depicting household analogues to the eight views around Lake Biwa at Otsu (61), and is remarkable since the original paper wrapper in which the set was sold still exists in Chicago with signed proof that this particular print and its seven companions once rested in Kyosen's personal collection.

He was the moving spirit among a group of brilliant young men who called themselves after Kyosen's family name, The Kikurensha Group. They were art amateurs and exchanged among themselves at New Year's elaborately printed greeting cards in which refinement of

taste and felicity of invention were prized. Since the year 1765, when Harunobu issued this set, was a notable year in Japanese history, the nine hundredth anniversary of Sugawara no Michizane (57), intellectual and artistic imaginations were excited.

To celebrate this auspicious year Kyosen and his intellectual group caused to be printed numerous fine prints bearing secret marks which represented the sequence of long and short lunar months, which in the Japanese system then in use changed from year to year.† Attempts were made to be especially clever in hiding these marks from all but the initiate, for the Tokugawa dictatorship punished severely anyone issuing calendars, which were a state monopoly and reserved for eleven favored publishers. So the months were indicated by broken designs in a kimono, or by the long and short hairs on a saint's chest, or in the scales of a dead fish, or along the pilings of a bridge. Such tricks provided a lot of secret fun but when the year was past the hidden marks were chiseled off the block and the resulting prints were sold to the public.

But print 39 is not a calendar print. Why is Kyosen's name signed to it? Probably because Kyosen commissioned the series for his group and suggested the idea of applying the eight famous views to ordinary family life. For years it was assumed that he had provided the specific analogies and perhaps even the designs and colors, but now that seems unlikely for a set of poems has been found which were composed by a precocious child in 1726 and which established the analogies used by Harunobu. For even more important evidence that Kyosen did not provide the design see the text accompanying print 39.

But other persistent doubts remain, for most of the prints in this set exist in second and third stages. In the second, Kyosen's name is dropped, which would be reasonable if the prints were to be sold to the public, and in the third Kyosen's name is gone but Harunobu's appears. What is disturbing is that with each subsequent stage artistic quality deteriorates. Colors become garish, the design which was never exceptional is worsened by wrong colors, and embossing is introduced where it has no place. The fine simplicity that a sensitive amateur like Kyosen might have insisted upon in original versions for his club is gone, and when Harunobu's name appears it is a sure sign the print

† In 1765, for example, the long months were 2, 3, 5, 6, 8, 10. For 1764 or 1766 they would be entirely different. Thus, any print which clearly indicates the sequence 2356810 could refer only to 1765.

has degenerated. If this set were an isolated example one could claim that some thoughtless publisher had acquired the blocks and cheapened them, but this same downhill trend appears in all prints once signed by Kyosen. Possibly all such cheapening was due to commercial publishers and it is charitable to propose that Harunobu never saw these later versions. But what keeps doubt alive is that the deterioration of values in successive states of Kyosen prints is precisely the deterioration one finds in all of Harunobu's work from the high poetic prints of 1765 to the garish and worn-out stuff of 1770.

Of Harunobu's personal life we know little except that he was bedazzled by four of the most beautiful girls in Tokyo: a waitress, a toothbrush vendor, a temple attendant and a leading courtesan. The first, O-Sen, who sold dumplings at the fox shrine of Kasamori, appears in more than fifteen prints designed by her admirer. She was a remarkable girl of such unforgettable beauty that the people of Edo devised the myth that she had come down from heaven on a cloud, as she is seen doing on the opposite page. Books were published about her, plays were composed, songs detailing her loveliness are still sung in modern Tokyo and a contemporary poet said of her, "O-Sen was born beautiful. Without taking pains of polishing, her appearance is clean, and without making her toilet she is lovely. Neither comb nor face-powder, neither hairpin nor rouge is of use to O-Sen, for she relies upon her own natural beauty." People actually made pilgrimages to see her until she confounded them all by eloping with a samurai to whom she was a devoted wife, living into the nineteenth century. A lot of nonsense has been written about Harunobu's idealistic passion for the "heavenly child of sixteen" but once more Chapter 20 should be read before accepting much of it.

The persistence of this man's exquisite vision is nowhere more

6 O-SEN, FROM *URIAME DOHEI DEN*
(Biography of the Sweets Seller Dohei)

Suzuki Harunobu

Location: Museum of Fine Arts, Boston. *Date:* 1769.
Size: 6¼ x 4. The original figure of O-Sen is two inches shorter than in this reproduction.
Signature: Harunobu ga. *Publisher:* Unknown.

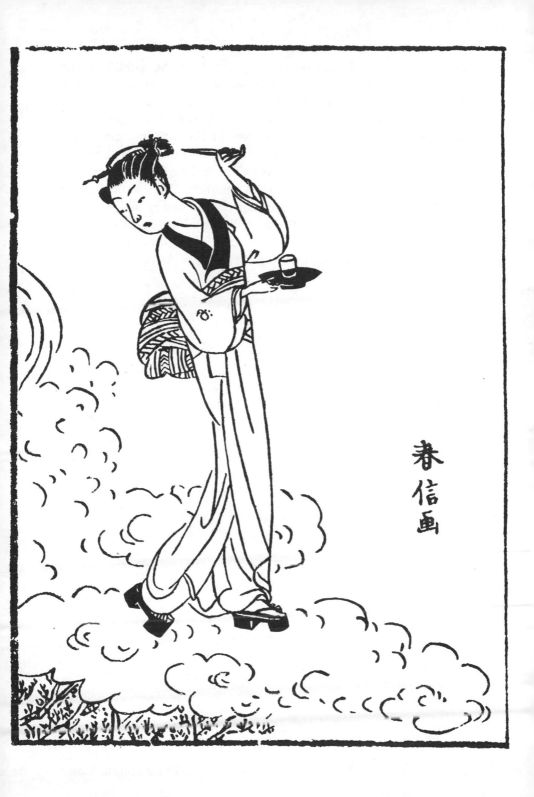

poignantly illustrated than in the amazing book he published just before he died, *The Beautiful Women of the Yoshiwara*, in whose five volumes he portrays all 166 leading courtesans of the city. We know that in 1770 some of these girls were young and of rare beauty but many must have been old harridans, yet in the artist's dream world they are all tender children, they are all pure and they all look exactly alike. Hinazuru of Chojiya, Harunobu's last love, is identical with all the others, and precisely like O-Sen, his first. Once on a print he added a poem, "Spring after spring flowers the cherry and never do we weary of it; then comes a flowering beautiful beyond all we have imagined." He never altered his vision, and it is for this constant vision that we praise this often overpraised artist.

10

The Basic Principles of Ukiyo-e

*N*ow that several masterpieces of the school have been presented, it is appropriate to state those major principles upon which the art is founded; for some of the basic assumptions of ukiyo-e are so alien to the western mind as to warrant special description and at times justification, lest the American viewer slip into the error of thinking that Japanese woodblock prints would look more like western art if only the ukiyo-e artist had had more skill.

Anyone who has studied and compared the national differences in any major art form—say sculpture from such diverse cultures as Africa, Polynesia, Periclean Greece, China, Aztec Mexico, Medieval Germany, Angkor Wat and Spain—inevitably concludes that each of these societies possessed sculptors of approximately equal merit, so far as the raw ability to carve was concerned. In one culture there will be about the same percentage of artistically gifted men as in any other but the quantity of their work will be determined largely by the demands of their society and the form by the material accomplishment of that society at the given moment when the individual artist lived. There were probably just about the same percentage of Athenians potentially able to write poetry three centuries before Christ as there were New Guinea savages able to compose powerful war chants three centuries after Christ. Whether these potentialities were called forth and in what form depended largely upon the demands of the society in which the poets happened to live.

Specifically the woodblock artists of Japan in the years from 1660 to 1860 were just about as gifted, had just about the same artistic vision and technical potential as the men of Venice who did their great work in the years from 1400 to 1600. It was the difference be-

tween the cities Edo and Venice that accounted for the difference between a ukiyo-e print and a Venetian canvas. It is inconceivable that the difference could have rested in the natural ability of the Venetian eye to see what a Japanese could not; nor did the nerve components of a Venetian mind react in any way differently from the nerve components of a Japanese mind.

This means that any potential painter in any society since the world began has been able to draw pretty much what he wanted to draw. Whatever pictures he has left us probably look pretty much the way he wanted them to look and it is not right to think that his work would "look more like ours" if only he had had the brains to make it so. His pictures look the way his experience and the taste of his society wanted them to look. Therefore, if ukiyo-e prints sometimes look strange to western eyes it cannot be because some primitive and ill-trained Japanese artist couldn't draw "in the right way," but rather because this extraordinarily subtle and well-trained man wanted his picture to look exactly the way it does. From the points which follow we can deduce what the ukiyo-e artist was driving at.

1. The ukiyo-e print is a flat piece of paper on which certain things have happened. It needs no frame and never had one. It differs dramatically from a western canvas where the major attempt has always been to escape flatness, to suggest depth and to retreat behind a massive frame which holds the foreground of the picture steady and establishes a point from which the non-flat canvas can recede into the imaginary distance. To hide a ukiyo-e print behind a frame and then to complain that it has no illusion of depth is a perversion of the artist's intention, for the typical ukiyo-e print is forever and ever a flat piece of paper with no pretensions to depth.

Which convention is more pleasing and the more conducive to great art? As to pleasantness neither convention is superior. No ukiyo-e print can convey the dazzling effect of a great framed perspective canvas by Titian or Velasquez. However, one often studies an acre of such canvases in either the Prado or the Pitti without ever experiencing that intimate sensation of complete art which sometimes comes from catching unexpectedly the simple beauty of a Kiyonobu black-and-white print or an exquisite Masanobu. Stated succinctly, almost any Rembrandt is preferable to the best Kiyomasu II; while the merest scrap drawn by Sukenobu is more shot through with the essence of art than all the canvases of Vigée-Lebrun.

As to the ultimate potential of the two styles, it seems obvious that western perspective art set behind a frame produced an enormous number of highly gratifying paintings; but in time it became so sterile, so rococo that the fresher principles of Japanese art were needed to revitalize it. But at the very moment when the wonders of ukiyo-e were astonishing France and England, in Japan the form was moribund, inbred and sterile. One great French artist like Cézanne or Renoir could have saved ukiyo-e with an infusion of new blood and new concepts. One concludes that any art form is good while it is vital but that without constant exchange of ideas it must perish.

2. The principal characteristic of a Japanese print is that it distributes its flat space with almost unfailing taste and judgment. It is invidious to select only three prints when almost all illustrate this point, but 3, 54 and especially 52 show with what sensitive appreciation of spatial relationships the ukiyo-e artist worked. Consider a more intricate and flamboyant example. Any one of the three separate sheets that combine to make 36, or the composition as a whole with its use of Japanese script, the inclination of the three trees and the placement of the signatures represents a disposition of space that is perfection. Almost any Japanese print can be studied from top to bottom, from side to side, from corner to corner or altogether in one quick glance, and the result is architecturally pleasing.

It is amusing to note that in 1900, art schools throughout the west began to direct their commercial students to study Japanese prints in order to discover the principles underlying effective work in poster design, big advertising boards and textile patterns. But almost invariably the prints set aside for such study were late things, inartistic daubs with atrocious color and rococo heroics, and there was hardly a decent print among the lot. Yet in spacing, design and allocation of written matter even these prints were artistically impeccable. No matter what happened to ukiyo-e's color or content, the unfailing judgment in space relationships rarely diminished. Apparently the artists did not forget what their basic commission was. Before them they had a flat piece of paper on which forms and titles and signatures and Chinese poems could be distributed tastefully, and neither wild content nor vile color ever deviated the artists from this basic task.

How did the Japanese artist acquire this mastery of flat space? Basically it was inherited from the ancient conventions of Asiatic art and derives directly from Chinese classical painting. Therefore little

credit is due the ukiyo-e artist. Nine centuries before Moronobu this exquisite sense of space was apparent in Chinese art and had already been adapted to Japanese forms. Probably this general Asian mastery of a problem which western art never fully solved can be explained by the fact that the Asian artist customarily sits cross-legged only a few inches above his paper and sees it always spread out flat beneath him. This simple physical fact possibly accounts for much of the difference between the western framed canvas intended to be seen from a distance and at eye level when standing, and the ukiyo-e print intended to be held flat and close to the eye. So that although there can be no physiological difference between the Japanese eye and the western eye in their capacity to carry impressions to the mind, it is a fact that here the two pairs of eyes were used in quite different ways, as a sea captain's eye, habitually accustomed to scanning a horizon, acquires a distinctive habit of looking at any scene, that is different say from a jeweler's.†

3. In addition to an unerring sense of space, the ukiyo-e artist also commanded a clean pure line. This has already been discussed so that we are here concerned only with guesses as to how this mastery was acquired. A two-fold explanation has been proposed.

First, Japanese culture has always placed a premium upon fine handwriting. In *The Tale of Genji*, court gentlemen repeatedly comment not upon the beauty or education of their mistresses but upon their handwriting: "Alas, her writing was still quite unformed and . . . considering the writer's rank and what would naturally be expected of her, it seemed a shame to show so childish a production." Also, the western visitor to Japan is unprepared for the cherished framed pictures he sees in the homes of his friends: an oblong sheet of coarse paper containing eight or ten scrawled characters. Upon asking what this treasure is he is told, "The words read, 'Shibata Yonezo stopped here.' See how mature and poetic the handwriting is." No distinction is made between a picture and a sample of calligraphy, and indeed the same Japanese word stands for both processes, so that customarily a Japanese critic will say of a print, "Masanobu wrote that." This adoration of fine handwriting is conducive to a firm line,

†Hasegawa Saburo, Japan's leading avant-garde artist, thinks this sense of space distribution derives from training while young in writing Chinese ideographs: "We were told always to put the characters on the paper beautifully." When pressed for an explanation of what determined whether the characters had been put down beautifully, he replied, "Anybody knows that instantly. You feel it."

a vibrant line and one that aspires of itself to beauty. It is this line that the Japanese artist inherits from the days of his youth.

Second, the psychological effect of using separate ideographs to represent specific words—rather than using an alphabet whose parts can be used over and over again to construct all possible words—is not only profound, but it also encourages control of the painting brush and attention to visual forms. It is not possible to describe the different emotions felt when a Japanese paints the unique ideograph for *man* and when a westerner writes the three letters *man*. The ideograph recapitulates a millenium of human experience and objectifies that experience. The mind, as one paints this ideograph, is actually engaged in painting a picture of an idea. Furthermore, each such symbol is a tactile summary, so that writing does indeed become a process of painting numerous pictures, and the use of one word to describe both writing and painting is logical.

Now consider the experience of western man when he writes the word *man*. The letters he chooses are in no way distinctive, they recall no picture deeply imbedded in the racial mind. They are simply three useful letters chosen rather arbitrarily to represent an abstract idea and if our man happened to have been born French five other letters would accomplish his job much better. Since there is no relationship between writing the word *man* and painting a picture of the idea, writing and painting in the west are two different occupations.

The likelihood that Japanese ideograph writing inclines the mind toward materialistic and pragmatic thought, whereas western abstract alphabets encourage philosophical speculation need not be explored here; but Japanese scholars are aware of this inclination and are considering abandoning ideographs in favor either of their own alphabet of complete syllables—like sa, so, se—which is not ideal, or the western alphabet of single letters, which is.

It is therefore obvious that any Japanese boy who reaches the age where formal art training seems advisable will already have had years of painting instruction. He will know how to use a pointed brush and black ink to paint an enormous variety of lines. He will already be a graphic artist.

4. The ukiyo-e print uses color in the same way that it once used black and white. Masses of color are distributed the way Kiyonobu distributed his masses of black and white. With few exceptions ukiyo-e color is flat, opaque and of two dimensions, as opposed to western

color which is apt to be tactile, iridescent and with the third dimension of varied intensity. Ukiyo-e color is distributed in areas, often enclosed by neat black lines, and until late in the art no serious attempt is made to shade one color into another, for the effect sought is not lifelike naturalism but the pleasing color-pattern sought after by any good cheap modern wallpaper. As before, the greatness of ukiyo-e color consists in the sure way these masses of flat color are distributed (45, 57). It is in this use of raw color to achieve maximum effect that the ukiyo-e print is so modern.

5. Sometimes ukiyo-e utilizes individual colors of sheer loveliness and with them obtains harmonies that are subtle and pleasing (39, 54, 62 and in its original form 38). It was masterful color like this that bedazzled European artists when the French palette had grown rather murky. The Japanese reminded Europe how wonderful flat masses of color could be, although of course men like Duccio and Ghirlandaio had known the secret.

There is no easy way to explain how this sense of color developed. Classical Chinese art denigrates color and the ultimate Japanese paintings are in black and white, although one antique style as we shall see used color pretty much in the ukiyo-e manner some six hundred years before Moronobu. But the sheer brilliance of ukiyo-e color cannot be thus explained. As in most ukiyo-e problems, one must look at sprawling, vital Edo for the clue. Commoners of great wealth dominated the night life of the city. Forbidden both by law and custom to use color in their own costumes, they took malicious delight in spending huge sums of money in dressing up the courtesans of the Yoshiwara and some of the most successful books printed in Japan were garishly colored reports on life in the green houses. These rich men also liked their prints brightly colored and the triumph of color in ukiyo-e is doubtless a triumph of the nouveau-riche spirit, the bourgeois taste. As such it has always outraged proper scholars and delighted the rest of the world.

6. Also bourgeois is ukiyo-e's insistence upon content that tells a story. It was never an abstract art, for even the monumental Kaigetsudo prints probably served as advertisements for the green houses. Ukiyo-e patrons demanded prints which reminded them of experiences they themselves might have had (30, 47), or of moralizing incidents from Japanese history (13, 18, 27, 28). There was also a lively market for scenes from Chinese history, though none of the artists had ever

seen China, which recalls the constant sale in western nations of romanticized scenes purporting to show Jerusalem or Galilee. And of course there was always an unsatiated desire for scenes of life in the great houses of prostitution (9, 50) or in the theatre.

7. In telling a story ukiyo-e uses the posed tableau rather than an arrested moment of actual life. This is an important distinction in art and no merit adheres to either convention at the expense of the other. Giorgione and Watteau created masterpieces in tableau form; Tintoretto and Rembrandt did the same with moments torn out of actual living. Ukiyo-e's greatest tableau landscape (55) is precisely like a Watteau and as lifeless. So, to a lesser degree is the Shigemasa posed street scene (19) or Masanobu's promenade (35). Among the prints in this book are three exceptions to ukiyo-e's standard tableau. Shunman's beautifully poetic night scene (17) is atypical because this artist, as we shall see, was a solitary genius somewhat outside the tradition of ukiyo-e. Moronobu's fish market (8) contains so much Edo vitality that it breaks out of the tableau form; and Sukenobu's tragic portrait of Ono no Komachi (13) portrays a story so poignant that it disrupts Sukenobu's placid style. But for the most part even in gay Yoshiwara scenes or violent theatrical prints it is tableaux that are presented.

8. In its gracefully posed tableaux ukiyo-e is pathetically the slave of fashion. Any new fabric (33, 34) or hairdress (54) or popular waitress (6) or champion wrestler (52) or dance (26) or returning courtesan (53 A) had to be memorialized. It is doubtful if any of the world's other major arts confined itself to so cheap and ephemeral a subject matter as ukiyo-e's. If a theatrical print arrived on the streets a day late it might not sell. A print which carelessly represented a courtesan in last year's hair style would be ridiculed. It has long been popular to describe the clientele of the ukiyo-e artist as the uncouth peasant from the hinterlands. More often he was the exact equivalent of today's smart and knowing night-club habitué. A print that did not please the sophisticated though largely uncultured man-about-town would be a flop. It was not till late in the history of ukiyo-e that emphasis was placed upon penny-postcard subject matter. Then pictures of places a man might have visited predominated and hicks from the sticks became the principal patrons.

9. Ukiyo-e prints strive openly for a deep emotional response on the part of the viewer. This may surprise westerners brought up on

the cliché that Japanese always try to hide their emotions, but when Harunobu painted his beautiful waitresses (6) he intended them to be loved. Kiyomasu wants to inspire admiration for the two warriors who fought half a day on a crumbling bridge (28). Masanobu clearly wants his customers to revere the memory of Soga no Goro (32) and Shunei intends to remind his public of Sugawara's deified goodness (57). Care was taken in selecting prints for this volume to avoid that flood of ferocious pictures, mostly triptychs, in which the heroes of old Japan bleed and writhe and die and rise again as fearsome ghosts. Anyone who persists in thinking the Japanese unemotional should be put in a room with two hundred such horrors.

10. In order to remind the viewer of this emotional content, ukiyo-e uses an intricate system of symbols which serve as an emotional shorthand. Japanese culture is normally rather richer in such use of symbols than western cultures, but ukiyo-e exceeded even the Japanese norm. The carp struggling upstream on Goro's kimono (32) is not only decorative; it is also an extraordinarily potent symbol of courage.† A pair of lovers under one umbrella (36) is not only a pleasing fancy; it is also packed with enormous emotion for it signifies that the young people are not married but that they are living together in defiance of their parents and of public opinion.

Of course, every culture develops and sustains such symbols and an artist is wise when he utilizes them. For example, Delacroix offers us a somber young man in velvet and it's a satisfactory picture; but this young man is standing by a grave, holding in his hands the skull of a long-dead jester and suddenly the picture carries a heavy emotional freight to anyone brought up in western culture, for the skull is Yorick's.

In its richness of iconography ukiyo-e must be compared with religious painting of the Renaissance, in which almost every picture contained an iconography that had to be known if the picture were to be appreciated. Theoretically, what is more boring after the hundredth version than St. Sebastian pierced with arrows, St. Lucy with her eyes upon a saucer, St. Catherine with her wheel or St. Bernardino with his

† Japanese adulation of the carp affords a neat insight into national customs. To Americans, the carp is a slovenly fish, while the noble salmon, battling its way upstream, is the symbol of courage. The Japanese, having no salmon in their rather trivial rivers, endow the sluggish carp with the salmon's virtues—as we would do if we had only carp.

model of Siena? But actually such repetition does not become tedious. Consider the thousands of representations of incidents in the life of the Virgin, where hackneyed iconography evokes a deep emotional response that would be quite inexplicable to anyone not reared in Christian tradition. Renaissance art becomes stronger through this apparent weakness.

In the same way ukiyo-e iconography is one of its chief adornments and upon almost every print in this book an extensive iconographical essay could be written, adding immeasurably to the print's emotional content. Sometimes the symbol is color as in 45, where the sullen brick-red immediately calls to mind the stupendous actor of the early 1700's who created a sensation in a costume of that color, so that his descendants perpetuated both the color and the costume. At other times it might be a posture as in 42, where a Robin Hood character from Japanese mythology stands in defiant pose with umbrella, flute and purple cloth about his head. Almost anywhere in Japan the pose would be recognized as a gesture of protest against pompousness. In other prints the symbol might be a casual bit of property, as in 38 and 46, where even the suggestion of a temple bell recalls a romantic tragedy. Or it might be some courtesan's fantastic headdress (54) which invokes the memory of this particular beauty; or a cuckoo (7, 19, 55) which is not merely a bird but a symbol recalling an entire constellation of poetry, philosophy and mythology. In the same way 20 shows not a monkey and a crab but a specially fiendish monkey who tricked and bedeviled a stupid crab until the entire forest community had to thrash the tormentor.

This is a good print on which to end this discussion, for no amount of interesting iconography ever made a bad picture a good one. If ukiyo-e boasted merely a fascinating subject matter it would be a very dull art indeed; but one look at 20 assures us that ukiyo-e is not only an encyclopedia of an age. It is also an art.

11. Ukiyo-e prints display amazing technical skill. Like content, skill alone is nothing; but it is certainly one of the foundations of any satisfying art. The great painters knew how to paint, the great novelists knew their business. The technical skill in drawing, wood-cutting and printing required for 52 is great. Consider merely the hairline. How would a clumsy hand cut wood to that degree of detail? Anyone trying to understand ukiyo-e should periodically study a hatch

of European woodcuts of comparable date to see what tremendous things the Japanese craftsmen were accomplishing and how downright incompetent European wood engravers sometimes were.

12. The last principle of ukiyo-e is probably the most difficult to understand. The perspective used is Asian and the results are apt to be quite the reverse of those obtained in western art. Consider 40, where the lines of the wall back of the mother converge near the spectator and draw apart as they run into the distance. The same principle is visible in the latticed roof of 9 and in the background of 21. In other prints observe how supposedly flat surfaces tilt sharply upward so that they don't lie flat at all (11, 18, 27, 38). Note particularly the tree in 25 and try to explain how the roots of the tree stand so far in front of the courtesan while the top stands so far behind her; yet the woman and the tree both remain in their correct private vertical planes.

These prints contain no error in perspective. The artists wanted them to look exactly the way they do, for the system of perspective adopted is one devised in China around the time of Christ. Here again, as in so many other instances, the ukiyo-e artist worked within the great tradition of Asian art.

An English critic with mathematical training, Wilfrid Wells, has analyzed this Chinese system for suggesting perspective and has found that its canons are just as methodical and scientific as those governing western perspective. He has shown that the point of derivation for major lines lies contrariwise to the point used by western artists and certain interior conventions are also contrary. But the result is just what the Asian artist wanted.

An exemplification of most of these rules can be found in the Philadelphia Kiyonobu (11). One of the important canons of Chinese perspective is that the bottom of a picture must represent the point nearest the spectator, so that here the tip of the courtesan's sash and the end of her kimono occupy that position. The bucket is measurably farther back and from the perspective of its drawing, the eye of the observer must be quite high. The edge of the porch is both higher than the bucket and farther back, and from its position we can deduce the major canon of ukiyo-e perspective: "the higher on the print, the farther back." Thus Danjuro, in the middle of the print, must be farther back in space than the woman even though his right arm

seems otherwise, and the straw eaves of the house at the very top of the print must be farther back than the porch on which Danjuro sits. A secondary principle, previously noted, also operates here, for the edge of the porch above the signature is nearest to the spectator whereas the edge over the woman's right shoulder must be farther away; yet the two parallel lines formed by the edge of the porch and the ground diverge behind her shoulder in direct contradiction to western art, which would require them to converge. Similarly the balustrade upon which Danjuro rests is low at the near part and high as it recedes. The same principle operates in the floor boards, which grow wider as they recede.

So far the print seems to adhere to the established rules: the higher up, the farther away; and lines, as they approach the foreground, must converge. But what of the waterfall and the trees and the grotto? Since they are noticeably lower than the straw roof, they should be nearer the spectator; but they are obviously in the distant background. In fact, they conform generally to western principles of perspective, but this conformity is only an illusion. They are, like the backgrounds of so many fine prints of this period, merely impressionistic. The constituent elements have been placed not in obedience to any law of perspective but solely according to what one might call a higher law: put things where they look good. It is this extraordinarily modern artistic freedom, dating far back in Asian cultural history, that makes the ukiyo-e artist such a powerful master of space disposition, for the ultimate aim of any print is to dispose its masses well. This wonderful harmony of space differs from the European tradition of 1800 but it is quite consonant with the international tradition of today as practiced, for example, by Chagall.

It is necessary to point out that all Japanese artists after Masanobu understood western perspective (30) and some of them produced work that was scientifically correct according to our standards. Unfortunately such pictures were neither inspired nor related to Japanese tradition so they were promptly abandoned. Consider the last print in this book (63 A). Kuniyoshi thought that some concession to western perspective was necessary in an architectural print of this kind and he set up his points correctly according to our standards. But when it came to shadows he faced another problem. Japanese tradition was adamant that shadows not be used for they destroyed the

illusion of flatness. Kuniyoshi thus had no inherited tradition to guide him and it is amusing to try to figure out how many moons would have been required to cast the various shadows he introduces.

How do ukiyo-e prints compare in technical excellence with western woodcuts or with work in the other European graphic arts? An entire book should be written on this by an expert, but the following highly compressed judgments will probably not be reversed when that is done. A careful student of the problem, Hans Alexander Mueller, settles one question bluntly: "With but few exceptions, then, the colored woodcut in Europe has produced a large but somewhat feeble progeny—insignificant in style, more or less crude in color. The best of them are still inferior to the Japanese." There is little reason even to make comparisons, so superior are the Japanese color prints.

But in black-and-white prints Europe not only competes favorably but there are times when the rude, powerful and wood-born prints with ragged edges of Dürer, Altdorfer and Bewick are a blessed relief from the too highly refined Japanese print which shows no sign whatever of having sprung from a chunk of wood.

In etching, dry point and engraving western artists excelled because Japanese artists did not try these forms, except experimentally, whereupon they consciously decided that they preferred their own woodblock system. It was in lithography, that marvelous and supple medium, that the western artist finally found a means of producing color work that, starting in 1798, finally challenged the Japanese color print. The mezzotint, though popular, never did. On the other hand, no system devised in the west, not even photography, ever enabled one man to copy the work of another so faithfully as the woodcut system of Japan.

A conclusion at once generous and correct is that Japanese artists did superbly well what they specialized in and western artists did equally well what interested them. That they never both concentrated on the same thing at the same time merely means that the world is now richer than it otherwise would have been: rough Dürer woodcuts, powerful Rembrandt etchings, majestic Kaigetsudo women, dazzling Masanobu color prints, and deft Toulouse-Lautrec lithographs. The harvest is better this way.

11

Integrity and the Artist

KATSUKAWA SHUNSHO

*N*o artist, regardless of the field in which he worked or the nation from which he came, ever had a clearer understanding of what he wanted to accomplish than Katsukawa Shunsho, who designed actor prints. None followed his particular interpretation of art more honestly than he, and few men in any field have ever attained so close to one hundred percent of their capabilities.

His vision of art was not grand, and it is understandable that some critics have called it tedious; nor was the talent available for executing the vision first rate in all requirements, so it is understandable that many have judged him a second-class artist. Few major men have ever worked so limited a field, but like the Kaigetsudo who attained perfection with just one idea—the statuesque courtesan in swirling kimono—Shunsho came close to perfect though limited art in his full-length portraits of actors in their leading roles.

His prints are numerous, and except for some undistinguished excursions into other forms that may have been forced upon him, they consistently measure about 12½ x 5⅞ inches, which is small for ukiyo-e but which yields a pleasing upright panel well suited to the housing of a single figure, with enough background to encourage the artist's ingenuity should he decide to fill it, but not so much as to yield emptiness should he prefer to leave it blank.

His prints can be identified by their placement of a small actor's figure in the exact spot on the paper where it will be most effective, in a living but static pose, representing a dramatic but subdued moment from some play. The colors used to convey this scene are usually the most appropriate that could have been selected, and marking the whole print as a Shunsho is a gentle harmony in which all elements

find their appointed places. Some have suggested that this harmony, which is immediately perceptible, derives from the mellowing of time and the fading of color so that what we praise is not harmony but neutrality. This is not true, for some Shunsho prints have come down to us in pristine condition and they exhibit color relationships that are completely delectable.

Prints 41–46 have been chosen with three criteria in mind. They are all in excellent condition. They cover a wide range of years. They are all portraits of Danjuro. A fourth criterion will be referred to later.

Print 41 is the left-hand sheet of a pentaptych showing five leading actors in a play which in 1768 fascinated Edo and made Shunsho the most popular theatrical artist of his time. The play deals with the Osaka otokodate (male gallants), chivalrous commoners who in the last years of the seventeenth century decided they could take no more pushing around from bullying samurai. "To be ever ready at a moment's notice to attack an oppressor, to rescue a girl from bondage, to aid the poor and needy, or to repel an unjustified assault, they had to cut loose from any regular vocation. So it came about that they took to gambling as a means of subsistence, paying their way liberally when in funds, expecting to be given credit for necessary supplies when out of money, and often rewarding ten or even a hundred-fold shopkeepers who did not insist upon immediate payment. In defending the rights of the people they risked their lives without hesitation. The people responded with adoration. Storytellers in the street related their doings. Playwrights introduced them into their dramas; indeed it has often been said that a play rarely had a chance to win popular favor unless it had one or more otokodate among its characters."[†] This particular play memorialized the five Osaka swashbucklers whose deeds had excited Japan but whose heads had been chopped off by the government, and although it was merely the latest in a long series of dramas dealing with these popular heroes, it was the best and was warmly received. When it opened, Shunsho was a relatively unknown artist of forty-two, an advanced age for Japan of that time, but during his long years of apprenticeship he had acquired basic skills which he now poured into five powerful portraits of the otokodate glowering

† Gookin, Frederick William: *A Master Artist of Old Japan, Katsukawa Shunsho, 1726–1793, A Review of His Life and Works*. Mimeographed manuscript in possession of Art Institute, Chicago, 1931, page 88.

in brick-red kimonos with single swords to indicate that they were commoners and flutes to show their insulting indifference to the government. The five tough characters stand feet apart or gathering up their kimonos in readiness for a brawl and they awakened deep loyalties among the commoners of Edo, for the first edition with handsome blue backgrounds sold out at once and subsequent printings without the blue were hurried onto the market. Shunsho's reputation was made and for the remaining twenty-four years of his life he was able to sell his actor prints just about as fast as he could turn them out. That his work never deteriorated and that he did so few really poor designs is a tribute to his integrity, for the pressures upon him were immense.

This first great Shunsho print also memorializes Danjuro V in one of the roles that helped him attain that supreme name. In 1768 he was still Matsumoto Koshiro III, son of Danjuro IV, who was still active. The son had served a long apprenticeship and by this date had probably appeared in not less than three hundred different roles, many of them minor but some of sufficient importance to test his worthiness and although small and thin, he was already known for his imposing presence, resonant voice and terrifying countenance marked by a big turned-down mouth, huge nose and matching chin. Print 41 was one of the first actor prints to attempt an honest portrait, preceding ones having been so highly stylized as to lack individuality,† and much of Shunsho's success arose from the fact that theatre patrons enjoyed seeing their favorites in recognizable portraits.

Print 42 presents another otokodate, this time from Edo and a most special character in Japanese history, for his exploits were so fantastic that he was integrated into the Soga legend as an epitome of gallant behavior. At a time when purple was reserved for the shogun, this Sukeroku appeared in purple socks and with a bold swatch of purple cloth about his head. Old theatrical records state that the mere appearance of Sukeroku on stage with his kimono tucked back for instant battle, his umbrella open to protect him from flower petals thrown by admiring girls, a flute jammed into his belt and a swagger that challenged any samurai to attack him—these attributes of Sukeroku caused instantaneous applause. Numerous prints depict this magnificent entrance, and Shunsho did several showing Danjuro V in that first

† Of early actor prints only those showing Nakamura Shichisaburo (10) were discernible as portraits. Even those presenting enormously popular Sanogawa Ichimatsu (31, 33, 34) were not recognizable portraits.

exciting moment, but our version shows the great actor in a quieter scene. He has furled his umbrella and stands under the blossoms at the great gate of the Yoshiwara where the drama is to unfold.

The signature of this print is noteworthy, for it appears as a seal in the form of a tsubo (jar) containing characters to be read Hayashi, an unimportant publisher of the time. It is said that Shunsho, both poor and modest, had no seal of his own in these early days and borrowed this one for his first prints, getting the nickname Tsubo-ya; but recent critics have claimed the seal was Shunsho's and is to be read in an adroit way which erases any relationship to the inconspicuous publisher, who seems never to have issued any ukiyo-e prints. Whatever the facts, the presence of this seal indicates an early Shunsho. This print, which appeared in 1771, shows Danjuro during the first full year of his ownership of that name and although he has not yet attained the full stature that marked his later years, he is already an ornament of the Edo stage.

Print 43 shows the final act of the Sugawara no Michizane play (57) in which the ghost of that illustrious statesman returns as Raiden (also Raijin), the thunder god, to torment the evil men who had betrayed him. This is one of Shunsho's finest prints with the god surrounded by storm, a branch of plum blossoms in his teeth and his excellent costume evoking the legendary age now nine hundred years departed. The print also demonstrates how adroitly Shunsho sometimes fitted an actor into a composition of which the basic outlines have been determined by external factors, in this instance the storm and the tree. The type of signature marks the middle period of his work: square, clear printing.

There is confusion as to which Danjuro appears in this print. It was long held to be Danjuro V, but recent studies indicate it is probably Danjuro IV, after he had relinquished the name to his son and had assumed one of the lesser names controlled by the family, Ichikawa Ebizo II. If this supposition is correct, then the present print shows the former Danjuro IV in the farewell performance of his career, during the fifty-eighth year of his acting life. Two years later, in 1778, he died.

Print 44 has been selected to show the vigor of Danjuro's acting, his full-face characteristics and the masterful way in which he used his body. The play is *Yoshitsune Senbon Sakura* (Yoshitsune and the Thousand Cherry Trees), whose remarkable villain-hero appears in this print. Tomomori, leading general of the Taira clan opposing Yoshitsune, tries to kill the young hero, fails and realizes that for the welfare

of Japan Yoshitsune's cause should triumph. He thereupon helps his enemy achieve victory, then lashes himself to an anchor and pitches it into the sea. In numerous other prints Shunsho has depicted this violent man, two of the versions being hailed as masterpieces, but neither shows Danjuro V. The signatures of this print and the next two should be compared, for in print 46 appears the final version, a relaxed and cursive scrawl, while 44 approaches it and 45 inclines toward the neater characters of 43. Thus the dating of these prints should logically be 45 earliest, 46 latest and 44 somewhere in the middle, which is correct.

Print 45 is a masterpiece, a happy combination of fine color, bold design and commendable draftsmanship. It is also a dramatic portrait of a distinguished actor, who is shown as he appeared in Japan's most unusual play. It is called *Shibaraku* (Wait a Moment!) and has customarily been a monopoly of the Danjuro family, which wrote and perfected it. The story of its birth at the hand of Danjuro I is well told in Faubion Bowers' *Japanese Theatre*, but his account of its rebirth aided by Danjuro II is more interesting: "At the first performance, his opposite player was the distinguished actor of villains' parts, Yamanaka Heikuro, who out of jealousy held the young Danjuro II in contempt. Before the performance began they had mutually agreed upon their cues. When Heikuro was to place his hand on the ledgerbook to remove it from its place of offering on the shrine, Danjuro II was to call out from off stage, 'Wait a moment!' Heikuro, to spite the youth, said his lines, but failed to put his hand on the ledgerbook. Danjuro II was angered and refused to speak out. The silence was embarrassing and Heikuro said, 'What now? Shall I tear down the ledgerbook?' At this point Danjuro II called out, 'Wait a moment,' but did not appear. Once again there was an awkward silence. 'Who the devil has called out, "Wait a moment?"' shouted Heikuro. Danjuro II merely repeated the words, 'Wait a moment.' Then Heikuro, beside himself in rage, screamed, 'And what is meant by "Wait a moment?"' At this point Danjuro II calling out, 'Wait, wait, wait,' rushed down the passageway onto the stage. According to critics of the day the angry faces of Heikuro and the young Danjuro matched each other in inflamed passion. The effect was like 'the struggle between a tiger and a dragon.' The performance from all accounts was a huge success. Applause was heard as far as the teahouses in the neighboring streets."

The Shibaraku role is played in brick-red robes bearing the huge con

centric squares of the Danjuro mon (crest) † and is marked by the stupendous sword and fan shown in print 45. The role challenges the finest actors and its depiction tests ukiyo-e artists. Hundreds of variations of this print have been designed, Shunsho himself having turned out more than twenty, of which I have been able to study eighteen. Of these, eleven showed Danjuro V in the role, and all were notable, there being hot argument over which is superior. Two have been generally praised: the one in which Danjuro huddles before the curtain of the Nakamura Theatre, only his forehead and nose visible and the fine version in the Boller catalogue. The rule seems to be that whichever print a collector happens to own, that one is hailed as "the obvious masterpiece of the set." I prefer the one offered here, for it demonstrates much of Shunsho's practice. A solid mass fills the lower portion of the print and is attained by spreading the costume arbitrarily. From the lower left corner diagonally to the upper right a strong line runs, formed by knee, costume and sword. The big mon on the right knee is square to the print and accentuates the massive foundation; the mon on the left knee is tilted and repeats the line of the sword. This line is again repeated above the sword by the forearm, the shoulders and that arbitrary peak of costume hung in the air; yet the squareness of the print is also accentuated by the jutting fan, the head and the hilt of the smaller second sword. In addition, the print is in beautiful condition and the portrait of Danjuro is appropriate to the role, his massive jaws set and his eyes properly crossed.

Print 46 represents both Shunsho and Danjuro toward the evening of their lives and it is a magnificent, autumnal thing. It is the right-hand panel of a triptych and represents the monk Anchin of Dojoji Temple, who resisted the advances of Kiyohime and died under the bell (38). In dance versions of this legend, which were popular year after year, it was customary to have two monks represent Anchin and to give them different names each year, so what the name of the role was in this particular version we cannot say.

To comprehend the greatness of Shunsho one must study the portraits he did of another actor with whom he was perhaps more congenial artistically than with Danjuro, for to Nakamura Nakazo, a tremendous actor, he accorded his very finest work. One, depicting this demonic man with large head as a ragged monk about to starve himself to death,

† Ukiyo-e collectors quickly learn to identify various mon. For example, the hereditary Danjuro mon, a cross-section of nested rice measures, is easily traced through prints 11, 29, 30, 43, 45, 46.

merits special attention since Shunsho's biographer Gookin, who owned numerous Shunshos, called it a masterwork "not surpassed by any other print in the whole range of ukiyo-e." It shows the frail and savage monk whose lifelong dream had been unfairly denied him by the Emperor. Wrapping a rope about his middle and hanging another from his neck, he stands at the foot of a cliff, his clothes in rags, his hair unkempt. In drawing, design and color, mainly black, green and ghostly gray, this print is admirable and one of the most perfect in attaining a balance of artistic skill and dramatic power to have come down to us.

Shunsho also designed many prints showing male actors in women's roles and in general these have been more highly prized than either the Danjuro or Nakazo series, though why I cannot understand. In color they are brighter but also apt to be slightly garish. Occasionally they are excellent in overall design, but customarily they fall below the prints we have been discussing. But since competition for them is keen, they bring high prices, and if six of the best had been selected for this book the result would not have been displeasing, but it would have been static.

Shunsho made several brief excursions into other types of prints but with no great artistic success. Once he designed a set of fan-shaped prints for a merchant, who sold them to be pasted on the wooden ribs of homemade fans, and although the series is historically important because it pioneered in the use of big heads of actors, a field which was to produce many of ukiyo-e's greatest prints, it must be considered artistically a freak. He also designed some massive prints showing famous wrestlers hulking along Edo streets, but the effect is heavy and without much merit, except when time has accidentally thrown a sheet of oxidization upon the giant forms, whereupon a ghostly and exciting transformation occurs. A third set is the only side excursion which has real merit, a series showing actors in private life. Informal, unprecedented and brilliant in design these prints in big format seem entirely outside the Shunsho world and at first glance are usually attributed to others. Shunsho, in collaboration with friends, also did two books which have received high praise. One, done with Ippitsusai Buncho, depicts popular actors on fans and is tedious. The second, designed with Kitao Shigemasa, has frequently been termed "the most beautiful book ever published in Japan." *Seiro Bijin Awase Sugata Kagami* (Mirror of Beautiful Women of the Green House) appeared in three volumes in 1776 and exhibited in dazzling colored pages the most popular courtesans of the

day. I am unable to understand the unrestricted praise heaped upon this book—some have even termed it the most beautiful book published anywhere—for in comparison with Shunsho's finest actor prints it seems gaudy, lacking in taste, and crowded; while in comparison with the finest Shigemasa single prints, and there are some stunning ones, the drawing seems compressed and lacking in style. However, the book is a phenomenon of color printing and its intricate richness entitles it to praise if its art does not.

Of Shunsho's personal life little is known beyond the fact that in view of the many prints he issued, he certainly taught a surprisingly large number of students and with good results except in the case of one young intractable to whom he gave the name Shunro but who soon handed it back, selecting for himself one that betrayed no apprenticeship to anyone: Hokusai. We also know that during most of his life Shunsho was more prized for his paintings than for his prints, a judgment which is reasonable in view of the excellence of his painting. There is also the unsupported claim, met with so often in ukiyo-e, that Shunsho was actually not a commoner but of a samurai family. British, German and particularly American writers insist upon such antecedents for artists, though why having sprung from the average samurai family is considered a cachet of intellectual or artistic greatness is difficult to explain. Most of the samurai from which a ukiyo-e artist would have been allowed to spring would of necessity have been the brawling, murderous, ill-paid, stupid, illiterate, pole-toting, third-rate armed servants that infested Japan and were a hungry drain upon their daimyo. One would suppose that biographers would endeavor to prove that their subjects did not spring from such unpalatable beginnings, but apparently the temptation to equate all samurai with landed gentry is too great, it not being realized that if these dreamed-up samurai families had enjoyed any real status they would never have been permitted to allow their sons to escape into the precarious art world of Edo.

There is however one bit of concrete evidence showing that Shunsho might have come from a cultured background, for in the preface to his book *Yakusha Natsu no Fuji* (Actors Compared to Fuji in Summer, 1780) he apologizes for presuming to illustrate a book about the private lives of actors: "I am fond of the theatre and it is my habit to see plays performed but, as I am not personally acquainted with the actors I know nothing of their private lives. Therefore I declined at first, saying I could not very well make drawings of their unpainted faces; but I

Integrity and the Artist 114

finally acceded to my publisher's earnest request, hoping that things which are not accurately portrayed may yet be entertaining." It is perplexing to reflect that an artist who had spent the major part of his life depicting actors took pride in the fact that he knew none personally and had never seen their unpainted faces.

Shunsho's power centered in his subtle sense of design, which although it sometimes flagged, permitted him to create within the narrow panel that he elected as his own, miracles of unerring taste. Sometimes even the edge of the paper upon which he worked becomes part of this subtle design, so harmonious is Shunsho's relation to his medium.

Everything is subordinate to this clean design, in which two factors not present in most ukiyo-e artists aid him. He is a master of simplicity; his only genius—for he had great talent rather than genius—was his passion for leaving things out. Prints 41 and 45 illustrate this capacity but more than fifty others illustrate it even more. His greatest Danjuro and Nakazo portraits are models of simplicity. He also had good taste, something difficult to prove but accorded him by most Japanese critics. In the poorest Shunsho there is evidence of a discriminating taste.

Shunsho was also a fine portraitist and one cannot study his work without becoming quite familiar with Danjuro, Nakazo, Hanshiro, Monnosuke and half a dozen others. From print to print these handsome faces are recognizable; they grow older as their owners age; they modify from role to role. I find no monotony in the lifelike progress of these famous actors; their faces are those of differentiated human beings.

But Shunsho's salient characteristic is his integrity. No alien current could divert him from the job he had set for himself. Harunobu with his seductive style dominated ukiyo-e during Shunsho's first days of success, but Shunsho kept to his actor prints, borrowing from Harunobu only certain color innovations. (Recent research suggests that maybe the borrowing was the other way around, for an early Shunsho is supposed to exist in which Harunobu's famous gray appears for the first time.) Kiyonaga, the encompassing master who drew others into his orbit the way a sun attracts planets, affected all but Shunsho, who kept to his actor prints while men of lesser integrity succumbed to Kiyonaga or quit the business. And when Utamaro dominated ukiyo-e, more persuasive even than Harunobu, his tall figures inviting the copyist, old man Shunsho kept going back to his theatres, kept turning out actor prints.

He never deteriorated. He never embraced the latest gimmick. We

have proof that once he was forced to turn out complete new sets of prints on four days' notice, but he went ahead in his secure style and did it in his way, always as well as he could, always with the visible soul of an artist impressed on each print he applied his hand to. Limited in breadth of vision he was, but in deep knowledge of his own capacities and aims he was profound. In the world of art there are few examples of personal integrity that equal Shunsho's.

12

The Inevitable Prison

ISODA KORYUSAI

Contrary to custom, two of the artists dealt with in this
essay were from the samurai or petty noble class. Koryusai was originally
a member of the retinue of the Tsuchiyo daimyo but for some reason
abandoned this calling and took up residence near the Ryogoku Bridge
in Edo, in the general quarter frequented by artists and publishers. In
later life he often signed his work "The Man with No Occupation Who
Lives at Yagenbori."

His first prints were done in the Harunobu style and have always
caused confusion, for some have felt that his earlier name Koryu was
merely a signature of Harunobu's, while others have claimed that quite
a few late Harunobus were actually designed by Koryusai. It is difficult
to understand such uncertainty, for Koryusai's bold color system op-
poses Harunobu's, and would no doubt have offended that sensitive
colorist.

Koryusai has three basic color schemes, all strong and all somewhat
clashing. His earliest prints stress a vigorous orange-red made from a
lead base which oxidized rapidly, producing a most attractive black-and-
orange mottled effect. This can of course be easily removed by applying
pure peroxide, which dissolves the oxidization and restores the original
color, but the mottled appearance is so much more attractive that most
owners of a good Koryusai print are sorry when they have corrected it.

The second color scheme features a strong brick-red heightened by
flashes of bright yellow, dominant purple and midnight-blue. Such
prints, especially the one of a maid repairing her mistress's clogs in the
snow, are brilliant and most popular among connoisseurs who are not
afraid of a good splash of color. Purists object to such prints, as indeed
they do to most of Koryusai.

In his third dominant scheme a singing black takes the vital role, being surrounded by rather dull colors, particularly a subdued blue. These prints are exceptionally pleasing to one who likes the effect of black, but at times the black becomes overwhelming in its force, so that regretfully one concludes that Koryusai always fought his colors and lacked a good eye for harmony.

His most famous prints in standard size—and it was largely his experiments that determined the standard adopted by almost all subsequent artists (15 x 10)—appear in a series of Yoshiwara beauties called by the fanciful title *Fashion Plates: New Designs as Fresh Young Leaves*. In this extensive series of beautifully executed prints he exhibits the most famous courtesans of the gay district, most of them accompanied by two young girls in training to become high-priced prostitutes. There was something cynical about such a series, for although the reigning courtesans were featured, much of the interest in the print derived from the pictures of the younger girls who would be available in a year or two.

These prints are distinguished for their monumental designs in which a much-kimonoed courtesan looms large and simply out of a blank, unprinted background, while the two younger girls play the same structural role as the buttresses in a Gothic cathedral, but as frequently happens the masterpiece of the set is a deviation from the general pattern. Through a rainstorm a gorgeously bedecked courtesan walks toward the right under a large umbrella held by a wonderfully drawn manservant, while to the back of the print, but preceding the woman, move two young girl attendants under their own umbrella. The big forms, the bright colors and the conflicting juxtapositions of the two umbrellas make this one of the most pleasing of all ukiyo-e prints. It would certainly have been included in this book had it not been necessary and logical to reproduce three other Koryusai prints.

If for nothing else, however, Koryusai would be famous for his strong and poetic series of prints depicting birds and animals. In a sense he picks up where Kiyomasu left off, for his finest works show falcons and eagles on lonely rocks at night. His masterpiece in this form, and one of the rarest ukiyo-e prints, shows a white falcon struck by moonlight as it stands defiantly on a crag against a jet-black sky. Koryusai used this device at least twice again, but what makes this white falcon such a distinguished print is that from the rock shoots an enormous banana plant, its ribs and stalks outlined by the moon, while at the base of the

rock grows a single chrysanthemum, the whole producing a design of majestic swirls shot through with power and beauty.

His less dramatic nature prints show chickens and parrots and pheasant and snowy cranes. He has a sure touch with birds and creates from their naturally graceful conduct prints of real distinction, but his pictures of dogs fail badly, probably because early in Japanese history certain conventions for drawing these animals were drawn up which were easy to copy but which unfortunately produced very dull pictures.

Here we must remember that most artists discussed in this essay were also gifted painters and that all except Sharaku left paintings on paper and silk of very high quality. In fact, the artists probably earned a good deal of their living in this way, since prints earned them little. We know that at least four of the finest artists ultimately abandoned prints altogether and made their living exclusively by the sale of paintings. It is noteworthy that the two ukiyo-e artists from the upper social class, Koryusai and Eishi, both followed this pattern.

One of the finest paintings in America of the ukiyo-e or any other school—if it had been done by an Italian it would be known throughout the nation—is a silk panel 42 x 19 inches by Koryusai in the Freer Gallery. Painted in black ink, various kinds of pigment and gold, it depicts a young girl walking gingerly through a heavy snow under an umbrella so perfectly placed against the dull, snowy sky and under an arching branch of tree that one instinctively gets from the painting a complete lesson in Japanese art.

Gifted as he was in the three fields so far mentioned, Koryusai is nevertheless chiefly remembered for a curious kind of print in which he excelled (47–49). To comprehend the unusual artistic problems connected with such prints it is suggested that the reader cut out a long strip of empty paper, 28 x 5 inches. Hang the paper lengthwise on a wall and decide what kind of picture could be squeezed onto it.

This problem faced many ukiyo-e artists and each from Masanobu, who invented the form, through Utamaro labored with the idea and in so doing devised completely delightful and stunning prints. The problem arose, as the problems of painting so often do, from architecture. The Japanese house, as indicated by print 18, provides many narrow pillars but few permanent flat wall spaces. Therefore, if one wanted to make pictures for such a house he must make either a kakemono-e (hanging-thing picture), an upright, narrow rectangular painting which

could be pasted on silk, hung in the narrow alcove and rolled up when not in use or a hashira-e (pillar picture), a print about 28 x 5 inches which could be hung on any of the many pillars. Since painters provided most kakemono-e, all that was left to the print maker was the hashira-e.

Since the sale of hashira-e was a sure way to earn money, families being willing to buy one for utilitarian purposes when other kinds of prints had to be considered luxuries, an immense amount of work and skill went into the production of these ridiculous pictures. Today they remain valuable because there are so few good ones. The uses to which they were put made them susceptible to destruction by fire or tearing or grease spots or inevitable wearing out. Of any hundred hashira-e in existence today, at least ninety are merely brown-stained, faded outlines of the lovely things they once were. In order to obtain the three perfect specimens reproduced in this book some five hundred were inspected; most were frail relics totally unsuitable for anything but regretful study.

The kakemono-e size that Masanobu pioneered was a workable one, about 27 x 12 inches, and in this format he produced many of his greatest works. Toyonobu also designed many notable prints in this long narrow form, but it was Harunobu who perfected the narrower and more exacting hashira-e.

It seemed as if he experienced new artistic vitality when faced by the challenge of this preposterously awkward strip of paper. One of his works in this form proves that an artist is a man who can organize and report experience in a way that other men cannot do. It represents Ushiwaka, the boyhood name of Japan's greatest hero Yoshitsune, as he plays on his fatal flute at the entrance to the garden of the Princess Joruri. We see him full length in a fine blue kimono that fills the lower half of the print. Midway the gate to the garden intervenes and chops the design jaggedly but perfectly into several contrasting patterns. Inside and emerging from the right edge of the print stands the princess' handmaiden, her arm aloft and holding a lantern which fills the upper center of the print. In what frequently in these prints is the empty upper third, a paper door betrays the shadow of the princess while the light which throws the shadow repeats the design of the handmaiden's lantern and the blue of the night sky repeats the blue of Ushiwaka's kimono.

It is a heavenly print, made more so by the tragedy of the scene it

presents, for Ushiwaka will gain admittance to the princess' room, and having seduced her he will steal her father's famous treatise on military campaigns, with which he will win great victories for his brother Yoritomo, death for himself and disgrace for Joruri's father. The princess herself will commit suicide in her abandoned sorrow and her name will be sung through all the alleys of Japan until the word joruri becomes not a name but a designation of tragic song. And from the joruri, of course, will come the puppet plays and kabuki itself.

Yet excellent as Harunobu was in designing pillar prints—and men like Shunsho, Shuncho and Kiyonaga did many almost as good—it was Koryusai who contrived the greatest prints in this form. I say contrived because he had a positive genius for solving the problem of the long, thin print, and in this respect he represents all artists. If a man intends to write a sonnet he is obviously bound by certain rules and limitations which he must master. The same is true of the musician who attempts a sonata. What we frequently forget is that every artist in every medium in every age is faced by his own inevitable prison of form. Giotto painting his frescoes in Florence was bound in by his wall. Dürer with his engravings was limited by the slab of wood he could get hold of, Beethoven by the range of the human voice and James Joyce by whatever he conceived a novel to be. This constant battle with form, this striking out against the limitations inherent in whatever one wants to do is one of the major experiences of art.

It is quite apparent that if Koryusai had been born in Italy in the year 1390 he would have painted some pretty wonderful frescoes, for he had a fine plastic sense. Similarly, if Signorelli had been forced to work not in Orvieto but in Edo, he would have produced some excellent hashira-e, for he had a highly developed skill in filling whatever architectural spaces were at hand.

I have known people who were shocked by contemplation of that fact that had Raphael lived in Edo he would surely have painted dazzling portraits of Yoshiwara courtesans instead of his Madonnas, whereas Koryusai in Italy would just as certainly have painted fine Italian Madonnas. Men paint what imprisons their senses. They write about what impinges upon them. They construct their philosophies in relation to what they have experienced, or what the poverty and disillusion of their experience tells them they ought to contemplate.

Art forever lives in a prison of the real. In the Renaissance there were

hundreds of superlative muralists. Now there are almost none. We have not run out of men capable of painting murals. We have run out of walls.

Koryusai, faced with paper 28 x 5 inches, created miracles, and although the arbitrary confines of a hashira-e are without aesthetic appeal, the greatest Koryusai prints have always been treasured. There is a freedom about them that is highly refreshing. There is a fairy-tale beauty that allures. The colors are strong, the drawing vibrant. They are joyous prints, perpetually fun to study. But more, they demonstrate how intelligently an artist can break out of the inevitable prisons in which he finds himself, for in not a single Koryusai hashira-e is there a feeling of contrivance or cramp, whereas actually everything is cramped, all is contrivance.

The three hashira-e selected to represent Koryusai in this book have been chosen to demonstrate the fascinating way in which he played his game. In each the top of the print is as important as the bottom. In each more than one figure appears yet in none is there crowding. The center print, of course, represents a hackneyed theme repeated dozens of times by hashira-e artists, Harunobu, Shunsho and Kiyonaga having done excellent versions. It represents Act VII of *Chiushingura,* which takes place in the Ichiriki Tea House in Kyoto, where Yuranosuke, leader of the ronin, reads an important letter while Kudayu the spy gets the message under the porch and O-Karu, the geisha, reads it by means of a mirror from the balcony.

The third print is rather special for it portrays a modern analogue of one of the supreme moments in Japanese fiction, the scene in *The Tale of Genji* when, during the third month, a football game takes place among flowering trees on a vast lawn at one end of which the Princess Nyosan, Genji's ward, stands hidden behind silken curtains. It is at the end of this game that Kashiwagi will see Nyosan for the first time and enter upon that intrigue which will lead to his death. "Yugiri soon induced Kashiwagi to join in the game, and as, against a background of flowering trees, these two sped hither and thither in the evening sunlight, the rough, noisy game suddenly took on an unwonted gentleness and grace. This, no doubt, was in part due to the character of the players; but also to the influence of the scene about them. For all around were great clumps of flowering bushes and trees, every blossom now open to its full. Among the eager group gathered round the goalpost, itself tinged with the first faint promise of green, none was more

intent upon victory than Kashiwagi, whose face showed clearly enough that there was a question of measuring his skill against that of opponents, even in a mere game; it would be torment to him not to prove himself in a different class from all the other players. And indeed he had not been in the game for more than a few moments when it became apparent, from the way in which he gave even the most casual kick to the ball, that there was no one to compare with him. Not only was he an extremely handsome man, but he took great pains about his appearance and always moved with a certain rather cautious dignity and deliberation. It was therefore very entertaining to see him leaping this way and that, regardless of all decorum. The cherry tree† was quite near the steps of the verandah from which Genji and Nyosan were watching the game, and it was strange to see how the players, their eye on the ball, did not seem to give a thought to those lovely flowers even when they were standing right under them. By this time the costumes of the players were considerably disordered, and even the most dignified amongst them had a ribbon flying loose or a hat string undone. Among these disheveled figures a constant shower of blossom was falling. Yugiri could at last no longer refrain from looking up. Just above him was a half-wilted bough. Pulling it down, he plucked a spray, and taking it with him, seated himself on the steps with his back to the house. Kashiwagi soon joined him, saying: 'We seem to have brought down most of the cherry blossom. The poet who begged the spring wind "not to come where orchards were in bloom" would have been shocked by our wantonness. . . .' He turned his head and looked behind him to where Nyosan and her ladies were dimly visible beyond their curtains." At this moment the tragedy begins.

It could be claimed that the three subjects reproduced here automatically compose themselves from top to bottom for hashira-e, but no matter what subject Koryusai chose, under his guidance it became a perfect composition. A young flute player in marvelous golden kimono steps out from under a willow tree against a slate sky, and no composition could be more perfect. Two women move sedately onto the panel, one with samisen filling the center of the print, the other with a fiddle, and again the composition is exquisite. A young woman finds her lover sleeping on the ground and bends down from her porch to slip a love letter into his kimono, and from this theme Koryusai creates a column

† The four goal-posts were a pine tree, a maple, a willow and a cherry tree, growing in tubs.

that seems both rational and inevitable. But in another very narrow print Koryusai jams in six young girls exemplifying the womanly graces, and they are neither inevitably placed nor crowded.

There are however two types of Koryusai prints which excel all others, and I regret that no usable copies were found in our museums. In the first a geisha in a cage reaches down through her bars to grasp the collar of a young samurai passing by the Yoshiwara. There are several variations of this and each is most appealing, unposed and fresh.

The other subject was probably not invented by Koryusai, for it seems to have been derived from Harunobu, but it provides half a dozen of the most notable hashira-e, including one by Kiyonaga which for color is exceptional. At the bottom of these prints a pretty girl sits dreaming, having fallen asleep over her writing desk, and from her heart winds upward a spiral something like the balloons that spring from cartoon characters. But this is a dream, and in the upper segment of the picture the girl experiences any of several wildly romantic episodes. In my favorite Koryusai a masked samurai in slate-blue kimono reaches eagerly up to catch her as she leaps down from a high wall lined with fierce bamboo spikes.

I suppose that any picture jammed into the dimensions of a hashira-e must essentially be a fairy tale, but there never were finer ones told than those of Koryusai.

13

The Complete Artist

*O*ccasionally a complete artist appears who unites in himself most previous traditions and who commands each requisite skill in perfect proportions. Titian was such an artist. So was Torii Kiyonaga. He could do everything.

In design he was beyond compare, one of the most perfect masters of allocating space on a flat surface the visual arts have produced. His uncanny judgment in balancing one mass against another enabled him to produce stately masterpieces which were the envy of his age. He reminds one of Beethoven in music or Milton in poetry, so secure was his sense of emphasis and balance.

In color he was bold, venturing forth with harmonies notably stronger than any which preceding artists had used. He pioneered many of the color relationships that later became standard: the use of jet-black for a central figure; use of somber, glowing colors for surrounding figures; introduction of a brilliant yellow for backgrounds; using three colors on top of one another to achieve a sense of airy summer clothing; subtle use of pastels to evoke mood; and the most daring kaleidoscopic effects which come dangerously close to confusion but which are held in place by the impeccable designs in which they appear. He used good colors for maximum emotional effect and willingly subdued them completely when necessary.

In draftsmanship he commanded a strong brush, sometimes presenting an entire human being in four or five bold and singing lines which curve and fall away in a beauty of their own, regardless of the subject they define, yet appropriate to it.

In addition to these basic skills he was ukiyo-e's best student of anatomy, a brilliant book illustrator, and a great reporter of the pagean-

try of Edo. He excelled alike in scenes of the theatre (51), frivolity in the gay quarter, landscape surrounding rural temples, glimpses of Edo Bay and the aching quietness of a lonely night (50).

He was a complete artist, more highly praised both in his lifetime and later than any other ukiyo-e master. He has been considered by most writers to be the apex of his art, the majestic towering peak of the color print either in Japan or the rest of the world. He was prolific and left enough varied prints to satisfy any taste. He demanded the best materials and his finest work has come down to us in glowing condition. He possessed an unfailing sense of what people of his day would buy, yet his prints are more popular now than when issued. He appears to have had a deep perception of the central problems of art, and his reputation has remained steady.

His life contains several fascinating problems on which both the art student and the biographer will want to reflect. His father (or possibly adoptive father) was the superintendent of tenement houses near the fish market (8) and Kiyonaga seems never to have traveled far from that spot. Born in 1752 he was soon apprenticed to Torii Kiyomitsu, the artist of rugged strength who bore the proud name of Torii III and who painted theatrical billboards. It was for this treasured job, which assured a decent living, that Kiyomitsu trained young Kiyonaga, ultimately taking the radical step of deposing another student who had been earmarked for the succession and according that honor to Kiyonaga, who thereupon became quite unexpectedly Torii IV.

Fortunately for the welfare of art, Kiyomitsu lived for some years and attended to the billboard business, leaving Kiyonaga free to develop those stunning capacities already described. In these early years he issued the first of the magnificent prints upon which his fame rests and although it seems impossible, before he was thirty he annihilated all competing ukiyo-e artists but Shunsho and either drove them from the field (Koryusai, Shigemasa) or drew them into his own orbit (Shuncho, Shunko, Shunman, Utamaro). There is no parallel in art to this complete intellectual and artistic triumph of one man's ideas.

Then, secure upon a height that no other could reach or challenge, he abruptly abdicated, halted his flood of prints, resigned himself to the tedium of painting hack billboards, and spent the evening of his life daubing paint on silk with modest success but rarely with the grandeur that shines in the prints of his youth.

Three reasons have been suggested for this behavior and each casts

much light on the problems of the Japanese woodblock artist. First, it is likely that filial piety dictated his decision, for Torii Kiyomitsu had practically adopted him and had accorded him, over more logical contenders, the revered name of Torii IV. Therefore when Kiyomitsu was no longer able to paint the posters, Kiyonaga felt honor bound to abandon whatever else he was doing, no matter how satisfying, and assume his obligations. He did so. Moreover, there is evidence which proves that he abandoned not only his own career. He undertook to train Kiyomitsu's infant grandson into the title Torii V, and in order to do this he commanded his own gifted son Kiyomasa to cease painting in Torii style lest the day come when there might be unintended competition between Kiyomitsu's grandson, who had no talent at all, and Kiyonaga's son, who had a great deal. Thus two men submerged their careers to honor the family tradition upon which Confucianism rests.

A second reason for Kiyonaga's abdication could have been overwork. Even before billboards fell upon him, he was prodigiously active. In 1783, his climactic year, he produced 144 complete prints, some in two and three panels each, plus nine complete illustrated books. When he accepted responsibility for billboards too he was required to paint in full color an estimated seventy-two giant posters a year plus sixty smaller ones. It is painful to describe the peonage in which ukiyo-e artists worked. With the exception of Tsutaya Jusaburo, whom we shall soon meet, and possibly the firm of Eijudo, which befriended Kiyonaga occasionally, publishers were avaricious monsters screaming for fresh designs. Always there must be something new, some daring color, some flashy trick. If the hair style of a leading courtesan should change between the time Kiyonaga finished a design and the print was published, some hack artist would be instructed to redraw the head. Kiyonaga published with twenty-eight different publishers plus probably a dozen not yet identified and each had the right to hound him. To one who lives in the 1950's when ways have been worked out whereby men, sometimes of even limited talent, can make a decent living in the arts, it is mournful to report that of all the great artists discussed in this essay, not one was able to earn enough money to live designing prints alone until Hiratsuka Un-ichi managed the trick in the 1930's. The expedients to which these sentient artists were reduced are terrifying. Here we see mighty Kiyonaga reduced to painting signboards. In Chapter 20 we shall meet a particularly evil way of making a few yen. When we study Hokusai we shall witness a vast spirit holding on by his fingernails and in the section

on Hiroshige we shall talk with an old man still living in Tokyo who recalls how his family had to support in near poverty the Hiroshige ménage when that sovereign landscape artist was off to create one of the most powerful evocations of nature ever issued from the brush of man. They starved, these artists. They haunted the shops of publishers for a few scraps. They were paid not in money but in occasional suits of cheap clothes, or lavish dinners in the Yoshiwara thrown their way as if they were beggars. An astonishing number of them gave up the effort as too mean to endure. Sometimes when I, living in a luckier age, hold one of their inspired prints in my hand I am sick with memory.

A third possible reason for Kiyonaga's surrender was the appearance of Utamaro, whose fresh designs startled Edo in the 1790's and captured the city the way Kiyonaga had done in the 1780's. It is not fantasy to suggest that the triumph of one artist could be so unpalatable to others that they would quit altogether. There are numerous instances in which gifted men no longer cared to continue the competition, feeling themselves driven out of favor by some dazzling comet whose quick success embittered them and whose style they did not wish to copy.

The greatness of Kiyonaga stems historically from the fusion in him of ukiyo-e's two main forces: the Torii tradition as established from precepts visible in Moronobu; and the Sukenobu tradition, which also derives in part from Moronobu.

The Torii teaching of bold line and daring adjudication of space was obviously available to Kiyonaga through his Torii training and is evident in certain historical prints he designed in the old Torii style. Writers on Kiyonaga have not usually pointed out his specific descent from Kiyonobu I, but nothing else can explain his strength of line and his majesty of design.

The Sukenobu tradition was available to Kiyonaga from his close study of Harunobu, whose work he copied slavishly in several series (39) and more freely in others. But he also went to Sukenobu direct and prints of his early and even mature years can be found in which figures and groups seem lifted bodily from the pages of the sweet Kyoto master.

Such borrowing should not be moralized over, for most great artists have been sensible enough to study their predecessors and Kiyonaga studied his. (Consider the early copying of two such diverse and radical innovators as Delacroix and Van Gogh.) In order, so far as we can now judge, Kiyonaga borrowed major ideas from Kiyomitsu, Shunsho, Haru-

nobu, Sukenobu, Shigemasa, Koryusai, Kitao Masanobu, certain Kano painters and throughout his career occasionally from Moronobu. Then, amusing as it seems, he became the ukiyo-e artist whom everybody copied, some so faithfully that their works can scarcely be separated from his. In this way the traditions of art in Asia were handed down and it sometimes seems that like Delacroix and Van Gogh, those who copied most attentively were later the men to break the confines of their art asunder and give it new life.

Today this amazing young man, who filled the sky of Edo like the sun at noon, lives again in the only complete scholarly analysis of any ukiyo-e artist available in English. (There is also a study of Sharaku, but knowledge there is fragmentary.) Miss Hirano Chie was a brilliant Japanese woman who worked twenty years, 1920–1939, at the Boston Museum of Fine Arts on a study which describes verbally and in photographs every Kiyonaga print then known. Because the existence of this admirable work makes it possible for any scholar to identify prints exactly, in the discussion that follows each work will be followed by its Hirano number.

Certain Kiyonaga prints have been widely hailed as masterpieces but sometimes the word has been incorrectly applied.

"Ono no Komachi Standing by a Stream" (H-634). "The finest design I ever saw," said one perceptive critic of this splendid print, for in color harmony built upon the softest pastels and in nobility of design whereby the tragic poetess (13, 18, 53 C, 54) stands under a drooping branch in such a way that her turned head, the long sweep of her body and her trailing court garments make a harmonious set of competing lines this print is a treasure. But it is outside Kiyonaga's traditional style and always perplexed me until one day in the British Museum I stumbled upon a little known print by Harunobu done at least seventeen years before the Kiyonaga, and there was the original from which Kiyonaga had copied this strange portrait. He did not borrow; he copied slavishly, even using specific lines and slashes in costumes, taking the curiously unfolded fan exactly as Harunobu drew it. Color too was copied, posture, face. There were however in Kiyonaga's version landscape elements which he could not have got from Harunobu and which I supposed were his contribution. Later, after I had discovered Sukenobu, I found in the fifth illustration of *Ehon Tokiwagusa* the superb portrait of Komachi, described earlier on page 58, from which Harunobu had stolen his portrait, line for line. And the Sukenobu original

also contained the landscape which was later to appear in the Kiyonaga print. Without possible question Kiyonaga must have had before him as he worked both the Harunobu print for the figure and the Sukenobu book for the landscape. Under such circumstances I do not see how one can call the result a masterpiece. I am fond of Brahms' *Variations on a Theme by Haydn,* but this at least contains some variations.

"The Ninth Month" (H-631). This has generally been chosen Kiyonaga's greatest print but I cannot understand why. It is reproduced as print 50 along with a batch of encomiums which seem literary criticism on the mood of the piece rather than artistic judgments. The print deserves emotional respect, for the scene at the window is truly a melancholy report on the loneliness that must have stalked the green houses on cold autumn nights, but there is much wrong with the print and the very attributes which make it so appealing to the west make it faulty as a print: I mean the attempt to puncture the flat paper and create an illusion of depth through the window. This is alien to the Japanese print, a side experiment as are the moon seen behind bars and the lights low along the shore, and not within the finest tradition.

"Buying Potted Plants" (H-583). Ledoux voiced a sound criticism of Kiyonaga: "One may admire him more than Harunobu but is certain to love him less." Kiyonaga has a certain coldness about him, an austerity that holds the viewer at a respectful distance, but of course the same can be said for the Parthenon, which is not thereby deemed less than a wayside hut with a rush lamp burning. Kiyonaga's aloofness expresses itself sometimes in mood, or chilly coloring; most often in a lonely grandeur of the figures. But this winsome little print of a flower vendor on a chilly day exhibiting dwarf trees to housewives at the corner of a shrine is a warm and tender delight. I cannot see how one would ever tire of this little gem and many critics have held it to be a masterpiece, but I find it lacking in those very characteristics of aloofness and grandeur which are the mark of Kiyonaga.

In fact, one rarely finds in his single prints the solitary, overwhelming work that one knows instinctively he must have accomplished. I could continue with at least thirty other prints from the great years of 1781–85 but each would be lacking in some particular; it was in the diptychs he produced during these same years that I find the completeness and grandeur which strike criticism dumb. No one has explained why Kiyonaga found the diptych so gratifying, for it yields a squarish proportion unpleasant to western eyes and is therefore avoided by our artists. But

in Kiyonaga's hand the two-page print, which could be pasted together to form one picture 15 x 20 inches, sprang to life in the finest complex designs ever attained in ukiyo-e. He also designed many triptychs which have been lavishly praised, possibly because the resulting proportions are closer to our tastes, but I find them decidedly inferior to the great diptychs. Since both Utamaro and Toyokuni created excellent triptychs, I shall leave that form for them especially since Kiyonaga's diptychs stand so far above any competition as to constitute a miracle of art.

"Summer Twilight on the Banks of the Sumida" (H-642). Even the name of this diptych, a favorite of most, evokes the spirit of Kiyonaga, for the Sumida River, which flowed through Edo, called forth some of his noblest efforts. To the left two tall women stand near one who sits as they watch the departure of three magnificent figures who walk off on the right print. It is a processional in which monotony, which Kiyonaga feared the way Harunobu feared age, is avoided by the spacing of the three figures on the left and by the subtle modulation of both the height and movement of the departing women. The satisfaction of this great diptych comes from the balance between the two halves: the left is static, the right is motion; the left is more gaily colored, the right more subtly drawn. Each is a fine print of itself, yet neither is satisfactory when viewed alone. (All diptychs were designed so as to permit the sale of single sheets to those unable to buy both sides; frequently one print will noticeably outweigh its partner, but that is not the case here.) Even though I distrust literary criticism that deals with a picture's mood or spiritual values, since such comment depends too heavily upon subjective judgment, which explains why so very much ludicrous art criticism is written, especially about Japanese prints, I must in discussing the massive Kiyonaga diptychs report the poetic mood he evokes, for this is one of his salient achievements. Here he creates evening and the quiet moment of parting. This is a noble print, cool, dignified and instinct with human feeling. Moreover it is a perfect blending of massive Kiyonobu and gentle Sukenobu in which neither triumphs. It is properly regarded as one of the peaks of ukiyo-e.

"The Iris Pond" (H-705). Many critics and collectors prefer this flawless and golden diptych which shows five women in delicately hued kimonos resting at the edge of an iris pond in the last warm days of spring. It is a work of positive loveliness: no ukiyo-e painter before Kiyonaga had ever painted flowers so faithfully, or the golden warmth of spring so truly. Water and sky are done together in one simple color

with no horizon, and the two halves of the diptych are in perfect harmony, held together by a brilliant innovation developed by Kiyonaga: use of a bright yellow for all ground surfaces. It is difficult to explain why this delightful diptych leaves some viewers disappointed, but probably it is because the human figures are somewhat dwarfed by their landscape and lack the austere dignity of the greatest Kiyonaga prints.

"Night Expedition" (H-629). This is my favorite, a diptych of such subtle yet simple beauty as to epitomize the best of ukiyo-e. It is dark night and a procession of seven people move along an Edo street, holding lanterns close to the ground and moving in ghostly illumination. There is nothing unusual about the coloring of the kimonos except that each subdued color is right for its position. There is no striking design except that the potentially monotonous heads are subtly varied in position so as to produce a satisfying pattern. The drawing is in no way obtrusive except that when you study the detached figure of the tea-house mistress you suddenly realize that she has been accomplished by a minimum number of lines. There is no striking background, only a rough black reaching up to the shoulders and topped by a pale gray. And neither half of this stupendous diptych amounts to much when taken alone, for the left is a little crowded, the right a bit empty. But taken together, weighing both mood and technique, this passage of noble human figures constitutes a diptych which makes the frequent comparison of Kiyonaga to the best of Greek sculpture not only reasonable but a way of expressing praise for the Greeks.

It should be obvious that I like certain Kiyonaga prints. Therefore I may be forgiven if I try to erase some misleading extravagances of criticism that have forestalled an accurate judgment of his work. For reasons which will become apparent in sections of this essay dealing with Utamaro, critics have felt it necessary to build Kiyonaga up and tear Utamaro down, obscuring the merits of each. The following myths should be removed at this time; others will be dealt with later.

Kiyonaga's type of womanly beauty is not more healthy, more normal or less neurotic than any other artist's, but this cliché is deeply imbedded in ukiyo-e criticism. Ficke says, "The artist of the prime (Kiyonaga) draws large-limbed, wholesome, magnificently normal figures as the symbols of his magnificently normal mind." Binyon describes the women as "his superb feminine forms, calmly sweet in a stable world and breathing the unconscious air of perfect health." Miss Hirano stresses the normal and healthy woman repeatedly: "It

is almost incredible that this son of a superintendent of tenement houses near a large fish market, living among people of the lower class who, even when wealthy, could scarcely boast of any great culture or high ideals toward life but indulged themselves in every kind of worldly luxury available—it is almost incredible that he could have produced such a noble, pure and healthy type of female figure." Such criticism positively bewilders me. On the one hand it is answered by the simple fact that Kiyonaga wanted to draw his women big and tall because his whole artistic impulse was that way. His coloring, his manner of drawing, his sense of design called for such women, just as Harunobu's entire artistic personality demanded women for his prints that were just the contrary. As a beginner, Kiyonaga used the Harunobu woman in hundreds of prints and produced some wonderful work thereby, but he gradually evolved a better artistic symbol, exactly in the way he evolved better design and finer color.

On the other hand, inspection of Kiyonaga's prints doesn't convince me at all that his women were supranormally healthy. In print 50 I see standing by the open window an elongated, drooping, sad courtesan with no future except tuberculosis. In the "Gay Party on a Balcony near Shinagawa Bay" (H-626) the women are again abnormally elongated, wasted in lassitude and probably steeped in vice. That they are handsomely drawn no one can deny, but by no stretch of imagination can they be called normal healthy girls. The most that can be said about Kiyonaga's women is that they are a most happy artistic invention; they captured the imagination of contemporary Edo because they were sexier than their stumpy predecessors drawn by Shigemasa; and they can be stood around to create noble, though often unlifelike effects.

Nor is Kiyonaga's world more healthy or more normal. The great diptych "Summer Twilight" (H-642) does show fine middle-class married women, but his major series, *Twelve Months in the South* (that is, scenes throughout the year in the rugged brothels of Shinagawa) certainly do not deal with suburban housewives. In this respect it is interesting to reflect upon the "Night Expedition" (H-629). A pair of maids from a tea house are delivering a gay young blade with a lot of money to another group of maids, one of them sniggering beyond control, who have been waiting to lead him off to an assignation at one of the roughest Shinagawa houses, where he is to spend the night. I am content to treasure this print without reference to its contem-

porary meaning, but when critics write nonsense and imply that Kiyonaga inhabited some ethereal other world one must haul the argument down to reasonable facts. A substantial number of his greatest prints came from the same evil surroundings that provided other ukiyo-e artists with their subject matter, except that they usually avoided the real sinks like Shinagawa.

Kiyonaga does not require distortion. On the basis of his prints alone he stands an amazing young man of the Edo streets who could design like an angel and who envisaged the stocky little people around him as huge, plastic forms. He also saw the ground near suburban temples as golden yellow and women's kimonos as flowing line. He created stately processions in which human beings move like gods, and when we consider that he attained all this before he was thirty, at which age he turned away from his triumph to paint hack signboards, we are awed, for we have been present at the death of a complete artist.

14

Certain Facts Not Widely Known

FUJIWARA NOBUZANE · KANO EITOKU
SESSHU · TAWARAYA SOTATSU

What is the relation of ukiyo-e to the total fabric of Japanese art? The answer may surprise many Americans, for of all the world's major arts we know least about the Japanese, and in this field, except for ukiyo-e, our museums exhibit their greatest poverty.

We are not concerned with Japanese architecture whose low, dark wooden buildings are apt to leave western minds unimpressed, even though these structures masterfully adapt local materials to available sites. Most westerners neither appreciate nor understand these gloomy buildings set beneath towering trees and reserve favorable comment for an unfortunate collection of architecture at Nikko, close to Tokyo, where the great mausoleums of the shoguns combine all that is flamboyant, tasteless and garish. Built by men of little judgment, these monstrosities bow down with red and gold and gingerbread and it is ironic that Japan, a nation with taste inborn, should so often be known for these gross and heavy tombs.

Nor are we concerned with the sculpture of Japan, whose masterpieces are innumerable. Certain statues of the goddess Kwannon are among the most poetic renderings of the human figure ever devised, perfect from any angle of view, soaring in spirit and lovely in concept. The war gods, the Buddhas, the temple guardians and the lesser deities comprise a collection of plastic excellence equal to the best of Greece and Rome. Especially satisfying are certain all-wood statues preserved without blemish for more than a thousand years. Some show clearly their Chinese derivation while a few indicate Greek, Roman, Persian or Indian origins. One of the errors in assessing Japanese art arises from the belief that no outside influences touched it. Throughout the

artistic history of Japan currents from all over the world brought impacts which were immediately felt through all cultural forms. Thus one of the sharp modifications in painting came from Venetian pictures and we have seen how Dutch engravings modified ukiyo-e perspective. The paucity of outside contacts deepened the intensity of their impact.

Nor are we concerned with two artistic fields in which Japan excels, ceramics and textiles. The quality of art here displayed has never been surpassed and it is interesting to note that in each field Japan's supremacy has been in exact proportion to her dependence upon the artistic designs of the men we are about to discuss. When her industrialists were willing to use fine designs of fine artists their products excelled. When hack designs were used hackwork resulted, and there is much of that in Japan.

There are numerous other aspects of Japan's artistic life which do not concern us now—landscape gardening, poetry, heroic fiction, the tea ceremony—but painting does concern us, for without knowing the accomplishment of Japanese painters we cannot appreciate the roots and derivations of ukiyo-e. Nor can we intelligently estimate ukiyo-e's relative importance to the other attainments of Japanese art.

Disregarding dozens of minor schools, there were in Japan two traditional and contrasting schools of painting. The older was the Tosa, specializing in Japanese subject matter. Humor is frequent. Vast battle scenes are popular. There is much good portraiture. Village life is portrayed and the animal and bird life of Japan is recorded. Some of the most exquisite landscapes in the world appear nonchalantly in Tosa art and rarely has architecture been more sensitively portrayed than in the work of this school.

Kano painting was more spiritual, more clearly derived from the Chinese, more abstract, more philosophical and much more recondite. It is difficult to believe that generation after generation of Kano artists painted scenes of China that no one of them had ever seen, but Japanese connoisseurs invariably inclined toward this school the way sophisticated Americans have usually preferred French painting above the national product. At times the Kano school became almost an art-for-art's-sake school, and its taste was truly impeccable. Therefore an art historian could predict what followed. It was not the more facile Tosa school that remained vital for many centuries; it was the more artistically informed Kano school which knew how to adjust to new problems in new ways. It was the Kano school which kept throw-

ing up into the main stream of Japanese art one brilliant innovator after another. Once more it was proved that it is the vitality of the artistic concept and not popularity of subject matter which determines the ultimate strength of an art.†

This dualism of Japanese painting concerns us because in many aspects ukiyo-e recapitulates the history of Tosa art. It goes back to Tosa's essential Japanese-ness: the local scene, the village, the young girls and old heroes. Although at first glance the early vigor of ukiyo-e could be considered a refutation of the generalization that it is the artistically informed school that survives, in the death of ukiyo-e we see again a perfect substantiation of the fact that without a constant influx of new aesthetic ideas an art must perish. Like the Tosa school it degenerated into barrenness. To the degree that it failed to accommodate itself to new artistic inventions it wrote its own death warrant. The history of ukiyo-e is inevitable and tragic.

Let us therefore weigh ukiyo-e at its moment of culmination against the work of four men of other schools. Fujiwara Nobuzane was born about 1180 and although not a member of the Tosa school, for that name was not given until some years after his death, he was clearly one of the progenitors. He was the son of a fine old portrait painter and a descendant of a minor branch of the wily and noble Fujiwara family, who by guile and intelligence managed for some thousand years to keep themselves close to whoever nominally governed Japan. Many pieces of Nobuzane's work have come down to us, notably a series of thirty-six portraits of the poets of Japanese antiquity. Some of these poets had been dead long before Nobuzane was born; some he knew. But each of the delicately colored paintings is differentiated. Humor, envy, pathos, contemplation, arrogance, stuffiness and greatness of soul appear. Three of his women poets become excuses for vast flowing designs of drapery presaging Kaigetsudo. The color and line of these portraits bespeak a real genius and rival the best of Holbein or Bellini. It is surprising therefore to find that Nobuzane's real fame rests upon quite a different type of work. On makimono (wound thing), long scrolls of paper wound upon sticks and filed away like books, Nobuzane painted overflowing accounts of life in ancient Japan. One is tempted to praise the content of these vast panoramas—

† The Tosa decline is also directly related to the decline of the imperial court upon which it relied for patronage; whereas much Kano vitality derived from the vigor of the shogunate, upon which it depended.

riotous life, the hardships of the artist, great battles, court pageantry, a much-loved countryside—but the more important fact is that the artistry far surpasses the content. These unwinding yards of paper contain literally hundreds of individual masterpieces. In coloring, design, spacing, dramatic use of line and general use of art to overwhelm the eye Nobuzane was gifted. In one of those delightful contradictions of Japanese life, this Fujiwara artist's greatest scroll glorifies the arch-enemy of the Fujiwara clan: Sugawara no Michizane, the beau ideal of Japanese history (43, 57). This Sugawara tapestry covers nine individual scrolls, from any of which it would be possible to snip out twenty or thirty masterworks which if they had been framed and circulated throughout the world would have made Nobuzane discussed as an equal of Van Eyck, Pisanello and in some respects Breughel and Bosch, for his capacity is so varied as to recall the characteristics of those European masters. His scene of evil Fujiwara men roasting in hell because of what they did to Sugawara equals Bosch. His quiet passages of village life recall Breughel and the airy wonder of his poetry is reminiscent of Pisanello. His delicate brushwork, usually without harsh outline and often in exquisite miniature, is like Van Eyck's. In coloring he resembles no European for he adheres to the Japanese style of big, flat areas which the flaking of time has given a delectable patina probably not in the original. His juxtaposition of colors and his use of jet-black are striking. Many other artists of the thirteenth and fourteenth centuries painted scrolls of this nature and it is disturbing for me to realize that I was past forty before I had even heard of these medieval masterpieces. Now, having studied them over a substantial period of time, I find no other art which surpasses them in their ability to lure the mind and eye from one lovely scene to another. All told there are close to four dozen majestic series of scrolls, some by men whose names are lost, and each constitutes yards upon yards of individual masterpieces. The effect of unrolling scenes of exquisite poetry, lovely color and fine drawing is an experience unique in art. Nothing in ukiyo-e equals the richness and majesty of these scrolls.

In some respects an even greater surprise for the uninitiated westerner lurks in the Kano school. About halfway through the history of this school, in 1543, a great-grandson of the founder was born. Not much is known of Kano Eitoku, except that either as a result of his own invention or through inspired borrowing he specialized in an art form so exactly appropriate to Japanese architecture that it accomplished

for the rich people of Japan what Koryusai's pillar prints did for the poor. Japanese castles were drafty, had spacious halls and provided long stretches of empty wall. It might seem that the latter were fitted for murals, but the walls were flimsy, so Eitoku offered something much better. On pairs of six-folded screens four to six feet high he painted luxurious murals which could be moved about to kill drafts, cut large halls down into manageable rooms and provide wall decoration. An Eitoku screen is one of the most dazzling art forms ever created. First the background was coated with solid gold leaf in squares four or five inches on the side and burnished so that even the tiniest fragment of light coming into the dark castle would be reflected many times. An Eitoku screen is first of all a dazzling burst of golden light. Next some simple and overpowering design from nature was worked onto the screen. His masterpiece consists of two facing screens, the left of which erupts forth a massive pine tree with its top lost in golden clouds. One enormous branch thrusts to the right across the middle of the screen and up toward jagged snow-covered mountains. An imperial-blue sea appears briefly at the bottom of the screen, from which rise wonderfully sculptured mountains, borrowed of course from China. The right screen complements the first. Its massive pine is to the right edge and reaches leftward. Its sea and mountains are equally spectacular, yet it is by no means a copy of the first for in many subtle ways it differs. Its pine is weighted with snow. Its dominant mountains are modulated and rolling. The screens are an admirable pair and must have been highly decorative in a drafty castle. Even as I have described them they would have to be admitted to the galleries of superior art, but Eitoku did more. Each pine carries an eagle, snowy white on the bare tree, brown and black on the snowy tree, and these majestic birds lend the screen a quality that no other decorative art has ever surpassed. The fidelity to nature of these eagles combined with a ruthless artistic adaptation in style, color, pose and impact make them birds of poetic creation. There are hundreds of such screens in Japan. Eitoku did some of the best, but many other artists, their names unknown, contributed pairs of golden murals which in their combination of sheer brilliance, affection for nature and high decorative purpose constitute a unique art form. Not all are as dramatic as the Eitoku masterpiece. Some show gentle scenes of life in China, or haunting cherry blossoms against a golden sky, or delicate wisteria falling upon golden grass, or a blizzard of plum blossoms, or peacocks and pheasants and prancing

horses and tigers from China and seagulls coming home to rest across a golden sea, or one of the loveliest of all Japanese themes, as ancient as the beginnings of the nation but forever fresh: bullock carts overflowing with flowers, encrusted with jewels and resting upon curious oval wheels that could not possibly turn but which seem exactly right for the poetic mood of the picture. I have heard many people orate upon the art of Japan who have never seen a real Eitoku screen, and it often seemed to me they didn't know what they were talking about. These screens are redundant, vibrant, overpowering. At their best they are like the crescendo music of Richard Wagner, patently overdone but nevertheless compelling, and they are spiritually cathartic. When theorists speak of the precious or tiny art of Japan I think of these screens. No other art in the world was ever so flamboyant, with such sure taste.

For a Japanese trained in classical traditions neither a Nobuzane scroll nor an Eitoku screen represents the ideal art. That designation is reserved for the work of an exalted Zen priest whose name we do not know. As a young man he mastered the spirituality of Zen Buddhism, which has dominated Japanese taste since its introduction from China in the thirteenth century. After spending his early years in a monastery, he surrendered himself so completely to Chinese thought that he abruptly left Japan in 1468 and went over to China, where he promptly became the greatest living master of the Chinese style. Overcoming real difficulties, he traveled to those very mountains whose imaginary outlines had long dominated Japanese artists and composed thousands of sketches which were to provide themes for unborn generations of Japanese painters. His triumphant departure from China and his return to Japan were each national holidays and from his journey he probably derived the name whereby we know him, Sesshu, the ship of snow. It is an appropriate name, for he worked primarily with jet-black ink upon large white sheets of paper and with these simple materials, aided by the subtle and resourceful Japanese brush, he created the supreme paintings of Japanese art history. On six-fold screens he painted black-and-white landscapes which epitomize Chinese art. He did excellent scrolls, superb studies of animal life, strong architectural drawings, scenes of village life, religious reveries and portraits. He also probably originated ink-splash painting, at which he became adept with a style that is completely impressionistic. He is, however, chiefly revered for his landscapes with their mystical Zen

world of towering crags, waterfalls, Chinese villages and lonely travelers. It is difficult to describe a Sesshu painting, for although he sometimes used color with fine effect, his typical painting is nothing but a collection of black lines, remarkably jagged, with a romantic mountain subject matter reminiscent of bad German paintings of the mid-nineteenth century. Sesshu does not communicate easily, and it is perhaps this very feature that makes Japanese prize him above their other artists. He represents the nation's umbilical attachment to China but is at the same time proof that Japan can almost always go beyond China. He is the perfect introspective Zen philosopher but at the same time he is a robust participator in life. He resembled, in American life, Ralph Waldo Emerson, distinctively American yet clothed with the respectability of having known Europe well. Some of his pictures he signed proudly, "Sesshu, who was in China." At other times he signed, "Sesshu, who occupied the first seat" at a Chinese Zen temple. Again he said of himself, "I journeyed to China, and while there saw famous Chinese paintings. Most of these artists used Kao Genkei as their model. Thereafter I also followed the fashion of the time, and in painting landscapes, I usually imitate Kao Genkei." He was a robust man and signed one of his paintings with the confession that he did it while completely drunk, for a friend writes of him, "When a time comes when he wishes to paint, he first drinks half a vessel of filtered wine and blows agreeably upon the bamboo flute. Then he sings Japanese songs and recites Chinese poems. Sitting crosslegged, he sucks his brush and confronts the paper. Finally his elated spirit mounts to ecstasy . . . and he paints." Of the four great masters I mention in this brief review of classical painting, I understand Sesshu least, but when my confusion is greatest I have merely to study one of his black-and-white Chinese landscapes and I become aware of a noble presence. Here is the intellectual mountain, the mystic waterfall, the lonely human figure, the solitary hut beside the river and the far expanse of white paper cut here and there by a jagged black line. These things bring me as close to the essence of Japanese mysticism as a foreigner can ever get. I do not understand Sesshu nor can I ever really understand Japan; but I recognize him to be a great artist the way I recognize Japan to be a considerable nation. Obviously, there is nothing in ukiyo-e to match Sesshu's aesthetic purity.

The fourth artist is a joy for me to report upon. He is so fresh, so gifted and so Japanese in the Tosa sense, as contrasted to the Chinese

quality of Sesshu, that I never look upon his work without a sense of real personal enjoyment. But to describe his unusual ability I must go back to a mysterious predecessor who started one of the minor and most fruitful of Japanese schools. It is difficult to describe Honami Koetsu with a straight face, so I take refuge in the words of others: "Koetsu, born in 1558 . . . was a sword connoisseur . . . was reckoned as one of the Three Pens or Finest Calligraphists of his day, while he was not less skilled in painting, lacquer work, pottery, landscape gardening, tea ceremony, bronze casting, sculpture, Japanese poetry and literature generally. He was also famous for his sand pictures and noh masks. . . . He also published books on paper made at his art village, of which he designed the illustrations and bindings."[t] On the side, he served as political adviser to the national government and when he tired of polite life at the capital sought title to the toughest, most immoral village in southern Japan, where he evicted a gang of robbers and established a model town inhabited by writers, artists and craftsmen, where for many years at the most critical time of Japanese history he turned out superlative work in all fields. He lived to the age of eighty and seems to have been primarily responsible for luring Japanese artists back to Japanese traditions and to the creation of a pure Japanese design. This vital old man did not leave behind him any impressive body of work; his influence lived on through the accomplishment of his pupils.

One of them, Ogata Korin, attained a deification reached by almost no other artist in world history. He is still not the delightful man I wish to speak about, but he was a remarkably pure artist who with one brush stroke could make a bold, simple design that would grace a piece of pottery or a bolt of cloth. In abstract design he probably never had an equal in any land, and even today his patterns dominate the decoration used on women's kimonos in Japan. His big screens are good, his nature painting exact, but few westerners are prepared for the enormous love with which this sometimes casual artist is regarded throughout Japan. His simplicity, his Japanese-ness and his unerring appreciation of an austerely simple design have enshrined him in Japanese history. I once said somewhat impatiently that I couldn't understand why so much fuss was made over Korin, whereupon a Japanese scholar took me to three strikingly different places: a

[t] Sadler, A. L.: *The Maker of Modern Japan, The Life of Tokugawa Ieyasu.* London, 1937, page 295.

kimono shop where dozens of Korin's designs were woven into silk; a modern pottery stall where his classic lines decorated the finest ware; and to the museum where his screens showed simply two fields of iris bending in the wind before a golden sky. Deceptively simple, Korin's designs were in each instance appropriate and of all the artists Japan has produced, I suppose that Korin is more alive today than any other. He walks upon the streets, he sits upon every table and his spirit of design infuses Japan.

But the artist I love was neither a stupendous intellect like Koetsu nor a free aesthetic spirit like Korin, yet he was a member of their group. Tawaraya Sotatsu was a hard-working artist who, up until a few years ago, was remembered as having worked in many media. His screens were good but not the equal of Eitoku's. His nature paintings were satisfactory as were his robust humorous scenes. His masterpiece, attractive but not unusual, was a pair of screens depicting the gods of thunder and wind, the latter skipping through the sky with a bag of storms caught over his bushy head. They would hardly elicit from anyone the affection I feel for Sotatsu. Then, only a short time ago, the imperial household exhibited a sample of its treasures and showed some hitherto not widely known screens decorated with fans painted by Sotatsu, and they are among the most delightful paintings extant. On them alone rests Sotatsu's right to first rank.† In style, the work is as modern as Matisse, with bold strokes and an unusual feeling for plastic values. Backgrounds are impressionistic and strong; human figures are drawn with a minimum of line. In color the fans are perfection. Backgrounds tend to be of mottled gold, very rough in surface and dazzling in effect, a condition which might be due to careless handling but which looks more like the artist's original intention. The other colors are applied thinly and with verve, somewhat in the manner of Cézanne or Tintoretto. They are extraordinarily modern and pleasing. In design the paintings are bold, with figures well disposed over the curious fan shape of the paper. In content they go back to the great scrolls of Fujiwara Nobuzane and recount heroic actions with a simplicity that is both inviting and effective. Since these fans have not been seen outside Japan and by only a few people in that country, a brief description of one is necessary. It recounts an incident from the ancient *Ise Monogatari*, the narrative of Japan's Don Juan. The

† Similar work by him exists on screens owned by the Daigo Samboin temple near Kyoto.

poet Narihira, great lover and traveler, peers through a window to spy upon his beloved. In public she has been putting up a good show as a polished lady, but now he sees her in her own home ladling rice and she is a complete slut. How one can portray the entire history of a woman by the way she ladles rice is difficult to explain, but Sotatsu does so and the effect is hilarious, a fleeting glance into the middle of two lives, for not only is the woman a total slut but the hero looks foolish as the devil. Sotatsu, as the culminating point of the Koetsu group, is a major artist, subtle, whimsical and joyous. No one in the ukiyo-e school equaled his humor, or Korin's mastery of pure design, or Koetsu's sheer intellectual power.

It must now be obvious that in Nobuzane, Eitoku, Sesshu and Sotatsu, Japan produced artists who compare favorably with the best the western world developed. They are less widely known because the nature of their art prevents it from being exported to European or American galleries, but the day will surely come when their merit will be acknowledged. Less obvious is the fact that it is men like these who represent the permanent tradition of Chinese-Japanese art and that to the Japanese connoisseur they are so much greater than the ukiyo-e artists we have been discussing as to make comparisons not only odious but downright ridiculous.

To put it bluntly, a Japanese collector who prided himself upon owning a Sesshu, an Eitoku and a Sotatsu along with a fragment of a Nobuzane scroll would probably not accept an ukiyo-e print if you gave it to him. He would consider the color gauche, the style unformed, the drawing crude and the subject matter beneath contempt.

No better summary of Japan's traditional attitude toward ukiyo-e can be found than the following, written by an American scholar in 1911: "This is the ukiyo-e or floating-world-picture school. . . . The great painters of Japan have never held this school in any favor. At one time or another I have visited nearly every distinguished artist's studio in Japan, and I know personally most of the leading artists of that country. I have never seen a Japanese print in the possession of any of them, and I know their sentiments about all such work. A print is a lifeless production, and it would be quite impossible for a Japanese artist to take prints into any serious consideration. They rank no higher than cut velvet scenery or embroidered screens. I am aware that such prints are in great favor with many enthusiasts and

that collectors highly value them; but they do not exemplify art as the Japanese understand that term. . . . Many people are even under the impression that the prints represent Japanese painting, which, of course, is a great mistake. . . . Apart from the fact that the colors employed were the cheapest the market afforded, and are found often to be awkwardly applied, there is too much about the prints that is measured, mechanical and calculated to satisfy Japanese art in its highest sense. . . . Many of the colors of these prints in their soft, neutral shades, are rapturously extolled by foreign connoisseurs as evidence of the marvelous taste of the Japanese painter. But, really, time more than art is to be credited with toning down such tints to their present delicate hues. . . . An additional objection to most of the prints is that they reproduce trivial, ordinary, every-day occurrences in the life of the mass of the people as it moves on. They are more or less plebian (sic). The prints being intended for sale to the common people, the subjects of them, however skillfully handled, had to be commonplace. They were not purchased by the nobility or higher classes. . . . They were generally sold for a penny apiece, so that in Japan prints were a cheap substitute for art with the lower classes, just as garlic . . . has always been the camphor of the poor in France."†

This statement is clear if not intelligent. Ignoring the incredible snobbery, excusing the cliché error that prints sold for no more than a penny each, and disregarding the astigmatism that compares them to cut velvet, there remains the bold statement that ukiyo-e prints need not be considered seriously.

Here is the nub of the problem. Here is why a study of ukiyo-e is so profitable. Opinions of the experts are so at variance that one simply has to form his own judgment. Most cultivated Japanese, longing for China the way many cultivated Americans long for Europe, contend that ukiyo-e is junk and apply to it such words as trivial, degrading, coarse, untutored and common. Some western critics, including many of the greatest artists produced by the west, pay homage to these prints in such words as delicate, instinctive, perfect in color, superb in line and gracious in design.

It is significant that most American museum people, other than those

† Bowie, Henry P.: *On The Laws of Japanese Painting*. San Francisco: Paul Elder Company, 1911.

specializing in ukiyo-e, tend toward the Japanese point of view that the prints are somewhat vulgar, somewhat second-rate, doubtless because museum people are sensibly trained in a classicism which sometimes inhibits individual judgment. An illustration came in 1951 when an exhibition of Japanese art treasures was sent to San Francisco to help celebrate the signing of the peace treaty ending World War II. To the disgust of museum people in America and Japan alike, some ukiyo-e prints were included and as always, stole the show. There was an outcry against such cheap stuff representing Japanese culture, so a new exhibition, widely shown in American museums in 1953, was assembled. This time no ukiyo-e prints were sent from Japan and specialists in both countries felt better.

My own judgment is that ukiyo-e is a major art form meriting serious attention but that three limitations prevent it from attaining those ultimate heights reached by certain other Asian and European schools. (1) Ukiyo-e remains on one level, which invites monotony and prohibits those flights of fancy that mark the top achievements in world art. (2) It lacks philosophical depth. (3) It lacks spaciousness or comprehensiveness of view. If one ignores the top ukiyo-e artists, the art could be compared to Dutch painting without Rembrandt: meritorious, pleasing, skillful, competent with excellent color, design and drawing. One would neither ignore nor castigate Dutch art because it was pedestrian. I must however admit that compared to the work of the finest Japanese artists of the other schools ukiyo-e does seem raw, unintellectual and to the effete palate barbarous. But it is never the inconsequential and unworthy thing that snobs would have us believe, and a few of its top artists were of the first rank, surpassing their school as Rembrandt surpassed his.

An excellent analogy to Japan's attitude toward ukiyo-e can be found in America's attitude toward jazz. Sometimes when traveling abroad I have been outraged by foreigners who discuss American music solely in terms of jazz, as if we had produced nothing else. A Japanese scholar feels the same when one talks to him of Japanese art in terms of ukiyo-e. He would no more fill his home with such prints than I would fill mine with jazz. I have been in hundreds of Japanese homes and have yet to find one where a print graced the family shrine; but often I have seen there pathetic copies of Sesshu's classic mountains.

But even so, sometimes it is world opinion that judges these things.

It is possible that the Japanese scholars are wrong about ukiyo-e and that I am wrong about jazz. Perhaps America's musical genius is jazz. Maybe in a hundred years this jazz will be recognized throughout the world as a major art form while my successor sits at home outraged by world judgment. Certainly it was the world as a whole that discovered ukiyo-e to be a major art, and whether Japanese scholars like it or not, that is the world's verdict.

15

How It Was Done

TSUTAYA JUSABURO · KITAO MASANOBU

*U*p to now we have been speaking as if any given artist, like Kiyonaga, had been solely responsible for prints published with his signature. Particularly, we have used phrases like "Kiyonobu's line," or "Shunsho's choice of subject matter" or "Harunobu's color," as if these three gifted artists had determined what the line should be or what the color.

That was not the case. Kiyonobu originally drew a line that was from three to five times as thick as the one we now see in his prints. Shunsho was frequently told what his subject should be. And Harunobu sometimes gave only the vaguest indication of what colors might go well with his designs, and with shocking frequency these suggestions were ignored.

Of all the sixty-five prints offered in this book, only two were conceived, drawn, cut, colored and printed by the artist (7 and 23) and they were done in this century. All the rest resulted from the co-operation of four almost equally responsible men: the publisher, the artist, the woodcutter and the printer. Among the major arts of the world there is no other so definitely organized along assembly-line principles. There is no other so clearly an artisan's art. To anyone who believes that art can result only when some brooding genius dreams in solitude, ukiyo-e is a permanent affront, for the glories of this art sprang from a union of hard-headed businessmen, inspired brushmen, and tested hacks. Let us see exactly how these prints were made.

In the hot summer of 1774 a slim young man of twenty-four opened an unpretentious bookshop near the great gate of the Yoshiwara. This was a likely spot for such a store because many of the patrons of the gay district were learned men and eager to keep abreast of the latest

publications. Girls in the houses, too, enjoyed books and were frequently shown reading *Genji* or the latest novel.

This young businessman chose as his location the fifth shop from the gate on the left-hand side of the entrance, and in time his establishment became one of the most famous in Edo. The young man had been born of an impoverished family called Maruyama, but as he approached twenty he had had the good luck to be adopted by a more substantial family, so that his name legally became Kitagawa Karamaru.

He appears to have had a rare intelligence and loved everything to do with publishing. In time he became well known for his comic poems, which he issued under the name of Tsutano Karamaru, but a much different fame was reserved for him: for in 1779, under his permanent name of Tsutaya Jusaburo,† he issued his first guidebook to the licensed houses of the Yoshiwara.

There had been guides to the gay quarters before, but Tsutaya's was different. His told not only who the most famous girls were but exactly where they could be found and for how much. All streets and houses were clearly labeled and special attributes of the girls were noted. Through the years this frail young man was to develop into one of the greatest patrons of art Japan ever produced, a far-sighted man who would initiate many of the finest nuances in ukiyo-e, yet during all this time he made most of his money from the sale of his guidebooks to the Yoshiwara. From the day he first issued his comprehensive guide, no chance visitor to the gay quarters could afford to be without a copy, for it was impossible to tell the girls without Tsutaya's scorecard.

His shop (Tsuta-ya means Ivy-shop) appears on several old prints (21). It was a two-story affair with a front that came down completely so that passersby could step directly in from the street to inspect the stacks of books and prints which lay piled on low tables. In 1774 it was the last house before open countryside, so that its whole orientation was toward the Yoshiwara, of which it was really a part. Tsutaya lived in the back, of course, reserving his upstairs rooms for the skilled artisans of whom we shall speak later.

Sometime after Tsutaya hit the jackpot with his guide to the girls, he started to publish prints and called his shop Koshodo, adopting the seal which has become a hallmark of the very finest ukiyo-e: a three-peaked view of Fuji enclosing an ivy leaf (21, 58). In following his

† In Japanese style he was known to his associates by his nickname Tsutaju. His first name is often spelled Juzaburo.

activities we shall discover the curious way in which prints were produced, an intricate system which has not previously been sequentially described in English.†

As publisher Tsutaya provided five invaluable ingredients: money, organization, materials, sales and taste.

The money came, as we have seen, from the sale of his guidebooks. A good deal was needed because to make even one fine ukiyo-e print demanded a lot of material, and in order to be successful in the business a publisher had to offer at any one time up to a hundred different subjects by as many as fifteen different artists, plus a large selection of books, maps and occasional trivia. Because he was a superb businessman, Tsutaya prospered while dozens of lesser houses perished.

But many Edo men had money. It was Tsutaya's good fortune to line up behind him an organization that seems to have been nearly perfect. He had the finest artists, the best engravers and the most skilled printers. We know that he paid his artisans rather more than other publishers, that he reveled in parties, that he kept literally dozens of hangers-on, and that he rewarded his friends with rip-roaring all-night binges in the Yoshiwara. He can be said to be one of the first successful practitioners of enlightened labor relations and dispersers of fringe benefits. His unique organization was never matched during the entire history of ukiyo-e.

With his money Tsutaya laid in large stocks of the three essential commodities: cherry-wood blocks sun dried and planed to mirrorlike finish; exceptional paper from Echizen and Iyo provinces; and more than fifteen basic pigments from all parts of Asia. He provided the best of everything and bountifully.

Tsutaya also provided an excellent sales organization. In addition to the famous shop at the Yoshiwara he ultimately acquired that of a competitor near the center of Edo. He also had traveling salesmen, lending libraries and sub-outlets throughout the city. He had access to the leading theatres, so that his artists could attend dress rehearsals and get the jump on other houses that planned to bring out theatrical prints covering the latest plays, and he had that distinguished seal of Fuji and the ivy leaf, signifying that here was the finest print available in Edo.

But above all these technical and commercial gifts, Tsutaya con-

† One half the system, the technical, has been excellently described by Hirano Chie; the other half, the operative, by Tys Volker, who did the pioneer work on this aspect of the subject.

tributed taste. Succeeding chapters of this book will bear multiple testimony to the judgment of this quiet gentleman. It was he who found and kept from starvation two of the heroic artists of ukiyo-e and at least three superb men of lesser rank. He provided sanctuary for three of Japan's finest novelists, and was the first publisher to pay a novelist a cash fee (1791) when he paid Santo. Although he did not invent, he did sponsor two of ukiyo-e's happiest innovations: the mica-background print and the yellow-background print. He issued a series of exquisite color-print books and was responsible for several volumes of nature studies in full color that have never been surpassed. In addition to all this he published excellent novels, good poetry, including some of his own, and certain other amazing books which will be discussed later.

He seems to have supervised each stage of his intricate business and it is appropriate that in the only print so far found which shows this rare and sensitive man (21) he is stepping quietly forward to sell some of the prints he had so lovingly called into being. For there can be little doubt that Tsutaya coached his artists quite carefully. He suggested books for them to do, themes for series of single sheets, colors that would strike the public eye and theatrical designs that would be popular.

It must not be supposed that Tsutaya was in any way unique, except in his impeccable taste. There were in Edo at this time not less than forty-five substantial publishers, one of whom, Eijudo, at times challenged Tsutaya for first rank, and another who had started issuing prints in 1675 and would continue down to 1867. Furthermore we are not guessing when we say that these powerful publishers did actually call forth many books and prints. In the preface to a book Tsutaya published in 1776 he implies that he brought two artists, Shunsho and Shigemasa, together and commissioned them to do a book; whereas in the preceding year Shunsho, working with another publisher, bluntly states that it was this man who thought up the book and asked him to do it.

Therefore, although custom has developed the sentence, "Katsukawa Shunsho produced this print," the truth lies elsewhere. How little Shunsho actually did is amazing, for always in the background to suggest, to supervise and to sell was some publisher. Those artists whom we are about to meet who had Tsutaya Jusaburo backing them were fortunate indeed, for whatever he touched he graced. Every critic who

has studied his quiet and unspectacular life has commented that upon his premature death in 1797 the great age of ukiyo-e ended. This could be explained by the accidental concurrence of many factors; all we know for sure is that at least five excellent artists did their best work under Tsutaya's guidance and accomplished very little after he died. Then there were no more exquisite books, no more breathtaking innovations, no more prints in small editions with impeccable workmanship. Now came the age of quick and sloppy work, and Tsutaya would have sold none of it under his seal of the three-peaked Fuji and the ivy leaf.

I am perhaps swayed by the personality of this man, whose social life I shall speak of later, because for some years I had the good luck to work deep inside a famous publishing house in New York and there I saw how many books are conceived by the publisher and sent out to the writer. I saw how a good publisher enlivens everything he touches, helps, guides, criticizes and rejects. I suppose it has always been this way, in every art that was not purely personal, and I have been most interested to find in Tsutaya Jusaburo the very beau ideal of publishing.

Of course, Tsutaya depended wholly upon his artists. He published for more than twenty well-known names but gradually began to focus his attention and resources on a few, who became among the most famous in ukiyo-e. Let us see exactly how these artists worked.

In 1784 an hilarious and delightful young man who was to gain considerable fame both as an ukiyo-e artist and as a novelist appeared at the shop of Tsutaya with an idea for a distinguished print. He was then only twenty-three years old and unknown, but ten years later, at the height of his fame, a fellow artist made a glowing portrait of his witty face, which now appears in print 56.

Kitao Masanobu, which was merely his arbitrary name as a print designer and indicated no relationship to the greater Masanobu now dead, had with him a rough sketch on heavy paper of a print that was to become number 55. The lines were thick and scratchy. Figures had been shifted back and forth by means of paper scraps pasted over the original. The cuckoo was indicated by a cross. But the spaciousness of concept was there and the beauty of a spring day was clearly indicated.

There was a problem. Kitao wanted his print to be large, almost twice the size of an ordinary print yet not in two separate sheets. Tsutaya had just finished publishing for him a dazzling book of enormous pages, each printed with more than twenty different colors in a spectacular rainbow effect. There were a few such huge blocks of wood avail-

able and Tsutaya had them, so he agreed to the oversize. He made a few suggestions as to placement of the figures but perceived at once what Kitao had in mind for the colors. Approval granted, Kitao went back to his desk and prepared a finished drawing.

He did it on special transparent paper, wafer thin. The principal lines he obtained from the rough sketch by tracing, the way a schoolboy does. He used a thin brush and jet-black ink, so that his resulting line was rather heavy, from three to five times as broad as it appears in the finished print. At places—as in the bottom billowing hem of the kimono worn by the woman with the umbrella—the line was uncertain and even wavering, but he knew the engraver would correct it. The meticulous ribs of the umbrella were merely suggested. Again that was the engraver's job. A few dabs were placed on the kimonos, indicating patterns, and no more was necessary, for an assistant would fill them in. Great pains were taken with the flowers, the cuckoo, the faces, even though all the lines Kitao used were rather coarse. He didn't bother with the hair, because his brushes couldn't possibly do as good a job as the engraver's knife, and besides, each engraver had a special way of doing hair and kept up to the yearly mode so that his finished prints would be in fashion. With the waves, too, Kitao merely indicated that he wanted some.

The finished copy on thin paper looked exactly like a little edition of one of Raphael's magnificent cartoons in London. It was rough, beautiful, spacious and a thing of art. But it bore as little resemblance to print 55 as a Raphael cartoon bears to the highly polished, full-colored frescoes of the Vatican. But this rude drawing was all that Kitao would provide and that only in black and white.

It is an astonishing fact that not a single print reproduced in this book was ever "painted" by the artist whose name is attached to it. In dealing with this lovely print of Kitao's we are dealing with one of ukiyo-e's masterpieces, but he never saw it as a finished product except in his mind's eye. Not a single print shown here was ever created in full color in any form by its artist. Even Harunobu, the finest colorist of them all up to the age of Tsutaya, never actually "painted" a picture to be used as a print. He worked solely in black and white, keeping the final picture only in his mind's eye.

When the initial outline block was cut, some weeks perhaps after Kitao submitted his original, the printer ran off sixteen or twenty copies called key-block prints (63 C) and gave them to the artist, who then

took these sheets one by one and visualized the colors he wanted for his print. Taking one outline sheet he would daub certain sections in sweeping brush strokes with a dull red ink. At the top he would apply a square of color, say blue. This meant that all areas daubed with red on that sheet would be printed in blue.

Taking a second sheet, he would smear the same red over other areas. These were to be printed in green. So he would continue, always using a dull red smear to indicate the loveliest of colors, until his sixteen or twenty key sheets were used up. And all this time he was coloring his print in accordance not with a finished painting before him, but as he had visualized it weeks before.

When he finished this exacting job, Kitao turned the indication sheets over to the engraver, who then cut the necessary number of color blocks and gave them to the printer, who proceeded to mix paints somewhat resembling the color smears Kitao had provided. If the exact green Kitao wanted was not available, some other green had to do. It was not until the last run through of the last color printing that Kitao and Tsutaya, watching breathlessly, could tell what kind of print they had. At that moment the collaboration of publisher, artist, engraver and printer was consummated and an ukiyo-e print was born.

The engraver was the most highly skilled member of the quartet. It took about four years of apprenticeship to become a satisfactory artist, about three to become a good printer, but at least ten to become a complete engraver. Of ten boys who entered the apprenticeship, only two ever mastered the final art of cutting blocks. Three became good enough to gouge out dead areas of wood, and the other five quit.

Tsutaya apparently did not employ his engravers directly but farmed his prints out to several highly skilled families whose members had worked as engravers for many generations. Since three cutters could keep ten printers rushed with work, Tsutaya needed access to less than a dozen cutters and preferred to have them work in their own shops. Furthermore, once the design had been handed over to these men, there was nothing Tsutaya or the artist could do about supervising that part of the job.

We know that these engravers were opinionated men, and it was useless to argue with them. An outraged letter of Hokusai's has come down to us, pleading with his publisher to have the engravers cut the way he draws: "I suggest that the engraver should add no lower eyelids where I did not draw them. As to noses: these are my noses (and he

draws two examples) and the noses usually engraved are the noses of Toyokuni which I do not like at all and which are contrary to the laws of the art of drawing. It is also the fashion to draw eyes like this (he provides a sample with a black point in the center) but such eyes I like no more than such noses." Late in his life he writes an ecstatic letter to his publisher crying that at last an engraver has been found able to cut what he draws. He begs his publisher to use no one but that engraver henceforth.

The cherry wood used for woodblocks came from large trees which yielded planks more than two feet wide and slightly more than an inch thick. After months of sun curing it was moved to Tsutaya's warehouse for another half year so that any chance of checking was eliminated. The planks were cut along the grain, of course, which yielded larger working surfaces than those used by wood engravers in Europe, where cross-grain blocks were customary. Cherry was easily worked, beautiful, and with a hardness that varied slightly from plank to plank. The most durable pieces were saved, naturally, for the key block on which all sharp lines had to appear. In fact, it was not uncommon for engravers to set into a cherry plank small squares of an ironlike northern wood onto which faces were cut, thus prolonging the life of a block four or five times. Since noses and hairlines were the first to wear out under repeated printing, such insets saved money.

The cutter sat on his ankles before a wooden desk three feet wide and two deep. The edge nearest him was one foot from the floor, the back edge about eighteen inches, so that the desk sloped into his lap, enabling him to apply the full pressure of his powerful cutting arm onto any part of the surface.

His first job, on receiving Kitao's drawing for print 55, was to paste the very thin, transparent paper face down on a suitable block of cherry. For this he used a fine paste made of rice or wheat flour with a touch of alum. When the paper had completely dried and was stationary, the cutter dipped his thumb in water and began to roll back one layer after another from the back of the paper until at last there remained only a microscopically thin filament of fiber containing the painted lines.

The engraver was now ready to go to work. Placing the board firmly on his desk, usually with the bottom of the design toward his stomach, he took a cutting tool shaped like a blunt paring knife and cut along the inside of a line. Thus in print 55 the cutter would start at the

wrist of the woman with the umbrella and in one fine sweep cut the entire inside edge of the line that falls so gracefully into the loop of the kimono. Then with a second, deeper and sharper single stroke he would cut the outside of the same line.

Certain conventions were followed. A top-rank engraver placed his board once and never moved it. So skilled was his hand that it was as easy for him to cut up or across as down. A line once started could not be interrupted but had to be finished with one clean stroke. And the thick line of the artist's brush, which varied from one part of the picture to the next, had to be trimmed down to one consistent thickness usually about one-third to one-fifth of the original thickness shown by the artist. Furthermore, there was rarely a single part of the original drawing that did not need some cleaning up or elaboration from the engraver.

The engraver had at his elbow, in addition to the basic blunt knife, a very fine one, five small gouges for kimono designs, and five microscopic triangular gouges for hairlines. For clearing large spaces he had three large gouges that looked like cross sections of soup spoons and two very solid hammers. To see an engraver use these latter brutal tools with big swinging strokes to finish off a block upon which he has worked meticulously for six days is exciting and a bit nerve-racking.

Usually the engraver worked in this sequence: cut the inside of the line; cut the outside; gouge needless spaces near these important lines; gouge the big empty spaces; use very small gouge to perfect any line that looks weak; touch up all lines one last time with the original cutting tool.

An important part of the engraver's job was setting the kento marks (63 B). The right-hand right triangle was set first to provide a snug corner into which the printing paper fitted. Then the left-hand gage was set, against which the base of the paper could fit. When these two kento had been duplicated on all the blocks of the series, perfect register was assured.

Once the key block had been cut, the printer struck off the sixteen or twenty outline sheets on which the artist was to provide the color keys. When these were returned to the engraver, it was a fairly easy job to cut the blocks conforming to the color areas. In case a pale green was to be used only at the bottom of the print and a purple-blue only in the sky at the top, one block might suffice for each of these two colors. For intricate printing such as hair three blocks might be

cut of almost identical pattern but with sufficient difference so that when slightly varied colors were applied the result would be a shimmering black head of hair (53 A). The mosquito nets so dear to late ukiyo-e artists were easy to do. On one block all the horizontal lines were gouged. On a second appeared all the verticals.

Most museums today own key blocks which have been preserved nearly three hundred years. In themselves they are works of art and demonstrate the love with which the old engravers worked. One of the most beautiful is the Kiyonobu owned by the Freer Gallery (10 A) but equally interesting is the block cut a few years ago by the finest engraver working in Japan today (63 B). These blocks show the varied types of cutting done, the delicacy of line and the shimmering beauty of wood and black ink.

The printer sat hunched over a desk that was quite the reverse of the engraver's. It was only six inches high in front and sloped away from him to a mere two inches in the back. The block was so placed that the kento marks were next to the printer's stomach, so that the paper, once slotted into position, would fall of its own weight down and across the inked block.

The paper on which ukiyo-e are printed constitutes one of their chief charms. It is amazing stuff, made from long fibers of short, bushy trees of the mulberry family. It is quite unlike anything we know today as paper for it has a silky sheen, a resilience that is unbelievable and resistance to tearing that is remarkable. In addition it is absorbent but not like a blotter whose absorbed lines run at the edges. Ink penetrates it, sometimes to the other side, so that when flecks tear off, color remains underneath.

Every collector of ukiyo-e recalls his first shock at discovering the true qualities of this amazing paper. You go into a junk dealer's shop and scrounge around for some old prints. They come up creased and greased and raveled. Apparently they are worth nothing, but the dealer takes a hot poker from the open stove, spits on it to generate steam, and passes it quickly back and forth across the reverse side of the print. Suddenly the creases unfold, the grease stains disappear, the ravels fall into place. When he offers you the print it is quite presentable.

Or there are times when an otherwise good print has been heavily pasted into an album with coarse glue. The print seems ruined, but a quick bath in warm water, a healthy scrubbing, a little pressing and the

paper springs back to life as good as it was two hundred years ago. In late prints, of course, European chemical colors run when wet; with such prints, practices that would be perfectly safe with original vegetable colors, must be avoided. The tensile strength of this unique paper plus its inherent beauty helps make the ukiyo-e print peculiarly delightful.†

When the paper arrived at Tsutaya's, the printers' helpers sized it with a flour paste and alum. After it had dried, it was stacked in large piles, with very damp sheets interleaved every twenty or thirty sheets so as to establish a norm of dampness that would be kept consistent throughout the entire printing, even if it took up to twenty days, as was often the case. This controlled moisture kept the paper from either shrinking in dry air or expanding when coming into contact with wet colors.

A block for printing was placed, kento to stomach, on the sloping table and ink applied. For this a brush resembling a whitewash brush was used, but smaller in width. On a rack before the printer hung as many as twenty-four of these brushes, with eighteen or twenty pots of pigment plus a bowl of water and another of rice paste.

Onto the block a dab of paste was dropped, then a smear of pigment. Next the two elements were mixed thoroughly and the entire surface of the block covered, each section being brushed carefully as many as a dozen times. Now a sheet of precisely dampened paper was lifted, dropped firmly into the kento slots, and flicked forward and down upon the block with the thumbs.

Then it was pressed vigorously onto the block by means of a circular pad the size of a small saucer called the baren. The rubbing surface was made from the tough smooth outer sheath of the bamboo sprout, and nothing else would do. The inner disk upon which the bamboo rested, and the part of the baren whose pressure gave the finished print its character, was made of finely twisted bamboo-skin twine, tied into abrasive knots and wound round and round in a tight spiral. There were many kinds of barens, and each was used for some special effect, but the difference always lay in the coarseness or fineness of the underlying bamboo twine. Some was so fine it merely tickled the hand, and this was used for flat color. Other kinds were so coarse they could remove skin if heavily applied, and these were used for striking back-

† Rembrandt hoarded whatever scraps of Japanese paper he could get hold of for his finest etchings.

ground effects (39, 40, 46, 50). Backing the twine was a curious filament of very thin tough paper built up of more than fifty separate layers glued together. The paper base and the twine were held in a finely lacquered cotton cloth shaped into the form of a very shallow saucer with edges. The sheath of bamboo, which was all that touched the print, gliding smoothly across it, was drawn tightly over this built-up pad and twisted over the bottom of the saucer so as to provide a handle.

The printer's desk was low so that he could lean forward with all his weight and apply enormous pressure to the baren. There were set ways for moving this highly polished buffer over the paper to achieve distinct effects. Surprisingly, for each individual color the baren was rubbed with great pressure back and forth up to two dozen times. It was a wonder that the paper did not disintegrate, especially since to obtain certain prized effects the printer discarded the baren and kneeling upon his haunches, threw his entire weight onto his elbow and used it to beat the paper onto some special pigment. This was also done when a block was being used without any color to produce embossing, an actual deformation of the paper to stress lines of drapery or the movement of a river.

When the colors for a print had been approved by publisher and artist, the printer proceeded to run off two hundred finished copies. For print 53 A this printing process took seventeen days. For print 62 it took about twenty-two days. An edition of two hundred copies was standard because after that number of printings the cherry blocks began to swell from the water in the pigment and registry was lost. A rest of about six months easily restored the original size of the blocks and made the initial kento markings satisfactory once more, but by now the prints would begin to show the wear and tear on their blocks. First to suffer would be the nose line, so that noses are the one best way to judge the condition of the blocks when a given impression was taken. Next the hairlines filled in and became muddy. Finally lines all over the print began to break up and show blank spaces.

There is much that a skilled printer could do to correct such damage. Even the best museums today have prints in which half the blocks, late in their lives, shrank one way and the other half another. In these prints the areas near the kento are in good alignment, but those elsewhere are out of register. A skilled printer might change his kento slightly and get a print that was almost satisfactory. He could reduce

certain areas, use a more satisfactory color for others, bring out the finest in each block and harmonize the whole.

The good printer was an artist. In fact, he was such a confident artist that we can be sure he established many of the colors that appeared on the prints and vetoed the artists when they tried to interfere. It is probable that half the color prints in this book were never seen by the artists whose signatures appear on them. We know that certain dedicated artists saw their prints through from first key block to last red tinge on the lips, but they were few. And we are almost positive in believing that not even these rare dedicated men bothered with the second or third edition of two hundred each. In the first place, since most prints didn't go into second or third editions, those that did were often passed along to the second-class printers, who made up whatever colors suited them. Finally, we know that late in the life of certain successful sets of blocks, they were sold for a few yen to the most disreputable printers available, who might use six garish colors to save money where the original printer, working under the eye of the artist, had used eighteen. This book contains two dismal case histories (pages 167 and 220) of what happened to prints under this system.

I think one can say this. Much of the exquisite beauty of the finest ukiyo-e is due to the work of inspired printers. All the debasement of wretched third and fourth stages, or garish colors, of dropped plates, of poor registry and worn-out faces is also attributable to the printers, who were however goaded on by unscrupulous publishers eager to squeeze a few more yen out of their tired and worm-eaten blocks.

Tradition says that Tsutaya Jusaburo never passed his blocks along to such fraudulent use. There is no record of his having done so.

As to why critics the world around still speak of "Kiyonobu's line" and "Harunobu's color," the usage developed when many of the facts noted above were not known; it continues for two reasons. There is no simple way of summarizing the above facts verbally and some shorthand system is needed. But more important, of the four component factors in the creation of a print, it was the artist who provided the intellectual, creative, and basic aesthetic elements. In all propriety we can call Kiyonaga an artist, even though he functioned in a manner not entirely respectable in western art.

16

The Popular Symbol

KITAGAWA UTAMARO

Critical astigmatism is regrettable when it obscures the vision of even one man, but when it confuses many men for several generations it is deplorable. No ukiyo-e artist has suffered more unjustly from astigmatic critics than Utamaro.

Four notable scholars of four different nationalities were responsible. First Ernest Fenollosa, the brilliant Spanish-American, constructed a basic theory to explain ukiyo-e: the art started primitively, rose to the magnificence of Kiyonaga and perished because of the decadent Utamaro. In order to prove this theory Kiyonaga had to be augmented, Utamaro torn down. He was labeled decadent, flabby, immoral and corrupting. His finest prints were used as exhibits of his decadence, three proofs being cited. One, he drew women extravagantly tall, obviously the work of a diseased mind. Two, he led a dissolute personal life. Three, he did not respect inherited tradition because he posed a Yoshiwara prostitute as a Chinese goddess.

Around 1910 the German von Seidlitz published in three languages an account of ukiyo-e admitting, "With few exceptions, I have relied upon Fenollosa's catalogue in describing the development of Japanese Colour-Printing, and the characteristics of the individual artists." In excellently reasoned prose he crucified Utamaro. "Although the elongated heads of the women with their narrow slits of eyes, hardly perceptible mouths, and huge coiffure which towers upward and broadens out at each side, can give us absolutely no idea of the real artistic ability of the man, since they belong to the time of the complete decay and degeneration of his art into mannerism, nevertheless these pictures, produced by him in hundreds and therefore so widely circulated, must be regarded as characteristic examples of the style and taste which pre-

vailed in Japan about the close of the eighteenth century, and which were mainly due to the influence of Utamaro himself."

Von Seidlitz also restated the major criticism against Utamaro that his figures were too long and willowy. "For expressing the inexpressible, the simple rendering of nature did not suffice; the figures must needs be lengthened to give the impression of supernatural beings; they must have a pliancy enabling them to express vividly the tenderest as well as the most intense emotions of the soul; lastly, they must be endowed with a wholly peculiar and therefore affected language for uttering the wholly peculiar sensations that filled them. Utamaro possessed the courage still further to exaggerate these effects even beyond the limits of the possible, until the point was reached when he could go no further, and a gradual relaxation imposed itself as an obvious necessity. This time of extreme mannerism did not last longer than a decade, from about 1795 to 1805, and was at its height about 1800."

Then, along with phrases like *complete degeneracy, degraded into caricature* and *after the period of delirium,* von Seidlitz unlimbers one of the most confused, back-pedaling and sanctimonious bits of criticism in this century: "Nay, if we could only admit the morbid and exaggerated to be as fit subject-matter for art as the healthy and sane, we must grant that this style is one of altogether enchanting originality, and that, however dangerous might be its immediate influence upon the spectator and particularly upon possible successors, it does none the less lift us beyond the cramping limits of reality and is therefore not wanting in idealism of a kind."

Edmond de Goncourt, the French novelist and aesthete, wrote a perceptive biography in 1891 called *Outamaro, le peintre des maisons vertes,* whose title indicates the major thesis: that Utamaro wasted a dissolute life in the green houses of the Yoshiwara. As von Seidlitz primly points out, "We should not be far wrong in calling Utamaro a decadent, the Parisian of his day; and it is significant that Goncourt, that finely sensitive explorer of the phenomena of decadence in our times, should begin precisely with this artist his series of biographies of Japanese artists."

It was an otherwise sensible and just American critic, Arthur Davison Ficke, who compounded all preceding moralizings and embellished them with his own self-righteousness. The organization of his book betrays his preconceptions. Third Period: Kiyonaga. Fourth Period: The Decadence.

For some curious reason Ficke directed most of his criticism against Utamaro's diseased mind: "The favourite types of this time are almost as unreal as those of the Primitives, but they convey a totally different feeling; on the one hand, in their curious perverted way, they are far more realistic than the Primitives ever dreamed of being; and on the other hand, they seem the products of minds weary of reality, who turn to the phantasies of the not wholly normal spirit for their ideals and their consolations."

Ficke also objected to Utamaro's tall women and found something positively immoral about the whole affair: "Her strange and languid beauty, the drooping lines of her robes, her unnatural slenderness and willowiness, are the emanations of Utamaro's feverish mind; as her creator he ranks as the most brilliant, the most sophisticated, and the most poetical designer of his time. His life was spent in alternation between his workshop and the haunts of the Yoshiwara, whose beautiful inhabitants he immortalized in prints that are the ultimate expression of the mortal body's longing for a more than mortal perfection of happiness. Wearied of every common pleasure, he created these visions in whose disembodied, morbid loveliness his overwrought desires found consolation."

Ficke sums up his displeasure with Utamaro in a passage of real meaning: "But on the other hand, Utamaro has used his keen realistic power merely as a scaffolding, and has proceeded to build up on it a work that goes over almost into the region of symbolism. In the slender delicacy of this figure, the splendid black of her elaborate coiffure, the drooping fragility of her body, the sensuous grace and refinement, the languor and exhaustion—in all these speak the supersensible gropings and hungers of Utamaro himself. Out of a living woman he created his disturbing symbol of the impossible desires that are no less subtle or painful because they are born of the flesh. With nerves keyed beyond the healthy pitch, he dreamed this melody whose strange minor chords alone could stir the satiated spirit. He caught and idealized the lines and colours of mortal weariness."

Finally, Ficke adds two bits of evidence which are not subjective. He reports that Utamaro was thrown into jail for a year and handcuffed at home for a further fifty days for having issued a triptych which brought "salacious disrespect" upon the reigning shogun. And he cites the repulsive portrait in the British Museum which shows Utamaro as a flabby-faced old man, sunk in vice, slack-jawed and lost.

There were seven reasons why critics at the turn of the century constructed this handy analysis of Utamaro. First, Fenollosa wanted to organize for western minds the history of ukiyo-e and felt that the most effective way would be the establishment of some dramatic theme which would tie together many diverse threads. He chose one of Grecian simplicity: Kiyonaga the hero, Utamaro the villain. Ficke, in a brief sentence, betrays this master plot: "Utamaro, in his earlier years at least, was as wholesome as Kiyonaga," but before anyone defines Kiyonaga's wholesomeness he should read Chapter 20.

Second, Victorian moralizing characterizes a good deal of the criticism against Utamaro. Von Seidlitz must have felt a surge of positive virtue when he stigmatized Utamaro as a Parisian; and Ficke certainly believed that any artist who hung around the Yoshiwara was clearly abandoned.

Third, since it is demonstrable that ukiyo-e did die, causes must be found. If the right reason is not at hand, a vivid one should be used.

Fourth, it is quite true that Utamaro's pupils were incompetent, particularly the inept one who usurped the title Utamaro II, whereas the followers of Kiyonaga were distinguished; but this is a common occurrence in ukiyo-e and most arts. No followers were worse than Hiroshige's.

Fifth, most critics were agreed that Utamaro's tall, willowy women signified degeneracy.

Sixth, there was a period when Utamaro's prints seem to contort the female body "almost to the point of madness," whatever that means. *Twelve Hours of the Yoshiwara*, published about 1796,† certainly does depict a selection of inordinately tall, languid young women of immoral calling. In 1797 appeared the striking series *Current Beauties at the Height of Their Fame* in which the girls are tall, their necks thin and their general demeanor one of extreme languor. In 1798 comes the special series *New Patterns of Golden Brocade in Utamaro Style*, where against brilliant yellow backgrounds young courtesans display their languid charms. And of course there is that unforgettable print of a young woman in purple kimono seated with fan and smoking implements, her right knee drawn up. She displays an enormous hairdress, a match-stick

† Dates become important in discussing Utamaro. The period of his maximum degeneracy is supposed to have been 1795–1800. Dating specific series is difficult and any single date proposed may be wrong by a year or two. However, every available source in Japan and the United States has been consulted and where substantial disagreements arise the prints involved have not been included in the argument. Specifically, wherever there is any disagreement as to date, the date which supports the reasoning of this chapter least has been used.

neck, frail ankles and a body that would have to be at least nine feet tall. It was of her that Ficke wrote:

> "He who this living portrait wrought,
> Outlasting time's control,
> A dark and bitter nectar sought
> Welling from poisoned streams that roll
> Through deserts of the soul."

Finally, there is that damning and bloated portrait of a diseased Utamaro in the British Museum.

Now what are the facts? Almost every one of the above criticisms is complete nonsense. The entire thesis is founded on misinformation, confusion and proud prejudice. There is positively no substantial evidence of degeneracy and one day's work with Utamaro's actual prints would have proved it. Without moralizing, let us look at the man's work and see what clap-trap has been written about him.

He was born in 1753 and one finds it difficult to keep in mind that he was only one year younger than Kiyonaga, who seems to belong to another artistic generation at least and sometimes to a generation two removed. Utamaro developed slowly, whereas Kiyonaga was precocious. Utamaro worked right up to his death, whereas Kiyonaga quit early. In fact, if one could consider Kiyonaga-Utamaro as one artist, the resulting life would represent a logical artistic development, a consistent growth and a harmonious accomplishment.

Utamaro was thirty-five before he produced much of note, but in that year he published with Tsutaya Jusaburo a colored book on insects which was both the first of his numerous studies of nature and one of the loveliest books ever published. Its fidelity, its beautiful design, its fine draftsmanship and color make it a prize either for the biologist or the collector. It bespeaks a most healthy mind and in its preface Utamaro's first teacher, who had practically adopted the boy, says, "I remember how Uta-shi in his childhood acquired the habit of observing the most minute details of living creatures; and I used to notice how absorbed he would become when playing with a dragon-fly tied to a string or with a cricket held in the palm of his hand." Books on birds, the sea coast and the world in winter followed, each a masterpiece of observation and art, each breathing the clean air of snow and wind. If such interests and attributes mark the degenerate man, then Utamaro was far gone by 1790.

In that year he began to design prints which dazzled Edo. Some appeared with a brilliant yellow ground, others with silvery mica. The subjects were often beautiful girls, usually not from the Yoshiwara. O-Hisa and O-Kita, two famous tea-house waitresses appeared frequently, as did Tomimoto Toyohina, statuesque daughter of the musician who appears in print 51. It is pretty difficult to detect degeneracy of any kind in these sparkling prints.

In 1793 he designed an impressive set titled *Twelve Handicrafts of Women,* which presents an almost tediously normal group of young housewives performing the most ordinary series of household tasks. The masterpiece of the lot, derived from a Kiyonaga triptych, shows a handsome young woman sitting spread-legged at a tub, washing laundry. The whole design of her body set against a spray of iris and the round tub is memorable.

Since Utamaro's degeneracy is supposed to have become habitual by 1795, when he was forty-two, it will be instructive to inspect him on the eve, as it were. Sometime near 1794 he issued with Tsutaya Jusaburo a series of eight superb prints—two inadequate additions were brought out later by an inferior publisher—called *Studies in Physiognomy* and sometimes signed, "Utamaro the Physiognomist, after mature consideration." In another place he explained that most artists merely copy what they see but he, the physiognomist, tries to get at the soul of the sitter and then to paint her so that all men will love her. His contemplation produced some of the most normal and satisfying portraits in ukiyo-e. Two have become popular symbols both of his finest work and of the Japanese print. One shows a young matron reading a letter held close to her face. She appears in voluminous and sedate clothing against a background that in most versions is shimmering white or occasionally and more successfully a rose-pink sparkled with mica. The second is perhaps the more popular and shows a young woman of frivolous physiognomy in faded blue kimono and yellow sash. The background is silvery white speckled with mica, and the tilt of the head, the sheer loveliness of color produce an immediately winsome print.

Then in 1795, when the man's corruption was upon him, he did a most contradictory thing: he began to issue—or was in the midst of issuing—one of the most sublime evocations of mother love ever to appear in any art. Japanese folklore says that the devoted wife of a warrior slain by enemies fled into the mountains with an unborn child, who became Kintoki, the Golden Boy, who was brought up by the wild woman of

the hills, Yamauba, until as an adult he became a cross between Hercules and King Alfred. In a series of at least eighteen notable prints Utamaro depicts the wild daily life of mad Yamauba and her red-skinned little boy. No other pictures that I know catch so tenderly the total range of love that exists between a tough little boy and his mother. It would be a joy to describe each of these enchanting prints but three will suffice. As Yamauba combs her tangled hair, Kintoki climbs her back. As she prepares to weave cloth, he sits impatiently with yarn about his wrists. As she gets dinner, he helps clean the duck. Words cannot convey the abundant human love expressed in these prints.

In 1797, when Utamaro was in the depth of his feverish delinquencies, he found time to produce one of his gentlest and springlike series, *Six Selected Beauties*, depicting popular young girls in Edo. Toyohina, the handsome musician was one. So were the famous waitresses O-Hisa and O-Kita, plus a notable widow and a girl who worked in a shop. The sixth, who appears in print 53, was most beautiful of all, the fabulous courtesan Hana-ogi of Ogiya, whose story can be found in Ledoux. She is known to have been gifted in poetry, filial piety, loyalty, religion and the arts of love. She was probably the most alluring woman in Japanese history after the poetess Komachi, whom she imitated in the aching tragedy of her later years. Print 53 A is especially interesting in that we have three distinct versions in America, and a fourth ought to turn up, illustrative of many problems relating to ukiyo-e.† The publisher Omiya issued this fine series originally with light gray grounds (53 A) and judging from the number of copies that have come down to us, with great success. Therefore, after the blocks were a bit worn, the publisher added a mica ground (53 B) which for some years previous had been outlawed by the Tokugawa government, and the series regained its popularity, so that much later, after the six girls were no longer so well known, the blocks were hauled out again and given a radical reworking (53 C). The original title was routed off the key block and a new title carved on a separate block. The cartouche which contained the original anagram (Fan-Ogi. Arrow-ya of yanone. Flowers-Hana. Fan-Ogi) was also routed out and a new one substituted in quite awful colors and bad drawing. But what the publisher now had was a series showing six still remembered young women as the six greatest poets of Japanese history, giving him a double-barreled sales pitch. Hana-ogi, appropriately, represented

† This print was copied quite directly from the print for the fourth month in the almost unknown Utamaro series *Bigan Juni-tate* (Series of Twelve Beautiful Faces) which so far as I know has not been dated. Probably 1787 or earlier.

Ono no Komachi, whose traditional portrait appears on print 53 C as if these two once-lovely women who had known such dismal last years should typify the once-fine blocks now battered and reworked. Again the series sold and when the blocks were far gone a fourth series was struck off: version 53 C but with mica ground.†

In the years that followed, far from showing evidence of distintegration, Utamaro showed new power. Some of his triptychs are among the finest in ukiyo-e: big powerful designs peopled with rugged fisherwomen, handsome peasants, gracious princesses from old romance. In art these triptychs are magnificent; in reporting the human scene they are as faithful as his earlier studies of insects, birds and sea shells.

And in 1804 he collaborated with a famous novelist, Jippensha Ikku, in creating one of the strongest Japanese illustrated books, *Annual Functions of the Green Houses in the Yoshiwara*, which recounts the festivals and processions of the gay quarter. Although assistants helped on some of the plates, the overall design and much of the work were his and it is noteworthy that up until the very last years Utamaro showed no detectable signs of diminishing power. Furthermore, throughout the years of his supposed degenerancy he issued many hundreds of prints not mentioned here dealing with everyday life and in particular one series, not formally organized, which shows the lives of average Japanese parents and their children. Less spectacular than the Kintoki prints, this conglomerate series illustrates again Utamaro's exceptional love of children.

In the orderly sequence of his prints, therefore, one finds no evidence of the deteriorating mind critics would accord him. In fact, one finds just the opposite. However, four difficult points in the basic charge against Utamaro remain: the salacious print for which he was thrown in jail for a year; the abominable portrait of him as a paretic; the print of a woman nine feet tall; and the fact that he haunted the Yoshiwara.

The salacious print turns out upon inspection to be so proper a brocade, and so dull, as to be entirely beyond suspicion of even the most prurient mind. The Shogun Hideyoshi is seated before a ghastly purple

† On a print in Boston, Frederick Gookin left a note suggesting the complete reverse of what I propose as the history of this distinguished series. Robert T. Paine, Jr., of the Boston museum, says he knows of no instance where mica was added later to a successful series; usually the costly mica appeared in the original version, was then omitted in cheaper second runs. Phillip Stern of the Freer agrees. This means that the authenticity of the mica versions must be questioned. Were they fabricated for wealthy American collections? Japanese critics think not and feel that this series is the exception to the usual practice of applying mica only on early editions.

cloth and is being entertained by his wife and four favorite concubines, which could have been interpreted as a slur against the reigning shogun, who also had at least four mistresses. But the print had nothing to do with Utamaro's being thrown into jail for a year. Actually he was in jail for only three days because he issued three quite different prints which lacked censors' approval but which did bear the names of historical warriors, a practice which had been forbidden by the Tokugawas as offensive to the martial spirit of Japan. Utamaro was handcuffed at home for fifty days but salaciousness had nothing to do with the case.

The portrait in London turns out to be of another Utamaro altogether and to have been painted long after our Utamaro had died. We do have several portaits of him at various stages of his life but they show a studious, slim, bald man of average height who liked to bite his under lip when working and who kept his saucers of paint neatly arranged when designing big murals.

There is, of course, that picture of the woman nine feet tall, a handsome print of excellent design; but as reproduced in criticisms of the artist it is falsely cropped so as to accentuate her height and kill the design. Furthermore, all this rot about sinuous women is a lot of nineteenth-century rubbish, inherited from John Ruskin and Mrs. Jameson, who went probing through Italy trying to identify which paintings were morally elevating and which were not. Tall willowy women have haunted art—and night clubs—since the dawn of history. They occur in Egypt, in Roman frescoes, in Byzantine Christian art, in El Greco, in Blake, in Toulouse-Lautrec and in Modigliani. The only sensible explanation I have heard for the strictures against Utamaro's version of this permanent theme was suggested by a writer whose name I cannot recall. He supposed the whole idea had been cooked up by some unpleasant little man who was scared of tall women. It is more perplexing than that, however, for Kiyonaga's women were supernaturally tall, yet they were applauded by the same critics as being Grecian.

That leaves one charge: that Utamaro frequented the Yoshiwara. This he did. He practically lived there. As a young man he lodged in Tsutaya Jusaburo's original shop near the main gate, where he designed his early prints, and it is obvious that without constant study of the nearby Yoshiwara he could never have produced the prints he did. In correcting old slander it would be folly to overcompensate.

We know that Tsutaya, Santo Kyoden, Utamaro and the novelist Jippensha Ikku often spent the night roistering in the Yoshiwara, and

the book on the district by the last two contains a poem printed amid apple blossoms and camellias: "O pealing bell of dawn, if you knew the sadness of parting, gladly would you sleep on rather than echo the six strokes." In another place Jippensha relates what happened to him when one of the girls in the Yoshiwara to whom he was attached discovered that he had been romancing a rival from another house. The wronged courtesan sent her young girl attendants to waylay Ikku at the main gate, but when they grabbed for him he upset the pyramid of water buckets used for fighting fire. Drenched, he tried to run off but upset a battery of lanterns and stumbled over a well, rousing a pack of dogs. From a nearby tea house a waiter was upended by the dogs, crashing his dishes down upon Ikku, who then upset a bunch of buckets used by sewage men and lost half his clothes when the girls grabbed at him. The crowd of cheering onlookers grew so large that Ikku could not escape and so was led away captive to the house of the courtesan who had launched the attack. There he was stripped to his waist, smeared with ink, dressed in women's clothes and tied up. The senior courtesans constituted themselves a court and tormented him for his unfaithfulness to one of their members. Utamaro drew a picture of Ikku's trial with four courtesans prosecuting, the old mistress of the house teasing him and habitués looking on. Ikku reports that he regained his freedom by paying a heavy ransom, promising to be faithful to his chosen girl and standing drinks all around.

We can assume that Utamaro participated in such roughhousing too, for although much is made of the fact that girls in the Yoshiwara could paint and write poetry, they also had other more sought after accomplishments. Furthermore, such self-portraits as we have show Utamaro working in the Yoshiwara surrounded by courtesans, while a famous triptych shows Santo Kyoden blind drunk in one of the houses. Yet at the depth of Utamaro's supposed depravity we find him doing a most normal thing. In 1796 he married a young woman who has left letters reporting how deeply she loved her husband and how happy they were together.

On one of his prints Utamaro expressed his feeling about the girls he drew: "To the woman of the street corner dark is the road of love; in the dusk she stands a lonely figure draped in black; O how heartbreaking to her that she must stand there with face exposed." It was this woman Utamaro made the universal symbol of ukiyo-e, recognized the world around.

We must cancel the old theory that ukiyo-e, after primitive beginnings, reached its apex with Kiyonaga, after which it declined because of Utamaro's decadence. It's a good theory but unfortunately every item is contradicted by the facts. The only tenable theory seems to be this: Ukiyo-e prints began with Moronobu, who was not a primitive but a sophisticated artist well versed in classical traditions; it received enormous impacts of vitality from Kiyonobu and grace from Sukenobu, the former of whom established the Torii tradition, the latter of whom made Harunobu possible. With Kiyonaga vitality and grace were united but in the culminating years of ukiyo-e, say 1795, Utamaro brought the grace of Sukenobu to its apex while Sharaku did the same for the strength of Kiyonobu. Decline came because no new ideas reached the art, no new exemplars of vitality or grace appeared; two authentic talents, Hokusai and Hiroshige, dignified the last years but they lacked sufficient force to revive the art.

According to such a theory Utamaro is recognized as one of the most successful artists who ever lived. He is like Raphael in the extraordinary grace he brought to all he attempted. He also excels most other artists in the remarkable breadth of his accomplishment: natural history, portraiture, landscape in his triptychs and books, genre masterpieces by the dozen, ornamentation, draftsmanship and a sure sense of color. In addition he displayed wit, human affection and narrative power. I am not personally inclined toward Utamaro—since I prefer Kiyonobu to Sukenobu—but from patient study of the man's actual work I am convinced he was an artist of positive genius who attained a higher percentage of successful work than any other in ukiyo-e.

17

Art's Mystery

The third mystery of ukiyo-e is also one of the major mysteries in the world of art. It exceeds any question of who built the monuments of Egypt or the arches of Mesopotamia, for it occurred only a few decades ago when records should have been kept. It is more perplexing than a problem like Chatterton, for the level of the art involved is immeasurably higher. Less is known about it than about the authorship of Homer. It confounds the mind and tantalizes the imagination for it is involved profoundly with the central problems of art.

These are the mysteries that confront us when we consider Toshusai Sharaku. How could an insignificant noh actor, without the slightest previous training in art suddenly burst upon the world of Edo with a stupendous series of prints which were unique in concept and perplexing in technique? How could a trivial, unschooled man of adult years explode into a bizarre meteor and produce nearly three dozen portraits that compare favorably with the best of Rembrandt, Bellini, Velasquez and Holbein? How, in any rational theory of art, could such things happen? And most enigmatic of all, why should a man who has accomplished so much suddenly halt work and disappear forever without a word as to his going?

Even our guesses about this astonishing artist must be limited, but there is good reason to support a theory that something like the following took place. Sometime during the fourth month† of 1794 an insignificant actor whom nobody has ever been able to recall entered the shop of Tsutaya Jusaburo and said that he would like to design prints. He explained that he was a noh actor employed by the Daimyo of Awa, that

† This awkward designation must be retained because the Japanese months did not at this time coincide with the west's.

he had had no art education, but that he was inclined toward sketching kabuki actors. As to his birth and youth there has never been a single clue.

When the fifth-month plays opened in Edo, this unusual man, who had never designed a print of any kind, worked at uncommon speed, drawing not only the famous actors in each play but also those who appeared in minor roles. He hurried his designs to Tsutaya, who must have been startled by them, for they were of a force he had not previously encountered. Tsutaya, a most knowledgable man, must have known then that there was little likelihood that these strange prints would catch popular fancy, but he must also have known they were exceptional art, for he agreed to publish them.

Fortunately, they were not expensive to produce. Their design was simple and required no intricate cutting. Few colors were demanded and those not the costly ones. The line used, although distinctive, presented no difficulty. There were no production tricks. Therefore it was probably Tsutaya, alert to these favorable economic aspects, who proposed that all the backgrounds of this strange series be covered with mica, which did cost extra but which gave the prints a better chance of sale. No doubt it was Sharaku who decided that the mica be kept dark, and he elected a powerful purple mica ground rather than the more sparkling white which Utamaro had made popular.

So in the fifth and sixth months the prints were issued, a series which ultimately contained twenty-three large heads of actors caught in moments of maximum intensity exactly as they appeared on stage. These first prints were all signed "Toshusai Sharaku drew this," but they were not a success.

Tsutaya appears to have liked them, for even though only a few of these huge and gaping faces required a second edition, he permitted the artist to provide additional sketches, including some in which two actors appear on each print. Again mica grounds were used, this time sparkling white as well as purple.

The reception was no better, but one connoisseur was at least interested in what Sharaku was trying to do, for he acquired a representative set and across the face of each wrote in his own Chinese characters the name of each actor with his nickname and sometimes the role he played. These prints are among the most highly prized of this artist. Modern writers, pondering the miracle of Sharaku, like to believe that this unknown gentleman acquired the prints because he recognized

great though startling art, but that is unlikely. Since the handwritten notes refer intimately to theatrical gossip it is more reasonable to suppose that he loved not art but the theatre and that in this respect he represented most people who bought actor prints.

Nevertheless, Tsutaya persisted and published another series, but this time an unforeseen accident worked against him, for Japan had fallen on evil economic days and the Tokugawa dictatorship forbade further use of mica backgrounds: they were too costly and diverted the attention of people from the grim business of restoring national prosperity. So Sharaku's next prints appeared in slightly smaller size and with bright yellow grounds lacking mica. They were definitely unsuccessful.

A change therefore took place, why no one can say. There has been conjecture that Tsutaya offered Sharaku one last chance to catch on, and the artist provided a blizzard of small prints, somewhat in the size and style of Shunsho's unforgettable actor series, often in triptych form. This series of actors posing full length in scenes from current plays was so unlike either Shunsho's classic predecessors or Sharaku's bold mica-ground heads that they had no chance of popular acceptance and were a major disappointment both financially and artistically.

With this series Tsutaya called quits. He had sunk his money in about 145 different prints and had got little of it back. Whether he terminated the venture or whether the mysterious actor-artist ended it for some reason that cannot now be guessed is unknown. All we know is that one day Sharaku left Tsutaya's shop for the last time and completely disappeared. We cannot say where he went or what he did or when he died. The most spectacular volcano in the history of art had shattered itself and was gone.

Forty years ago, before the museums of Japan, America and Germany were ransacked for any bits of evidence relating to Sharaku, a popular legend gained general credence. It had five parts. First, Sharaku as a noh player was employed by aristocrats in the aristocratic theatre and consequently must have despised kabuki players, whom he murderously lampooned. Second, the kabuki men struck back by ostracizing both him and his prints. Third, this magnificent series of prints took less than four years to complete. Fourth, it was symbolic and touching that the great heads with mica ground depicted the heroes of Japan's finest drama, *Chiushingura*. Fifth, Sharaku disappeared from Edo a heartbroken man, a personification of the tragedy that stalks creative artists.

Scholarly detective work has corrected the legend. Sharaku was indeed

a dancer in the noh troupe maintained by the Daimyo of Awa, but in the records of that distinguished family, the Hachikusa, not a single reference to Sharaku can be found. His personal name was discovered to be Saito Jurobei. His street address has been found but not one fact about his personal life. We know for certain that his prints do not apply to *Chiushingura* at all—what a lot of high-blown analysis went down the drain with that discovery—for it was not on the boards while he worked. Actually, his prints relate to a very ordinary bunch of plays, almost none of which has lived. A few additional curious facts were uncovered. Any print signed Sharaku merely, without the Toshusai, is a late print. And a book published in 1802 refers to him as one of the major artists, off by himself in a school of his own, so that he was at least known by his contemporaries.

But the major discovery, firmly established, has made the mystery of this man even more provocative. He did not compose his prints over a period of about four years. He did them all in less than ten months. This means that he turned out his majestic portraits at the rate of one every two days (about 145 known prints in about 300 days) which considering their high quality exceeds the accomplishment of Kiyonaga's best year (144 prints and 9 books) or Hiroshige's stupendous output, much of it quite inferior (5,400 odd color prints in 40 years). Sharaku's productivity is the more remarkable in that most of his twenty-three heads, his double portraits and his seven fine prints showing two full-length actors on each print seem to have been done within a period of less than fifty days. Many artists have worked fast, Mozart and Wagner among them, but few have achieved the level of work that Sharaku maintained throughout his cyclonic productive period.

Of what does his excellence consist? It has been argued earlier that to judge any print one must consider the three essential components: how space is distributed on a flat surface, use of line, and color; and of these three the first two are unquestionably the more important. Sharaku however presents a special case in this as in all else.

His utilization of space is not distinguished. Granted, his first large heads are disposed well with their masses skillfully arranged on the flat paper, and occasionally a given head, as in the case where Bando Mitsugoro as Ishii Genzo is hunched forward toward the left-hand edge of the print in the precise position to establish the tension of a man drawing his sword in anger, is startling. But for the most part the spacing of Sharaku's prints is either undistinguished (as in the case of his prints

where two figures appear) or poor (as with many of his triptychs with cluttered backgrounds and ill-placed actors). Yet immediately one has said this, other prints come to mind which prove that Sharaku was operating on some new principle in locating his masses on his paper. The famous red portrait of Danjuro V, after he had surrendered that austere name and become Ichikawa Ebizo III, attains most of its rude power from being hunched up at the top of the print. Likewise the gaunt figures of Koshiro and Tomisaburo as Magoemon with Umegawa bending down to fix his clog are posed with the intensity of a coiled spring, completely unlike the version presented in print 51. So with most of his prints, the figures are not put down with that static respose which characterizes Utamaro and Kiyonaga, but with a restlessness, a cramped excitement that conveys itself to the observer.

Nor is Sharaku's use of line distinguished; but it is unusual in several respects. First, in depicting the human face it is apt to be extraordinarily thin, but in costume bold. Some nose lines, for example, are thinner than human hair, especially when some color other than jet-black is used for the key block. Second, it is a spare line, almost impressionistic and never the warm, lush line of Utamaro clinging to a beautiful face or outlining the fall of a graceful garment. Third, it is a line of violent dramatic power and conveys both story and feeling. In faces this can be seen in the early big heads; in costume and body lines it is best seen in the late triptychs. Finally, in spite of its pyrotechnical brilliance it is usually a more subjugated line than that used by most leading ukiyo-e artists. To see either an Utamaro or a Kiyonaga print in black-and-white key-block outline only is to see a work of art already in being, to which the addition of color will add only secondary values without altering the essential beauty of the print; but a key block of Sharaku, especially if black has not been used, is disappointing. In other words, to him line is not an end in itself and this lends credulity to the theory that he never studied art formally, for the average Japanese art school imparted a training in line that has never been matched in schools of any other nation. Sharaku seems to have skipped this.

Nor is his use of color noticeably good. Opinions on this are divided, since some critics hold that he was a master colorist, but on what grounds I am unable to understand. Others insist that he was defective in color judgment, specifically in his failure to obtain harmonious juxtapositions. For some years I believed this, but it now seems to me that although Sharaku was deficient in what one might call an abstract color

sense—for he does come up with some very bad individual colors and worse combinations—he had a most secure sense of what he wanted to accomplish and was therefore really effective. For example, I think one is pressing pretty hard if he contends that the coloring of print 58 is in any way distinguished, particularly in its unfaded form. The juxtaposition of two reds about the neck, a third in the kimono, and the yellow of the chrysanthemums would never have been allowed by either Utamaro or Harunobu. Nor is the yellow of the comb very vital either of itself or in harmony with the other colors. Yet the total effect of the color scheme is dramatic and conforms to what Sharaku was endeavoring to say about the pompous actor he was depicting. One cannot claim that Sharaku's distinctive use of purple mica was brilliant, for although on some prints it helps establish a mood, on others it detracts. So one could move from print to print, finding color disharmonies that at times become actually offensive, yet Sharaku's palette produces the same tension, clash and suspense that characterize his use of space and line.

Sharaku's greatness cannot lie in his mastery of the three fundamentals of ukiyo-e, for he seems never to have mastered them. What he did obtain was a balanced and judicious harmony among the three components in which none excels but all contribute. This harmony alone would not account for the man's greatness, but it was the avenue by which that greatness was approached.

His power lay not in technical skill but in the psychological content of his portraits. This is a dangerous qualification to propose because it immediately suggests that a western mind is applying a western concept —that human portraiture needs psychological content—whereas obviously much eastern art is composed on exactly contrary principles, whereby a portrait is intended to be mainly decorative. It is wrong to establish for any art criteria which did not philosophically apply when the art was created, for then we are merely appraising ourselves and not the art. At this point it would be wise for the western reader to restudy prints 53 and 54, which provide supposed portraits of Hana-ogi, the most beautiful woman in Japan during the time of Sharaku, and to compare these likenesses with the three provided in the Ledoux catalogue under Koryusai, Choki and Utamaro, or with any of the three dozen or more by other artists that can be found in our major museums. It would require an extraordinary detective to isolate the Hana-ogi elements of these prints, for not even a Japanese would recognize that they all pertained to the same woman. At one time I kept on my wall seven

prints of this famous courtesan, and no one who saw them—Japanese, American museum officials, casual visitors—ever detected that they were all portraits of the same sitter; yet we know that each of the seven artists knew Hana-ogi personally. What this kind of Japanese portraiture aimed at was a synthesis of the feeling that Hana-ogi inspired in contemporary Edo society, and this synthesis had to be expressed in terms of masses disposed on a flat paper, with the use of brilliant line and appropriate color. Psychological content or facial likeness was of no account.

This means that Sharaku is praised in western circles because he is less Japanese than any other ukiyo-e master. Abandoning the traditional style of his nation, he acquired one that makes western acceptance easy, and it is ironic that today great numbers of westerners applaud Sharaku because he is so Japanese, whereas the truth is that he is largely un-Japanese and quite like us.

Certainly, two actor portraits, one by Shunsho and the other by Sharaku, bear small relationship one to the other. Shunsho offers a restrained portrait; Sharaku a realistic analysis. Shunsho presents an actor come before the curtain to pose; Sharaku catches him in a moment of living passion during the play itself. Shunsho works in the Chinese-Japanese tradition; Sharaku has invented his own tradition. Shunsho utilizes a disposition of space that goes back to Kiyonobu, Sharaku slaps his men on their little area of paper with disregard for old customs. Shunsho provides a highly refined color scheme perfected by Harunobu with the help of many other ukiyo-e artists; Sharaku's colors clash. Shunsho ignores psychological content because that was no concern of the artistic heritage within which he worked; Sharaku, ignoring Shunsho's heritage, was supreme in his ability to infuse spirit and profound human meaning into his prints. Shunsho was Japanese; Sharaku was of the whole world.

It is impossible even to guess intelligently how Sharaku devised his style, so evocative to the western mind. Possibly it related to the fact that he was a classic noh player and therefore naturally antagonistic to rowdy kabuki actors, whom he lampooned viciously. Observe the confusion of this theory: that because a man was a classicist in one art he would become an iconoclast in another. I am afraid this whole theory is purely western and I should like to suggest the following weaknesses in addition to the basic one just mentioned. First, if Sharaku had been deeply grained in classical culture he would have drawn better and he

would have signed his name with Chinese ideographs written with more distinction. Second, if a man of superior culture stooped to lampoon kabuki he would probably ridicule a few of the leading actors and let it go at that, but Sharaku is notable for his many portraits of really insignificant actors and for the fact that he covered almost all aspects of each play he illustrated. One gets an irrepressible feeling that he loved this robust theatre and that he went into it with joy and enthusiasm. Third, it is far from established that he actually did lampoon any actors, but the supposition that he did has become so deeply imbedded in western criticism that it seems futile to try to dislodge it now. However, doubt must be cast.

Before I went to Japan and actually saw kabuki I believed that Sharaku had savagely caricatured kabuki actors, for obviously I had never seen on a New York or London stage any actor remotely resembling a Sharaku print. I accepted the theory that kabuki actors would have been outraged by such portaits and that they had been instrumental in ousting both him and his prints. But after I had lived in Japan and seen some two hundred kabuki plays I found that I had met on stage positively every human face that Sharaku had drawn. I had seen every pantomime that he had captured in his prints. Specifically, I had seen men acting the roles of women who looked precisely like the prints that are most often cited as proof of Sharaku's contempt for kabuki. I had to conclude that far from lampooning kabuki actors, Sharaku was the first artist ever to report honestly what they looked like. It seems logical that his own training in the noh theatre, far from inclining him toward bitter cartoons, had had just the contrary effect. It allowed him to see the stage as it actually was. This suggestion gains credence from two facts. First, Sharaku portraits seem to be real and honest portraits in the western sense, and not caricatures at all. Returning to the thesis that throughout history most artists have been able to draw things pretty much the way they wanted them to look, it is logical to suppose that Sharaku's actors look the way they do because that's the way he wanted them to look. (Remember that Utamaro, whose several portraits of Hana-ogi are not portraits at all but highly stylized symbols, could nevertheless paint an insect on an ear of corn so lifelike that each seems to be alive.) Certainly Sharaku's varied portraits of four actors, to name the easiest to recognize on his prints, can be identified from print to print by even a novice: Yamashita Kinsaku's crazy, screwed-up face; Ichikawa Yaozo's peculiar young-old face; Sanogawa Ichimatsu's angu-

lar face with puffy lumps at mouth end; and Segawa Tomisaburo's pinched face (58). The various portraits of these actors are consistent from print to print and can be instantly spotted. So can many others, although not so easily because their faces are less distinctive. Second, in the fairly numerous cases where other artists copying Sharaku's general style designed portraits of actors he had already represented, identification of facial features is usually unmistakable. For example, Toyokuni's portrait of Iwai Hanshiro IV looks like the man in Sharaku's picture of the same actor. Many other examples come to mind and one is forced to conclude that Sharaku was much more a portraitist than a caricaturist. Moreover, there is no evidence that actors considered him their enemy. On the contrary in recent years one of the prints most often cited as an example of his savage treatment of kabuki actors was put on the market by a family which had treasured it for many generations: the family of the actor himself. In 1794 this actor had purchased the print because he liked it.

From such evidence one is led to believe that most of the romantic theories regarding Sharaku and the theatre were thought up by westerners who had seen little kabuki, for the only thing of which we can be certain about this mysterious and shadowy man's inner life is that he was of the theatre, that its great moments were deep in his blood and that he portrayed its actors with profound and terrible emotion. Whether he respected or despised them we had better not try to guess, but it is positively certain that he understood them. Of his 136 recorded prints—drawings and fans bring the total known items to 146—only five do not deal with the theatre and of these, four derive from the spiritually related world of wrestling.

Yet contemporary evidence is irrefutable that Sharaku's work was not well received: "He drew portraits of actors but exaggerated the truth and his pictures lacked form. Therefore he was not well received and after a year or so he ceased to work." This is substantiated by concrete evidence. Relatively few copies of his prints have come down to us; some of the later triptychs have sheets altogether lacking; and there were noticeably few second editions.

The most likely explanation of Sharaku's rejection is that those very characteristics which now endear him to westerners alienated him from his own contemporaries. His portraits lack repose, so today we hail him as a man able to catch the psychological torment of man; whereas his contemporaries had lived in a placid nation that had not known war or

religious upset or protracted civil turmoil for almost two hundred years. Neither his spacing nor his line nor his color are traditional, so we acclaim him because he was able to subjugate everything to psychological content; whereas his contemporaries had been reared in tradition and preferred it. He breaks with Shunsho's highly restrained actor portraits, so we greet him as a realist; whereas his contemporaries had shown for a century that they preferred stylized actor portraits. He rejects the convention of male actors being portrayed as ravishingly beautiful women, an illusion they were never able to create completely, so we hail him as an honest iconoclast; whereas everyone who attends kabuki seduces himself into believing that the men masquerading on stage are indeed beautiful and resents the truth. Sharaku, in short, was not a Japanese of his day, so we embrace him as an internationalist of ours. For these confused reasons he is probably overrated right now.

It is more accurate I think to consider Toshusai Sharaku as one of the supreme exemplifications of the mysteriousness of art. How did he arrive at his highly personal concept of beauty? We shall never know. How was he able to leap full-born onto the highest pinnacle? We haven't a clue. How did he acquire the energy to work at such dazzling speed for ten months? We don't know. Why did he stop? Where did he go? We may never know.†

A few facts remain. There is a persistent rumor that in 1795 he turned his back on ukiyo-e and painted classical pictures, but none have come down to us and no record substantiates this legend. It is said that he died in 1801 but a Japanese scholar insists that he saw a noh program of 1825 on which the dancer Saito Jurobei was listed, but no one else saw the evidence and none can tell where it is now. Some years ago a fanciful theory was evolved that the little-known ukiyo-e designer Kabukido Enkyo was in reality Sharaku, who had fled his aristocratic daimyo to live in Edo poverty and peddle his prints, but nothing in the artistic content of Kabukido's prints supports this wild guess. However, it is only fair to point out that some of Sharaku's later triptychs are far from masterpieces and are occasionally as dull as known Kabukidos. It is also important to record that Sharaku did not invent the big actor print

† Lately a new theory has been advanced. His master, the Daimyo of Awa, one day discovered that his noh dancer Saito Jurobei was dabbling in pictures of the common theatre, thus bringing disgrace to both the daimyo and himself. Therefore the daimyo simply commanded his man Jurobei to stop. He did. A corollary speculation says that Jurobei was sent home from Edo and lived out his uneventful life in southern Japan.

(Shunei may have) nor did he invent the mica ground (Masanobu probably did) nor was he first to use either the white mica ground (Utamaro probably) or the yellow ground (Kiyonaga no doubt).

All we can say for sure is that one day he appeared in Tsutaya's shop with a vast idea. Ten months later, having watched that idea perish, he left. But the scorching trail he blazed during those three hundred magic days can be seen yet, flaming more brilliantly now than ever before. It seems unlikely that it will ever subside.

18

Must an Artist Be Original?

UTAGAWA TOYOKUNI

*I*n the chapter on Okumura Masanobu emphasis was placed upon his extraordinary fecundity of invention and he was credited with having innovated many of the concepts which saved ukiyo-e during its first critical period. It was proved that such invention was good for the art and it was assumed that it was good for the artist. Now it is necessary to question that assumption. Does any law of nature or art require an artist to be original? What happens to him if he isn't?

Toyokuni, one of the most gifted and prolific ukiyo-e artists, displayed no originality whatever, yet he became a major artist. Born in 1769, he was apprenticed young to that master teacher, Utagawa Toyoharu, who had acquired from Masanobu and Dutch paintings the tricks of western perspective.

Toyoharu gave his pupil both his name and his style, and in a triptych designed in 1791 Toyokuni portrays a New Year's celebration in which the receding planes of the mansion are derived from his teacher and presented in western perspective. A boardwalk to the left, however, remains in Japanese perspective and, when contrasted with the passages borrowed from Toyoharu, hits the eye as an upright ladder rather than a level walk. Yet the triptych is generally pleasing, exhibiting good taste and fine color.

Shunsho was the next man Toyokuni copied and in minor prints of actors he demonstrated that he could work just as capably in Shunsho's precise Japanese style as he had in Toyoharu's western patterns. A few of his Shunsho copies are delightful.

Kiyonaga came next. During the years when his statuesque grandeur dominated Edo, Toyokuni copied him so exactly in a series of nobly conceived prints that many cataloguers have confessed that were these

183

prints not signed, they would be accorded to Kiyonaga, for attribution to Toyokuni would be unlikely.

Choki was his next preceptor, a poetic and lovely print maker whom Toyokuni imitated so precisely that without his bold signature such prints would surely be given to Choki. There is the same subtle coloring, the hard straight line down the back of the principal character and the same indefinable presence of taste. Kiyonaga is easy to copy; Choki is most difficult, yet Toyokuni mastered the style of each.

Shuncho exerted a powerful influence on this copyist, for although Shuncho probably did not originate the brilliant yellow landscape he did perfect it in a series of highly pleasing prints. His style delighted the people of Edo and hundreds of imitations appeared, some of the best being provided by Toyokuni. One triptych portraying a princess and her attendants on a balcony surveying a golden landscape equals Shuncho's best.

Eishi now launched a series of courtesans set against vibrant yellow backgrounds which caught the fancy of Edo and of Toyokuni, who produced some of his most charming designs in this style. Once more, these prints would pretty surely be attributed to Eishi, except for their bold Toyokuni signatures.

Utamaro, however, exerted the strongest influence on Toyokuni prior to the climactic year of 1794. In the latter's *Series Depicting Three Exquisite Girls* he successfully challenged Utamaro's great half-length figures. These Toyokuni prints exhibit fine drawing, a most delicate sense of color plus an overall good taste in both design and feeling. The prints are also noticeably warm and suffused with gentle humor. Toyokuni was markedly successful as a copyist of Utamaro and could probably have spent the remainder of his life lucratively employed in this way. However other influences were about to erupt upon his artistic life and these were to divert him sharply from Utamaro.

Shunei first attracted Toyokuni to the style which in 1794 would strike him with cyclonic force. In a series of simple-background prints featuring large heads, Toyokuni aped Shunei's inventions and once again achieved excellent results. His prints of this period lack the supreme effectiveness of those masterworks he was about to offer Edo, but they also lack the bombast which would mar most of the work of his later life. From this long sequence of apprenticeship—Toyoharu, Shunsho, Kiyonaga, Choki, Shuncho, Eishi, Utamaro, Shunei—the great copyist had mastered the skills of his job. He was twenty-five years old

and at the age when many artists are ready to launch into their own vision of the world, but he was not required to do so, for at hand he found the most compulsive teacher of them all.

Sharaku, as we know, struck Edo like a visual and psychological tornado, but nowhere was his effect so overpowering as on Toyokuni. The first flood of Sharaku's actor prints had scarcely reached the public before Toyokuni recognized that here was the grand style for which he had been searching. In 1794 and in succeeding years he produced a wealth of majestic prints, falling in three main series, the most famous of which was *Yakusha Butai no Sugata-e* (Pictures of Actors on the Stage). These are full-length portraits, most often of single actors (59), set against severely plain backgrounds which were printed with the aid of a very rough baren, so that showing through the solid colors are accidental designs caused when the heavy knotted cords of the baren rubbed the paper brusquely onto the inked block.

At the turn of the twentieth century, when connoisseurs began to appreciate this series it was believed that it contained about sixteen prints. By 1922 more than twenty were known. A little later twenty-six were thought to complete the set, but more were found and a recent book states that the series probably contained about thirty-nine prints. Now it appears there may have been as many as forty-four. Controversy has also centered on the question: Are any of these prints as good as Sharaku? The answer resembles the one relating to Shunsho's numerous prints of Danjuro V in the Shibaraku role (45). Whichever version a particular museum happens to own is proclaimed the masterpiece. So it is with *Yakusha Butai no Sugata-e*. Of the forty-odd prints, at least eleven have been hailed by one critic or another as the masterpiece, worthy of comparison with Sharaku. I find the best of this series, when met in perfect condition with baren marks clearly showing, truly enviable. Granted, they are less explosive than Sharaku, psychologically less profound; and since those were the attributes of Sharaku's greatness these Toyokuni prints must by definition be lesser. But in other respects—color, design, taste—they equal Sharaku and in perfection of line they occasionally excel that master.

The second series of actor prints in the Sharaku manner I find less pleasing. These are the big heads set against plain backgrounds, but even some of these, were they not clearly signed, might be mistaken for Sharaku. It is the third series that is most satisfying, prints of the most austere simplicity in which single actors stand very tall against

solid backgrounds again made with heavy baren. The New York Public Library owns two of these prints in excellent condition. One shows an unnamed actor as Sugawara no Michizane wearing a green, rose and faded pink costume against a pearl-gray ground. It is a serene print depicting an illustrious figure of Japanese history, and whereas Toyokuni was quite unable to match the best of Sharaku, the latter would have been unable to produce this majestic print. The second shows Sawamura Sojuro as a warrior in the act of drawing his sword. The upper half of the background is jet-black, the lower half gray. I prefer either of these two prints to the best of *Yakusha Butai no Sugata-e*, but since no living critic has ever seen all the prints of that distinguished series, my preference signifies little.

These prints marked the high achievement of Toyokuni, and at this auspicious moment let us review the progress of this inspired copyist. He had issued a multitude of prints based upon whatever style was popular at the moment. In many cases he could have palmed his prints off as the work of others, so uncanny was his assimilation of varied styles, but he was an honest workman and always signed his prints in bold, prideful characters. In discussing the function of originality in art, the high excellence of these early prints must not be overlooked. Furthermore, it has been established that sometimes competing artists like Utamaro or Eishi copied him. Also, starting in 1786 he produced at least 350 separate books, among them some of the most successful ever published by ukiyo-e artists. Most volumes contained not less than a dozen illustrations in which all the work seems to have been his. He was the darling of at least six different major publishers and most remarkable of all, he was the leader of the most prolific art school in the history of ukiyo-e, the Utagawa. He was destined to leave an indelible mark upon the entire subsequent history of his art.

With no original ideas of his own, with a character totally devoid of inventiveness and without even a personal style he nevertheless attained the top rung of the ladder, something that frequently happens in other arts and indeed in all fields of human endeavor.

Then, through one of the sad, ironic twists of history, this pleasant, empty man found that since he was the acknowledged leader of the ukiyo-e school, he was required to lead. Kiyonaga, Utamaro and Sharaku died. Whom could Toyokuni copy now? He was thrown back upon his own meager resources and what transpired was a debacle.

His once-sure line began to falter so that in later years his drawing

became quite objectionable. His sense of design collapsed completely and he turned out literally thousands of the most awful conglomerations of twisted figures, ugly balances and garish curleycues. His feeling for the human body, which had made some of his actor prints exquisite, vanished and from his emptiness he contributed his single original idea: the haggard, angular, meaningless face which is the hallmark of the rottenest days of ukiyo-e. But in none of these deteriorations was his influence so malign as in his pathetic confusion regarding color. He helped develop a palette so ill suited to ukiyo-e that it is quite impossible to believe that the man who had once matched Shunsho the colorist brush for brush had so completely collapsed.

The Utagawa school, as run by Toyokuni, was a source of positive infection in which every skill calculated to destroy an art was taught. Had the poison he purveyed been typhoid fever or measles he would of course have been arrested, but no one really cares when it is only an art that is being destroyed. Indeed, at the time no one recognizes what is happening.

The gap between the best of Toyokuni up to 1799 and the junk that appeared later is unmatched in art. The debacle was caused by four factors. First, the original artists whose work had held ukiyo-e together had disappeared, leaving the great copyist foundering. Second, the two powerful landscape men who would breathe new life into the art, Hokusai and Hiroshige, had not yet asserted themselves, the former because he was one of the most slowly developing artists in ukiyo-e and the latter because he was only two when the collapse started. Third, with the passing of the publishers Tsutaya Jusaburo and Eijudo, the latter a friend of Toyokuni's, positive influences for good were removed and ukiyo-e fell into the hands of commercial charlatans. Accounts have come down to us of how publishers worked in those evil days. Speed and cheapness became the gods of ukiyo-e. Toyokuni, and especially his immediate successors, would attend the theatres during rehearsal if possible. We know that Toyokuni himself used to sit hunched up in the dressing rooms, sketching like mad. He would then hurry home and put down his violent designs—the days of *Yakusha Butai no Sugata-e* were long dead—while a last-minute spy from the theatre would assure him as to what exact costumes and colors the actors had finally decided to wear at the opening performances. This information Toyokuni would pass on to his subordinates, who would costume the figures he had drawn. Meanwhile the publisher had a group of block cutters standing

by, each with a segment of prepared cherry wood smaller in area than the total print. As soon as Toyokuni's design arrived, it would be cut apart and parceled out to the engravers who speeded their work, each knowing that when his portion was completed it would be strapped to the next, whereupon a skilled cutter would join and harmonize the lines of the various segments. The printers worked equally fast and during his later years Toyokuni probably did not even bother to check what colors were used on his prints. He indicated what he wanted, yes, but what he got was the printer's decision. He had to accept it. The old days when Utamaro supervised each step were gone. As soon as the printers rushed their work through, runners grabbed the prints and dashed about the city distibuting them, and it is said that if any publisher's actor portraits hit the streets more than five days after a play opened, he was out of luck. What made this frenzied process worse was that Toyokuni and his fellow artists drew stacks of designs which publishers, in order of seniority and reputation, were free to inspect, reserving those that pleased them and passing the rejected ones down to cheaper publishers until the designs were used up, so that frequently Toyokuni was probably not even aware of what was happening to his work. In considering the collapse of ukiyo-e, the venal commercial practices of the time must not be overlooked, and they injured no one more than Toyokuni, who might have been bolstered up by a man of taste like Tsutaya Jusaburo. But of course it is not necessary to search outside Toyokuni for an explanation of his sad collapse; only the fourth reason need be cited: he had no originality. He had no clear picture either of himself or of his capacities. Lacking both originality and driving personal conviction, an artist must ultimately run down. For a time it had seemed that Toyokuni would escape this confrontation with himself, but when chance and the death of greater men left him sovereign of an entire art, the awful emptiness of his artistic life was apparent. The bone and sinew which enable a man to stand were lacking, for they had never been encouraged to grow.

It is in Toyokuni's black-and-white books that one sees most coldly the disintegration of this great talent. Of the 350-odd there are some few that sing with the poetry that Sukenobu once knew, but most are hasty, cluttered, meandering and formless. One is not annoyed by their obviously unfinished state, for that very sense of being caught in mid flight is what makes Utamaro's black-and-white work so vital—and as we shall see, Hokusai's too—but one is disgusted by the lack of evi-

dence of any controlling mind. It is claimed that Toyokuni's books were so facile and popular that his blocks were worked to death so that today we rarely see a fine impression and cannot really judge their contemporary merit, but I have studied some six hundred examples of his various books and have run upon some good impressions, and it is these which most clearly betray his lack of control.

Five somewhat disconnected facts remain. First, throughout his lifetime Toyokuni never ceased looking for someone to copy and in his later years, when the giants were gone, he was reduced to stealing from his own pupil Kunisada. Some of his unhappiest prints were the outgrowth of this incestuous regression.

Second, many of the worst Toyokuni prints were not by him at all, but by students who filched his name, so popular had it become. These are easily detected, especially if the signature is in a red cartouche, which Toyokuni himself seems never to have used. Such prints must not be considered forgeries; they were tributes to a successful though moribund artist and a persuasive though lethal teacher.

Third, a whole corpus of sentimental criticism has grown up around the fact that Toyokuni's younger brother Toyohiro escaped the debacle which engulfed Toyokuni and spent his life honorably turning out minor masterpieces, thus demonstrating that even among brothers there will be one who clings to the right while the other surrenders to the wrong. This theory is fine except for two flaws: Toyohiro's prints (20) are not better than Toyokuni's early work; nor was Toyohiro Toyokuni's brother. Somebody read a tombstone wrong.

Fourth, although all critics denigrate Toyokuni and deride his work, each nominates two or three prints which escape censure and which are, in the opinion of the critic, masterworks. Amusingly, each man's list differs from his neighbors', so that if all Toyokuni prints that have been so designated were assembled one would have about sixty really fine items. Many artists of original genius died with far less to their names.

Finally, Toyokuni had a positive flair for designing triptychs and there are at least five that must be judged altogether excellent. Most popular is the free and fresh and singing picture of young girls on a windy day tying poems to the branches of a cherry tree. The rhythms, colors and intertwining figures please almost everyone. A second noble design shows the poet Narihira and his entourage passing the foot of Mount Fuji, where a distinguished landscape is indicated in simplest

terms. In two other successful designs—"Women Playing in the First Snowfall," which can be studied in the Ledoux catalogue, and "Washerwomen as the Six Rivers Named Tama"—he demonstrated his capacity to handle outdoor scenes and the judicious spacing of human figures. On the other hand, the often praised interior showing a woman dreaming of the foxes' wedding is awkward and garish. One of the finest triptychs done in the ukiyo-e school is the amazing scene inside a women's bath. Each print shows two figures, all but the one in the tub fully clothed, with an insouciant samurai lounging on his elbows at the window, enjoying the view. The merit of this fine composition lies in its contrapuntal design, its impeccable drawing, its handsome use of various materials in the women's kimonos, and the powerful effect attained by a sullen yet wonderful dull, brick-red for the woodwork. The triptych is also notable since it seems to have been one of the very first to incorporate shadows—as if Toyokuni had been tempted to copy some western painting he had come upon—but they appear only along a small part of the picture and not at all where the lighting of a bathhouse would require.

This triptych is so good that I catch myself exclaiming with cataloguers of the past, "Except for the signature I'd swear it couldn't be a Toyokuni."

19

The Life of the Artist

In 1817 an impoverished artist already in his mid-forties and lacking fame concluded that some dramatic gesture must be used to attract attention. Accordingly he lined off an area before a temple in Nagoya and prevailed upon a group of loafers to help him paint the largest picture so far seen in Japan.

With rocks he weighted down a pasted-up sheet of heavy paper containing 2,250 square feet, an area larger than ten average-sized Japanese rooms. One end he lashed to a huge oak beam to which ropes had been fastened so that when completed the monster picture could be hauled aloft. Then, with big vats of ink and tubs of color, with brooms and swabs of cloth tied to sticks he went to work.

Tucking his kimono up about his waist and kicking off his sandals, he ran back and forth across the huge paper, outlining a portrait of Japan's best-loved saint, Daruma, who once sat so long in one position contemplating the nature of world and man that his arms withered away. Of Hokusai's portrait it is recorded that a horse could have walked into the mouth of the gigantic saint.

Soon the temple court was filled with people of Nagoya marveling at their mad painter as he sped about with his brooms, slapping color down in tremendous and apparently unplanned strokes. By dusk the portrait had taken form and when men at the ropes hauled the oaken beam into position, the vast expanse of paper rose into the air and disclosed Hokusai's miracle, a portrait of Daruma nearly sixty feet high.

The artist had accomplished his purpose. He was talked about. He became known as Hokusai, who painted pictures so big that a horse could pass into the mouth of the subject. Not content, Hokusai soon

painted with an ordinary brush the picture of two sparrows so small they could be seen only with a magnifying glass. These exploits were reported at court and Hokusai was summoned to exhibit his unusual powers, which he did by ripping down a paper door, smearing it with indigo ink and catching a rooster, whose five-pointed feet he dipped in red ink. Shooing the bird onto the flat door, where his tracks produced an impression of red maple leaves, Hokusai cried, "Leaves in autumn on the blue Tatsuta River."

No kind of personal exploitation was beneath his dignity. He gave public demonstrations during which he drew from bottom to top, from right to left and painted with a finger, an egg, a bottle or a wine stoup, yet he was one of the most careful and dedicated artists. In his great sketch books, published in voluminous editions for students, his work seems thrown down in confusion and contempt, yet we have discovered as many as four meticulous experimental studies which he worked out in detail before daring to put down in final form what appears to be a casual sketch. He had profound belief in his work and charged a high price for it, yet he lived his entire life in abject poverty because he held money in contempt: he paid his bills by tossing uncounted packets of yen at tradesmen. He became one of the most famous and popular artists in Japan, yet he lived for years in obscurity, hiding from bill collectors.

He was a prodigious man. He lived in ninety-three different houses, abandoning them in turn when they became either too dirty to clean or too burdened by back rent. He used more than fifty aliases, abandoning them too whenever he discovered some new artistic principle meriting a new name. He fought with his gentle teacher Shunsho and threw back the name Shunsho had accorded him, but he collaborated happily with at least nine different artists in publishing books.

His interests were as vast as the world. He wrote excellent poetry, was a good novelist, published many humorous works and revived the lessons of the Chinese *Mustard Seed Garden*, allowing it to influence his prints as it had influenced Harunobu years before. He had wide knowledge of both Chinese and Japanese literature, a profound interest in anatomy, an obvious love of all living things, a preoccupation with rocks and mountains, and an inquiring mind regarding scientific principles of art.

Certain of his imaginary sketches could be slipped into Leonardo da Vinci's scientific notebooks without detection, for his mind ranged

over enormous fields of speculation. His finest studies in Chinese ink are like Rembrandt's, whom he resembles in many ways. His greatest drawing shows a group of blind men leading one another through a stream and is such an impressive human document that one is reminded instantly of Breughel's masterpiece on the same subject in Naples. Some of his exquisite surimono (printed thing), sumptuous pictures to be used as New Year's greetings, show gardens that recall Watteau's romantic world; others are similar to the masterpieces of China. But for the most part these similarities to European and Chinese predecessors, whom he could not have seen, are today forgotten and it is his late, authentic Hokusai style that the world prizes: that rugged, powerful, handsomely organized world with the touch of awkwardness that is a touchstone of his art.

In his youth he was another precocious, poverty-stricken Edo boy. At thirteen he was a wood carver and he is the only ukiyo-e artist who is known to have cut blocks, although he cut none of his own. He was by turn an errand boy, a bookseller, a cheap novelist, a hawker of calendars, a merchant of red peppers and an itinerant painter of banners.

He married twice and had several children who were a tribulation plus a grandson whose financial operations finally threw Hokusai into bankruptcy and flight. For several years he hid out in the village where Kiyonaga is rumored to have been born. When he returned to Edo he sequestered himself under an assumed name in the corner of a temple, where he continued to design prints.

Even in age tranquillity eluded him. At sixty-eight he suffered a stroke which should have killed him, but he remembered having read about an ancient Chinese cure based on lemons and doctored himself back to health, writing and illustrating a medical report on his self-cure. At seventy he was a pauper and ready to launch upon some of his greatest work. At seventy-eight his eightieth-odd dwelling burned and not only left him literally naked in the street but also destroyed all remaining notes and sketches, to which he remarked, "I came into the world without much," whereupon he directed himself to new projects, posting in his home the admonition: "No compliments. No presents."

An account of how he survived the rice famine of 1836 says that he sat in his room with sheets of paper before him and invited people with even a cupful of extra rice to come and make random lines and splashes on the paper, whereupon he would swiftly link them together

and produce a spirited picture, signing it proudly with one of his many names.

Only a few of the amazing strategems by which he managed to survive have been recorded, but there seems no indignity to which he would not stoop if only it permitted him time and material for drawing. Once he cried, "I find that in all representations of Japanese and Chinese warriors there is a lack of power and of movement, which are the essence of such subjects. Disappointed by this imperfection, I have been on fire to remedy it and so to supply what was lacking." This vital drive kept him alive till ninety and permitted him to design somewhere near forty thousand separate drawings.

Betrayed by his own children, forced deeper into poverty by his determination to erase his grandson's ignominy, Hokusai had only one solace, his gifted daughter Oei, whom he called Chin-chin because of her odd face. She was one of the few Japanese women who became skilled in ukiyo-e and left creditable prints of her own. Blessed with an hilarious disposition which enabled her to forget the personal tragedy of her own married life, she watched over her father and reports that one day when he was past eighty she found him at his drawing bench weeping because "even at that age, and in spite of all his study and effort, he had not yet truly learned to draw things as they were."

Of this acute problem that faces every artist—that life slips by and one learns nothing, that the mind perceives things as they are but imperfect skills prevent one from reporting the truth except in occasional lucky flashes which make one's ordinary work even more distasteful—of this Hokusai wrote, "From the age of six I had a mania for drawing forms of things. By the time I was fifty I had published an infinity of designs, but all I have produced before the age of seventy is not worth taking into account. At seventy-five I have learned a little about the structure of nature—of animals, plants and trees, birds, fishes and insects. In consequence, when I am eighty I shall have made a little more progress. At ninety I shall penetrate the mystery of things. At a hundred I shall certainly have reached a marvelous stage, and when I am a hundred and ten, everything I do—be it but a line or a dot—will be alive. I beg those who live as long as I to see if I do not keep my word. Written at the age of seventy-five by me, once Hokusai, today The Old Man Mad about Drawing."

It was this gigantic human being, as large as his own portrait of Daruma, who was working better at ninety than he had been at

twenty-nine, who shouted in despair on his death bed, "If heaven would only grant me ten more years, or only five, I might still become a great artist." When he was gone people perpetuated the myth that his mother had been the daughter of the nobleman who was killed by the Forty-Seven Ronin (63 A) but this was ridiculous, although possibly he was descended from one of the petty retainers of that unfortunate man. We do have his own estimate of himself, for he kept a sign before whatever house he happened to be living in: "Hokusai, the Peasant."

His accomplishment as an artist has been exaggerated in both Japan and Europe and for some years it was believed that he was both the culmination and greatest master of the ukiyo-e school. Today one acknowledges the grandeur of the man's life but also sees the unevenness of his work and is apt to agree with Hokusai's own estimate of himself: that if he had had ten more years he might have achieved his promise. For his rate of growth from age sixty, when he started to mature, to age ninety, when he died, is without any close parallel in any field of human endeavor. The nearest approach in the arts would be Giuseppe Verdi.

It is instructive to speculate on what Hokusai's reputation would now be if he had died at sixty, by which age Harunobu, Utamaro and Kiyomasu were dead and Kiyonaga and Sharaku had abandoned the field. A notice of his work would read: "A book illustrator of prodigious fecundity and sloppy execution, he was known in turn as Shunro, Sori and Hokusai. His early illustrations for the *Chiushingura* display no original talent and are probably the least inspired that have tried to depict that tragedy. He is noted primarily for his beautifully executed surimono, which he appears to have made finer each year for a small, discriminating group of aesthetes who demanded the best in greeting cards, so that one is tempted to conclude his was a jeweler's skill, an aptitude for pretty, trivial work, and that substantial design or bold adventure were beyond him. This hasty conclusion however is offset by his extraordinary volumes called *Mangwa,*† which should properly be translated *Drawing Things Just As They Come*, but which has come to mean something like *Sketches from Life*. In these strange books thousands of human beings in all postures and conditions

† Logically, Mangwa should be spelled without the w, but the word has become so ingrained in western literature and catalogues spelled in the old-fashioned way that to change it now seems precious.

of life swarm the pages, crabs crawl from the sea, ghosts appear and flowers. Men dive under the sea in bells which hold air captive for them to breathe, while horses swim to show how their legs operate. Architecture, history, wild life, wrestlers (22), warriors and mythological fantasies are treated haphazardly. The *Mangwa* shows that Hokusai had a passionate interest in life but positively no organizing ability and if one studies all his extant prints one finds no central tendency and only mediocre floundering. In fact, just before he died he seemed to be heading off in one more arbitrary direction, for a few prints offer landscapes, but they do not compare with the noble prints of Kiyonaga. It is doubtful if Hokusai, had he lived, could have accomplished much as a landscapist, for here too he lacked the power of control which is so essential if an artist is to present either the vastness of nature or its complex interrelated manifestations."

Such would have been his record had he died at sixty, but fortunately he did not and the record of his life as he approached seventy and went on to fulfillment in his eighties is a warming document of the human spirit. I should like to speak briefly about his major accomplishments in this period.

Hokusai Gafu is one of his many collections of sketches but it is notable for containing five double sheets which had they been turned into prints would have commanded great respect but which even as sketches prove that the prolific man was about to attain full control of design. On a windy day a child and four adults with big straw hats bend into the gale and not only is the wind wonderfully suggested but the drawing of each body is clean and powerful. By a hedge along a village street a group of children torment the ancient poetess Ono no Komachi, now a madwoman, while adults stand by. This haunting picture reminds one of the earlier version by Sukenobu (13) but again the drawing of the villagers is new and strong, their rugged bodies being suggested by few strokes of marked force. The *Gafu* contains several excellent snow scenes, none finer than the witty one in which a train of people carrying large straw umbrellas parade behind a pompous official. Hokusai also experiments with rain and in a memorable drawing shows five bedraggled men and one horse under a huge cryptomeria through whose branches the rain pours in thin silvery lines such as Sukenobu had used earlier (12). Finally, it is in the *Gafu* that Hokusai's finest drawing appears, the scene of the blind men already referred to.

The Thirty-Six Views of Fuji is his most famous series and it would

be redundant to describe these prints beyond making a few arbitrary observations. The set contains forty-six prints in all but of the latter ten, added after the original series proved a huge success, nine are disappointing. Of the total, about twenty-five lack distinction, either their design or their color being poor. Another ten cannot be considered top work unless critical judgment is discarded, but the remaining ten contain masterpieces of the print world. The two massive views of Fuji, one in storm and the other in clear weather, are popular favorites and worthily so, for they demonstrate what tremendous control Hokusai finally attained. The wave of Kanagawa is an almost perfect piece of art, one of those happy inspirations that arrive once or twice in an artist's long life. It has been enjoyed by people of all lands and all conditions of education, but it is also valuable as being typical of the series in that it is mainly blue, a Prussian color that Hokusai began to use in old age and which characterizes his greatest prints in this series. Generally, whenever two versions of a Fuji print have come down to us, one mostly blue and the other doctored up with additional colors to make it more saleable, the former is almost always the better and probably closer to what Hokusai intended. My favorite in the series is the fisherman upon the rock at Kajikazawa, for here the wonder of Fuji is best captured, its gentle slope matching the four frail fishing lines as they dip into the sea. I find little artistic merit in the popular great pine at Mishima and imagine that much of the praise heaped upon it derives from the fact the men trying to measure the pine seem trivial in comparison with either the living pine or the dead grandeur of Fuji. I grant this is a pretty conceit and pay my respects to its philosophical overtones but still feel the print is unsatisfactory. Suwa Lake and Hodogaya with trees and travelers framing the mountain are other fine subjects. Considering all forty-six views of Fuji, they constitute an amazing record of a monomania. Like a ghost haunting the world, this omnipresent mountain peak, the most beautiful known, teases the mind of Hokusai in nearly four dozen varied forms. At times it is ignored while men sweat in its shadow earning a meager livelihood. Pleasure-seekers pause to observe it casually. It appears in snow and rain and sullen haze and storm. From the sea and from the city and from the village of Iwaza at dawn this commanding presence looks down on human activity. As a concept around which to organize a series of prints the idea of mighty Fuji standing sentinel over the islands of Japan is one that has never even been closely approximated.

The numerous series depicting Lake Biwa (61), the many sets showing the Tokaido road and the scenes of Edo evidence both affection and critical selectivity, but they are trivial compared with this magnificent concept of Fuji and its human charges. It is perplexing to guess why it took so long for Japanese artists to bring this mighty mountain into their works, for the tradition of painting mountain scenery goes back to the first beginnings of Chinese-Japanese art and in the thousand years preceding Hokusai, Japan's artists must have produced toward a hundred thousand paintings showing imaginary Chinese mountains. Many of the acknowledged masterpieces of Japanese art show such mountains, but none show Fuji, incomparably lovelier than the Chinese hills. Confusion is doubled when one reflects that almost no Japanese artists had ever seen the mountains of China. Two possible explanations come to mind. The earliest Japanese masters lived in Kyoto and may never have seen Fuji, so that by the time that great mountain was known, a style had already been so firmly established that Fuji had no chance of accommodating its strong features to the style. This is more logical in eastern art than it may sound to westerners. More likely however is the fact that Fuji's magnificent cone was too perfect, too finished and too well known to be brought into the center of a Chinese-style painting, which is elusive and suggestive. Furthermore, even though Japanese painters did forego Fuji, they nevertheless created some of the world's most provocative imaginary mountains: crags, suggestions of a precipice in the mist, far summits falling away in fog, wild fevered mountains of the mind. Once throw Fuji's imperial slopes into such a picture and Fuji, not the mind, runs away with art. It took a powerful peasant intellect like Hokusai's to slap mighty Fuji upon his paper and subordinate everything else to the grandeur of those poetic slopes. In this sense two of the most instructive ukiyo-e series are these prints of Fuji and Eishi's triptychs dealing with Genji, for they represent popular art invading the secret places of an older tradition, which is the essence of ukiyo-e. It must be noted, however, that peasant though Hokusai was, he was even more an artist. His Fuji doesn't really look a great deal like actual Fuji. He makes the cone more nearly perfect than it is; the slopes adjust to his demands; the visibility is too pronounced; the supporting landscapes are too neat. It is not Fuji we see; it is the spirit of Fuji as it affected Hokusai. Obviously, were this not so we would consider Hokusai a photographer and not an artist; being definitely the latter, he naturally hauled Fuji

and everything else in heaven or earth that he needed for his composition to those places and conditions best suited to his purpose. Today, unfortunately, Fuji is rarely as visible as Hokusai makes it, principally because of industrial smog. Day after dreary day it is shrouded and I was in Japan six different years before I caught my first good view of Fuji.

The *Large Flowers* is a set of at least eleven sheets in which handsome and sometimes delicate flowers are handled as if they were mountains. In big, bold patterns quite unprecedented, these blooms fill large sheets and gratify the eye. The lilies, pink with purplish-blue leaves, are most striking.

Eight Views of the Ryukyus are remarkable for their intense Chinese feeling, probably an invention of Hokusai's to indicate that these islands, which contain Okinawa, had a largely Chinese culture. It is doubtful if he himself had visited the islands, it being more reasonable to suppose that he borrowed notes or sketches from other travelers. Anyway, the prints are splendid airy things quite unlike his other work yet harmonious with the accomplishment of this period since they also demonstrate his complete command of design and organization of data.

The *Waterfalls of the Provinces* (60) and *Views of Famous Bridges* chronicled in strong, vivid prints the wonders of the islands. I am particularly partial to these prints for in them one finds a most satisfying merger of art and nature. They provide an intimate report on the way Hokusai worked. First, he saw something which pleased him. Next he applied his powerful mind to the problem of design and we can feel the bridges and waterfalls being wrenched about into proper position. Finally, some inner sense of art erased both the initial sensory impression and his too-obvious disposing of nature and substituted what we term an artistic impression. We can be certain that no bridge and no waterfall in Hokusai's finished prints looks anything at all like the original. Instead, an old man's artistic sensibilities, worn into deep grooves by a lifetime of contemplation and practice, take command. I find especially pleasing the "Suspension Bridge between Hida and Echizen," for it is not only a fine blending of nature and art; it is also a subtle combination of Japanese and Chinese convention. It is a most satisfying print.

The *Hundred Poems Explained by the Nurse* has often been called the most typical Hokusai series in that it lampoons classical preten-

sions and hauls the revered anthology of ancient times right down into the kitchen where a busy and illiterate nurse explains to children what she thinks the poems signify. It is a happy, lusty, silly series in which grandiose court allusions are exemplified by day laborers; and Hokusai must have enjoyed working on it, even though he finished only twenty-seven of the hundred projected plates, drawings for many others being in existence. One need not regret the missing prints for those we have show little artistic merit.†

Hokusai's finest book was published when he was seventy-four. The *Hundred Views of Fuji* recapitulates some of the views used in the print series, but the best pages are those created fresh for this work. At least a dozen ought to be described, for they are free, singing creations in which Hokusai's beloved mountain once more appears at unexpected places, looking down upon varied human endeavor. One print, far from the best artistically, has sometimes been held to be Hokusai himself: an old man happens to look out of a round window and unexpectedly catches a sight of birds flying across the perfect cone. In an ecstasy of joy he throws back his head, clasps his wrist and shouts his delight at seeing the mountain again.

I have saved till last the series which most critics and collectors deem his masterwork. Certainly it contains a higher percentage of successful prints than any other, eight of the ten being superb. *Imagery of the Poets* consists of sheets in the unusual size of 21 x 9 and each shows a perfected blend of Chinese-Japanese drawing plus excellent Hokusai colors and a surcharge of emotional implication. The designs of this series are majestic and were intended to pictorialize the ten most poetic concepts which Hokusai, himself no mean poet, could recall. Four are especially treasured: Li Po transfixed by a tremendous waterfall; Nakamaro in China gazing homesick toward Japan; Toba halting his horse in the snow to ponder a gnarled tree whose branches are laden; and a particularly poetic landscape in which Jakuren's poem about cutting rushes is used as an excuse for exhibiting the figure of a workman at the edge of a marsh. These fortunate prints are in the great landscape tradition: they compare with the finest Chinese masters or

† Phillip Stern of the Freer, who has specialized in the unpublished Hokusai drawings for this uncompleted series, objects vigorously to my low opinion of the few finished prints. He points out that never did Hokusai draw with greater artistic effect. It would therefore seem that here we have a documented instance in which cutters and printers did not keep up with their artist, a fact Hokusai several times complained of.

Sesshu; yet they remind one of Claude; the human figures find a place in majesty of nature the way Rembrandt's men and women spring naturally from Dutch soil. But more than this felicity of observation, these prints offer an old man's testament of art: that things should be arranged, that they should be a little larger than life, that mountains should be made to conform, that one can take the best of China, the finest of Japan, the new perspective from Europe and blend them together; that there is in the heart of man poetry which expresses itself in simple yet overwhelming imagery.

Here is the place to point out briefly that all the criticism, reams of it, explaining how Hokusai discovered landscape is uninformed. Landscape in eastern classical art goes back to the time of Christ and always constituted the dominant subject matter both in China and Japan. When the Lorenzetti were taking some of the first crude steps in Siena, Asia already possessed magnificent concepts for depicting flowers, birds, rivers and mountains, concepts that had been formulated more than a thousand years before.

Nor did Hokusai introduce landscape into ukiyo-e. It came in with Moronobu, whose landscapes in black and white are superb. Kiyomasu, Masanobu and Kiyonaga all did excellent landscape prints and Toyoharu specialized in them. In ukiyo-e books it is difficult to find an artist who failed to use this form, Harunobu and Utamaro having done some of the finest work.

What Hokusai did was to perfect conventions already thousands of years old and to specialize in new woodblock techniques—colors, dominance of scenery over human figures, perspective—which produced prints whose total effect was revolutionary. That he accomplished this at an age when most men are either dead or retired from activity is a marvel. That he was able to conserve his capacities and ideals during nearly seventy years of poverty and personal tragedy so that they were ready for the experiment is beyond explanation.

His last letter sums up his life: "The King of Hell being very old is retiring from business, so he has built a pretty country home and asks me to go and paint a kakemono for him. I am thus obliged to leave, and when I do go shall carry my drawings with me. I am going to take a room at the corner of Hell Street and shall be happy to see you whenever you pass that way.

HOKUSAI."

20

The Other Books

\mathcal{A}nyone familiar with western art who studies the prints reproduced in this book must conclude that one of the striking characteristics of ukiyo-e is its freedom from erotic content.

Here one does not find the voluptuous nudes of Rubens, the naked beauty of Titian or the erotic charm of Velasquez. Ukiyo-e avoids nakedness and foregoes slick suggestiveness. True, in certain prints there are hidden erotic symbols appreciated only by the initiated—such as bundles of a certain kind of paper commonly used in the Yoshiwara—but these do not intrude and are not, indeed, very common.

Certainly, compared with western art, ukiyo-e is singularly free from erotic content, and although nearly half of all prints before Hokusai deal with pretty girls,† they are the rugged, handsome women of Kaigetsudo (14) or the frail loveliness of Sukenobu (4) or the pristine virginity of Harunobu (6). In general, ukiyo-e women are aloof, solemn and as properly behaved as convent children.

But if one were to conclude from this that ukiyo-e ignored the erotic element of life, one would be guilty of maximum error. No art of which we have record produced more sex pictures than ukiyo-e.

From Moronobu to Kuniyoshi, every artist dealt with in this essay except two produced the most startling prints and books. Every publisher represented here made most of his money selling such works. Each innovation that sped the progress of ukiyo-e also advanced the sex book, until some of these stark works became masterpieces of printing and engraving. At first, hand-applied color made the books more attractive, but with the invention of kento marks for registry, full

† Although the proportions varied from period to period, experts guess that the following figures apply for the over-all period 1660–1860: Girls, 40 percent; kabuki, 35 percent; landscape, 15 percent; miscellaneous, 10 percent.

color made them irresistible. It has been estimated that about half of all prints sold were erotic in nature. Naturally, they are not shown in public exhibitions today.

In fact, erotic is hardly a satisfactory word to describe these amazing works. They are the most bold, frank and explicit sex pictures ever produced by major artists, so that no matter what one's experience has been with the erotic work of any other civilization, the ukiyo-e picture book astonishes most viewers at first acquaintance.

The books fall into three general categories. First is the pseudo-respectable pillow book, which purports to introduce young brides to the various problems of love. These are called by fanciful titles, such as *The Twelve Months of the Year*, with a most explicit lesson for each month. There has always been in Japan a tradition that each family should have such a book to be passed on from one bride to the next, and treasured examples exist that date from around the year 1000; but with the advent of quick, cheap block printing the pillow book became merely a robust and riotous sex publication for sale under the counter to young men and unmarried girls. It still served its original function, no doubt, but it also became an easy and exciting way to make a lot of money.

The second type has no pseudo-scientific justification at all. It is frankly a book of sex experience, poorly drawn, poorly colored and cheaply sold. It is not much different from similar works published in all nations in all times, except that in the case of ukiyo-e the very greatest names appear on these salacious publications. Without these names, it is doubtful if the type of book would ever have attracted much attention, but when even such a book is clearly by Utamaro or Kiyonaga or Sukenobu it does deserve study, if only to help one arrive at some conception of these gifted artists and the ways by which they made money.

The third type of book has much wit to commend it. Here a narrative is contrived, usually with broad, hilarious overtones, and each picture furthers the plot. Three will be immediately recognized as part of the universal mythology concerning sex. A strong, handsome young man is shipwrecked on an island containing only women. His adventures are many, but in the last print he is invariably dead of exhaustion, covered over with a clean white sheet. Another young man, eager to understand the world, is made invisible so that he can inspect what is actually going on among the noble families of Edo. His discoveries

are startling so in a popular sequel he is allowed to move far back into history to see if the great heroes of Japan behaved much differently and he finds they didn't. The last kind of book in this category is difficult for a westerner to understand, for in it some popular actor of the day, his name and crest clearly given and his facial likeness cleverly reproduced, exhibits a prowess that would have made him the most talked of gentleman in any society. There is evidence that the actors approved of such publications since the advertising helped in many ways. A notorious example showed what happened to a dignified and famous court lady, also a real person, who day-dreamed so much about Danjuro VI that he mysteriously appeared one night in her boudoir, to her complete satisfaction. Even more shocking is the fact that occasionally the artists depicted themselves in such situations, apparently with no embarrassment, for tradition says that the finest extant self-portraits of Utamaro are those which show him as the protagonist of such a novella.

From almost the first days of Japanese art history there were erotic scrolls, handpainted and costly, for the delight and edification of nobles. Every court seems to have enjoyed such works and some of them, upward of forty feet in length, were excellent both as art and as physiological guides. They seem to have been real pillow books for the instruction of young married women and as such were treasured through as many as thirty generations of a single family.

Painters of all schools produced these scrolls, but the best are in the Tosa tradition and include as well as the most violent amorous exploits bits of landscape, architecture and costuming of the time. They give every evidence of maximum art in execution and jealous care in preservation. It is interesting that these great sexual panoramas were constantly produced right down to 1900 by the finest artists in pretty much the same form, concept and color as used in the year 1000. I shall speak of their artistic merit later.

The first Asian erotic works published as books and with color to heighten the erotic effect probably appeared in China some time after 1556, or as one has grown to expect, about 150 years before their advent in Japan. In 1605 one such Chinese book appeared in Nanking printed in five colors: red, yellow, blue, green and black. Apparently it was printed from woodblocks, although stone could have been used. It was a most excellent work and not until the great books of Tsutaya Jusaburo in 1790 did Japan equal its perfect use of color.

Such books were surreptitiously issued in Nanking through 1626 and for a reason which throws much light on their great popularity in Japan at later dates. For late Ming rule in this part of China contained much of the same kind of governmental repression, sumptuary law and stupid class stratification that characterized the entire Tokugawa period. In fact, Ming rule became so repressive and sterile that all circles—literary, merchant and military in particular—patronized the erotic book dealers as a kind of social protest. More will be said on this later.

In Japan one of the first popular works was issued around 1600 by Koetsu's press, so that this distinguished gentleman adds yet another dubious laurel to his overflowing crown. It was a curious affair, the first half a direct copy of a very good Chinese classic, the last half an atrociously poor Japanese original.

By 1625 the city of Kyoto contained several publishers who were turning out rather gruesome and clumsy black-and-white originals in Genji costume and without a trace of Chinese influence. The art, the sex, the figures and the text were all very bad. But in 1640 colored books began to flood the market, handpainted on top of basic woodcut designs, and with them the authentic Japanese erotic book begins. The colors used were the very red and green that later were to grace those wonderful ukiyo-e of the benizuri-e period. This happy choice of palette seems to have been borrowed from Chinese porcelain, and the books were called tanroku-bon (red-green books).

Kyoto long flourished as the headquarters for sex books and one native son, Yoshida Hanbei, produced some of the most suggestive ever printed, while a visitor from Osaka, Shimomura Shichirobei, excelled in stark black-and-white accounts of goings on in the gay quarters.

But by 1671 the business of purveying such books had moved to Edo, where with new techniques in printing it became a flourishing trade which some fifteen Tokugawa edicts failed to suppress. A staggering flood of beautiful, expensive books on the one hand and lurid, ugly cheap smut sheets on the other swept over Japan from the Edo shops. For the most part they seem to have been sold quietly in bookstores to a select clientele who paid good prices for them; but whenever one of the periodic Tokugawa laws was promulgated outlawing them, they were distributed through the countryside by itinerant peddlers, who smuggled them to housewives, who seem to have been steady customers.

Were they art? A great deal of nonsense has been circulated about the artistic merits of these prints.† A fable has arisen that only in the erotic prints can one find the ultimate in ukiyo-e art. This myth is kept alive because no one can reproduce in an ordinary journal plates to prove his point and no museum will exhibit the prints and books to enable the general public to form its own impressions. I have been allowed to inspect many of the leading collections and would like to submit my personal conclusions.

Of a given hundred erotic books, selected at random, at least ninety are pure junk and have almost no claim to artistic merit, not even when definitely attributable to Kiyonaga, Shunsho or Utamaro. The drawing is very bad, the coloring unreasonable, the engraving sloppy and the printing wretched. The paper is second class, the registry is frequently inaccurate and the spacing of text, figures and spaces on the page shows no artistry whatever. One can only conclude from studying reams of this dismal junk that every step in its preparation was done hurriedly and carelessly by men who were interested only in making some money. Such a judgment is not entirely fair, for there were also overtones of strong social protest against the Tokugawa government in such work, but artistically the books are dreary. I used to think that art students were being deprived of great treasures because our conventions forbid the exhibition of such work, but having seen most of what is available I can affirm that the world has lost extraordinarily little art in keeping ninety percent of its Japanese shunga books locked up.

In general the same observations apply to the single sheets, where one would naturally expect the artistic content to be higher. There are a few superb Kiyonaga and Utamaro sheets, beautifully conceived and executed, but for the most part none of the single sheets compare with the best examples of the more sedate sheets that were put on public sale and which now grace our museums. Specifically, if one had before him all the single sheets of all the artists, he would possess no new artistic fact that he does not already have. He would have certain illuminating sidelights as to the characters of his artists; but again, in keeping these sheets locked up we have lost remarkably little artistically.

There does exist, however, a small minority of scrolls, albums, books and single sheets—particularly the first two—whose artistic merit is

† They are called shunga generically, makura-e (pillow pictures) generally and spring pictures (the translation of shunga) by Americans and Englishmen in second-hand bookstores.

very high and whose loss to the public is to be regretted. In the brief comments on specific artists which follow I shall endeavor to specify a few of these works, but first a few generalizations. Some of the medieval scrolls are superb and if their subject matter were more conventional they would certainly merit exhibition in any museum seeking to show the wonder of Tosa brushwork. These are brilliant works of art, brilliantly designed and executed, pleasant to behold and very joyous in spirit. The sexiness springs naturally from the situations chosen and the entire result is human and honest and good.

Some of the albums published in the age from Moronobu through Masanobu are excellent and it is amusing that from these oversize erotic pages have come some of the rarest treasures of ukiyo-e; for it was the custom of artists to issue their erotic albums in twelve sheets. The outside cover was traditionally a pastoral scene of the two lovers who were going to run wild on the inside pages, and the twelfth leaf customarily showed the same lovers back in the ways of peace. Therefore each album contained two non-erotic prints, under whose respectability the inside pages could be hid. In the course of time dealers ripped away almost all these outside pages and sold them to museums, where they now appear sedately in the most respectable collections. It is always a jolt, however, to see these proper lovers either before or after their abandoned behavior and to recall in one's mind the missing pages. Now let us consider the work of several leading artists.

Moronobu did some of his finest work in a select few of his erotic albums. There is no sign of bad drawing, hasty engraving or poor printing. The bulk of his work however was undistinguished, except for the outside sheets which are among the finest Moronobus extant, poetic compositions with lyrical figures and the most gracious harmony of design and execution. American museums own several of these cover sheets. But even so, the average Moronobu erotic album contains few gems, and what has been said in general regarding the art of shunga applies to at least two-thirds of his work. However, Moronobu's shunga play an especial role because it is largely through them that certain difficult problems of scholarship can be attacked. He published many of these albums, the last one sometime after he renounced earthly pleasures to enter a monastery. His publisher apparently thought so austere a provenance for so unaustere a work needed some explanation so he printed a foreword to the album in which he bluntly stated,

"We in no way apologize for concluding the publication of Hishikawa's work with the present erotic book."

Kiyonobu, as might be expected, produced some of the most powerful and reasonable shunga albums. In particular his outside pages were masterpieces, many of which are now in American museums. Artistically, his inside pages, while not so numerous as Moronobu's, occasionally reach a high artistic level.

Masanobu composed a few magnificent albums. One in particular equals the finest of the scrolls. Carefully hand colored in lemon-yellow, blue and red, it clearly has the highest artistic merit of all erotic albums I have so far seen. I would say that the convention which prevents the general public from seeing this glorious and vital album deprives the art world of a real addition. On the other hand, a good many of Masanobu's routine erotic pages are junk.

Sukenobu provides a real surprise, for he was a truly sensitive artist, a man whose gentle brush caught all that was best and most highly perfected in Kyoto life. Even a casual inspection of prints 4 and 12 discloses an artist of tender sensibility and delicate charm. It is therefore surprising to find that his erotic books were so sensational that they had to be forbidden by special law in 1722 because they were corrupting the entire nation. He did many books of such ravishing quality that they must surely be among the erotic masterpieces of all time. He appears to have conducted some of Japan's first experiments with printing in color from blocks, for several of his erotic works have survived from around 1715 to 1720 so printed. They are exciting, lovely books of extreme erotic content. It is, however, rather a jolt to find in these books the happiest and most successful of Sukenobu's ordinary work redesigned into erotic pictures. Thus one may grow to love a particularly fine Sukenobu page and find in it the essence of Kyoto propriety and old Chinese wisdom. But one can be sure that if it was really a satisfying design, Sukenobu would somewhere in his erotic work merely redraw it and use it as the basis for some staggering sex celebration. Of all the shunga that have come down to us, and there are voluminous collections scattered about the world, I would judge that only Sukenobu's, and possibly one other artist's whom I shall mention later, would have much sexual appeal to the average westerner. In general the drawing is so ridiculously exaggerated as to cause no excitement at all, but only stupefaction. This is the reaction of almost all western observers. But Sukenobu is different. He seems to have

loved drawing his lusty pictures, and his sales were apparently sensational. Long after the Tokugawa government took special note of him in an unprecedented personal prohibition, he continued to grind out his sex books. Most of them are masterpieces.

Shunsho did many shunga, but none that I have seen have had the slightest merit. Two of his outside covers are appealing but so far behind either Moronobu or Kiyonobu as not to warrant comparison. I do know certain collectors who prize his erotic work, but I have been unable to understand why.

Kiyonaga experimented with full-size single sheets in full color, and some of them are fine. Six that I know would confirm his stature as an artist if exhibited publicly, but the rest are hack stuff that must have been turned out in a great rush in between his many com mitments. His books are undistinguished. Apart from the fine single sheets, then, he does not suffer from having his shunga kept locked up.

Utamaro, although he did a great many books, at least thirty-five being catalogued, accomplished in them little of artistic merit. Some are dreadful affairs lacking either wit or skill or even gutter taste. On the other hand he did finish in fine style a weird set of twelve single prints showing what would happen to Ono no Komachi were she to venture into contemporary Edo. In these prints all of Utamaro's bursting love of the Yoshiwara and preoccupation with its citizens comes to the fore and results in what one rather sober Japanese critic hails as the artist's masterpiece of sexual reporting: "These are the treasure among the treasures, with voluptuous beauty, elegance and eroticism. They are among the top-ranking unexhibited works by Utamaro." It is a shame that they cannot be shown, for they clearly depict Utamaro's basically healthy attitude toward sex and could not possibly have been created by the diseased mind that some critics want to give the man. They would however add little new to his stature as an artist, but I must admit that the conceit of having Komachi the star of the series lends them an extra interest and a definite Utamaro touch.

Harunobu has been saved for this summary position because his shunga present special problems. In discussing Harunobu's general work notice was taken of the fact that he is often called by sentimental western critics the "Japanese Fra Angelico." At that time the inappropriateness of such characterization was mentioned but no reasons were given. They can now be guessed. Harunobu produced dozens of salacious books, scores of single prints and withal some of the most

hilarious, sensuous, erotic and skilful shunga in existence. To compare his lusty, tricky and earthy mind with Fra Angelico's mystical, religious and introspective brooding is not only irrelevant but misleading. It ignores the salty quality of the ukiyo-e artist and submerges his strong sexual drive. The very Harunobu prints which western sentimentalists prize most highly as evidencing his ethereal quality are those which, with a few changes here and there, become his most basic shunga. No series of prints in ukiyo-e is more famous than the eight-print set from which 39 is taken, for these extol the simple virtues of home living in well nigh impeccable artistic taste. Yet one can find in Harunobu's shunga almost all the symbols used in this series adapted to erotic prints in which the most amazing conduct is exemplified. Further, Harunobu is unique in frequently taking one of his most delicate prints, redrawing a few vital blocks, and producing an erotic result quite opposite to the original. His shunga are very sexy, very well done, very strong in their evidence that the artist enjoyed his work. The whole Harunobu problem is reduced to simple terms when one considers the much-idealized love affair with O-sen, so idyllically presented in many of his public prints, including 6. Some critics have constructed, from suggestions in these public prints and from tradition, an idealized romance of touching proportions between Harunobu and the beautiful waitress; but such a romance—of which we have no substantial evidence—would have to have had a rather salty base, for we do know that Harunobu delighted to draw pictures of the frail young girl getting into and out of a bathtub nude, which prints were widely sold, and in some of his shunga he made O-sen the heroine. For example, there is the story of Yonosuke, the boy of the world, who prays to O-sen at Kasamori Shrine. She appears to him as a goddess and agrees to make him so small that he can slip into all the secret places of Japan to report what is going on. He checks on what happens between the teacher of handwriting and his pretty girl student, why the silk workers suddenly stopped working and what occurred in the samurai's house. In other shunga O-sen plays a more active role. These facts are not reported to denigrate Harunobu but rather to bring him into complete focus. He was a most gifted artist, a Yoshiwara habitué and a man of extreme artistic sensitivity. To transform him into merely a sentimental colorist is repugnant. Furthermore, he underlines the fact that most men of artistic impulse have a lively concern with the erotic elements of life, as indeed they are concerned with all the basic ele-

ments of life, and that without this concern they would be very half-baked indeed and would probably not have become artists in the first place. Along with the work of Sukenobu, the shunga of Harunobu appeal strongly to western judges. All the delicacy that he gets into his greatest prints of sweet young girls, he gets into his shunga. Often he gets the same girls in, too. All the brilliant colors of the one he borrows for the other. All the sure draftsmanship, the supple line and the sense of spring reappear in his shunga. He pioneered in the creation of single shunga sheets, which artistically equal his public prints, and continued the Sukenobu tradition of narrative books, in which the art is usually of a low order. Artistically therefore his case is much like Utamaro's. In hiding his shunga we have not lost any new artistic facts, for most of his work was in book form and most of that junk, but we have lost insight into the mind of a complex artist and perhaps into the nature of art itself, for to eliminate all the sexual bases of art is to eliminate vitality.

Hokusai, as might be expected, created the most profound shunga. I am not speaking of his many books, which strike me as quite bad, nor of his commonly known single sheets, which are routine stuff. I speak of a handful of contorted and harrowing sheets in which the old man set down scores of agonizing human beings caught up in the reductio ad absurdum of sex. Here, in these demonic sheets, each with a dozen frenzied couples, one sees the ultimate in human experience: the longing, the savagery, the bitterness, the joy, the ridiculousness and the unsatiated hunger of sex. These sheets are greater, I believe, than the mad visions of Hieronymous Bosch. They are more vital than Breughel and more mysterious than Charles Meryon. It is a great pity that they cannot be exhibited, for until one has seen their mocking faces and their contorted bodies, one can have no final image of Katsushika Hokusai. This was the final irony he permitted himself, this savage comment on sex, and yet as one studies the writhing sheets one finds that they have been constructed with a considerable amount of human love and with much earthy joy. Here are the human beings of Japan, the ridiculous procession of naked people who make up the subject matter of ukiyo-e. I hold these demented sheets, these hilarious and mirth-evoking broadsides, to be one of the major accomplishments of ukiyo-e, for they speak not only of lonely and fugitive Hokusai, but also of ukiyo-e itself.

Ukiyo-e was always an art of social protest. It was an art of gentle ridicule and it was an art which thumbed its nose at the Tokugawa dicta-

torship. In none of its other manifestations did ukiyo-e exhibit its true character more than in its unending barrage of shunga. Often the duped husbands were pompous samurai. The men the princesses ran off with were commoners. The young blade who crept into the nobleman's bed while he lay snoring was the gardener. In shunga, the common people triumphed.

Apart from this, shunga were the means by which most artists lived, the medium by which the greatest publishers stayed solvent. I recall an extremely indecent book by Utamaro. Grandiloquently and with a dozen barbed allusions, he dedicated the book to Tsutaya Jusaburo's mistress, and Tsutaya published it. A little later, in 1791, when Tsutaya published another book offensive to the Tokugawas, fifty percent of all his property was confiscated and his business ruined, but within a few months he was back at work, issuing new shunga, whose profits were to make the culminating 1794 prints of Utamaro and Sharaku possible.

They were a tough lot, the ukiyo-e men, and their shunga proved it. All the classical artists represented in this book drew shunga except Eishi and Sharaku, and although the work they did in this field has always remained underground, it represented in sales just about fifty percent of their entire effort. It is little wonder, therefore, that occasionally the student of ukiyo-e needs to go back to these lusty books and startling prints to remind himself that art, like the life it reports, has numerous facets.

21

The Function of the Eye

ICHIRYUSAI HIROSHIGE

We last saw the novelist Jippensha Ikku roistering through the alleys of the Yoshiwara accompanied by his drinking companions Tsutaya Jusaburo and Kitagawa Utamaro. In those days he was known in Edo as a minor wit and seemed destined to waste his life in the hilarious fleshpots of the time; but in 1802 he startled Japan by publishing the first section of a remarkable novel which was to bring him immortality.

Hizakurige is best translated *Shank's Mare* and best comprehended as the Japanese *Pickwick Papers*, for it recounts the adventures of two lusty Edo yokels, Yajirobei and Kitahachi as they travel the great Tokaido Road to Kyoto. Year by year, until 1822, Jippensha issued new accounts of these two disreputable idiots and yearly his fame grew. The novel is very funny, very earthy and the best possible literary introduction to the world of ukiyo-e. In 1929 a commendable English translation appeared and *Hizakurige*, a perpetual favorite in Japan, is belatedly attaining broader fame.

The wonderful nonsense of the novel is typified by the case of the man who noticed high winds blowing in Edo and consequently sold all his property to buy up boxes: "Well, I worked it out in this way. Every day there was an extraordinary amount of wind and as Edo is a very dusty place I thought the dust would naturally get into people's eyes and there would be a large number who would go blind. Then, according to my idea, I thought all these blind people would want to learn the samisen, so the samisen makers would get very busy and a large number of cats would have to be killed, and there would be an increase in the number of rats, which would gnaw all the boxes to pieces, and

213

thus the box trade would certainly flourish. So I laid out all my money in buying a large stock of boxes."

" 'That was a good idea,' said Yaji."

The novel is packed with local allusions, sayings of the time and references to living persons like Kubo Shunman (17). A feature is its wealth of witty doggerel:

> The smoke goes up into the sky
> From Fuji's crest. I wonder why.
> The girls at Mishima should know;
> They light the fires of love below.

But the main reason for *Hizakurige's* fame was its reflection of the craze for travel that had overcome Japan. It was this mania for going places and bringing back souvenirs that accounted for the unprecedented popularity of the ukiyo-e landscape artist Ichiryusai Hiroshige, who specialized in travel prints.

Jippensha Ikku died in 1831 and the very next year Hiroshige, a minor official in the fire-brigade detachment responsible for protecting the shogun's court, set forth to accompany a gift horse being sent from the shogun in Edo to the Emperor in Kyoto. Naturally, the horse was led along Jippensha's famous Tokaido Road with its fifty-three historic overnight stations.

On this trip Hiroshige, thirty-five years old, made a multitude of sketches from which he would borrow again and again during the following quarter of a century; but the finest were immediately used and in 1834 appeared his set of fifty-five prints—fifty-three posting stations on the Tokaido plus the beginning at the Nihonbashi (8) and the arrival in Kyoto—which insured Hiroshige an even greater fame than Jippensha had won with his novel.

In the next ten years Hiroshige hammered out one set of prints after another: scenes of Edo, of the suburbs, of Lake Biwa at Otsu (61) and bright new pictures of Kyoto. He used at least forty-six different publishers and whereas classic ukiyo-e artists had once supervised the entire traditional run of two hundred printings from one of their designs, Hiroshige was lucky if he saw any of his being made, for instead of the customary two hundred meticulous copies some of his appeared in total editions approaching ten thousand. He was easily the most popular ukiyo-e artist of all time, so far as sales were concerned.

And then, as if he needed help, the Tokugawa dictatorship in 1842

prohibited manufacture or sale of prints showing actors or courtesans, an embargo that lasted more or less effectively for twelve years and abetted Hiroshige's semi-monopoly. He had to take assistants who seem to have helped him produce some of his later series. He did at least twenty different versions of the ever-popular Lake Biwa series (61) and whenever he or his publisher of the moment needed a few more yen he would turn out a new set of fifty-five Tokaido prints, reviving unused sketches made years before.

Of course, these late prints were pretty bad. Yet in spite of such inevitable decline Hiroshige avoided the debacle that overtook Toyokuni, who suffered a similar experience, for no matter how many bad prints Hiroshige designed in a series he always managed to come up with at least one striking success, so that if the many fine prints of his early period are compared with the few top prints of his late years no decline in power is apparent.

It has been said that of a hundred random Hiroshige prints of different subjects, eighty will be poor, ten acceptable, nine good and one superb. No other major ukiyo-e artist had such a low average; but since he issued the astonishing number of about 5,400 different color prints,[†] if he succeded only one percent of the time he still accounted for at least fifty near masterpieces. Many western critics would put the figure higher but his reputation has always been inflated outside Japan.

Still no one can deny that occasionally he achieved landscapes which are among the elite of the world. So without trying to review the enormous number of different series issued by this prolific man—whose work has never charmed me as much as it does most collectors—I should like to investigate certain categories which may account for his peculiar and appealing success.

Snow scenes provided him with subject matter for at least seven superb prints and some wise collectors would be willing to accept his top two dozen snowscapes and forego the rest of his work. No other artist has ever come close to his repeated success in depicting snow in the dull dead of winter. Print 61 is a fine example and shows with what economy of line and color he achieves his effects. Many understandably prefer the scene at Oi from the Kisokaido set of seventy prints depicting the sixty-nine stations of another road to Kyoto, for this excellent design shows Hiroshige uniting snow and men to perfection. White mountains fill

† In 1930 Uchida Minoru estimated about 8,000 different designs, of which about 5,460 were color prints.

the background while left and right two mighty pines, snow laden, make a frame for a group of men: two barefoot in the snow, two on panniered horses. The brilliance of this print lies in the fact that no man's face shows, only the round circles made by big straw hats as they bend through the storm and come right at the viewer. In one series after another all prints will be either average or downright dull until one reaches the snowscape. It will be breathtaking. For example, the series *Wrestling Matches between Mountains and Seas* is fairly dreary, but the wrestling match that snowclad Mount Yugai conducts with its arm of the sea is positively glorious and illustrates Hiroshige's predilection for a color scheme of blue, white and gray plus a few effective touches of red. Much of the magic of his snow scenes derives from his willingness to leave large portions of his paper completely blank. I can think of no other ukiyo-e artist who consistently used the beauty of Japanese paper to such creative advantage. In leaving these handsome snowscapes I must point out that the one which brings the highest bids at auctions and appears to be the favorite in this category, Kyoto's "Gion Shrine in Snow," is artistically one of his least successful because it lacks focus, uses too many colors, shows little blank paper and is haphazardly drawn. It does however tell a sentimental story of professional women—that lovely Japanese euphemism—in the snow under bright yellow umbrellas and does make a near perfect Christmas card.

Night scenes fascinated Hiroshige and were the occasion for some of his stateliest work, his most popular single print being in this form. "The Bow Moon" is better designed than most of his prints and shows a silver wedge of moon rising between two mountains as if from the depth of a gorge while far above hangs suspended a webbed bridge over a roaring waterfall. In most series Hiroshige offers night scenes and frequently finds a happy design with which to exhibit his mastery of nature, for no one can study such scenes without realizing that the artist had wedded Chinese convention to those parts of European tradition best suited to Japanese taste, all the while remaining preponderantly Japanese. In showing several receding planes while disregarding tyrannical European perspective and shadow, he is excellent. His suggestion of deep night, yet with all objects visible, is traditionally Japanese but he adapts the convention brilliantly to his purposes (as did Shunman in print 17).

Rainy scenes accounted for his initial Paris and London success, for his use of bold parallel lines laid right upon the face of a print to indi-

cate rain was both startling and artistically pleasing. In Europe he was credited with having invented the trick, and such lines were called "Hiroshige rain," but today we know that Hokusai had used the device before Hiroshige. It would be difficult to trace the brilliant scheme back to its origin (18, 12 represent two steps) but although the device had been available for at least a century, Hiroshige was the artist who used it most creatively. Among the clutter of uninspired prints in the extensive and disappointing late set *Hundred Famous Views of Edo* is "Sudden Shower at O-Hashi," where seven travelers are caught by a torrential downpour while crossing a bridge. This print summarizes Hiroshige's many attacks on the problem of how to express rain. Here he throws upon the print a second set of parallel lines slightly askew to the main storm and the effect is enhanced. No prints show his constant and restless investigation of nature more clearly than these rain scenes. In his greatest, "Night Rain on the Karasaki Pine" from the set of which print 61 is a member, the rain comes straight down in lonely and unrelieved power. In "A Shower at Shono," on the Tokaido, it slants down in heavy gusts not parallel to one another. At Azuma no Mori in the environs of Edo it drifts down in silvery mist. Again it comes as white rain, disappearing before it strikes earth. Always Hiroshige gives the impression of Japan's heavy rain as he recalls it from his journeys when, unable to afford a palanquin, he trudged weary and wet to the next station.

Scenes in clear air provided Hiroshige with a problem which he tackled at about the time it was being studied by artists in Europe who were conducting the experiments which would lead to Cézanne and the mastery of plein air. In general, Hiroshige's prints based on this as the central problem are not widely appreciated, for they lack focus and suffer from weak design and color; but they are important for they show Hiroshige's preoccupation with nature in all its manifestations. "The Tea House at Mariko," on the Tokaido, is at first glance merely another uninspired print showing a tea shop at the crest of a hill with an uninteresting tree which sends forth tentative blooms; but the entire scene is bathed in a cold, diffused light of absolute clarity. Distances, planes and the effect of clear air are handled with notable accuracy.

Mist provided the occasion for several weird and futuristic prints, the outstanding being the scene at Miyanokoshi on the Kisokaido, where a farmer and his family cross a bridge in the foreground while in middle distance strange trees rise against the moon in a half-mist and in the

background a vaguely outlined traveler moves toward a ghostly house. In some unfathomable way this print catches the exact feeling of a misty night. Once along the Tokaido near Mishima I saw precisely this weird, cubistic effect and realized that Hiroshige had invented a new technique to report a very ancient phenomenon. Speaking of Mishima, the misty scene at this station in the Tokaido set is usually hailed as Hiroshige's finest in this medium, possibly because it has been reissued numerous times. Actually it is inferior in most respects to the Miyanokoshi print just described and in my judgment even to the Nagakubo, also of the Kisokaido set.

Humor occurs more frequently in Hiroshige than in the work of any other ukiyo-e artist and it is appropriate that his set dedicated entirely to horseplay shows those redoubtable pilgrims Yajirobei and Kitahachi of *Hizakurige* experiencing their misadventures on the Tokaido. The Metropolitan in New York has several original Hiroshige drawings intended for prints in this series, but instructive as they are in demonstrating how the artist worked, they mislead because they fail to show what Hiroshige had in mind for the finished print: humorous scenes, to be sure, but used as an excuse for landscapes. One of his most perfect night scenes shows Yaji and Kita being tossed bare-bottom out of a tavern but raucous as the event is, the enveloping night and its gray-black beauty dominate, for Hiroshige could plan nothing without making nature the hero of his print.

Birds and flowers, the costume jewelry of nature, provided Hiroshige with many delicate and alluring themes (62) about which opinions vary sharply. In such prints Hiroshige, whose palette is usually subdued or, as in certain snow scenes, almost completely absent, splashes bright pigment freely and achieves brilliant effects. Also, his stodginess in design vanishes and he suddenly produces bold arrangements of drooping branches against the moon and sprays of flowers decorated with light, airy birds. Such prints seemed to set his spirit free and, although less monumental than either Kiyomasu's or Koryusai's and less accurate in zoological observation than Utamaro's, are surely the most dazzling and instantly winning nature pictures done in ukiyo-e and a challenge to any designed anywhere.

There remains one print so mysterious in its evocation of nature that it has become a perpetual wonder. "Autumn Moon on the Tama River" comes from a set of eight superb prints commissioned by an amateur poet (as in the case of print 39) who may have had something to do

with the delicacy with which the prints were designed. At first glance everything seems wrong with this famous work: the sky is crowded with several poems; the moon and the main tree collide awkwardly; there is too much light for a night scene; the trees are too near the center of the print, and the drawing of the human figures is poor; while the color is bleak and the design haphazard. Yet curiously the result of such imperfections is one of the most limpid, poetic evocations of nature that any art has so far produced. What is the mystery of this contrary print that has bewitched so many persons? The secret lies, I think, in Hiroshige's absolute fidelity to nature. This is the way an unpretentious stretch of river ought to look. The moon ought to tangle awkwardly in the branches of a broken-toothed willow and not stand posed off to one side. If one could distill the essence of a white autumn night it would look like this, for the man who created this print had looked with a fresh, clean eye at nature. His apparent lack of art creates the apotheosis of art and he produces a strange, heavenly print.

From the above summary several conclusions can be deduced. In most of the outward manifestations of art Hiroshige had only a modest talent and no genius at all. His designs are apt to be weak, his drawing undistinguished. Specifically, he lacked a capacity for focusing his prints and a great number wander aimlessly. He also betrays the fatal weakness of the artist without philosophical commitments: except for the infrequent masterpiece, his pictures get worse as he grows older.

But he had one constant attribute which offsets these easy criticisms and it is an attribute so rare that it exalts anyone who possesses it. He could see. He had an honest, clean eye. He could see nature's varied forms and changing climates. Of all the artists who have ever lived, only a few could see. Cézanne, Whistler, Turner and Monet come to mind, along with Piero della Francesca and Velasquez. There are other artistic gifts just as rewarding as seeing, but few are able to set the beholder of art so free as companionship with some great artist who has had the film of historical acceptance washed from his eyes. A man like Hiroshige can teach an entire nation, or even a substantial segment of the world, to see. After sharing with him the manifold aspects of nature one cannot go back to blindness. Hiroshige's inspired eye saw the world and the wonder of the misty rain and now we see it, too.

Although Hiroshige produced more prints than any other ukiyo-e artist—it has been claimed that the total number of his prints, counting all contemporary editions, just about equals the number issued by all

other artists combined, in all various editions—few people have ever seen an authentic Hiroshige. What we see are pathetic late copies, and it is one of art's most tantalizing anomalies that the poorness of the average available Hiroshige is in a twisted way proof of how great an artist he was. The contradiction can be explained as follows: he was primarily concerned with the relationships of light and natural phenomena and expressed this in prints so subtle that only pristine copies prepared under his direction convey even a slight idea of what he had in mind; late runs, when printer and publisher were in a hurry to make a few extra yen, became merely crude travel prints and bear almost no relationship to the artist's intentions.

I cannot stress too strongly the fact that the ten thousandth copy of a Tokaido scene is simply not a Hiroshige, even though struck off from his blocks and in something approximating his colors. I doubt if even the three hundredth copy ought to be called a Hiroshige. Let me report my own experience. I had seen perhaps seventy different complete sets of the Tokaido in many of the world's major museums and had acquired a low opinion of Hiroshige's major work. Then I happened by chance to visit the Newark museum when they had on display about two dozen Tokaido prints from a set which John Cotton Dana spent years assembling in a determination to get at least one series in first-class condition.† Then I discovered that I had never seen Tokaido prints before. I recall one dreary subject, a daimyo's train preparing to break camp at Seki, which in design, drawing and customary coloring has positively nothing to commend it. But in the Newark copy it was a majestic rendering of bright light inside the compound and mysterious pre-dawn darkness outside. It was so extraordinarily beautiful that one could only feel humble before it. It was the work of a man who could see and to whom all else was unimportant save an honest reporting of what he had seen. Today I would not hazard an opinion on any Hiroshige print until I had seen at least three versions, one very early, for I assure the reader that from a casual glance, especially at a late printing, one can have not the remotest idea of what Hiroshige might have been striving for. The table on page 222 shows briefly what lamentable wrongs were done to Hiroshige by avaricious publishers. Fujikake once assembled twelve distinct versions of a single subject from the Tokaido, each in different color, but each struck off from the original blocks. To

† The choicest two dozen were on exhibit. Other impressions in the Dana set were only average.

consider the late monstrosities as any way comparable to those of orig-
inal and crystal purity is unfair. Hiroshige can probably be condemned
for not having overseen his work more carefully, but I suspect he was
much like Ernest Hemingway, who has repeatedly said he is not con-
cerned with what Hollywood does to his stories. If he can get them right
the first time, that's more than most men can accomplish. What hap-
pens after that is inconsequential.

Comparison of the two landscape masters, Hokusai and Hiroshige,
is inevitable. Hokusai, coming first, was the bolder and more inventive;
he established major patterns for ukiyo-e landscape. Hokusai was also in-
comparably the better designer, using emphasis, subordination, exagger-
ation and counterpoise in ways quite beyond Hiroshige; yet it must be
pointed out that occasionally Hiroshige had an uncanny gift for placing
himself in just the right spot to catch a marvelous composition. One is
tempted to suggest that Hokusai moved the mountains to suit himself,
whereas Hiroshige moved himself to suit the mountains; but that is not
altogether true, for one of the most instructive experiences any student
of art can have is a comparison of Hiroshige's Tokaido prints with
photographs made only a few years later of the exact spots he portrayed.
Books offering the prints on one page and the photographs facing are
common in Japan and startling, for Hiroshige drew no scene as it
actually was. He modified everything. In each change one can see the
frantic, searching mind of the artist at work, shifting the landscape
about so an honest report on nature can be attained. He could well be
charged with being a liar as a pictorial reporter, except that his prints
continue year after year to show us what the now vanishing Tokaido was
like in its glory, whereas the photographs show nothing.

In suggesting atmosphere Hiroshige is so far superior to Hokusai as to
be beyond comparison; only in plein-air rendering of suspended atmos-
phere at great heights can Hokusai even challenge him. In depicting
specific atmospheric conditions such as rain, mist, fog, and twilight haze
Hiroshige is markedly superior; but in rendering snow Hokusai, in his
black-and-white drawings, achieves magnificent effects, which Hiroshige
no doubt studied. In depicting the ocean Hokusai is vastly superior and
is clearly better in showing any kind of water such as rivers, lakes and
falls.

In bird pictures Hiroshige is notably superior, mainly because Ho-
kusai insisted upon making the eyes of all his living creatures look like
those of tigers or dragons, which can be frightening when seen on a

Areas	Print A	Print B	Print C	Print D	Print E
1	Empty	Empty	Distant Trees	Empty	Distant Trees
2	Light Gray	Green	Pale Gray	Yellow	Muddy Gray
3	White	Pale Gray	Gray	Green	Spotty Gray
4	Medium Gray	Pale Gray	White	White	White
5	White	White	Black	Red	Sloppy Black
6	Dark Clouds Touch Peak	Clouds Do Not Touch Peak	Clouds Barely Touch Peak	Entire Mountain Missing	Fuzzy Clouds Do Not Touch
7	Black	Pearl Gray	White	Brown	Green
8	White	White	Gray	Green	Sloppy Gray
9	Black	Pearl Gray	White	White	Green
10	White	White	Dark Gray	Brown	Dark Green

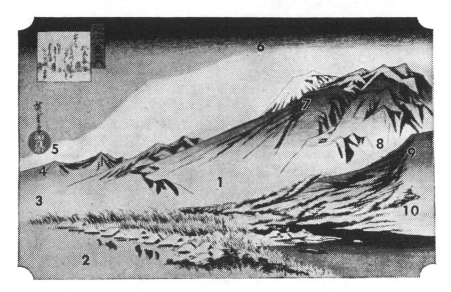

HIROSHIGE: "Evening snow on Mount Hira" from *Eight Views of Lake Biwa*.

The prints referred to in the opposite table are located as follows:

PRINT A Mansfield Collection, 2474, Metropolitan Museum of Art. New York City. See Print 61. Almost certainly the original version.

PRINT B Private Japanese Collection, but almost identical to copy in National Museum, Ueno Park, Tokyo, Japan. Small area of green added and grays varied.

PRINT C Phillips Collection, 2848, Metropolitan Museum of Art. New York City. For an excellent print which offers a slight variation on this edition see Ledoux, Volume 5, Print 26, where area 3 is pure white and area 5 pale gray. Most noticeable changes are addition of glacier streaks and radical alteration of black and white values on mountain.

PRINT D Print 21.6807 Museum of Fine Arts, Boston. The upper mountain has been entirely omitted. Cheap colors have been added to lure the eye, and upon the lake, printed in a ghastly opaque blue, snowflakes fall. This print is far removed from what Hiroshige intended, but it must be noted that Boston has other excellent copies.

PRINT E Private Japanese Collection. Very poor reprinting with garish green added liberally to heighten appeal. Hiroshige almost certainly never saw this version.

tiny sparrow. In flower pictures the work of the two men is so dissimilar as to make comparison unprofitable. Hokusai drew his as if they were mountains or monuments and his effects were magnificent; Hiroshige drew his in soft whispers of spring air and his results were enchantingly poetic.

In depicting human beings the laurels are divided. In actual drawing to attain an impression of living people Hokusai excelled and in addition occasionally caught that majestic light that plays upon the human tragedy. His figures bend with sorrow or break with toil. They are trivial worms at the foot of Fuji or lost souls in ghostly imaginings of the mind. These are of course literary and philosophical readings of his work and probably have little to do with art; but Hokusai was a voracious student of life and if those observations were what he was struggling to get into his prints then he should be judged on that criterion. Hiroshige, on the other hand, reported the human comedy and even apart from his labeled comic series introduces a warm regard for the people he met in his travels: two beat-up male tourists fighting off set-jawed women who are determined to drag them in off the street; workmen toasting their bare bottoms at the fire. One could list a hundred prints that immediately cause a chuckle; but of course the figures are drawn poorly, placed awkwardly and often colored badly, yet as in the case of Hokusai one must respect what the artist intended.

Hokusai was a powerful intellect; beyond a facility for doggerel Hiroshige evidences no mental gifts. Hokusai was a lonely, brooding man; Hiroshige was a delightful, sake-guzzling bourgeois. Hokusai had a glowing inner eye focused upon the problems of the entire universe; Hiroshige had that rarest of gifts, a simple eye that could see the world about him. In his mastery of atmosphere and space, Hiroshige can be compared to Cézanne, but a more evocative comparison is to Rowlandson of England and Posada of Mexico, for in addition to being a superb reporter of the world's atmosphere he was a witty reporter of the human scene.

We know a good deal about Hiroshige, for he left voluminous notebooks of his travels. Most of them were destroyed in the 1923 earthquake but some had been transcribed and we can see this ruddy-faced, pedestrian, heavy-drinking man as he trudged across Japan. Three impressions stand out in these diaries. First, he loved to eat and to note daily menus, often with relish or sarcastic comment: "Was invited by Tujiya for the evening. The fish was good but the sake and soba were bad, so speedily

left." He especially loved getting drunk: "In evening all went to theatre and saw two acts of play. This was a day of great booze." "On the way back got into bad trouble by stepping into a stream by mistake. This was an evening of great drink." Second, he enjoyed the excitement of travel and spent long hours picking up yarns which illustrated the peculiarities of whatever village he was stopping in. He made poems for casual friends and reports how an elderly gentleman employed him to write an insulting poem addressed to a faithless mistress for which "I was treated by him with tea and candy." Third, he was meticulous in recording both the weather and his reactions to it. One can see him sniffing each day, judging it: "April 9th, Clear weather. April 10th, Cloudy. April 12th, Rain. March 4th, By beach the view exquisite, beyond capability of describing with brush. March 7th, Was persuaded not to go aboard on account of wind not favorable. Seeing four boats sailing out regretted of not going on. March 3rd, Rainy. From the relative of the house a bottle of sake was gifted. Had feast. Painted a little. In evening Tokogen the barber came and had feast."

Hiroshige was especially favored in Europe, where he was more promptly and passionately accepted than any other ukiyo-e artist excepting Utamaro. Three reasons can be proposed. First, the staggering number of his prints plus the fact that they had only recently been issued meant that in any bundle of ukiyo-e reaching Europe after the opening of Japan there would likely be a good many Hiroshiges, some of them in first-rate condition, and we have seen how striking such prints can be. Second, the pioneering work in landscape done some years earlier by Turner—and to a less extent by Constable and Bonington—prepared the way for Hiroshige. The similarities between Turner and Hiroshige were remarked by most writers of the day. Third, and this is probably the most important though least discussed reason, Hiroshige's iconography presents no obscurities. His travel prints could be immediately recognized as delightful, fresh comment on life and nature. Even today Hiroshige is probably the most universally accepted ukiyo-e artist.

In America he had spectacular acceptance and comparison with two local artists became inevitable. Currier and Ives, between 1835 and 1907, presented about 6,700 different lithographs compared to Hiroshige's 5,400 color prints between 1825 and 1858. In artistic merit Hiroshige's work is patently superior and need not be particularized; but in spoils, breadth of coverage and continuing national impact the Americans were superior reporters. In quality of reproduction, curiously, the run-of-mill

Currier and Ives is better than the average Hiroshige, but the finest prints supervised by Hiroshige quite outdistance the best lithographs.

His bird and flower prints have also been compared with Audubon's, and here the competition is close. In fidelity to nature Audubon must be given a slight advantage in birds but not in flowers; neither would pass muster today. Artistically it is difficult to choose, for although Hiroshige is incomparably better in design one sometimes feels his work to be a bit cloying, whereas Audubon keeps the clean, astringent smell of the swamp about him.

In writing of a past age we struggle bitterly to catch some glimpse of a man who once lived but is now long dead. Rarely do we succeed, but one afternoon in Tokyo I met old Baron Morimura Ichizaemon, seventh of that name. He said, "My grandfather, Ichizaemon V, was a silk and leather merchant. My father started the porcelain works which made the fortune we lost in the war and won for us the title. But it is not of business that you came to speak. It was my grandfather who knew Hiroshige, for the artist's family lived next to his. They were poor and had no social standing and I remember my grandfather telling about the time Hiroshige got a chance to go off on a trip to draw a new set of prints. He had no money of course and no way to feed his family while he was gone but nevertheless he went. My grandfather took care of his people and saw that the Hiroshige family kept going. In time the painter came back.

"My father often told me how as a boy he collected a large pile of Hiroshige's prints . . . whether he bought them all or whether Hiroshige gave him some I don't know, but for some he paid what would be three American pennies. He pasted them in a big children's book and I can remember playing with it as a child, because of course our family never imagined Hiroshige's work was worth anything. A poor neighbor like that. Sometimes I shiver when I think how I tore those pages apart one by one in our games. If I had that book now I would be a rich man."

On Hiroshige's memorial tablet was written this summary: "He studied hard by himself, and had often to climb mountains and descend to valleys, in order to sketch from Nature."

22

Why an Art Dies

UTAGAWA KUNIYOSHI

Before discussing why ukiyo-e died it is necessary to prove that it did. It was my original intention to offer in proof one of the real horrors of ukiyo-e in full, garish, repulsive color, for then the death of an art would have been self-evident, but when it came time to do so I could not tolerate wasting a page on such a print. Instead I shall try to describe one.

It is by Utagawa Kuniyoshi and shows Yoshitsune, to whom we have referred before, fighting with Benkei (24) and comes from a series depicting the life of Japan's cherished hero. The first thing that catches the eye is senseless clutter, so that one is tempted to conclude that in its final days ukiyo-e lost even its good taste. This is correct. For example, on this one print there are ten separate bits of writing, some in ornate cartouches with baroque curleycues, all badly placed, none lettered with distinction and one flecked with disturbing brown and yellow spots to suggest gold dust.

The basic design is equally bad. The positions of Yoshitsune and Benkei are poor, for they stand clear of neither the cluttered background nor each other. The upper left corner is filled with a laborious yellow wall which is supposed to balance the fighting figures but which overbalances them.

The drawing is exaggerated and in no way pleasing. Color is sensational, capricious and lacking in taste. The minor cartouches are an ugly red and so prominently spotted that they resemble measles, while an intrusive tree in bloom dominates the entire upper half of the picture in a sickly white. The ultra-fancy major cartouche is completely revolting in an unacceptable blue, while the costumes of the two warriors lack any color organization whatever.

It is impossible to say a good word for this print, since it violates the most fundamental principles of ukiyo-e. The sovereign line is missing, spacing is barbarous and color is violent. Nevertheless, from 1850 on Japan seemed to prefer such junk for it constitutes the bulk of publishing. More than three dozen artists whose names begin either with Kuni- (borrowed from their teacher Toyokuni) or Yoshi- (from Kuniyoshi) filled new-born Tokyo with repellent prints of this nature. Moreover, pathetic as this Kuniyoshi print is, it looks quite acceptable when compared to what happened when vile German aniline dyes reached Japan. Then all restraint disappeared and some of the most grotesque prints ever issued flooded the shops.

Two anomalies should be noted. First, it was these grotesque horrors which helped awaken Europe to the beauties of the Japanese print, for many of the first books on ukiyo-e published abroad dealt mainly with "the Kuni's and the Yoshi's," but the real artists of Paris quickly learned to appreciate the more subdued beauties of Utamaro and Hiroshige. Second, it is these repellent later prints which most American tourists today lug home from Tokyo as prizes. One of the unpleasant by-products of an interest in ukiyo-e is the number of times each year one is dragged protestingly to a portfolio of "Japanese prints" which some family wants to be assured are worth thousands of dollars. Invariably such portfolios contain only these monstrosities. Invariably they are worth nothing. In Japan today they are available in the thousands at eight cents each. True, they are original, they are prints, and they are Japanese; but they completely destroy the beauty of any room in which they are placed. In New York there is an art store which used to keep a stack of them in the window under a sign: "Original Japanese Prints. 98¢. You May Make Your Fortune Here."

How did this debasement of a sensitive and beautiful art occur? There were two major reasons, but these I will postpone until certain misconceptions have been cleared away. The decline definitely was not caused by the absence of artistic ability. Kuniyoshi and the multitude that followed him could draw, could design and could color as well as any of their predecessors. Their skills were not used and the greatness that was within them was not called forth. I shall prove this most abundantly later.

Nor was the subject matter of the print to blame. Kuniyoshi did a triptych of Yoshitsune serenading Princess Joruri that is a parallel of excellent predecessors by Kiyonaga, Eishi and Utamaro, yet his is gro-

tesque and cluttered, quite lacking in beauty. Even when these men used the old subject matter there was something in the general debasement of Japanese taste that helped drag them down.

Nor were the curious new conventions for drawing the human face to blame. In most late prints all Japanese look like Hapsburgs, with jutting jaws plus contorted eyes and mouths twisted awry. The convention is not pleasant, especially when such faces are attached to bodies twisted into impossible convolutions by dramatic agony. However, if great artists had used this convention with good line, spacing and color, we would now look upon those faces as concomitants of great art. What has happened is that we have come to associate such faces with late prints and to recognize at once—by seeing the flag, as it were—that the print which contains that face is worthless. It is illogical to think that this late convention of drawing is any poorer in basic artistic value than the early ones used by the Kaigetsudo for their women or by Moronobu for his. This can be proved by the fact that frequently in pawing through a stack of horrors one will come upon a print fundamentally no different from the others, but there will be about it an accidental harmony that is pleasing. Almost every major collection has one or two such prints and they demonstrate what this group of unfortunate artists starting with Toyokuni and Kuniyoshi might have accomplished had they lived in luckier times when society and the conditions of art would have buoyed them up rather than sucked them down.

Nor were German aniline dyes to blame. This is frequently cited as a major cause for the death of ukiyo-e, but an honest inspection of prints issued before the arrival of these admittedly cruel colors proves that the basic elements of degradation were well established before the dyes arrived. Granted that no pre-aniline print is quite the complete horror that most of the post-aniline prints are, one feels sure that if artists of ultimate taste—say Harunobu and Shunsho—had used even these wicked dyes they would have produced pleasurable prints. Aniline merely underscored the debasement that had already taken place.

Now for the real reasons. First, a feudal society of long duration was obviously coming to an end. New forms, new patterns, new ideas were needed. Prints of ancient heroes, actors and courtesans were no longer enough. Vast new movements and ideas were impinging upon the Japanese mind and only vast new artistic forms could have kept pace. Affectionate street scenes of Edo life could not supply this need, for Japan was walking upon a new and greater street that led to Paris and London

and New York. It is ironic that ukiyo-e, the art which had been closely connected to this rising new spirit, should have been the soonest to perish when that spirit triumphed.†

The second reason was the absence of publishers with integrity. It is inconceivable that Tsutaya Jusaburo would have turned out such empty, ugly and unpleasing prints as those which characterized the late Kuniyoshi and his followers. Even with aniline dyes Tsutaya's taste could have accomplished something.

A major reason for the death of the art was the series of stupid laws passed by the Tokugawa dictatorship restricting the art. From time to time in this essay brief mention has been made of one repressive law or another handed down by the bakufu in hopes of controlling ukiyo-e, which had been early recognized as an incitement to riot and a support for dissident elements. Now we must draw together a brief summary of the government attitude.

1650—Before ukiyo-e began to thrive, the bakufu had promulgated strict laws prohibiting samurai from patronizing theatres or other poplar art forms of the people, an attempt to maintain the martial spirit of the samurai.

1690—By this decade the persuasive nature of ukiyo-e was recognized and numerous laws were promulgated exhorting samurai to keep away from it. These laws were part of the general sumptuary edicts sponsored by the bakufu and the fact that they had to be so constantly republished has been interpreted as proving how difficult they were to enforce.

1714—Kaigetsudo was banished from Edo.

1721—Severe laws were promulgated restricting ukiyo-e, the total suppression of which was attempted but not achieved. Prints were held to be destructive of public morals, a waste of money and a general invitation to levity.

1722—A specific restriction was placed upon Sukenobu's shunga, whose widespread popularity, disturbing to the bakufu, had possibly been responsible for the repressive laws of the preceding year.

1725–1785—In this period many attempts were made to suppress ukiyo-e on two grounds: that prints were a waste of money and that they damaged the national spirit.

† Ota Masao, referring to the social function of ukiyo-e, reflected, "Had the Meiji era come two hundred years earlier, no ukiyo-e would have come into existence." With adequate books, newspapers and reasonable intellectual freedom, ukiyo-e would have been unnecessary.

1789—After a series of increasingly menacing threats, which produced few results, the bakufu decreed that all prints must henceforth bear a censor's seal, the new law apparently going into effect not before 1790. Santo Kyoden (56) was punished. Harumachi Koikawa, the author of a kibyoshi-bon (yellow-covered book)—a type of broadly humorous and satiric little book with ukiyo-e illustrations—ridiculing such laws, was summoned to the dictator but committed suicide instead.

1790—Because times in Japan were generally bad, strict suppression of ukiyo-e was attempted. Certain expensive operations were forbidden and censor's seals were required: kiwame (approved) as seen in the round seal on print 58, or aratame (inspected).

1791—For evading the above laws Tsutaya Jusaburo had half his property confiscated. Santo Kyoden was handcuffed and forbidden to work for fifty days.

1794—As an example of the specific laws constantly promulgated during these years, the application of mica to prints was now forbidden.

1796—Repressive laws against artists and publishers were strengthened, and the government seems to have contemplated outlawing ukiyo-e altogether.

1799—Censorship of prints in draft form was insisted upon, since the abuse had developed of printing an entire run and then pleading with the censors for approval on grounds of the expense so far incurred. There is, however, evidence that censorship of drafts had been in effect before this.

1800—New and harsher penalties were announced.

1801—In this year the bakufu decided to control the ukiyo-e gang once and for all. Publication of prints and books was severely repressed. Toyokuni, Shunei, Shuntei and Tsukimaro, the latter a student of Utamaro, were punished.

1804—Utamaro was punished by three days in jail and fifty in handcuffs for infringing a rule that had been on the books since before 1600.

1805–1840—Numerous laws were handed down. Numerous artists were punished, but it is evident that the bakufu, while empowered to issue edicts, were usually powerless to enforce them rigidly. The most repressive laws were accompanied by the finest prints.

1842—In this year of general famine and trouble, the bakufu, anticipating the revolutions which would soon engulf their dictatorship, moved vigorously to consolidate the nation. The most severe laws yet seen were directed against ukiyo-e. First, the maximum number of

blocks allowable for any one print was eight, since the year before, a print had been issued requiring seventy-eight different colors. Second, prints showing actors or courtesans were prohibited altogether, the bakufu holding that such subject matter added nothing to the martial spirit of Japan. Third and most significant, the bakufu insisted that the proper subject matter for art was the heroic past. Artists were directed to produce prints which glorified that past: battles long ago, samurai dying for their lords, the mythology that was supposed to nourish the martial spirit of the nation. By such spurs Kuniyoshi and his followers were driven to produce their uninspired and endless heroic triptychs in which Japanese history was presented according to the current tastes and requirements of the military dictators. The experiment killed ukiyo-e and did not help the bakufu, for when the rising tide of reform finally engulfed the Tokugawa, who had called forth the heroic nonsense, the propaganda proved hollow. Tokugawa armies collapsed in a manner exactly contrary to the behavior extolled in the prints. In any society at any time there will be many otherwise sensible men who will want to force the art of their nation into the job of glorifying the mythological foundations that are popularly supposed to account for that nation's greatness. Inviting and rational though such a course might seem, especially in times of duress when spiritual encouragement is needed, the result is inevitably the death of art and the weakening of the nation.

Hand in hand with dictatorial intervention went an even more certain destroyer of art: ukiyo-e was dying for lack of an artistic idea. Looking at the vast history of art, good ideas spring commonly from either an inspired individual like Masanobu or Utamaro or more often from international interchange of art forms. When the art of one nation dies away, that of another infuses new life into it and this has been particularly true in Asia. Normally, therefore, when ukiyo-e proved itself run out, some idea should have entered Japan from the outside but such intercourse was as we know prohibited. For example, had there been in the 1830's any interchange of artistic experience with France it is probable that some spark which later flamed into French impressionism would have revitalized Japanese ukiyo-e and thrown it into comparable channels. Enough new vigor would have been generated to have kept the art vital for an entire new cycle. If this theory sounds preposterous, the last chapter of this essay will demonstrate how woodblock prints were ultimately revived by ideas from Norway, Holland and Germany.

But in the 1830's no such ideas were forthcoming. The cross-fertilization which alone keeps art alive was absent and ukiyo-e perished. Once more it is ironic that whereas impressionism, which could have saved ukiyo-e, never reached Tokyo, when the impressionists themselves required new blood, ukiyo-e delivered it to Paris.

For all these reasons, Kuniyoshi's great print of the night raid from Act II of *Chiushingura* is completely tragic (63 A). Here in this magnificent work one sees what Kuniyoshi might have become had he not been driven into his abominable triptychs. Here is a print so pure in artistic concept, so instinct with mind, so powerful in simplicity and poetic in mood as to place it among the very greatest prints.

Working alone in dying Edo—where social, political and aesthetic concepts were defunct—Utagawa Kuniyoshi, twenty-eight when he designed this masterpiece, discovered for himself the artistic principles which would flower almost a hundred years later in the oils of Maurice Utrillo. Here is the same use of white, the same perspective, the same haunting atmosphere and the same mastery of subdued color. It is obvious from this print that Kuniyoshi knew the old-style nonsense was moribund. It is obvious that a really superb artistic genius was at work here, a man who could have progressed to any accomplishment.

It is a tragedy of noble proportion that Kuniyoshi tried repeatedly during his early years to project himself far into the future, foretelling numerous experiments that later artists would make in Paris and London and Philadelphia, only to be dragged perpetually back to those dismal heroic triptychs.

It is difficult to describe what Kuniyoshi accomplished but I should like to mention four prints in addition to the night raid which presages Utrillo. There is an early scene of two men in round straw hats later made famous by Hiroshige standing neck deep in marshy water against a background of rushes. They fish for eels under a leadened sky and the entire print is a poem to nature: the blue mountains, the wonderful representation of water, the toiling rower in the distance, the excellently portrayed rushes bending with the wind and the magnificently suggested sky . . . all accomplished with keen regard for planes, for atmosphere and for the function of airy space. In this print he anticipates much of Cézanne.

There is a mysterious picture of a solitary boatman heading for shore, where curious rocks loom into the moonlight under a cloud-

wracked sky. Down from crevices move two weird giant crabs hidden from the boatman, while a bird sings on a fence. Ryder could have done this print.

There is another Kuniyoshi in which an ethereal woman in an imaginary and mountainous landscape steps strangely forward and with her clog pins down the rope tied to the halter of a superb and monumental horse who kicks high in protest. This is a most striking print, a memorable vision from the brush of a man completely freed from the preconceptions and traditions of his art. Clearly it presages Chirico.

And there is that mad, tormented series in which the faces of human beings are composed of the writhing bodies of smaller human beings. No one could term these beautiful, and even though other artists made similar experiments, these are the strivings of an original mind, of a great authentic man trying to follow new paths when he knows the old can lead nowhere. In such prints he anticipates Tchelitcheff.

The tragedy of Kuniyoshi is this. His experiments were rejected for trivial reasons. When he issued the night raid from *Chiushingura* he offered the public the culminating print in what he intended to be a series of twelve that would rework the old story in clean new lines; but the reception was so unfavorable, was indeed so laughable, that he abandoned the very project that might have saved ukiyo-e. And what was the reason why the public rejected his print? Look at the birds flying in the middle of the print. What is the cone toward which they fly? It is Fuji, the sacred mountain. Kuniyoshi saw clearly that for Japanese artists to continue grinding out pictures of Fuji precisely as it had always been represented would be artistic suicide, as indeed it was. Therefore on his own and without support from similar experimenters working in Europe—although it is known that he studied whatever Dutch paintings he could lay hold of—he stumbled upon the idea of an abstract representation of Fuji. The public would have none of it. They protested that to show Fuji thus was outrageous, so the project was killed and Kuniyoshi went on to his acres upon acres of heroic triptychs.

So far as I know, no major American museum has a copy of this finest Kuniyoshi, but two others are available here that have been frequently cited as masterpieces. However they are in the old tradition and are boring. The first is from a set of ten depicting the life of Priest Nichiren, a much overpraised series reminiscent of Hiroshige in that nine of the prints are quite ordinary and bombastic while the tenth

is a snow scene and rather appealing. It shows Nichiren toiling up the side of a steep hill during a snowstorm and appears in two versions, the first of which has a heavy horizon line where sea and sky meet. In a better and apparently later version, this line is eliminated—constituting an unusual exception to the rule that in ukiyo-e, second guesses result in poorer prints.

The second heralded Kuniyoshi is admittedly the best of his heroic triptychs but unbearably pompous. It shows a wild seascape with horrendous waves on which rides a boat which Yoshitsune and Benkei defend against the ghosts of the Heike Clan, who rise from the deep to attack.† This triptych is well designed and reasonably free from clutter, but it is a windy thing and serves to underline the tragedy of a man who knew in his heart how to design but who was forced by his public, his government, his confreres and his age to do otherwise. What heightens the tragedy is that he was born and died at about the same time as Hiroshige, whose witty mind and crystal eye did remain unperverted.

I have never been able to lament the long and pathetic decline of Toyokuni, who seems to have surrendered his talents wilfully without ever having appreciated his own capacities. But Kuniyoshi was a man of size and when such a man goes down it is lamentable. When he takes an art down with him it is tragic.

It is said that in dark barrooms Kuniyoshi had his entire back tattooed and that he stayed drunk for many days and that he died after long dissipation. Comparing his finest prints with his worst, one can believe these reports.

† Leader of the attack is Tomomori (44) who had drowned himself after having aided Yoshitsune.

23

The Dispersal

At the moment when ukiyo-e was visibly moribund in Japan, it was entering a most vital life in Europe. The history of western art, especially as it focused in Paris, is studded with the impact of Japanese prints upon the mind and style of one western artist after another. A full account of this impact would consume many pages and should properly appear in some book on western art; therefore only the highlights will be noted here.

From 1850 on Paris was aware of the brilliantly colored, artistically arranged Japanese print, for during this decade Felix Bracquemond, a young and gifted etcher, fell under the spell of Utamaro and Hiroshige, forming, from sources that are now unknown, an extensive collection of ukiyo-e. He also became a moving spirit of The Japanese Society, which met in the home of the director of the Sevres porcelain factory, where Bracquemond insisted that everyone eat with chopsticks and drink sake. His work immediately reflected Japanese motifs, for he borrowed from Hiroshige and was for some time a one-man propaganda agency. In maturity, of course, he arrived at his own style in which Japanese elements are hard to identify.

In 1867 the Paris Exposition Universelle exhibited enough prints to make a powerful impression on artistic circles. Journals of that time reflect the impact of Japanese flat color on the western mind and from this time on the reputation of ukiyo-e was firmly established. Other exhibitions followed until there was no artist working in Paris who could have remained unaware of the Japanese influence.

Specific results are easy to identify. Whistler did at least four canvases with obvious Japanese derivations, the most famous being a scene of women on a balcony which he copied directly and successfully from

Kiyonaga. Manet was struck by ukiyo-e prints and filled several pages of his notebooks with sketches so completely Japanese in character that he copied meaningless Japanese characters below them for titles. To his "Portrait of Zola," he added in the background a hulking sumo wrestler borrowed probably from Shunko. Degas' "Portrait of Tissot" uses the same device, this time a screen of Japanese origin replacing the wrestler. And Van Gogh not only found ukiyo-e color, design and spirit completely satisfying, borrowing from it frequently, but in his letters to his brother Theo he specifically reported his infatuation with this free and lovely art.

The most famous exhibition of ukiyo-e in Paris occurred in 1890, when the finest prints from many private collections were shown at the Ecole des Beaux Arts. Among those who attended were Degas, Camille Pissarro and the American artist Mary Cassatt, sister to the austere president of the Pennsylvania Rail Road. So deeply moved were these artists that each went home to try his hand at the Japanese style. Mary Cassatt persevered and in 1891 finished ten excellent prints of which she said, "The set was done with the intention of attempting an imitation of Japanese methods. Of course I abandoned that somewhat after the first plate and tried for more atmosphere."

The prints were among the finest work she accomplished and on April 3, 1891, Camille Pissarro wrote to his artist son, "You remember the effects you strove for at Erogny? Well, Miss Cassatt has realized just such effects; the tone even, subtle, delicate, without stains or seams; adorable blues, fresh rose. . . . The result is admirable, as beautiful as Japanese work." Her two prints, "Gathering Fruit" and "The Bath," are Utamaro throughout. The latter especially, in its bright yellow, its use of a child for design, the flat color effects of the dress, the convention for representing a woman's head of hair and particularly the placement of the signature, recalls the Japanese master.

The effect of this 1890 exhibition was greatest however on Pierre Bonnard, who hung out with a group of artists, writers and musicians in a café near the Academy. They called themselves the Nabis, and Bonnard, because of the spell he was under, was known as "the very Japanese Nabi." His work in 1895 and 1896 could have come straight from Japan, his color lithograph "Woman with Umbrella" having been lifted bodily from the Yoshiwara. Vuillard and Gauguin were similarly affected, but the artist who seems to have digested the ukiyo-e influence with the most satisfying and lasting results was

Toulouse-Lautrec, whose big posters promptly took on a Japanese system of design, line and color.

However, if any of these artists had merely slavishly mimicked ukiyo-e, the influence would have been baleful. Happily that was not the case. What Paris saw in Japanese art was a freedom that was peculiarly the result of ukiyo-e's long years of social protest. I can never forget the biting comment of old Pissarro as he speaks of walking to see the Japanese exhibition. There was a pompous academy show on at the time, from which he and great painters like him had been excluded, and he remarked that over there the big empty canvases were on display, glorifying the official point of view, while ahead lay the true art. One could almost hear Hokusai applauding. It was Gauguin, however, who summarized the meaning of ukiyo-e to the western artist: "Look at the Japanese, who certainly draw admirably; and you will see life outdoors in the sun, without shadows."

How these prints got to Europe is an exciting story in itself. It has long been supposed that they first reached Paris as wrapping paper stuffed into empty spaces to prevent chinaware from breaking on the difficult voyage from Nagasaki. There have always been rumors of extraordinary Dutch collections assembled from such ballast by dock hands from 1750 on. There is probably not much truth in either yarn.

In 1775 a Swedish naturalist, Carl Peter Thunberg, spent a year in Nagasaki working with the Dutch, who controlled European trade at the only port then open. In the course of his work, which earned for him the title of "The Japanese Linnaeus," he made a collection of ukiyo-e, including some excellent Harunobu and Koryusai prints which are now in the Nationalmuseum, Stockholm.

The fact that a Swede easily recognized the merit of ukiyo-e lends credence to the suspicion that canny Dutch sea captains did likewise and that throughout Europe from about 1800 on there were small collections of prints. We know that one belonging to the Dutchman Isaac Titsingh, who had been captain of the Dutch establishment at Nagasaki for some years, was known in Paris as early as 1806, and some years after that prints from various sources began to concentrate there, Titsingh's being sold after his death in 1812, so that by 1850 Bracquemond was able to assemble a respectable collection.

In 1856 the English writer Kinihan Cornwallis published *Two Journeys to Japan*, in which he tells of landing at Admiral Perry's port of Shimoda, where he purchased stacks of ukiyo-e prints. While he was

engaged in doing so a hurried order from the shogun directed that all sales be halted because "the pictures in question would give too good an idea of what was going on in Japan to the people of other nations." Cornwallis adds, "Upon hearing this, some of us at once went through the various stalls before the merchants had a chance to pack them away, and took under our arms every picture we could lay our hands upon."

In its issues from July 7, 1860, on, the British magazine *Once a Week* devoted considerable space to a report of a trip through Japan and illustrated it with woodcut reproductions of ukiyo-e, Hiroshige's landscapes predominating. The next year, Sherard Osborne published in London a book called *Japanese Fragments*, in which ukiyo-e prints were described, and from then on their presence in European cultural life can be taken for granted.

It is interesting to note that the first color reproductions of ukiyo-e outside of Japan appeared in a volume published by the United States Congress in 1856 for the Department of the Navy: "Narrative of the Expedition of an American Squadron to the China Seas and Japan in 1852–54 under the Command of Commodore M. C. Perry, United States Navy." Three color plates were reproduced by a Philadelphia firm, one showing an excellent copy of a view near Kyoto by Hiroshige.†

Interest in ukiyo-e had grown to such an extent by 1862 that a Japanese curio shop opened in Paris called La Porte Chinoise, through which the first great flood of commercially sold prints passed; and a year or two later Arthur Liberty opened his Oriental Warehouse in London for the same purpose.

Then, in 1878, an unusual young Japanese businessman came to Paris and promptly became both the principal salesman of ukiyo-e and the personal advisor to those men who were to form the first great collections. Hayashi Tadamasa is remembered for several reasons. He helped Louis Gonse write the first intelligent occidental account of Japanese art. He did most of the spadework for Edmond de Goncourt's studies of Hokusai and Utamaro. His faint reddish personal seal (31) on many of the masterworks of ukiyo-e is probably the highest cachet of respectability, for if he accepted a print into his own collection, it was genuine. And sometimes in Japan he is reviled because of

† Tomita Kojiro, who kindly brought to my attention the Perry volume, also points out that in 1822 the Dutchman Isaac Titsingh published *Illustrations of Japan* containing a Nagasaki print reproduced in full color. Since Nagasaki-e are often not considered ukiyo-e, this publication has usually been overlooked.

the instructions he sent his wife from Paris when he awakened to the fact that foreigners would actually pay money for what he himself had once considered worthless scraps of paper: Mrs. Hayashi was to wander up and down Japan buying anything that could be called an ukiyo-e. She was to search out old shops and attics and old people who might need money. Regardless of who drew the prints, she was to collect them "like fallen leaves gathered by a bamboo rake." The Hayashis between them pretty well stripped Japan, paying about one cent a sheet before people got wise, up to seven or eight dollars for a good Utamaro with mica background when word got around.

In France, Germany and England huge collections were formed prior to 1900, and some of the prints reproduced in this book once rested with Vever or Koechlin or Mosle. In time a few of these collections found their way into the Louvre or the British Museum, but most of them were dispersed at public sale and came to America.

In the United States more than a dozen truly impressive collections were assembled. Foremost would be that of the Spaulding brothers in Boston, probably the finest ever gathered so far as comprehensiveness and quality are concerned. It contained more than 6,000 prints representing more than 120 artists. There have been larger collections, many of them, but none with the consistently high quality of this.

The collection started inconspicuously. A few days before their ship was to take them from Japan at the end of an extended visit in 1909, the brothers happened to see some prints. No one had thought to show them ukiyo-e before, for the art was held in very low repute, but the Spauldings were bedazzled by what they saw. They had time to acquire only one print, a perfect Hiroshige, but they took it home to Boston with them and before long they were buying avidly, both single prints and entire collections. An enormous number of prints sifted through their hands, but they kept only the best. In 1921 they disposed of their duplicates and rejects at large public auction, from which lesser collectors were able to assemble respectable junior collections.

Their appetites were insatiable, their taste keen and their wealth apparently unlimited. A recent Japanese source book states that in 1913 "the American architect Frank Lloyd Wright came to Japan for the first time and at the request of the Spauldings collected ukiyo-e, spending more than $125,000 in one hundred days." Again in 1919 this source reports, "An auction was held of the property of the Marquis Ikeda of Oyama. The total sale of art works fetched $425,000, but the

ukiyo-e alone brought $87,500, the entire lot being knocked down in one lot to the American Frank Lloyd Wright, who is said to have spent in all on ukiyo-e about $225,000."

Today this superb collection rests in Boston's Museum of Fine Arts, where it constitutes one of our nation's chief cultural possessions. Moreover it is backed up by other collections of staggering richness, notably the enormous Bigelow collection, assembled in Japan in the 1880's.† And in museums near Boston still further important collections are available.‡ As with so many problems of Asian scholarship, Boston, because it was the intellectual capital of the clipper-ship trade, is better stocked with study materials than any other city of the world outside of Peking, Shanghai, Tokyo and Kyoto, and in ukiyo-e it excels even Tokyo in its collections, comes a close second in study materials. Curiously, because our west coast never previously regarded Asian culture highly, one of the poorest places to study Asia is California. However, this is belatedly changing.

The Boston collection is followed closely by that in the Art Institute of Chicago. Here an extraordinarily wise bequest by the wealthy Buckingham family has permitted the curators of the museum to add to an original collection of early ukiyo-e prints, mostly from the famous Fenollosa collection, thousands of superb examples. From Europe, from the big collections near New York and from the admirable collections which were assembled around Chicago in the early years of this century, the museum has acquired a treasure house of masterpieces. Concentrating wisely on the artists prior to Harunobu, the Buckingham collection is unmatched in that period. It contains 119 different Masanobus, 58 different Toyonobus, plus many duplicates. To appreciate the foundations of ukiyo-e, one must study at Chicago.

America's third great collection is in the Metropolitan in New York. Here several fine individual collections have been combined: the Havemeyer, the Phillips, the Mansfield, much of the Lathrop and the choice items of the Ledoux. The collection is noticeably smaller than those of Boston and Chicago and lacks their wealth of either study

† Spaulding 6,000 prints. Bigelow and others 17,000. Modern 1,000. Bigelow study prints, many unique, 30,000. Plus outstanding collections of books, paintings and kabuki playbills. For example, about 700 different Utamaro designs, 500 Harunobus, 500 Kiyonagas.

‡ Fogg Museum, Cambridge, 2,000 excellent prints from Duel and other collections, plus an unmatched collection of 1,200 surimono, and 800 books. Worcester 1,000 fine prints plus 3,000 for study. Springfield and Hartford have good small collections.

materials or supreme individual works. Yet from its prints one can obtain a most excellent understanding of ukiyo-e, exhibited in the most friendly surroundings. It would have been possible to illustrate this book exclusively from the Metropolitan collection, but to do so would have necessitated the inclusion of many works that have become almost hackneyed, so frequently have they been reproduced in both Japan and the United States. The New York Public Library has a large and excellent collection of Utamaro plus many of the better known ukiyo-e books. To study the latter intensively, however, one must go to Chicago, which has a huge library, or Boston, which owns many rare items. Paintings of the ukiyo-e masters are well represented in Boston and especially in the Freer Gallery in Washington, which has a collection unmatched even in Japan.

American public interest in ukiyo-e dates from 1889, when the Grolier Club of New York exhibited 123 prints and 77 illustrated books. The state of scholarship at the time was high, for the prints were properly divided into their proper periods and schools, artists were accurately identified, and dramatic subject matter was usually explained correctly. It is probable that the notes were dictated by some young Japanese studying at Columbia University, for prints associated with *Chiushingura* are catalogued as from the play *The Royal Ronin*, which must represent the young scholar's difficulty with the word *loyal*, which he certainly would have used.

In 1896 a really impressive sale of 447 prints was held on Fifty-seventh Street with a substantial catalogue that summarized research up to that date. Little needs to be changed today so far as the basic principles are concerned, although some of the attributions were too hopeful and have since been reassigned.

One of the curiosities of ukiyo-e collecting in the United States was the intense excitement the art caused in and around Chicago, where literally scores of perceptive men assembled collections, held private exhibitions, horse-traded back and forth and commissioned their own agents to comb Japan. This delightful mania seems to have arisen from a chance display of Japanese ukiyo-e at the Columbian Fair of 1893 and culminated in the wish of the Buckingham family that the Chicago Art Institute build a first-rate collection in honor of Clarence Buckingham. One of the old gang, Judson Metzgar, has recently published a surprisingly frank account of the goings-on in Chicago and has conveyed the

intense excitement these men, not all of them wealthy, derived from competing with one another for the latest shipment of prints from Japan. Another of the Chicago coterie, Arthur Davison Ficke, wrote the finest American book on ukiyo-e, and a third, Frederick William Gookin, helped most of the great American collectors catalogue their possessions.

But it is the return of ukiyo-e to Japan itself that is most interesting. In 1878 Ernest Fenollosa, recently graduated from Harvard with honors in philosophy, arrived in Japan to teach at the University of Tokyo. He was only an amateur in art but immediately recognized the virtue of Japanese classical painting; however, his original contribution lay in his exploratory work with ukiyo-e. During the following twelve years he collected a wealth of prints and it can fairly be said that he introduced ukiyo e to Japan. In return, the government literally heaped honors and decorations upon him and he became an intellectual leader of the new nation. In 1890 he returned to America as curator of the Oriental Division of the Boston Museum of Fine Arts, where his collection of classical paintings had been shipped in 1886 to become the nucleus of today's outstanding Boston galleries. In his new job he started the ukiyo-e collections which were to become the finest in the world.

Twice more he returned to Japan to awaken the Japanese to the treasures they had ignored under their own noses. It was largely thanks to Fenollosa that a few Japanese collectors belatedly entered the ukiyo-e field, but most of the finest prints had by then fled to Paris and thence to America. In 1908 this brilliant and persuasive scholar died in London, but in accordance with his desire his body was taken back to the village of Otsu, where a secluded tomb was built on the Mii Temple grounds from which mighty Benkei is supposed to have stolen the bell (24). There, under a seven-tiered stupa, the inspired American rests, his grave looking down on Lake Biwa and its eight enchanted views.

So far as we know, Fenollosa never met a powerful Japanese industrial baron named Matsukata Kojiro, one of the most dramatic men produced by post-feudal Japan. The son of a legendary samurai who in the first days of freedom rose to be a prince of the realm and major advisor to the Emperor, Matsukata Kojiro became known as the Peter the Great of Japan. He went to Yale for his education and earned three American degrees. Returning to Japan with hundreds of burgeoning ideas for the improvement of his country, he built a huge fleet of ships,

pioneered the first battle cruisers, invented a satisfactory submarine and insisted upon spending a fair share of his profits on English tutors, whom he imported to Japan to teach his employees western learning.

During World War I he was in England, directing many shipping enterprises for the Japanese government and incidentally making a treble fortune in foreign exchange. His younger brother reports, "He was a very lonely man in those days, with barren quarters in Queen Anne's Mansions near St. James Park. In the evening he used to walk across the park to St. James Street, where for want of anything better to do he stared at the windows of the art shops.

"In his loneliness he started to buy Dutch paintings, as if under compulsion. So far as we know he had no personal interest in art whatever and never had a picture in his room. But he became a firm friend of Monet. Brangwyn painted his stocky, black-haired head, and he owned at one time or another every great bronze by Rodin. It's amusing to think that it was Kojiro who paid for the casting of many of the best Rodins now in France. He never bothered to bring them home to Japan.

"In time he assembled one of the finest collections of French impressionist art and came to know most of the artists. This too he left in Europe, scattered about in many different locations. When asked why he bought art so determinedly he said, 'Some day it will inspire the art students in Tokyo.' We hope that by 1956 we can bring it all back to Japan.

"During the worst part of the war my brother heard that the famous Vever collection of ukiyo-e was for sale. Vever had it hidden in Paris and was afraid of bombing or fire. Somehow he spirited it down to Bordeaux, where it remained in storage boxes. He intended to sell it to Americans, but one of Yamanaka's salesmen heard about the deal and went to Kojiro.

" 'Should I buy it?' my brother asked.

" 'By all means!' the Yamanaka man replied, so Kojiro bought the entire collection without ever having seen a single print in it. In 1920 it was shipped home to Japan, 7996 pieces in fine condition. My brother had the world's finest collection of Sharaku, some of the best primitives."

But Matsukata Kojiro's luck was running out. A bank with which he was intimately connected failed temporarily and Matsukata threw his ukiyo-e collection in as collateral. Fortunately, they did not have to be sold; when the bank was salvaged he did not recall the prints but pre-

sented them to the Emperor, who turned them over to the National Museum, where begrudgingly about one thousand of the irreplaceable sheets have been designated as treasures of the nation.

Rumors persist that private Japanese collectors, unknown even to scholars have secret hoards of ukiyo-e which, when added to the Matsukata collection and its satellites in the National Museum, will make Tokyo's collection even more impressive than Boston's. I am afraid this is wishful thinking, but I do admit that I have seen three fine collections which if combined with the Matsukata might challenge Chicago; but they would fall far short of Boston.

In 1937 the Japanese military dictatorship, as if to prove the basic theory of this essay, reacted to ukiyo-e precisely the way the Tokugawa dictatorship had reacted for two hundred years. Prints were condemned as "harmful to the wholesome development of the national spirit." Ukiyo-e collectors were viewed with disfavor and persistent efforts were made to prove that their prints were decadent and un-Japanese. Of course, when the war ended and freedom returned, ukiyo-e —ever a child of freedom and perpetually a thorn in the rump of authoritarianism—was again accepted by the citizenry. But when the next dictatorship hits Japan it is certain that ukiyo-e will again be proscribed as irreverent, irrespectful and an incitement to riot, all of which charges are true.

One of the most amusing results of the ukiyo-e craze that swept the world from 1880 on occurred in Australia, where a talented and apparently wealthy Sydney book designer named P. Neville Barnett published in the 1930's six amazing oversize volumes on Japanese prints. More beautiful books have rarely been printed or bound, and each was notable for its many full-size, handmade woodcut copies of masterpieces imported from the publisher Watanabe in Japan. These prints were handtipped into the books and insured an excellent appearance, but unfortunately the text that went along with them was a sad mishmash of information acquired mostly from American and English books, misinformation acquired from everywhere, and sickening sentiment. What is more surprising is that most of the books were published in editions of less than a dozen copies and that all of the six volumes had about the same selection of prints and same hodge-podge of information. They had, however, been called forth by Barnett's deep love of ukiyo-e and form a curious and affectionate footnote to any study of that art.

In discussing the dissemination of ukiyo-e it is necessary to point out that a good many prints in American collections are fakes. Possibly one or two may even have slipped into this book. From 1885 on there was in Tokyo a flourishing racket of antiquing paper, reconstructing old pigments by chemical means and copying original blocks so meticulously that only a few experts could tell the difference. Ways were found to imitate worm holes,† a special kind of grease was developed which yielded authentic thumb smears and the end result was a print so perfect that it was practically an original, so that no collector need feel ashamed for having been occasionally fooled. Grosser fakes were also rampant, but these were subsequently culled from most of the important collections.

A man whose father helped detect the fakery says, "A brilliant paper maker found that the original paper of Moronobu and Kiyonobu could be imitated exactly by mixing mulberry pulp and dusty cobwebs from old barns in one of the very snowy provinces of Japan. When he tried ordinary cobwebs he found they contained too much dirt and his fraud could be detected. But his finest imitations no one could catch and I suppose many are in museums today."

Now most collectors are on guard, as are all museums. This led to an amusing contretemps a short while ago. An expert finally assembled several score of the most perfect prints uncovered since 1910. But when he tried to sell them to an American museum they were rejected "because they look too clean." Today nobody would think of offering a clean fake. The counterfeits look much older than the originals!

In these ways the prints of Japan traveled to all parts of the world and by curious accidents came home at last to their country of origin. That so many reached America to find permanent residence in our museums will increasingly be recognized as an enrichment of our national culture.

† When holes punched with an awl were detected by magnifying lenses, the counterfeiters actually assembled boxes of live worms to bore through their prints.

24

Japanese Prints Today

KOBAYASHI KIYOCHIKA · HASHIGUCHI GOYO
ONCHI KOSHIRO · HIRATSUKA UN-ICHI

When an art has been as vital as ukiyo-e, there will be many attempts to keep it alive. Kobayashi Kiyochika, who was born two years before Hokusai died and who was eleven at the death of Hiroshige, made the most intelligent effort. He had studied western art from an English painter and introduced many striking innovations into his prints. A single source of light dominates. Shadows are scientifically apportioned. Perspective in the western manner is followed and street scenes have at times a photographic quality. Nature is accurately copied.

Kiyochika was a good artist, capable in both drawing and design, and he had a fine eye for what made up a print. He was in the true ukiyo-e tradition so far as subject matter went, for his prints report the activity of Tokyo, as the great city of Edo was now called. Fireworks at night, the arrival of the new railroad, rainbows on the Sumida River, heavy snow on the Ginza, a shrine in winter, and a large section of the city burning down—these were his subjects. One eerie print, showing a husband and wife hauling a ferry boat upstream through the shadows cast by a full moon is usually considered his masterpiece.

However, his laudable attempts to breathe new life into an old art failed. His prints had an archaic quality about them the day they were issued, whereas Kiyonobu's and Moronobu's time-worn classics seemed younger and more modern each year. His colors were arbitrary and lacking in emotion, while the precision of engraving and printing, carried over from the days of Hiroshige, were quite out of place. In Kiyochika's prints there is a fundamental lack of harmony between

the artist and his techniques, for principles of reproduction appropriate to a stately Utamaro head simply do not apply to what Kiyochika was endeavoring to do. Therefore his prints, alluring though some of the night scenes are and delightful as a few of the nature subjects will always be, demonstrate how empty the classic principles of ukiyo-e had become.

There was, nevertheless, to be one last noble effort to sustain the art, and from this attempt sprang half a dozen really superb prints. Hashiguchi Goyo was twenty years old when this century began. He was a brilliant art student, a fine writer and a good scholar. He won all the prizes at the Tokyo Academy of Fine Arts and excelled in both western and Japanese painting. At the age of thirty-five, and with a secure reputation behind him, he applied himself seriously to the problems of engraving on wood, a subject he had studied for many years and about which he had written, and after mature deliberation he found that he was in complete harmony with classic principles. The artist should draw, the engraver should cut the blocks and the printer, always carefully checked by the artist, should strike off the copies. Furthermore, he found himself quite in tune with the classic subject matter of ukiyo-e, for he had a notable skill in drawing beautiful women. Upon this firm philosophical foundation he went to work.

In all he produced only fourteen prints, and very few copies of those, but they are magnificently done and are numbered among the treasures of this century. They are also the last gasp of ukiyo-e, for they demonstrate, as Kiyochika's experiments had done thirty years earlier, that the classical technique, even when brought to perfection as it is in Goyo's superb prints, conveys little emotion to the modern mind. The line that was once poetic now seems hard. The flat color whose patterns evoked praise from critics throughout the world now seems merely flat. What was repose is now stasis, and what was masterly control on the part of artist, engraver and printer is now rigid formation.

I have spent many hours poring over the exquisite prints of Goyo and agree that in technique they compare with the very greatest Kiyonagas and Utamaros. In beauty of subject matter they challenge Sukenobu or Harunobu. I recognize that the history of art is richer for these fin de siècle works, but I am even more impressed by the fact that they represent the end of the road. Not even the combined energies of Kiyochika and Goyo—the first an experimenter, the second

an avatar—could revive this dead art. Frequently in studying the prints of these two men one finds himself wishing that somewhere the knife had slipped, that somewhere a flood of strong, living blood had got onto the print.

How did Japanese woodblock artists get out of this cul de sac? In December 1953 Onchi Koshiro, one of the leading color-print artists in the world today, made a self-portrait. Onto a slab of ordinary wood he smeared a heavy coating of glue, upon which he wound a thick strand of butcher's cord to form the rough outlines of a human face. When the glue had hardened, Onchi hammered the butcher's cord with a big mallet to flatten it out so that it would yield, when ink was splashed across it, a bold, thick line. Then quickly, on a second rough chunk of wood, he cut several areas onto which ink or tempera or oil paint or anything else at hand could be smeared, and when everything was ready he haphazardly pasted down some kento grooves to give a rough and ready kind of alignment. Then, using whatever paper he happened to have, he jammed a sheet onto the blocks, rubbed it vigorously with the heel of his hand and produced a vibrant, coarse, exciting print.

Onchi, whose masterpiece appears as print 23, says, "So far as the classical ukiyo-e artists are concerned I feel positively no relation to them and no debt to them whatever. Today our attitudes toward art are completely different. In forming my judgments I ignored all classical Japanese work and stepped right into the main stream of European art. It is true that the prints which Kanae Yamamoto did while he was in Holland showed me what could be accomplished with the medium and pleased me very much, but my teachers were the Norwegian Edvard Munch and the Russian German Wassily Kandinsky."

Van Gogh, whose works appeared in Japan long before they were known in America, also influenced Onchi and his group, and after the memorable exhibitions of contemporary European art held in Tokyo in 1913 and 1914 the complete emptiness of classical ukiyo-e patterns was obvious.

It is difficult to explain how completely alien the work of Onchi is to the tradition of ukiyo-e. Perhaps a step-by-step account of how print 23 was made will indicate some of the motives which drive this remarkable artist.

From a Tokyo art shop Onchi picked up eight good blocks of six-

months cured katsura wood, much softer than cherry, much more easy to work. Says Onchi, "Since I wanted to make only one print, it didn't matter to me that the blocks would begin to wear right away. Hiroshige, who had to get at least four thousand copies from his worn out blocks, wouldn't have looked at katsura."

Working from memory and a few photographs, Onchi then drew in rough outline his portrait of a dead poet who had been his fine friend, and here was his only point of harmony with classical masters like Utamaro and Sharaku: the portrait was as idealized as any memory of beautiful women that Utamaro drew.

Slapping the portrait face down on the katsura plank, Onchi rubbed it briskly with his thumb until a faint general outline was transferred to the board. Then, with bold gouges and a hammer, he went to work to cut away the needless portions and here a major and radical change was observed. He says, "In the old days our skilled engravers cut each side of the line deeply and beautifully with their sharp knives. They did this to preserve the line, for their primary job was to copy and to improve the line. That was how they were judged. But we say to hell with the line, for we are not copyists. It is on the board that I really create my picture. Therefore I never cut the line, not on either side. I use this big gouge and cut up to the line, letting things happen as the wood and the gouge decide. For really bold lines, like in the poet's face, I even use this flat gouge and allow the chips to stay wherever they tear loose."

Fifteen blocks in all were cut over a period of three days, and when they were finished rough kento grooves were pasted on to give a ready alignment. Twenty-one different colors were needed, and these were obtained from whatever supplies the art shop had available, at least three quite different media being used.

But as always, it was with the paper that Onchi spent most pains. He says, "It was 1943 when I made this print. We were at war and good mulberry paper was hard to find. I walked all over Tokyo and one evening stumbled on some really fine stuff. Absorbent, vibrant. I bought all of it but used it up pretty soon. Here you see the four different kinds that were used for this print at one time or other."†

Now Onchi began to print. He attempted only three copies, and of

† Of the four blank samples he showed, I easily picked what seemed to be the finest, but the print made on that paper was nearly worthless. The paper he liked, and which yielded magnificent results, looked pretty much like the beaten-up old stuff that Moronobu had used nearly three hundred years before.

these two were useless. Yet he was happy with the result, for he was not endeavoring to mass produce a print but to make one final copy that would be as unique as another artist's canvas. In printing he worked rapidly, freely. When ink spilled over, as at the back of the poet's neck, he was content, because this added a rough strength to the portrait. When lines from the various blocks did not exactly register, as under the left eye, he was again content, because the result was strong. When conflicting media left unassimilated specks across the face of the poet, it was all right, because these specks reflected light and gave the finished product an added vibrancy.

The finished print was immediately recognized as one of the greatest portraits in Japanese art history, partly because it was of a poet whose entire being had rebelled against the militarism of Japan, partly because it was a deeply moving human document. At any rate it was photographed and reprinted many times while the fifteen original blocks, from which only one finished print had been made, lay in a corner.

When General MacArthur assigned a young American to take charge of cultural relations with Japanese artists, one of the first things this intelligent man did was to insist that Onchi run off a couple dozen more copies of his now famous print. Reluctantly the artist dragged out the blocks and assembled enough pretty sad paper for ten tries, but he messed up four of them. There were now seven copies of the print in existence. They sold for lots of dollars.

The young official, recapitulating ukiyo-e history in which foreigners always prized prints more highly than Japanese,† wasn't content with a mere six additional prints and begged for more, but Onchi had by now grown tired of the portrait. So the young American moved the fifteen woodblocks to the atelier of another artist, who ran off twenty more copies, some of them on excellent paper. These too sold immediately for high prices.

The American made a third attempt to get more copies struck off, but by now the katsura blocks were deteriorating. If cherry had been used, and if the blocks had been well cut, the twenty-seven prints so far lifted would have been merely a trial run to get the blocks warmed up for the actual run of two hundred finished copies. But under the modern system the blocks were dead.

† It seems that from the first moment the Dutch at Nagasaki saw ukiyo-e, they recognized their merit. One Dutchman commissioned Hokusai to execute special work for him. A Dutch doctor did the same.

Onchi Koshiro—the name is given in Japanese style and is frequently spelled Onzi—was born in 1891. He is tall and slim, has bushy gray hair, a big mouth, big smile, big rambunctious manner. He wears black-rimmed glasses and his forehead is wrinkled in a permanent smile. He laughs a great deal and lives on the edge of Tokyo with a delightful wife, children and grandchildren. His daughter Mio is exceptionally pretty, jokes with him most of the time, and does his translating for him. She also acts as business adviser but confesses, "Father always says he'll make more copies for the people who come here pestering us for prints. But he never does."

Six copies is about the maximum he has ever made of any print, one being the usual number. Since he often prints from the initial block, then gouges it to make the second block, it is obvious that many of his prints can never be reissued. He has experimented with positively every conceivable kind of material, some of his finest work resulting from hastily cut paper stencils which when brushed vigorously yield a smeared line along the edges. He seems to have a savage contempt for the old traditions of ukiyo-e as if they were a jail from which he had broken with considerable effort. Once, in answer to a pretty formidable questionnaire about art, he scrawled, "I try to work fast. I'm not silly enough to spend days on one job. I enjoy a good life and try to allow my pleasure in living to show through in all I do."

He earns his livelihood as a book designer, is an avid photographer, a keen student of nature, a collector of European symphonic music and an aviation enthusiast. His prints he keeps in a jumbled stack in a corner. He could probably make his living now from selling them, but that would mean conforming to public taste and that he will never do.

Of quite a different character is Hiratsuka Un-ichi (name in Japanese style), whose brilliant black-and-white prints are sold widely, making him one of the few woodblock men in history able to earn a living solely from the sale of prints. Because he has pondered exactly what he stands for in art, I shall allow him to do the speaking.

"I was born in 1895 in Matsue, where Lafcadio Hearn lived. From my earliest days I was fascinated by the powerful coloring of black ink on white paper. Sesshu and the gorgeous Moronobu, that splendid artist, formed my taste, and I have always felt much closer to Moronobu than to Sukenobu.

"Like all men of my generation, I was impressed by the prints made

by Kanae Yamamoto in Holland and saw that he was right. To be a real artist one must cut his own blocks and do his own printing. That's the way Dürer and Bewick worked, and Kanae learned from their example.

"But the most powerful influence I experienced was from a stack of early Buddhist prints. I still keep them over there, and from the first day I saw them I wanted to combine their naïveté with the strength of Moronobu. Later I studied western techniques and think of myself as a fusion of east and west, but the base of my art is the old oriental concept of portraying the soul of whatever subject matter I work with.

"I suppose the old ukiyo-e artists were less vocal in their philosophizing than I, but you can be sure of one thing. Kiyonaga and Utamaro made their physical world conform to their preconceptions of beauty. They never worked the other way around, and the important thing to remember is that their peculiar preconceptions were something they created. That you cannot borrow from anyone.

"I use katsura wood rather than cherry because I want a bold, black line. Some of my students use plywood and get excellent results. Mulberry paper I can't find much any more, so I use a strong mixture of pulp and grass, so that long fibers remain in the paper. I never issue over one hundred copies and usually not more than twenty. To get one hundred, I must print about one hundred fifty and cull them carefully, throwing away one out of three. I take unusual care of blocks, but even so, katsura is completely worn after one hundred fifty prints.

"Like everyone else these days, I'm my own publisher, because the main role of the publisher in the old days was to get a smooth working team together. Today, with no team necessary I felt the organizer wasn't needed. However I notice some of the younger men are going back to publishers because this assures them gallery exhibitions, which are a necessary thing.

"I usually work this way. I draw in very bold rough pencil strokes a black-and-white sketch on quite thin paper. Then I paste it face down on the katsura board so that my pencil strokes show through on the back. Now what you see on my sketch couldn't possibly make much sense to you, because this black line means cut away the wood under it so the paper will remain white, while this line, exactly similar to the first, means don't cut away the wood because the paper is to be printed black. What's worse, as I work I'll change my mind half a dozen times,

so that right now I can't say what any given black line really means. In my mind I have a burning idea of what I want this print to look like and if necessary I would ignore all my original pencil marks to get at that concept. You might say that I do my drawing with my knife."

The prints for which Hiratsuka is famous are his glowing black-and-white studies of classical Japanese architecture. His temples and pagodas, executed in a kind of rough pointillism, are much appreciated, but the print I have chosen with which to end this essay is perhaps stronger and certainly more interesting (7).

The central figure is a puppet doll from Osaka, whose ancient manipulations paved the way for kabuki. She is our old friend, the gay incendiarist O-Shichi, wearing the tie-and-dip kimono design that Toyokuni and Kuniyoshi used so frequently in their worst prints. The face of this doll is masterfully done, for in a few strokes of the knife Hiratsuka has indicated both the wooden head of the doll and the real head of young O-Shichi.

The prints which surround the doll are all by Hiroshige, with whom Hiratsuka feels an emotional identification. In the upper right is "Shimizu Harbor," of which Hiratsuka says, "It is the first print I owned. I remember buying it when I was seventeen. It has honestly never left my mind since them. . . ." In the upper left is Hiroshige's "Cuckoo and Iris," from the same series as 62. Lower left is a view of Edo, showing that part of the city which O-Shichi burned down and the scene where she herself died at the stake.

The print to the lower right has a gruesome fascination for Americans, for it shows that scene from Hiroshige's *Fifty-three Posting Sta-*

7 THE BUNRAKU (PUPPET) DOLL
YAOYA O-SHICHI

Hiratsuka Un-ichi

Location: Oliver Statler.
Signed: Un-ichi Hiratsuka. *Date:* 1952. *Size:* 24⅞ x 19¼.
Publsher: Hiratsuka, whose seal appears lower right.
Technical: Sumizuri-e in ancient tradition, but single block cut and printed by artist. Seal in red, hand stamped: Hiratsuka Un-ichi. Title penciled in English by the artist: Bunraku Doll, "Oshichi."

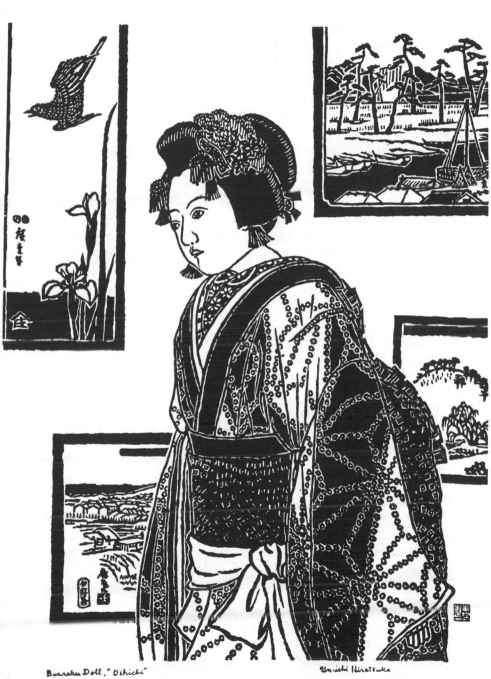

Bunraku Doll, "Oshichi" Un-ichi Hiratsuka

tions on the Tokaido dealing with the village of Hiratsuka, some forty miles from Tokyo. Obviously, the artist chose this print because his family name was derived from this town, but at the foot of this mountain begins a wonderful and sweeping sandy beach. It reaches far to the north and provides prompt access to Tokyo Bay. It is a beautiful stretch of sand, rolling with dunes and easy to approach from the sea. Here, at the foot of this mountain, the United States Army had decided to land in the invasion of Japan. Had this assault taken place the name Hiratsuka would have been forever engraved in American history and thousands of American homes would have been the poorer, for in the mountains of Hiratsuka, Japanese guns were deeply dug in, commanding every inch of the inviting beach.

"These days when I think of America," Hiratsuka says, "I feel as if history is repeating itself. It was you Americans who really appreciated classical ukiyo-e and today it has been other Americans who have recognized artists like Onchi and me. Your soldiers organized exhibitions of our work. You came to our shops, wrote about us and gave us encouragement."

Here Hiratsuka handed me a recent history of ukiyo-e and pointed to the preface: "These modern prints . . . have shown a rapid advance in popularity since the war, stimulated greatly by the warm appreciation of those American connoisseurs who happened to come to these shores." The preface went on to say that it was General MacArthur's young cultural official who in effect introduced modern Japanese prints to Japan.

Then from the pile of treasured Buddhist prints Hiratsuka took down the one which had inspired him as a youth, and it turned out to be the same print that opens this book. Strong, ancient, wood-marked Bishamon looked up as he had eight hundred years ago.†

Ukiyo-e, which had started from rude rough prints, had now returned to the same style. This art, which had vitalized European painting in the late nineteenth century, was now itself revitalized from European sources. Americans, who had once bought up all available classic ukiyo-e prints, were now eagerly collecting modern works with equal affection and understanding. Hiratsuka owes his debt to Hiroshige and

† My decision to write only of Onchi and Hiratsuka among the moderns was made on historical grounds. Contemporary critics in both Japan and America would have preferred that I chose brilliant younger artists like Munakata Shiko (1905–), Saito Kiyoshi (1907–) and Sekino Jun-ichiro (1914–).

a thousand years from now someone in Tokyo will be drawing a new portrait of O-Shichi, who once burned down the city.

Art must move in cycles. The old must come back. The new must become the old and die. There must be continuous interchange. That is why it is sometimes so instructive to follow the life and death of some one particular art.

The Prints

ALTHOUGH this account of ukiyo-e covers the major artists, there are four omissions. It would have been possible to include the following men but only at the cost of not providing an adequate explanation of greater men like Moronobu, Kiyonobu and Masanobu.

The most glaring omission is Choki, a veritable poet, some of whose works would be more highly prized by certain American collectors than any reproduced in thsi book. My apology is that Choki seems to me to be a unique artist outside the main stream. More important, his work has been excellently reproduced in America, especially in the Ledoux catalogue.

The omission of Toyoharu is regrettable from a historical point of view, since he specialized in perspective prints (30) and also produced some amazingly good scenes of Venice done in the Dutch style from engraved copies of European paintings.

Others will object to the absence of Toshinobu, said to be a son of Masanobu, whose lacquer prints are perhaps the most typical of that form, and Eisho, whose large heads of famous prostitutes are one of the minor glories of ukiyo-e. For some years I have kept an Eisho head facing me as I work and although it is a constant pleasure it is a diminished Eishi, a lesser Utamaro and a minor Sharaku.

In selecting prints to be reproduced special effort was made to avoid hackneyed subjects. To safeguard, a compilation was made of all prints appearing in the ten leading publications on ukiyo-e. Included were Ukiyo-e Taisei, Ukiyo-e Taika Shushei, the Ledoux and Matsukata catalogues, and the impressive Vignier and Inada publications. In these ten collections, 8926 prints are available, covering most of the great prints. It is therefore noteworthy that in this present volume 43 of the 65 different subjects have not previously been published in any commonly available collection. Of the 40 prints appearing in color, only four have previously been published in color.

Nevertheless, two familiar subjects do appear. Kiyonobu's vigorous dancer (26) occurs in five of the ten leading sources. Toyonobu's famous portrait of Sanogawa Ichimatsu (34) has also been chosen four times. Probably they should have been eliminated in favor of less widely known prints, but each is so historically important that it was kept.

An effort was made to provide a representative selection of prints. The theoretical distribution of subject matter reported on page 202 helped determine allocations. Thus, portraits of beautiful girls occupy a leading position (for example: 3, 15, 25, 53, 54). Kabuki scenes are common (11, 27, 35, 58). Landscape is portrayed (16, 18, 60, 61). And miscellaneous subjects are particularly well covered (9, 13, 20, 28, 55).

The various forms in which ukiyo-e prints appeared are also represented: books (for example: 4, 6, 8, 12); albums (9); large single sheets uncolored (5, 10, 15); large sheets hand colored (2, 26, 27); and the multicolored print in standard size (51, 56, 59, 61). The curiosities appear, such as simulated stone rubbings (16), uki-e (30), and wash drawings reproduced by woodblocks (20). Unusual forms peculiar to ukiyo-e are also covered, such as pillar prints (47, 48, 49) and bird prints (62).

Readers familiar with ukiyo-e will notice that the well known popular artists like Harunobu, Kiyonaga, Hokusai, Toyokuni, Sharaku, Utamaro and Hiroshige, while represented by excellent and typical prints, are not so well covered as four earlier artists: Moronobu (four prints); Kiyonobu (four); Sukenobu (three); and Masanobu (five). Reasons were two-fold: the more popular artists are well represented in easily available publications; and it is necessary to understand the powerful progenitors from which ukiyo-e sprang.

In the notes that face the prints data relating to kabuki actors, plays and theatres were provided by Yoshida Teruji, who works with today's kabuki theatre and who is an acknowledged authority on that aspect of ukiyo-e. Technical data on non-kabuki prints were supplied by Kondo Ichitaro, ukiyo-e specialist at the National Museum in Ueno Park. Data concerning publishers were provided by T'ys Volker of the Rijksmuseum Voor Volkenkunde, Leiden, The Netherlands. Those acquainted with the literature of ukiyo-e must by this time realize that in the writing of this book I was deeply influenced by Dr. Volker's ideas. What seem to me especially fruitful cross-references to events in western art—particularly western graphic arts—were dug up with much effort by Carl Zigrosser, Curator of Prints, Philadelphia Museum of Art. To these fine scholars I am deeply indebted. However, since occasionally I altered spellings to conform to modern usage as I understand it, and since occasionally I elected to follow some earlier piece of research when it seemed closer to the truth or more illuminating, in a very real sense any errors that appear in the following notes are my fault.

8

To understand ukiyo-e one must understand Edo. And the center of Edo has always been the Nihonbashi (Japan Bridge) from which all distances are measured. It was first built in 1603, practically at the birth of Edo, and around it have revolved novels, great events, many kabuki plays and the drama of Edo life.

It crosses an insignificant stretch of water which today resembles more a canal than a river, but the road that crosses it has always been the main thoroughfare of Edo. Scenes along this road as it approaches or climbs the bridge are common in ukiyo-e, but none surpasses in sweep and documentation this spirited drawing, which appeared in Moronobu's twelve-volume guidebook to the city in those years when it was attaining maturity and greatness.

Center foreground shows five fish peddlers bidding at an auction of the day's catch, while the clerk records prices. Two who have completed their purchases haul them off. Starting across the Nihonbashi (colloquially pronounced Nihombashi) is a group of two-sworded samurai, a servant with a yari (spear) and one with a luggage box. On the river, depicted in traditional way (28), appear boats which will be copied by later artists, always with fine effect.

Much can be learned from this print regarding Moronobu's style. Faces seem as if each had a harelip. Men stand or walk with both knees bent. The print is packed with movement. And wherever even two people stand near each other, there is some dramatic or psychological relationship between them.

Hundreds of thousands of American troops crossed the Nihonbashi during their stay in Japan, and if the determined samurai keep headed in their present direction they will soon reach the spot where the famous Ginza PX once stood.

Book title: Edo Suzume (The Sparrow of Edo). Twelve volumes.
Location: Art Institute, Chicago. *Date:* 1677.
Size: 9¼ x 13¾. *Publisher:* Tsuruya Kiemon.
Signed: The Painter Hishikawa Kichibei, Resident of Edo in the Province of Musashi.

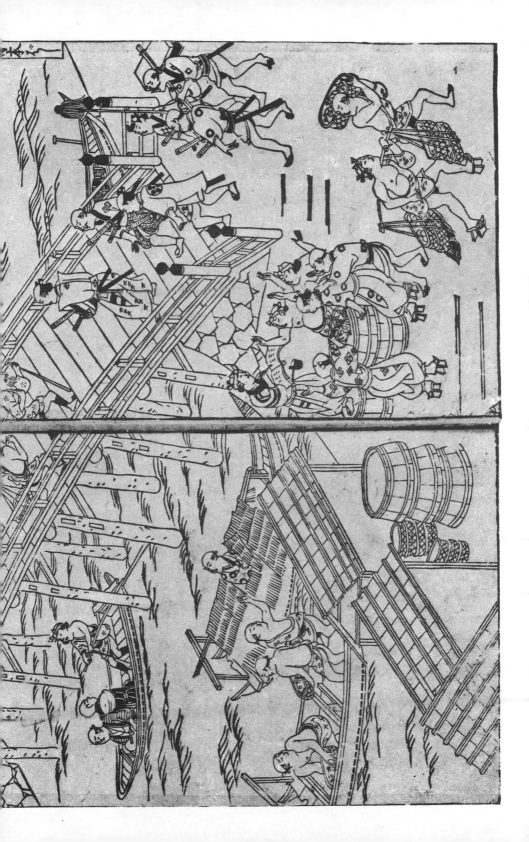

From the moment this book was planned I was determined to include this choice print and it is the only one that was never considered for elimination. It represents the essence of ukyio-e subject matter, the spirit of Tokugawa Japan and the robust quality of Edo life.

Left to right along this Yoshiwara street move a courtesan and her go-between; a blind masseur trailing a samurai who keeps his face hidden to escape identification; a fan vendor; a food peddler; and a bare-legged servant carrying a lantern for his master. A samurai talks with a courtesan, while inside a cage of the Takashima pleasure house another courtesan plays the samisen and her friends sing.

Finding a copy was not easy, only New York, Stockholm and Tokyo having ones that I knew of. The first had been mutilated by some late owner who had colored it to his taste; I wanted to avoid Japanese copies in order to show what was available for study in America, or if necessary Europe; so I applied for permission to use the Swedish copy. Came the reply, "It was with us only on loan. Sold later to an unknown American." Somewhere in the States it hides, the best copy of the three, and I hope someday it will reach a public museum.

This is the New York copy photographed through heavy filters to eliminate the obnoxious colors. It is the only photograph in the book so treated, but I felt that inclusion of this excellent and favored print was a necessity. Then, just as the book was about to go to press, I found in the Worcester Art Gallery the finest example of this print. It had been there for many years.

Album title: Yoshiwara no Tei (Scenes of the Yoshiwara).
Location: Metropolitan Museum of Art, New York. *Also:* Worcester.
Size: 10½ x 16¼. *Publisher:* Yamagataya, at Toriabura-cho.
Signed: No signature. *Date:* 1680c.
Translation: On the curtain at the door: Takashima. (One of Tokyo's finest modern department stores is called Takashimaya.)
Technical: Sumizuri-e. Orihon (Fold Album). This copy hand-colored in completely unappropriate colors by some late owner.

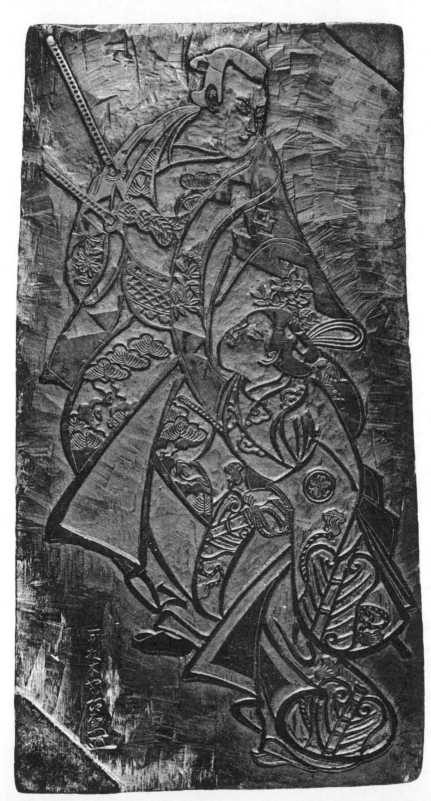

10a, b

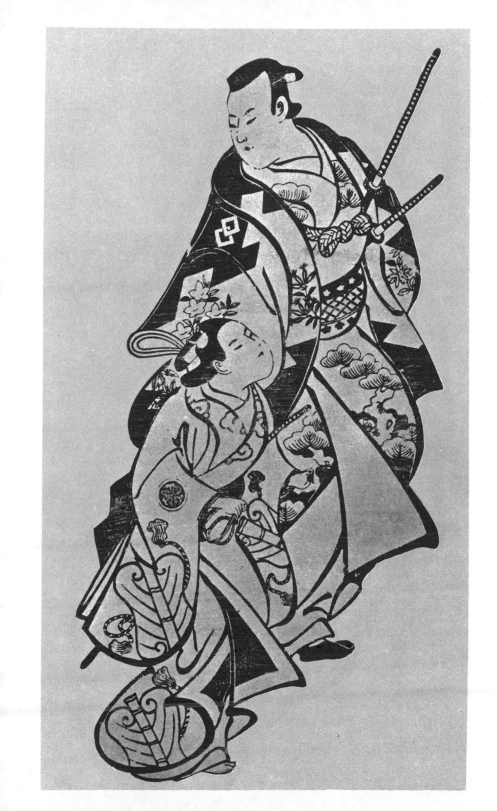

TORII KIYONOBU I

This strong Kiyonobu print is, so far as I know, a unique copy. Badly
stained along fold lines and its few colors completely faded, it is never-
theless a noble thing recalling the formative days of kabuki. For many
years it was supposed to represent *Chiushingura,* not the superlative
drama of 1748 but one hastily thrown together only twelve days after
the events of 1702. Recently the actual text of a quite different play pro-
duced in 1751 was found, with a cover containing a redrawn version of
this print. The play was one of the outstanding successes of Danjuro I.

Narukami, one of the Danjuro family's Juhachiban (Eighteen Best),
tells of the outraged monk Narukami, who uses magic powers to halt all
rain in Japan. To divert him from such revenge, Princess Taema leaves
Kyoto and goes into the mountain retreat where Narukami keeps the
rains tied up. After seducing him, she cuts the sacred straw rope holding
back the waters, and Japan is saved.

The play was either written or commissioned in 1684 by Danjuro I
and rewritten in 1698. It enjoyed long runs in 1710, 1715 and 1726, but
its greatest fame was attained in 1743, when it was completely redone
for Danjuro and Kikugoro (32). Of course, for the 1751 version men-
tioned above it was again rewritten. When I saw the play recently it was
called *Onna Narukami* (Woman's Narukami) because it was felt that
turning the monk into a woman and the princess into a handsome
young man would give the ancient play added excitement. This woman's
version first appeared in 1696. In this way kabuki uses and reuses its
material.

Location: Philadelphia Museum of Art. *Publisher:* Unknown. *Date:* 1715.
Size: 16¼ x 10¾. *Signed:* Torii Kiyonobu zu.
Kabuki: Ichikawa Danjuro II as the monk Narukami, and Nakamura Take-
saburo as the Princess Taema in the performance of January, 1715, in Edo.
The name of the play at this performance was *Bando ichi Kotobuki Soga*
(The Felicitous Soga Play Performed at the Beginning of the Year, the Best
in Kanto) indicating that already the famous story had been dragged into
the Soga world.
Technical: Tan-e, but colors almost completely faded. Three different words
are frequently used immediately following a ukiyo-e artist's signature: ga
(paint), hitsu (brush), zu (draw); from which Tomita Kojiro proposes ga
(pictured or painted), hitsu (brushed or drawn), zu (delineated). Hitsu is
often read in its Chinesy pronunciation fude. Ga is often spelled gwa, which
conforms to the old pronunciation still favored by rural people.

The leading figure in this excellent book illustration is Sukenobu's ideal type and her effect on Japanese art was so lasting that she will be seen walking through the rain, her umbrella high and her neck bent forward, until the last ukiyo-e print is drawn. She will be plagiarized by a dozen artists and whenever the violence of Kiyonobu seems about to gain the day, her fragile beauty will contest the field. She is very Japanese and can be seen today in any village. She explains why Sukenobu is so tenderly regarded.

The woman in the foreground is right out of Moronobu and illustrates Sukenobu's debt to the great forerunner, a fact often overlooked by criticism which deals with Sukenobu only as a Kyoto purist. He was a universal Japanese and signed his work so.

Japanese books are assembled in a special way. Each page is double, the fold appearing at the outer edge of the book, the loose ends being bound together in the middle. For example, this illustration was printed on two quite separate sheets of paper, each the size of this completed picture. The reverse was left blank, of course, since it would never be seen. The other half of the right-hand sheet not shown here contains part of the preceding picture—Japanese books are read from back to front—while the other half of the left-hand sheet contains part of the following illustration. Since this illustration was printed on two separate sheets of paper, it does not quite match at the join. The paper is miraculously thin, and ink from one picture sometimes shows through the other, even though the paper is double, so that when photographing such pictures white cardboard must be inserted into the fold to make the almost transparent paper completely white.

Book title: Ehon Tamakazura (The Vine of Jewels). Two volumes. This print in Vol. I, print 14.
Location: Art Institute, Chicago. *Also:* New York Public Library, two copies.
Size: Double page measures 8⅞ x 12⅝. Picture measures 7³⁄₁₆ x 11⅛.
Publisher: Kikuya Kihei, Kyoto. *Date:* 1736.
Book signed: Yamato-eshi Karaku Bunkado Nishikawa Sukenobu. (Great-Japan Painter from the Flower Capital Kyoto. Literature Hall, Nishikawa Sukenobu.)

Of the ninth-century poet Ono no Komachi little is known except that she was a heartless beauty, a brilliant wit and in her old age a miserable pauper, yet she haunts the memory of Japan. She is counted the most beautiful woman, one of the greatest poets; and imaginary scenes from her life appear in ukiyo-e prints, noh dances and kabuki plays. "Komachi Washes the Book" has her dipping a volume of poems in water, proving untrue a rival's charge that she had stolen her poem from an old source, for the poem washes away, having been surreptitiously added by her accuser. "Komachi Visiting" tells of her demand that a suitor sleep outside her house for one hundred nights before she will consent to marry him. In "Parrot Komachi" she repeats the Emperor's poem with only one syllable changed and gives it new meaning, while in "Komachi Praying for Rain" (18) she saves Japan from a terrible drought by her inspired poetizing. Prints 53 C and 54 show her as a poet while the present one records her final misery. She died near the village of Otsu, where a temple to her memory exists. Even today beautiful young Japanese girls are known as komachis.

Most of the poems attributed to her are by others, but two which seem to be hers catch the poignancy of her verse. "The flowers have faded and I knew it not, kept indoors by the long storm." And, "Out of the despair of my loneliness I cry, 'O that the roots of this waterweed, life, were cut and I swept away by the compelling stream.'" She has been called the Japanese Sappho. For the importance of the book from which this rugged print was taken see page 62.

Book title: *Ehon Yamato Hiji* (Picture Book of Things Japanese). Ten volumes. This print in Vol. II, print 2.
Location: Art Institute, Chicago.
Size: Book 8⅞ x 6⁵⁄₁₆. Picture 7¼ x 5¾. *Publisher:* Six different Kyoto publishers combined to publish ten volumes.
Signed: Nishikawa Sukenobu. *Date:* Drawing started 1735. Ended 1738. Publishing completed 1742.

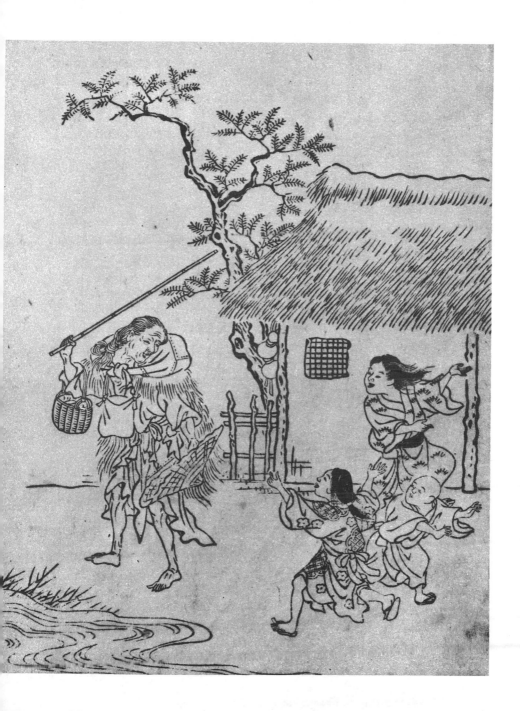

One of ukiyo-e's major mysteries concerns the signatures of the great Kaigetsudo prints. This one reads "Nippon Gigwa Kaigetsu Matsuyo Anchi zu," which translated means "Japanese for-fun-only picture. Kaigetsu Anchi, the last leaf, drew this." Various theories relating to the phrase "the last leaf" are discussed earlier.

This signature, so flowing and so nearly identical on each design (5, 15) shows that Dohan created twelve of the prints and the finest, Doshin only three and Anchi seven, including those with the most beautiful women.

But who these artists were we do not know. Late theories propose that they were all one man, Kaigetsudo Ando, a well-known oil painter who used various names to confuse the authorities, but sober critics deny this. Strangely, we do not even know how these men called themselves, for Doshin can be read Noritatsu, Anchi's name can be pronounced Yasutomo and the characters read Dohan can just as reasonably be read Norishige. Indeed it is by these alternates that the Kaigetsudo are known in Europe and sometimes in Japanese. Dating these remarkable prints has also been done arbitrarily, 1714 having been chosen as a date that seems reasonable.

Whoever the Kaigetsudo artist was—one man or four—and whenever he worked, he created a symbol which has come to represent ukiyo-e: this handsome, stocky woman with round face and brilliant kimono gathered in front who stands like a mighty and imperturbable statue. These are the most treasured of all Japanese prints.

Location: Metropolitan Museum of Art, New York. *Also:* Chicago.
Size: 22¾ x 12¾. *Publisher:* Santaya Kihachi. *Signed:* See above.
Translation: Upper round seal: Anchi. *Eggplant seal:* The trademark, firm name, and address of the publisher Santaya Kihachi. *Square seal:* Takeuchi no in (Seal of Takeuchi), a former owner.
Technical: Sumizuri-e. Kakemono-e.

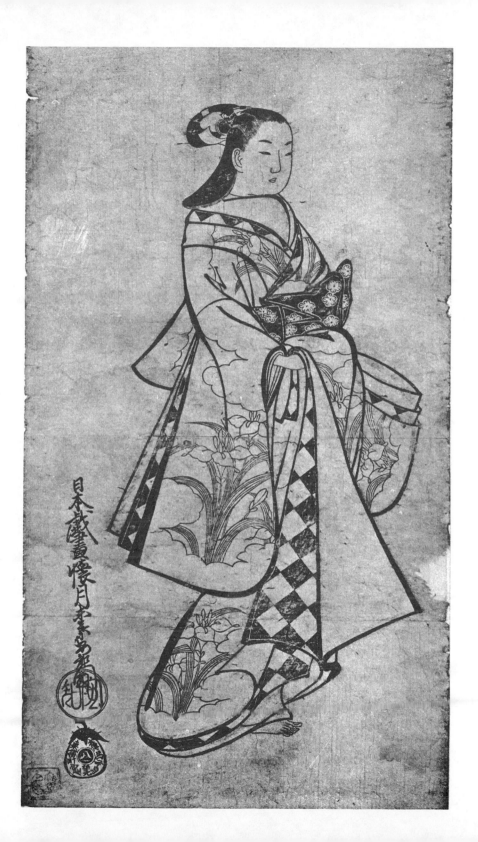

Only thirty-nine copies of these towering Kaigetsudo prints are known, twenty-four in America, seven in Japan, five in France, one each in Britain and Belgium and one momentarily lost in some private collection. Only twenty-two different designs were used, so similar that no one could mistake them. Even the major variations are inconsequential. One shows a woman seated on a box, a second gives the woman a girl attendant, a third has a kitten in the lower left corner. Twelve of the women face the viewer's right as in print 14 while the remaining ten face his left, as in this example.

Each of the known designs appears to be part of a calendar covering two years. Thus the feathers and leashes in print 5 relate to falconry and September. The iris of print 14 clearly portrays May, while the bridge and pine branches of this print indicate January. It is assumed that the two additional designs, now lost, brought the total to twenty-four and that if found they will round out the two-year calendar.

It also seems likely that these beautiful women represented leading courtesans of Edo and that the prints were therefore some kind of advertising for the major houses in the Yoshiwara. The poem held by this courtesan has been translated by Ledoux, a former owner, as, "Morning, evening. Sooner, later. Sooner, later. . . ." It has a Yoshiwara ring, and is probably a cryptic reference to some fashionable saying or song current at the time. Portraits like this of reigning public beauties were always popular and appear through all the various stages of ukiyo-e.

Location: Metropolitan Museum of Art, New York.
Size: 23½ x 12½. *Publisher:* Unknown. *Date:* 1714c.
Signed: Nippon Gigwa Kaigetsu Matsuyo Dohan zu (Japanese for-fun-only picture. Kaigetsu Dohan, the last leaf, drew this).
Translation: For two prominent seals see print 14. *Faint seal lower left:* indecipherable, but probably that of some former owner. *Round seal:* Dohan. *Square seal:* Takeuchi no in (Seal of Takeuchi), a former owner.
Technical: Sumizuri-e. Kakemono-e.

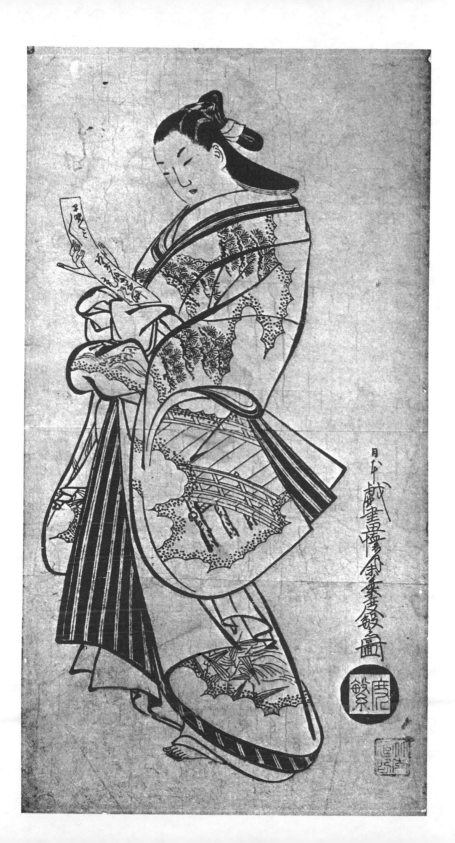

One of the most pregnant approaches to Japanese culture is the novel *The Tale of Genji*, whose final sedate chapters recount the love of two friends for beautiful Ukifune (Lady Drifting Boat). She lives with Kaoru, son of the football player and Princess Nyosan (49 and page 122), but one day Nio, Genji's grandson, visits her while his friend Kaoru is absent and so bedazzles her that she elopes with him by boat across the Uji River (28).

Remorse and heartbreak overtake the three. Ukifune disappears and is judged a suicide. Nio is broken with grief at such result of his action, and Kaoru wanders the countryside a religious convert and a solitary. In the last pages of this great novel he finds Ukifune in a nunnery and sends fresh assurance of his love. She reads the letter but is unable to reply, and Kaoru stands bewildered, unable to comprehend the tragedy that has befallen him.

On this solemn and autumnal passage *Genji* ends, a novel of vast scope and deep insight. It has been beautifully translated into English and study of its poetry-filled pages will lead anyone to the central areas of Japanese thought.

In this unusual print Masanobu recreates the *Genji* mood as Ukifune and Nio elope across the Uji River not far from the town of Otsu on Lake Biwa. The scene recalls certain traditional kabuki dramas in which men lie back in boats and chant poetry while court ladies do the paddling.

Location: Art Institute, Chicago.
Size: 12⅝ x 6. *Publisher:* Okumuraya Genroku, Masanobu's business name.
Signed: Hogetsudo Okumura Bunkaku ga. *Date:* 1740.
Translation: The color of the Isle of Tachibana would not change but I know not the destination of this floating boat. (Lady Ukifune's name means "Drifting Boat.") *Gourd:* Tanchosai, one of Masanobu's trademarks.
Technical: Ishizuri-e (stone-printed pictures) are adapted from Chinese techniques in which stone carvings were covered with paper which was forced into the incisions and carbon was rubbed over what remained exposed, yielding a white-on-black print. Masanobu of course used only wood. The rest of the process was the same, except that he used ink instead of carbon.

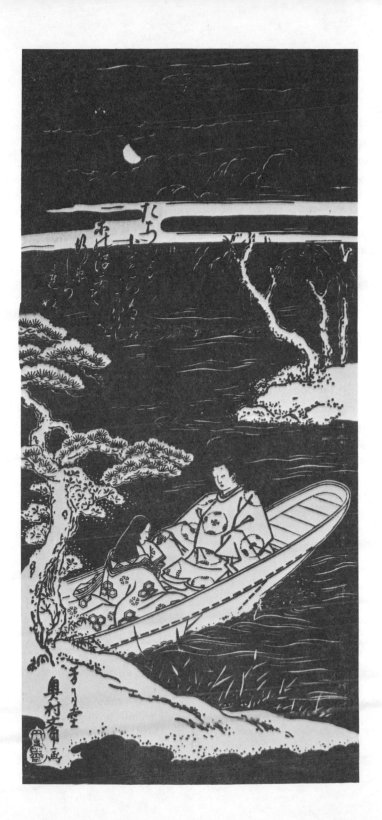

17

Japanese art criticism frequently uses as its supreme accolade the word *shibui*, which cannot be translated but which has been equated to the exercise of restrained and perfect taste. Shibui, for example, is the essence of the tea ceremony. A gold cup inlaid with ivory and jewels à la Benvenuto Cellini would be repulsive, whereas a plain, chipped earthenware mug, dating back four centuries to some Korean hill would, if it demonstrated severe taste, be the living spirit of shibui.

Only two ukiyo-e artists represented in this book have been accorded this maximum Japanese approval: Shunman, whose perfect night triptych is here represented by the right-hand sheet, and Toyohiro, whose exquisite print of the monkey and crab (20) illustrates perhaps even more certainly the presence of shibui.

Shunman, who quit ukiyo-e to become a writer, has left two magnificent prints which gladden the hearts of collectors: a magnificent hexaptych showing the six rivers named Tama, in which pre-Hokusai landscape appears at its best; and the present print, which is part of a triptcyh showing a group of middle-class married people saying farewell after an evening party of poetry reading. The gentle beauty of this work is so immediately apparent, so instinct with shibui, that one immediately is drawn to it, even though shibui itself is not a criterion that ought to be applied to ukiyo-e.

Location: Art Institute, Chicago, which has two copies as does Boston.
Size: 14⅜ x 9⅝. *Publisher:* Fushimaya Zenroku.
Signed: Kubo Shunman ga. *Sealed:* Shunman. *Date:* 1787.
Technical: Right-hand sheet of a triptych printed mainly in black and gray but with soft color showing wherever night lights cast their beams. This convention enabled the artist to indicate night without obscuring his picture with heavy shadows. Also, all parts of the print remain clearly visible.

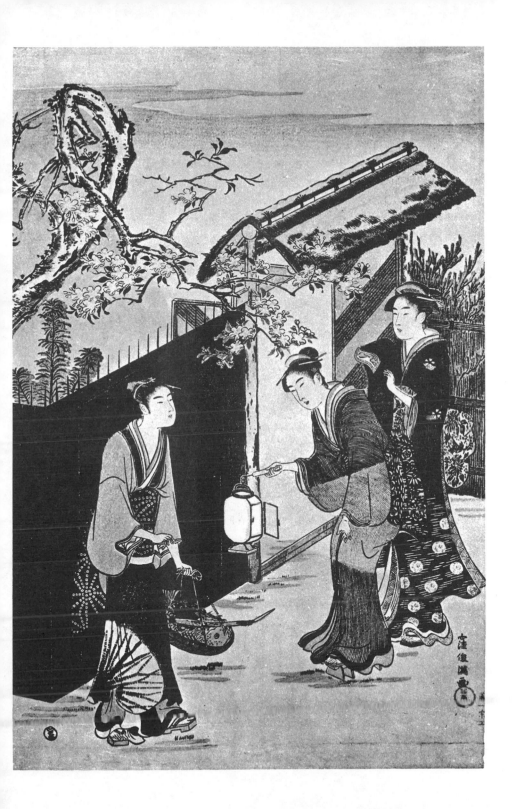

Eishi would merit a full chapter if space permitted for he was the most graceful of all the ukiyo-e artists. Born of a samurai family, he studied classical painting, shifted to woodblocks, with which he made scores of lovely prints, many of which deal with classical subjects, and abruptly quit the field to devote himself to painting in the ukiyo-e style.

He is noted for slender women of patrician grace; for complicated triptychs; for prints done mostly in gray, of which this is a fine example; for dazzling figures against yellow ground (54); and for a few strange women who stand against dark chocolate backgrounds. These latter, considered by most to be his masterpieces, are discussed fully in Ledoux, but I prefer his Proust-like triptychs showing scenes from *Genji* in modern dress. These spacious prints present memorable landscapes, the graciousness of dreamlike figures and exceptional color. Unfortunately, when reduced sharply they lose their quality, and they are so intricately designed that single panels cannot do them justice. They are however available in Boston and Chicago, while Philadelphia has a fine pentaptych of Ushiwaka serenading Joruri-hime, the only five-sheet print I know that is not tiresome.

The present print shows Ono no Komachi (13, 53 C, 54) as she saves Japan by praying for rain after more important personages had failed to end a long drought. As in most Eishi prints dealing with classical subjects, Komachi, the people about her, and their costumes are drawn from contemporary Edo.

Series Title: Cartouche: Furyu Nana Komachi, Amagoi (Seven Elegant Modern-day Komachis: Komachi praying for rain).
Location: Museum of Fine Arts, Boston, which has two copies. *Also:* New York.
Size: 15⅛ x 10. *Publisher:* Izumiya Ichibei.
Signed: Eishi ga. *Date:* 1788.
Translation: Seal: Senichi Han, trademark of the publisher.
Technical: Oban, Nishiki-e. Printed in several shades of gray with slight blue areas in the water, a technique known as beni-girai-e (red-avoiding picture). Although it has long been held that beni-girai-e were the result of bakafu sumptuary laws, that does not seem to have been the case in 1788. It was the reason in the 1840's.

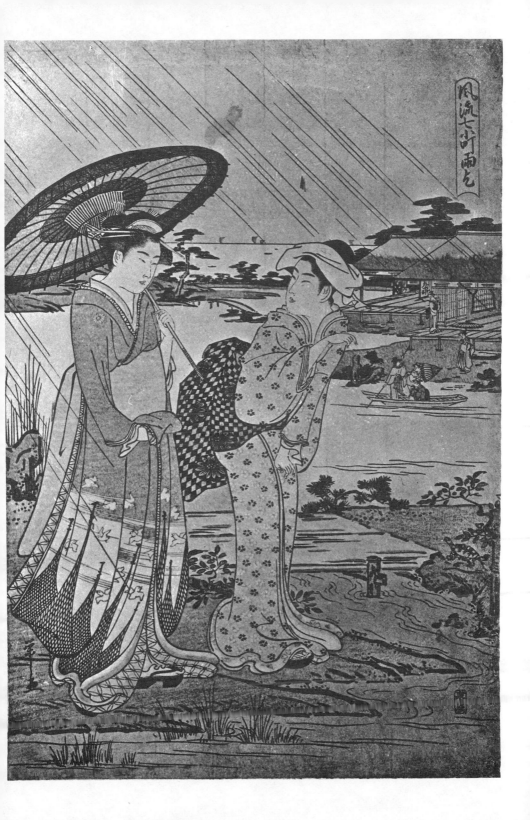

The perfect evocation of ukiyo-e is a curious book called *Shiji Koka* (Miscellany of the Four Seasons), which represents in twelve double-page spreads a visual survey of Edo streets in the year 1798. For variety, vigor and the sweep of Edo life, nothing excels this delightful book.

A foreword explains that the artist-novelist-roustabout Santo Kyoden, who is shown in print 56 and whose masterpiece is reproduced as 55, was accustomed to wander about Edo selling tobacco and making sketches, which were turned over to that excellent artist Kitao Shigemasa, who whipped them into some kind of order.

The print facing shows scenes of the fourth month, presided over by the cuckoo. From right to left, top to bottom, we see a samurai on horseback, a cake seller and a Buddhist. Next come a komuso with big hat and three monks trundling a temple bell and begging alms, the first man bearing a banner which states that a belfry is to be built. The man lower right is pounding rice to make cakes as a shellfish vendor with pole on shoulder passes a jelly merchant. Next comes a man with fish to be sold either raw or cooked, while a servant carries a box of gifts and iris, the flower of spring, to a temple about to be visited by a housewife. The other eleven prints show the brawling, the comedy and the Chaucerian life of Edo, but none is better designed than this. As in most of Shigemasa's work, there is a strangely static quality in even the most active scenes but in a formal fresco, which this book is, such a monumental and posed style is appropriate.

Location: Museum of Fine Arts, Boston. *Also*: Chicago.
Size: Double page 8½ x 11. *Publisher*: Tsuruya Kiemon.
Signed: Kitao Masanobu and Kitao Shigemasa. *Date*: 1798.
Translation: *Upper right*: Fourth month.
Technical: The title of this book has also been read as *Shiki Koka* and *Shiki no Yukikai* (Changing Street Scenes of the Four Seasons).
In western art: Thomas Bewick publishes his *British Birds*, 1797–1804, containing some of the west's finest wood engravings done on small end-grain squares of boxwood.

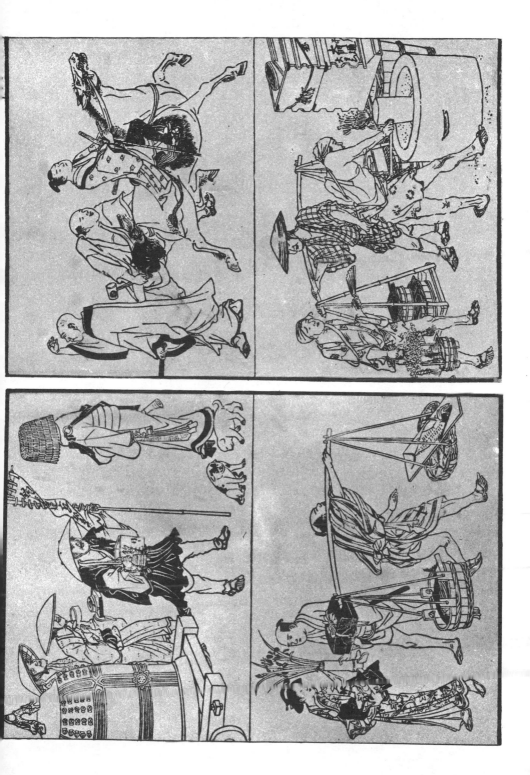

Experienced collectors both in Japan and America when looking over the prints assembled for this book were apt to be blasé. After all, they had known most of these prints for years. However, two fresh and unusual subjects almost always stopped them: this strange, poetic thing and print 63 A, the tragedy of which I recount in Chapter 22.

Monkeys are famous in Japanese legend, where the design "See no evil, hear no evil, speak no evil" originated. One day a particularly clever monkey met a crab about to eat a rice cake, which he was tricked into trading for a dry persimmon seed held by the monkey. The crab accepted his loss, planted the seed, and produced a fine fruit tree but had to ask the monkey to climb it and throw down the ripe persimmons. Instead, the monkey gorged himself, then pelted the crab with hard, green fruit, almost killing him. The monkey's friends—an odd lot: a chestnut, a bee, some seaweed and a mortar and pestle—decided the time had come to punish the arrogant monkey and invited him to a feast in his honor. As he sat by the fire the chestnut hidden within exploded and burned him. When he ran into the kitchen for water the bee stung him and he slipped on the seaweed, making such a clatter that the mortar fell on his head and the pestle on the other end, causing him so much pain that he ran away and never pestered the crab again.

A feature of the monkey in Japanese art is the limitless reach of his right arm. In this perpetually delightful print, showing an earlier trick played on the stupid crab, the arm is relatively short.

Location: Museum of Fine Arts, Boston. *Also:* Chicago.
Size: 14 x 9⅛. *Date:* Probably between 1790–1800.
Signed: No signature, but another copy in Chicago is signed Toyohiro ga.
Sealed: Ryusai.
Technical: Sumizuri-e, but printed from two blocks, black and gray. No key block for monkey in order to simulate fur.
In western art: Francis Wheatley in midst of publishing his mezzotint series, *The Cries of London,* 1793–97.

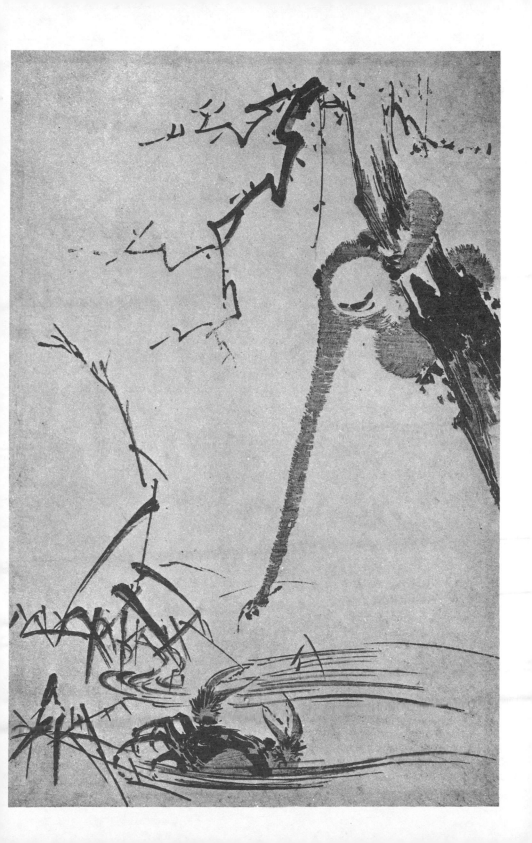

This is the shop of Tsutaya Jusaburo. His trademark, the appearance of which on a print is a guarantee of quality, was the three-peak Fuji enclosing an ivy leaf. This is Tsutaya's new shop in Toriabura-cho, which he bought in 1783. It stood not far from the Nihonbashi (8). As in most Japanese shops, the front came down completely so that in winter the shopkeeper huddled over a brazier or kept his hands muffled as the man extreme left is doing.

Tradition says that this bald-headed man is Tsutaya, friend of artists, innovator of brilliant techniques, poet, novelist and of special interest to all writers because he was the first Japanese publisher ever to pay a living wage to his writers.

Prints were kept in stacks and a good shop would have a good many on hand to choose from. One of the racks shows the golden boy Kintoki with axe, possibly an Utamaro print. Below is a stack of books bound with twine. Behind the sign a man trims prints with a heavy knife, while behind him a second binds books.

Of special interest is the two-sworded samurai bargaining with Tsutaya over an actor print. The Tokugawa dictatorship sternly forbade samurai to interest themselves in such frivolities as prints, which is probably why almost every picture of a shop that has come down to us shows a samurai customer.

Book *title*: *Azuma Asobi* (The Eastern Play).
Location: Museum of Fine Arts, Boston. *Also*: Chicago, New York and New York Public Library.
Size: 10⅜ x 6¾. *Publisher*: Tsutaya Jusaburo. *Signed*: Hokusai.
Date: 1799 uncolored. 1802 colored, but from worn plates.
Translation: *Top of print*: Store selling Picture Books and Ukiyo-e. *Top of store*: Koshodo (Tsutaya's business name) and trademark. *Columns right*: Advertisements of four recent picture books, including one of Santo Kyoden's (56). *Short pillar*: Dealer in Beni-e. Tsutaya Jusaburo, Toriabura-cho.
In western art: Aloys Senefelder discovers the principles of lithography whereby a greasy crayon on grained limestone permits numerous and identical color reproductions of original work, enabling western artists to compete equally with Japanese color woodblock printing, 1798.

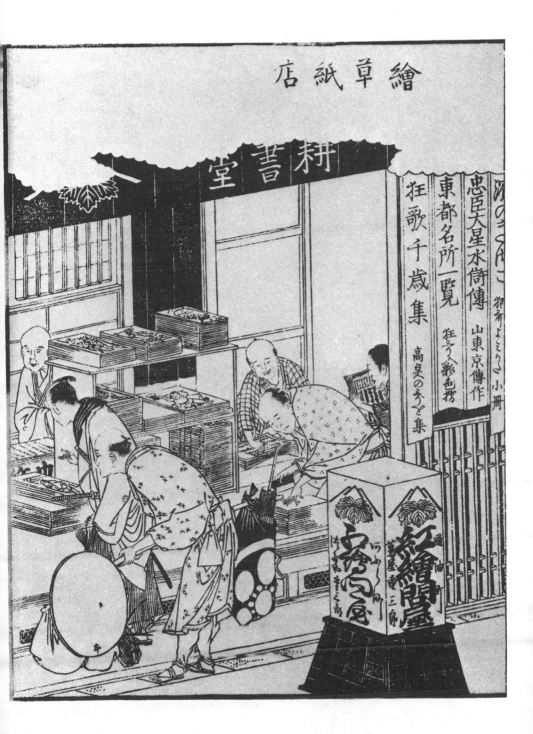

繪草紙店

耕書堂

忠臣大星水傳　山東京傳作
東都名所一覧
狂歌千歳集　高��のうを集

In 1954 A. Hyatt Mayor of the Metropolitan in New York organized an exhibition, mainly of prints, called *Art and Anatomy* in which two pages of Hokusai's *Mangwa* appeared, one showing fat men, the other skinny ones. This was most unkind to Hokusai, for to place his nighly personal interpretation of anatomy against the penetrating scientific studies of Pollaiuolo, Mantegna, Dürer and Rembrandt proved instantly how really little Hokusai knew.

But after this first quick—and accurate—reaction one was still faced by the problem: "Who created the better art?" We know that for apparently haphazard sketches like those of wrestlers, Hokusai sometimes made dozens of the most meticulous drafts, changed them, restudied arms and legs with endless patience to get just what he wanted. We can be sure these writhing figures look pretty much the way he intended.

Pollaiuolo and Dürer got what they wanted: positive knowledge of rounded human structures upon which to build realistic art. In time that realism went to seed and failed to produce new art. Hokusai got what he wanted: an effect of human beings populating a flat world. In time this two-dimensional art also became introverted and stopped producing. So the late European descendants of Dürer borrowed from Japan to revive their moribund art, while the descendants of Hokusai borrowed from Europe to revive theirs. No art form, realistic or otherwise, is good for very long unless it gets new ideas, new exchanges of vigor.

The Metropolitan show permanently killed any claim that Hokusai was a profound anatomist. It underlined the truth that he was a profound artist.

Book title: Mangwa (Sketches from Life).
Location: Art Institute, Chicago. *Also:* Boston, New York, New York Public Library, Philadelphia, Worcester.
Size: 6¹⁵⁄₁₆ x 4¹³⁄₁₆. *Joint Publishers:* In Edo: Takekawa, Hanabusaya and Kadomuraya. In Nagoya: Erakuya.
Signed: The fifteen volumes of the *Mangwa* are signed by Hokusai. *Date:* This volume, 1815. Volume 1, 1814. Volumes 14 and 15, after Hokusai's death.
Sumo (horn-power) *Wrestling:* Within the small ring rimmed by bundles of rice straw, two giants posture and pose for many minutes, then suddenly spring at each other and by means of one clever hold or another seek to force their opponent from the ring or cause him to touch the earth inside the ring with any part of his body other than the soles of his feet. The entire ceremony is conducted as a religious rite.
In western art: Francisco Goya issues his bull-fight aquatints, 1815.

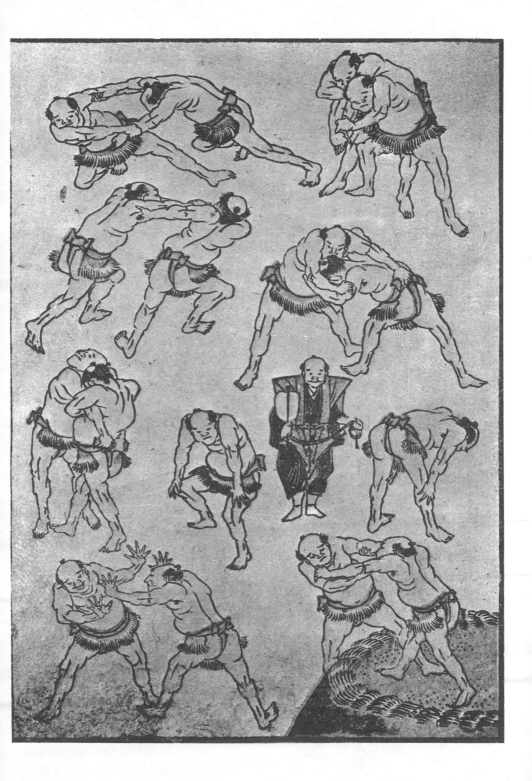

23 ONCHI KOSHIRO

The date of this print, "The Author of *The Ice Island*," is important, for it was done in 1943, when Japanese militarism controlled not only Japan but all of Southeast Asia. At no time was military emotionalism more pervasive and compelling, but Onchi Koshiro produced no posters, no aggrandizement of the momentary mood. Instead he created one of the finest portraits of our day.

Hagiwara Sakutaro was born in 1886 and after publishing seven volumes of nihilistic poetry died in 1942, completely overwhelmed by life. Of him Onchi says, "In dictatorship he saw only massive tragedy, spending his days in drink, his nights in nothingness. When he left my home there would be a circle of cigarette butts in the hibachi." Says Onchi's daughter, "In France, Hagiwara would have been a new Baudelaire. In Tokyo we were not ready for him."

Eight reasons explain why Onchi's work should not be considered a part of ukiyo-e: 1, Originally he made only one copy of this print and considered it a painting. 2, He had no desire to issue many copies and sell them widely and cheaply. 3, Although the subject matter resembles that in print 56, this print was not created in harmony with the times or for the mass populace. 4, Onchi did all the work, the designing, drawing, cutting, printing. 5, In cutting the wood no attempt was made to copy line or achieve perfect registry. 6, The basic designing was done with the knife and not the brush. 7, Style and spirit are European or international, rather than Japanese. 8, The entire Chinese-Japanese tradition of both painting and ukiyo-e has been ignored.

Location: Oliver Statler. *Also:* Boston has one of the copies struck off by Onchi's friend and pupil Sekino Jun-ichiro.
Size: 20¾ x 16⅜. *Publisher:* Onchi. *Date:* 1943.
Signed: Onzi. Signature applied by means of a separate stamp. Sealed with a German K in a circle (for Koshiro).
In western art: John Taylor Arms, Thomas Hart Benton, Aaron Bohrod, Adolf Dehn, William Gropper, Helen West Heller, Yasuo Kuniyoshi and Lynd Ward active in American prints.

This not a print. It is a painting from Otsu and was done in about eight minutes. No subject for an Otsu-e could be more appropriate, for it shows the wandering priest Benkei, possibly a real man, but also a legend, who plays Little John to Yoshitsune's Robin Hood. Eight feet tall, strong as a hundred men and accustomed to ten gallons of soup, he became a wandering priest and from Kyoto sneaked over the hills to Otsu, where he stole the bell of the Mii Temple near Mount Hira (61). He lugged it back to his own gang of warrior monks, where the bell refused to sound, whimpering only, "Take me back to Miidera." Enraged, Benkei kicked it all the way back, scratching it deeply. In 1954 this giant bell of Miidera was exhibited in Tokyo, weighing nearly a ton and showing deep scratches which have never been explained but which Japanese like to believe were the result of Benkei's rage.

Once Benkei stationed himself on a Kyoto bridge and bullied all comers until he had collected 999 swords. His next opponent was Japan's foremost hero, Yoshitsune, who although only a youth, defeated the braggart, who became his servant. This fight appears often in Japanese art and for years it was assumed that print 28 depicted it.

Benkei is also the hero of the famous kabuki play *Kanjincho*, in which he saves Yoshitsune's life by some fast thinking. This role, one of the most sought after, allows the actor to pose, posture, dance, get drunk, beat up his master, indulge in wise cracks and make what is probably the most memorable exit in any theatre.

Location of this painting: Museum of Fine Arts, Boston.
Size: 13⅝ x 9¾. *Date:* Unknown, but later than 1780.
Signed: No signature, but a few Otsu-e of this type were signed by artists of whom nothing is known.
Translation: Tokaido Otsu Juku Sekisenen (Otsu Station on the Tokaido, at the Garden with the Spring Near the Barrier).
Iconography: Otsu-e were sometimes used as religious charms. This subject was guaranteed to protect a home from fire and theft.
Technical: Otsu-e. Single sheet. One of the ten traditional subjects of fourth period. Tsurigane Benkei (Benkei with the Bell).

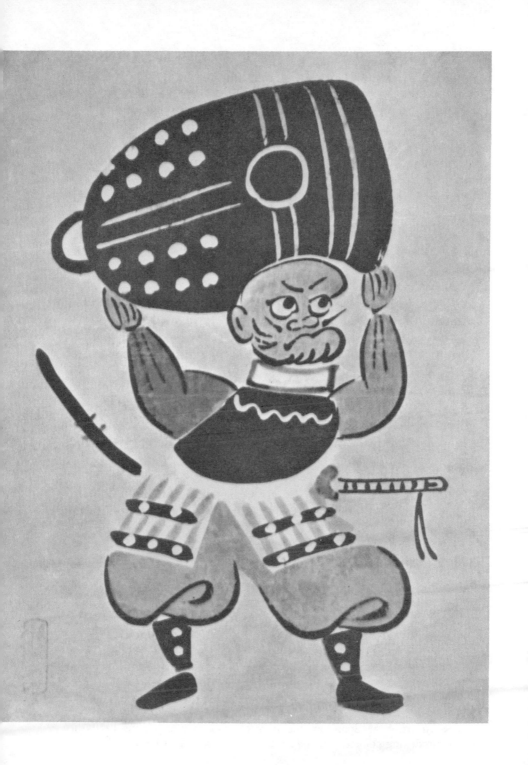

This print has always been attributed to Moronobu, but many who have studied it have wondered if it might not more properly be ascribed to a later student. Japanese critics claim the woman lacks the Moronobu face; but all agree that this print is a fine example of the first hand-colored sheets. Other prints concerning which questions of attribution must be raised are these:

Print 2. Probably Moronobu but not signed.

Prints 3, 28. Signed Kiyomasu, but we don't know exactly who he was.

Print 10. Carving on block lower left later than block, and therefore not a signature, but portrait of Shichisaburo resembles others signed by Kiyonobu.

Print 20. Not signed, but a copy in Chicago is.

Print 22. Regarding any page from the *Mangwa* one must ask, "Did Hokusai do it or one of his collaborators?" This is pretty surely Hokusai's.

Print 26. There has been much argument over this but it seems to be by Kiyonobu I.

Print 27. Signed Kiyonobu but sealed Kiyomasu.

Print 31. Not signed, but another copy with faded colors is.

Print 39. Not signed, but a later version is.

Print 41. Not signed, but a companion print from the pentaptych of which it is a part contains Shunsho's tsubo seal.

Print 56. Signed Eiri, but we don't know exactly who he was.

Prints 4, 8, 9, 12, 13, 19, 21, 22 are unsigned but are from books or albums either signed or clearly attributable because of other documentation.

Location: Art Institute, Chicago.
Size: 21¼ x 12. *Date:* 1688c.
Technical: Tan-e. To a sumizuri-e outline color—usually red lead, yellow and olive-green—is added by hand often not by the artist but by skilled old women who handle stacks of two hundred prints at one time. Ichimai-e. Kakemono-e.
In western art: J. M. Papillon, historian of woodcutting, claims his father started producing colored wall paper from woodblocks in Paris, 1688.

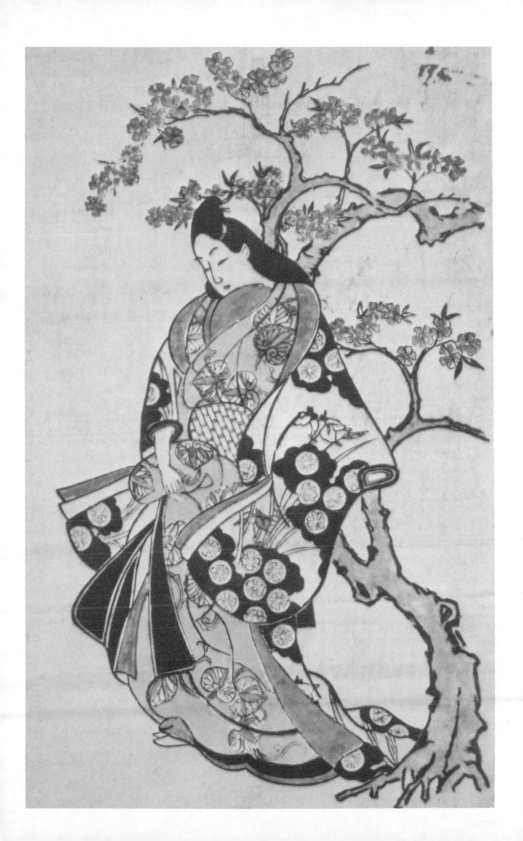

This big print, made from two sheets of paper pasted together in the way Rembrandt pasted his paper from Japan—which he reserved for his finest work—presents many problems. It is universally held to be one of Kiyonobu's greatest and most representative works, yet it is not signed and the only copy bearing an artist's name is clearly signed Moromasa. It appears in three forms: the present published by Igaya, another by Yamamoto from the same blocks, and a third by Yamamoto in a completely recut version. Furthermore, half a dozen excellent forgeries seem to have been published contemporaneously. When it first appeared in Europe it was credited to Masanobu, which is understandable since Masanobu plagiarized the subject (Metropolitan No. 546).

Its popularity is understandable, for the print epitomizes Torii tradition. A little larger and it could serve as a theatre signboard, for it was intended to hold the eye and invite the body to dance. Its disposition of space is admirable, its use of symbols artistically brilliant. Observe how the second yari, thrown into the picture arbitrarily, repeats the parallel lines of the dancer's feet and knees and swords and shoulders. I know of no better print in America with which to demonstrate the vigor of Torii art.

The actor is a Kyoto man, Tsutsui Kichijuro on his initial appearance in Edo. In 1691 another Kyoto actor on his first appearance had created a sensation with this spear dance, so all subsequent arrivals had to mimic him. It was, as can be seen, a lively dance which poked fun at women who make a fuss over spring cleaning. A contemporary poet wrote, "Everybody dances with spears . . . no, it's broom or duster. O, joy of house cleaning!" The fact that two yari, the plumed staffs of the daimyo's blustering servants (8), were used to represent a woman's feather duster added to the mockery of the dance.

Location: Museum of Fine Arts, Boston.
Size: 21 x 12⅜. *Publisher:* Igaya. *Date:* 1704, from theatrical records.
Translation: Kyo Kubari (lately arrived in Edo from Kyoto) Tsutsui Kichijuro. *Left seals:* Of former owners. *Square seal:* Can be read in part, Treasure of the House. *Right seal:* Publisher Igaya at Motohama-cho.
Kabuki: This trivial and spontaneous dance was known as the Yariodori (Spear dance) and was an enormous success for a few generations, then died out and was forgotten. Nakamura Theatre.
Technical: Tan-e. Ichimai-e. Kakemono-e.

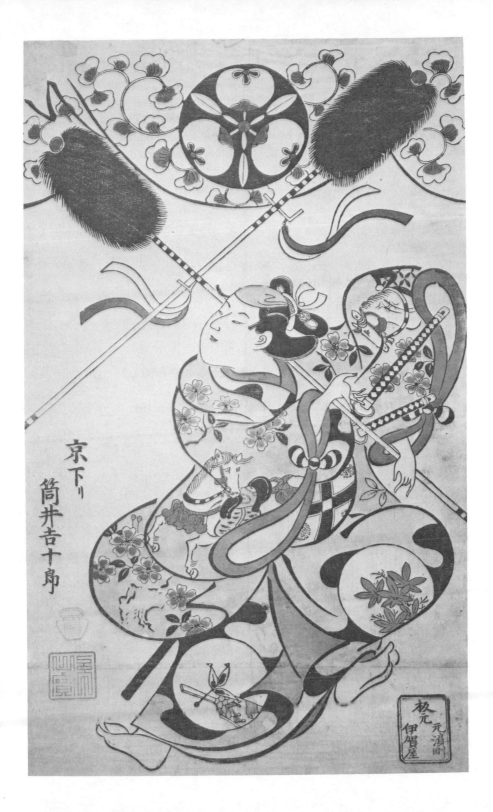

This fine large print is in better condition than most Kiyonobus and represents the famous actor Sanjo Kantaro as the lovely incendiarist Yaoya O-Shichi, who in 1683 burned Edo for love, accompanied by the temple page Kichisaburo, played by the lesser known actor Ichimura Takenojo.

It is now appropriate to review the types of theatrical prints offered in this book:

Kabuki play derived from a noh dance, which preceded both puppets and kabuki, 37.
Puppet doll, also representing Yoaya O-Shichi, 7.
Early aragoto (rough-thing) drama, 30.
Early nuregoto (wet-thing; i.e., tear-jerker) drama, 10.
Juhachiban of the Danjuro family, 11, 30, 42, 45.
Incidental dance interlude, 26.
Dance within a play, 29.
Shosa (place where something is done), a dance interlude with musicians on stage, 51. A make-believe shosa, 38.
Musical interlude introduced because particular actors happened to be musicians, 35.
Traditional actor print, 29, 41–46.
So-called big-head actor print, 57, 58.
Portraits sold mainly because they represented matinee idols, 31–34.
Famous theatrical lovers presented as they were in real life, 36.
Scenes from six of the most famous plays:

Sugawara Denju Tenarai Kagami, 43, 57.	*Sukeroku,* 42.
Yoshitsune Senbon Sakura, 44.	*Shibaraku,* 45.
Musume Dojoji, 46, 38.	*Chiushingura,* 48, 63.

Location: Museum of Fine Arts, Boston.
Size: 21¾ x 12½. *Publisher:* Komatsuya Dembei.
Signed: Torii Kiyonobu but sealed Kiyomasu. *Date:* 1718.
Translation: Round seal: Kiyomasu. *Square seal:* Komatsuya at Yushima Tenjin Onnazaka no shita (his address).
Kabuki: The name of this play *Nanakusa Fukuju Soga* (The Felicitous Soga Play of Spring) indicates that lovely Yaoya O-Shichi had already been dragged into the Soga world. Ichimura Theatre, 1718.
Technical: Tan-e. Ichimai-e. Kakemono-e.

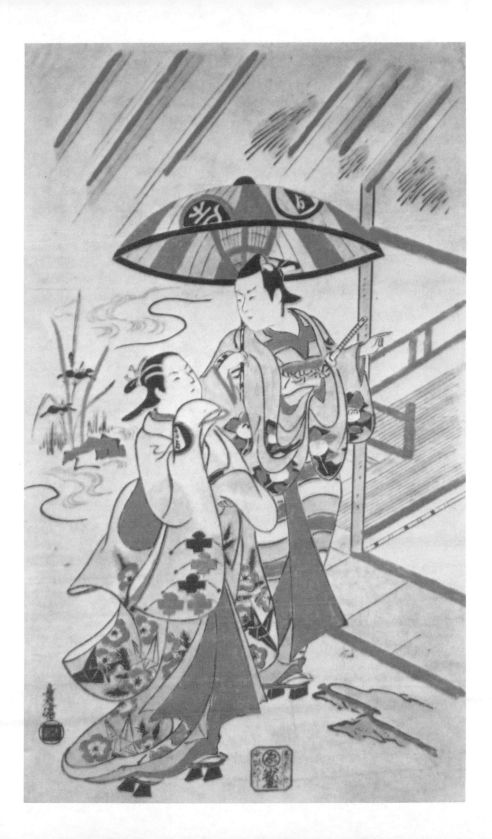

This violent scene represents the big colorful sheets at which Kiyomasu I excelled. It is in fine condition and shows the verve with which Torii artists attacked their work.

For many years it was catalogued as Ushiwaka humbling Benkei (24) at Gojo Bridge in Kyoto, a subject to which many spirited prints have been devoted. Benkei, a bully, stationed himself at the bridge and appropriated 999 swords of travelers whom he assaulted and vanquished. He was delighted when he saw that his next adversary was a handsome young dandy mincing along, and with a vicious swipe he sought to cut the boy down. To his amazement the youth, young Yoshitsune while still using the name Ushiwaka, fought Benkei to a standstill, whereupon the bully swore perpetual allegiance to the boy who was to become Japan's greatest hero.

Unfortunately, this print shows a different Kyoto bridge, another pair of warriors. Once when Yoshitsune's army ripped up the planks of the Uji Bridge to prevent the Taira clan from attacking them, a brave Taira leader, Tsutsui Jomyo, dashed upon the remaining crossbeams and challenged the field. The young soldier Ichirai Hoshi leaped out from Yoshitsune's force and fought with Jomyo an entire afternoon. Here Hoshi springs upon Jomyo's head in a daring trick which saved him from sure death.

Observe how the Uji River is indicated and the Torii manner of contorting faces to underline drama. This print, while lacking the powerful design that marks Kiyomasu's best theatrical scenes—none of which seem available in good condition in America—is the finest of its type in our major museums.

Location: Museum of Fine Arts, Boston.
Size: 20½ x 12½ but trimmed at bottom. *Publisher:* Seal cut in half but Volker suggests possibly: Iseya Ichibei. Kondo suggests that it could read: Publisher Igaya at Motohama-cho.
Signed: Torii shi Kiyomasu zu. *Date:* 1716.
Translation: Seal left: Probably publisher's. *Seal right:* Probably Kiyomasu.
Technical: Tan-e. Ichimai-e. Kakemono-e. This print well illustrates the two half-derisive epithets thrown at Torii art: hyotanashi (gourd legs) and mimizugaki (wriggling-worm lines). The former were supposed to create an illusion of violent strength. The latter represented twisting vigor.

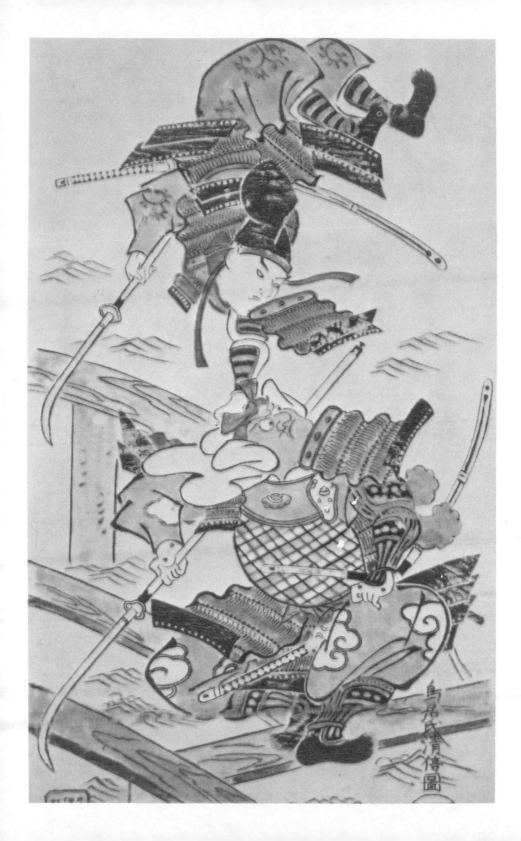

29 TORII KIYONOBU II

With this spirited and beautiful print of Danjuro II dancing in the role of Soga no Juro it is time to review certain technical terms used in ukiyo-e.

Sumizuri-e (ink-printed picture): prints 3, 5, 7, 9, 10, 14, 15. With two blocks: 20.

Tan-e (tan-colored picture): prints 25, 26, 27, 28. Also 2, 11.

Urushi-e (lacquer picture): prints 32, 34, 57. With gold dust: 29.

Beni-e (beni-colored picture): these are colored with beni (a rose-red from madder or saffron) by hand and are difficult to distinguish. I have never seen one in America.

Benizuri-e (beni-printed picture): original form containing only beni, apple-green and black: prints 35, 36. Later form in which blue and yellow were added: 37, 38.

Kira-e (cloud-mother, i.e. mica, picture): prints 53 B, 58.

Kurenai-e (deep-red picture): another name for beni-e.

Nishiki-e (brocade picture): all prints from 39 through 63 plus 17, 18, 23.

Ishizuri-e (stone-printed picture): print 16.

Beni-girai-e (red-avoiding picture): print 18.

Uki-e (bird's-eye picture): print 30.

Ehon (picture book): prints 4, 6, 8, 12, 13, 19, 21.

Location: Chicago.
Size: 13 x 6⅜. *Publisher:* Igaya.
Signed: Torii Kiyonobu hitsu. *Date:* 1733.
Translation: Seal: Publisher Igaya at Motohama-cho.
Kabuki: The name of this play *Hanabusa Bunshin Soga* (The Soga Play Performed by Father and Son Who Are Like a Flower) indicates that Danjuro II "divided his body" and played both of the Soga brothers, Juro and Goro. As if that were not enough, Sukeroku (42) was also added to the Soga world. The mon on curtain right is read kotobuki (happiness) and is a good-luck word for January, when the Soga play was traditionally performed. The left mon is Danjuro's. Ichimura Theatre, 1733.
Technical: Urushi-e. Gold dust liberally sprinkled. Hoso-e.
In western art: William Hogarth publishes his *Harlot's Progress*, a set of engravings, 1733–34.

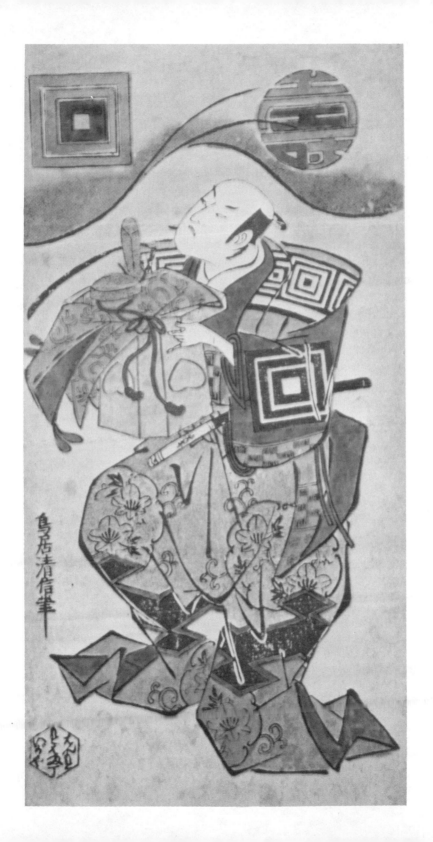

This print is important for several reasons. It can be dated precisely. It proves that Masanobu issued uki-e (bird's-eye pictures) based upon European perspective derived from the Dutch. And it shows the inside of the Nakamura Theatre.

The stage still retained the basic design of a Shinto shrine, which even today is used for noh plays and was traditional for Japanese wrestling down to 1953, when television required the removal of the four corner posts. The hanamichi (flower walk) is shown left and demonstrates why a robust exist, marked by mannered gestures and wild shouting, could be impressive. Musicians sit left; the playwright, considered a hack of no importance whatever, sits right and bangs the blocks to mark moments of climax.

Kabuki plays started at dawn, lasted till dusk. Because of fire hazards, no lights could be used, so huge open windows marked the upper floor of the theatre.

Location: Art Institute, Chicago. *Also:* Boston.
Size: 18¼ x 26¾. *Publisher:* Masanobu.
Signed: Okumura Masanobu shohitsu. *Date of this Performance:* December 19, 1740.
Translation: Right pillar: Yanone Goro. Performance by Ichikawa Ebizo. *Left pillar:* Names of three types of dances to be given, Okina, Senzai, Sambaso. *Central pillar:* Admission 16 mon. *Tablet over stage:* Purification, ten thousand times. *Legend right:* A perspective picture showing a view of a kyogen play stage. Shop located at Torishio Street, the picture wholesaler at the sign of the gourd, Okumuraya Genroku the publisher. *Legend left:* Foremost Edo picture by Hogetsudo Tanchosai Okumura Bunkaku Masanobu, his authentic brushwork. *Gourd seal:* Tanchosai.
Kabuki: The play *Miyabashira Taiheiki* is part of the Soga world and was given at the Nakamura Theatre in 1740 with Ichikawa Ebizo, formerly Danjuro II (29) as Soga no Goro, who is seen sharpening his arrows prior to New Year's Day. A dream will show him his brother Juro in trouble, whereupon Goro will dash into the street, fight with a radish merchant, steal the man's horse and make a tremendous exit down the hanamichi, brandishing the radish and shouting wild threats. The chanter is Ozatsuma Shuzendayu, the samisen player Kienya Kisaburo.
Technical: Tan-e. Very large size. Uki-e.

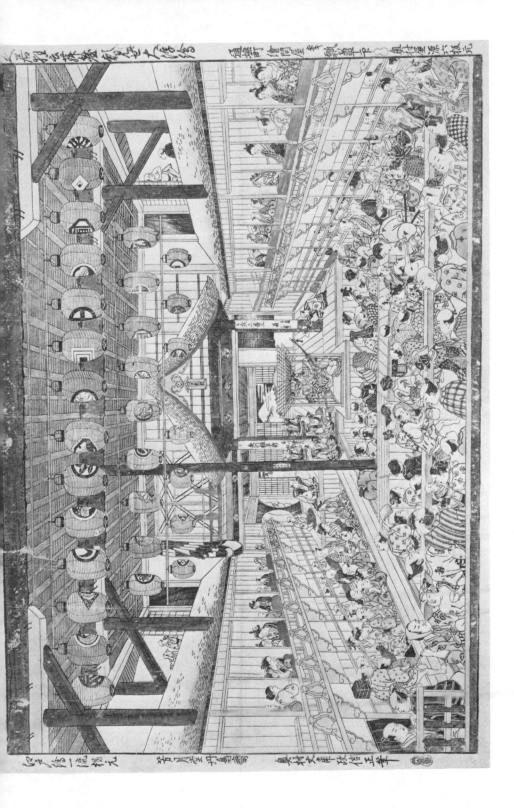

In illustrating how publishers worked, the next four prints are the most interesting in this book. Early in the life of print 32 the block split vertically along a line from the actor's left heel, up through the middle of the hat and over the left shoulder. Boston has two copies showing this split, which mars but does not ruin the print. Later the split widened, making additional prints impossible and Masanobu, who served as both artist and publisher, must have been tempted to discard the block. Instead he sawed it trimly down the split and continued with the left half, from which he sold distinguished pillar prints (Vignier-Inada, I, 128).

The head appearing on this print became so popular that it was copied identically on many other Masanobu prints. No doubt one of Masanobu's skilled cutters specialized on this head and was handed roughed-out sketches and told to "supply a good, standard head."

Possibly blocks 31 and 33 also split and were trimmed down to their present narrow size, but since I have seen no unsplit versions the assumption is not a good one. At any rate, prints 31, 33 and 34 show one of the most phenomenally popular actors of all time, Sanogawa Ichimatsu I. Women pestered him with love letters, proposals, and gifts. They haunted his cosmetic shop and applauded him when he appeared on the street. The cloth shown in prints 33 and 34 became the rage of Edo and is still sold today as "the Ichimatsu pattern."

His acting style was derived from that of the heavenly Nakamura Shichisaburo (10 B) and enjoyed the same kind of popular success, although he was not regarded by his fellow actors as being particularly skilled. The next page explains what happened to his head.

Location: *Both:* Art Institute, Chicago. *Also:* 32: Boston, two copies, split block.
Size: 31: 27½ x 5⅞. 32: 25¾ x 8⅞. *Date:* 31: 1743. 32: 1744.
Publisher: *Both:* Okumuraya Genroku, Masanobu's business name.
Signed: 31: Signed on a second copy in Chicago: Hogetsudo Shomei Okumura Masanobu, his true brush. *Also sealed:* Hayashi (see page 239). 32: Hogetsudo, genuine name, Okumura Bunkaku Masanobu, his genuine work.
Translation: 32: *Poem:* In the darkness of love, with his own voice, the cuckoo (a pun on own and Onoe). *Gourd seal:* Masanobu's trademark.
Kabuki: 31: Shows Sanogawa Ichimatsu entering the theatre. 32: Shows Onoe Kikugoro as Soga no Goro in *Nanakusa Wakayagi Soga* (Youthful Soga Play of Beginning of Year), an adroit mixture of the Yaoya O-Shichi story and the Soga world. The carp fighting its way up the waterfall is the symbol of Goro's dedication to revenge. Ichimura Theatre, 1744.

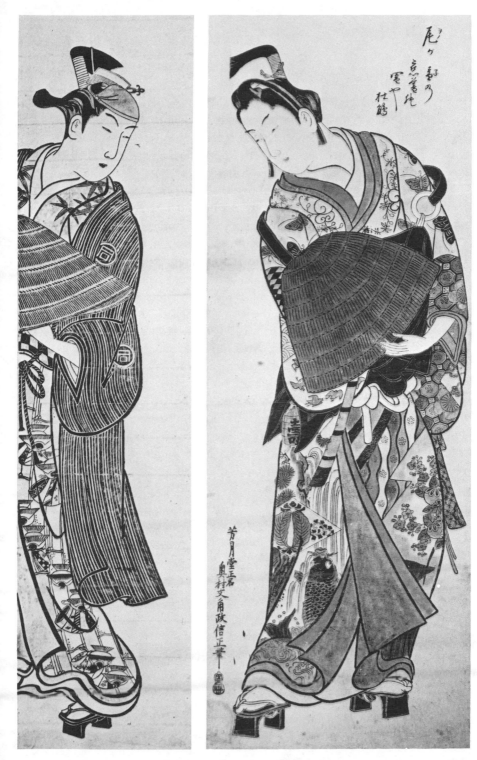

31 32

33
34

In 1743 Masanobu issued a portrait of the fabulous matinee idol, Sano-gawa Ichimatsu (31). The sale was apparently enormous for immediately a competing publisher ordered Shigenaga to prepare print 33, which offered a typical Shigenaga body topped by a typical Masanobu head. With this print the second publisher picked up a lot of business.

But soon the second publisher got one of his other artists, Toyonobu, to issue print 34, which is even today remembered as one of ukiyo-e's notable popular successes. It is a magnificent, hand-colored print and captures something of the gentle beauty that must have characterized Ichimatsu. It monopolized the business so completely that Toyonobu's publisher, who had also brought out the Shigenaga print which now sold no copies, gave the Shigenaga blocks to his cutters and told them, "Rout the Shigenaga head, plug the hole, copy the Toyonobu head."

This was done. Shigenaga's head was cut away. Kimono, hands, feet and torso were left in the Shigenaga style. But the new head was copied from Toyonobu's and the converted print sold well. A copy can be seen in Boston, another in the Metropolitan.

There are hundreds of Ichimatsu portraits. My two favorites are by the little-known ukiyo-e artist Kiyoshige and can be seen in the Fogg Museum in Cambridge. They are rugged Torii art at its best: handsomely colored and strongly posed. Other writers have preferred Toyonobu's very large print showing Ichimatsu tending his cosmetics shop. I know of no Ichimatsu portrait that is dull.

Location: Both: Art Institute, Chicago. *Also:* 33: Boston and New York, but with Toyonobu head. 34: New York.
Size: 33: 25¾ x 6. 34: 28 x 10¼. *Publisher:* Urokogataya Magobei.
Signed: 33: Senkado Nishimura Shigenaga hitsu. 34: Tanjodo Ishikawa shuha Toyonobu zu.
Date: 31, 33, 34 have always been listed as 1743. If correct, 31 and 33 must have come at the beginning of the year; 34 at the end, and the plugged version of 33 with the Toyonobu head some time in 1744, or later.
Translation: 33: *Seal:* Urokogataya's trademark. 34: *First square:* Ishikawa-shi. *Lower square:* Toyonobu. *Oblong:* Urokogataya's trademark.
Kabuki: Both prints show Ichimatsu as he appeared in the second act of *Kado Midori Tokiwa Soga,* an especially adroit mingling of the Hisamatsu story (36) with the Soga world plus overtones of Yoshitsune! Nakamura Theatre, January 1743.
In western art: Giovanni Battista Piranesi publishes first version of *Imaginary Prisons* about 1745.

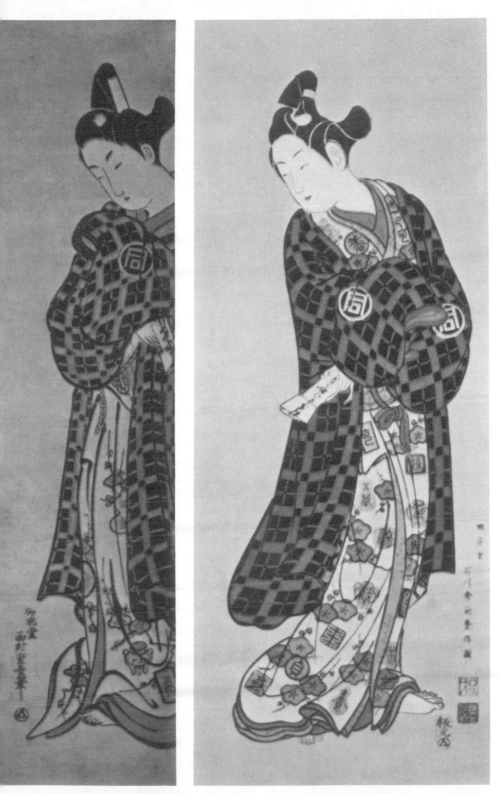

33 34

One of the main characteristics of ukiyo-e is repetition of subject matter. In this book four out of several hundred recurring subjects have been chosen for emphasis. Any one of them could have provided more than enough prints to fill the entire quota.

The Soga world, that arbitrary assembly of kabuki plays, accounts for prints 11, 27, 29, 30, 32, 33, 34, 35, 42 and 58. Many thousands of prints have come down to us illustrating this agglutinative epic, some exhibiting great power, many quite tedious.

The durable Ichikawa Danjuro line provides prints 11, 29, 30, 41–46. Any of the first seven Danjuros could have filled this book.

Ono no Komachi is shown in prints 13, 18, 53 C and 54. One could start with Moronobu and include prints of Komachi from almost every artist down to the last days, and in my opinion no other similar series would include so many masterworks.

Yaoya O-Shichi, the gay firebrand who considered Edo well lost for love, is perhaps the most appealing of the recurrent characters, and although her story relates to prints 7, 27, 32 and 36—and appears in scores of other fine designs—print 35 is unquestionably the masterpiece of the lot, as indeed it is of Masanobu's later years. Few benizuri-e have survived to the present in such exquisite condition.

Location: Museum of Fine Arts, Boston. *Also:* New York.
Size: 17½ x 12⅛. *Publisher:* Probably Masanobu, but no seal.
Signed: Hogetsudo Tanchosai Okumura Bunkaku Masanobu, his genuine work. *Date:* Positively dated by records to 1750.
Kabuki: Tsujin Chimata Soga is still another wedding of the Yaoya O-Shichi incident and the Soga world, made additionally popular in that the famous lovers, as seen opposite, appeared dressed in the traditional costume of beggars who sang along the roads leading to the great shrine at Ise. Ichimura Theatre, 1750. Nakamura Kiyosaburo as Yaoya playing a samisen; Onoe Kikugoro as Kichisaburo playing a kokyu. The mon worn by Nakamura Kiyosaburo is not his own but that of Arashi Kiyosaburo, who in 1708 created the role of Yaoya with such enormous success that all subsequent performers used his mon, as may be seen in print 27.
Translation: Poem: Here in sacred Ise, where the cherry is always in bloom, we find our hill of happy meeting.
Technical: Handle of samisen print in brown, achieved by a red base with green overprinting.
In western art: Giovanni Battista Tiepolo issues his etchings *Various Caprices,* 1749.

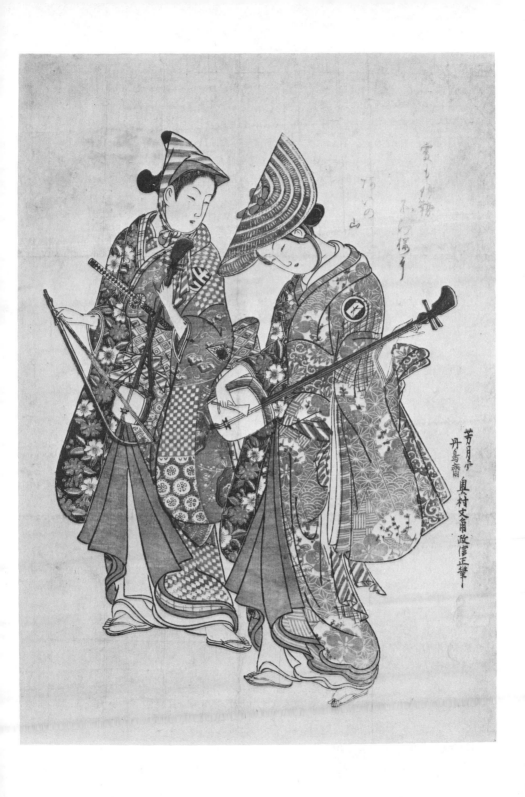

雲も伊勢
和河揚り

たかの山

芳月堂
丹鳥齋
奥村文角
政信正筆

Two young people under one umbrella is a Japanese way of hinting that they have been living together without letting their parents know. This rhythmic uncut benizuri-e triptych has come down to us with color unimpaired, though the left margin has been severely trimmed. It depicts three famous pairs of lovers as they appear in legend, drama and ancient account.

To the right, under a cherry tree, come O-Some and Hisamatsu, just about the most star-crossed lovers of all time. They went through two double cycles of tragedy. When he was free to marry, she wasn't; and when she was free, he was caught in the toils of duty. She stabbed herself in the throat and he plunged a sword into his heart.

In the center, under a maple tree, young Kichisa in his Ichimatsu kimono (33, 34) walks with his devoted incendiarist, Yaoya O-Shichi, who burned down much of Tokyo for his sake. She was burned at the stake and he fled to a monastery.

To the left, under a plum tree, appear O-Ume and Kumenosuke. He broke priestly vows to be with her. She rejected her parents' choice of husband to be with him. Together, at the doors of the temple, they committed double suicide.

In all respects—color, design, sentiment, placing of poems, use of trees, harmonious relationship of figures, and choice of characters—this print is the essence of things Japanese.

Location: Art Institute, Chicago. *Also:* Middle sheet, Boston. Left sheet untrimmed, Boston, Worcester.
Size: 11¾ x 16¾. *Publisher:* Maruya Kohei.
Signed: Ichikawa Toyonobu hitsu. *Date:* 1755.
Translation: Title: Sharing the Umbrella. Poem right: Two faces touching like cherry blossoms. *Poem center:* Maples in evening, a brief nuptial kiss. *Poem left:* On the road in the spring shower and the green plums making her mouth water. (Green plums are cherished by pregnant women.)
Seal: Maruko han Toriabura-cho, trademark of the publisher.
Technical: Benizuri-e. Uncut triptych. Each hoso-e titled. Signed and sealed, ready for cutting.
In western art: John Baptist Jackson publishes Essay on the *Invention of Engraving and printing in Chiaroscuro* containing four prints in full color, 1754.

This print is remarkable for the preservation of its color and for the portrait of Segawa Kikunojo II, left. No other man acting women's roles inspired ukiyo-e artists so deeply and so fortunately as he. Kiyohiro used him often; so did Shunso, and for Buncho (40) he provided inspiration for a group of magnificent prints. Yamashita Kinsaku II was less fortunate. This print shows him at age twenty-four; thirty-seven years later Sharaku will design some of the ugliest actor prints of history around his twisted face.

The noh drama which this print represents is *Matsukaze,* which illustrates Japanese theatrical art in that the dramatist had at hand a powerful love tragedy—the infatuation of two brine maidens for the nobleman Yukihira, who had been exiled to their village—but the playwright bypassed the climaxes of passion and sought, Japanese style, a more poetic moment. A priest, wandering through their village, by accident evokes their long-dead ghosts. In lines of overwhelming tragedy they recount the sorrows they had experienced on earth:

Murasame: It seems as though the waves were at one's very feet at Suma Bay.
Together: And yet 'tis tears, despite the beauty of the moon, not waves, that wet our sleeves. . . .
Chorus: If only sleeves were grasses in the fields, and tears but dew, by sunlight dried away. . . .
Matsukaze: Oh, how familiar is this beach at dusk! The fishers' calls sound faintly. . . .

Location: Art Institute, Chicago.
Size: 11⅝ x 5½. *Publisher:* Urokogataya Magobei.
Signed: Torii Kiyohiro hitsu. *Date:* 1757.
Translation: Right: Yamashita Kinsaku. *Left:* Kichiji or Segawa Kikunojo.
Seal: Urokogataya's trademark.
Kabuki: The writing on this print proves that at the play *Kaeri Bana Konozakura,* Ichimura Theatre in November, 1756, the promising actor Kichiji assumed the august name Segawa Kikunojo. In this way the dating of ukiyo-e prints and kabuki plays interlocks.
Technical: Benizuri-c. Hoso-e.
In western art: Thomas Gainsborough is working on his *Landscapes,* soft ground etchings, 1758–60.

In preparing this book I have had to leaf through these prints nearly a thousand times over a period of several years. It has been a privilege, for these 63 prints comprise many of ukiyo-e's treasures, yet the one which has consistently given me the most pleasure has been this faded, childish thing. A group of children are imitating the play in which Kiyohime dances under the bell of Dojoji monastery, trying in vain to lure the monk Anchin (46). This girl had met Anchin as a child and had fallen passionately in love, haunting him until he took refuge under the sacred bell, which trembled at her touch and fell to the earth, covering him. She then became so tormented with love that she turned slowly into a serpent and wound herself about the bell with such fury that flames spouted from her body and melted the bell until she and the monk finally expired together, though some say she escaped in the guise of a dragon.

The gentleness of this print is a constant delight. Its faded colors show exactly what has happened to ninety-nine percent of all benizuri-e, for the fugitive reds and greens have gone and only these ghostly pastels remain. The drawing, the design, the perspective and the costuming are all as archaic as the color scheme, yet until one comprehends why many collectors would rather own one of these faded benizuri-e than even the most brilliant later prints one has missed the charm of ukiyo-e. With this delicate print we leave the benizuri-e. They were unique in world art: unreasonable, arbitrary and slightly preposterous, but they were works of subtle poetry and among the most delightful of all prints.

Series Title: Osana Hakkei (Eight Views of Youth).
Location: Metropolitan Museum of Art, New York. *Also:* Chicago.
Size: 12⅜₁₆ x 17³⁄₁₆·. *Publisher:* Maruya Kohei.
Signed: Torii Kiyomitsu ga. *Date:* 1764c, but before 1765.
Translation: Cartouche: Dojoji no Bansho (Evening Bell at Dojoji Monastery). *Poem:* At sunset the flower may also be bending at Dojoji. *Circular seal at dancer's feet:* Publisher's trademark. *Square seals:* Kiyomitsu.
Technical: Benizuri-e. Unusual size. Note the hiragana (cursive Japanese script) that appears alongside Chinese characters to aid the near illiterate.
In western art: Jean Honoré Fragonard's etchings, *The Bacchanales,* 1763.

Sometime around 1745 Torii Kiyohiro designed a print showing a girl being followed by a young man in exactly the pose here adopted by Harunobu. Even the poem which appeared on the print had a Harunobu ring: "The wind of love whispers and there is yielding of the willowy limbs," but the basic design had been lifted from that richest source of ideas, Sukenobu.

Shortly thereafter Torii Kiyomitsu needed a good theme so he took Kiyohiro's print and changed the young man into the maid who appears here, producing the liveliest of the four prints under discussion. He placed the leading figure under an umbrella and gave the fan to the maid, whom he took directly from one of Sukenobu's books.

From this Harunobu copied in 1764 his first version of this subject, showing a girl and her maid leaving the Tomiyoshi store in Edo. The umbrella is folded and the fan has disappeared. When, in 1765, a design was needed to complete an important series of eight prints, Harunobu returned to this Sukenobu-Kiyohiro-Kiyomitsu-Harunobu invention and produced one of the two masterpieces in his set of eight. In 1778 Kiyonaga borrowed the scene from Harunobu with hardly a change. He used it twice more in 1778 and twice again in 1779.

Sukenobu and Kiyomitsu, in their versions of the maid, used one of ukiyo-e's neatest conventions to indicate that she was an older woman. They drew her face exactly like the young girl's but omitted eyebrows, and where they would have joined inserted two wrinkle marks in the shape of facing v's. Harunobu, who could tolerate no signs of age, allowed his maid to keep her eyebrows and escape the wrinkles. Kiyonaga, in his five versions, also eliminated the wrinkles.

Series Title: Zashiki Hakkei (Eight Views of Indoor Life).
Location: Art Institute, Chicago, which also has the seven companion prints (the original set of eight once owned by the poet Kyosen). Also the original wrapper which proves this ownership. *Also:* New York.
Size: 11¼ x 8½. *Publisher:* Unknown.
Signed: Kyosen. For significance of this strange signature see pages 90–92.
Date: Sugawara's anniversary year 1765.
Translation: Seal: Kyosen no in (Seal of Kyosen).
Technical: Nishiki-e (brocade picture). Chuban, Harunobu's favorite size. Later reissued with Harunobu's signature, but in poorer colors.
In western art: J. M. Papillon's *Traite Historique et Pratique de la Gravure sur Bois* completed. Published 1766 with examples of chiaroscuro woodcuts.

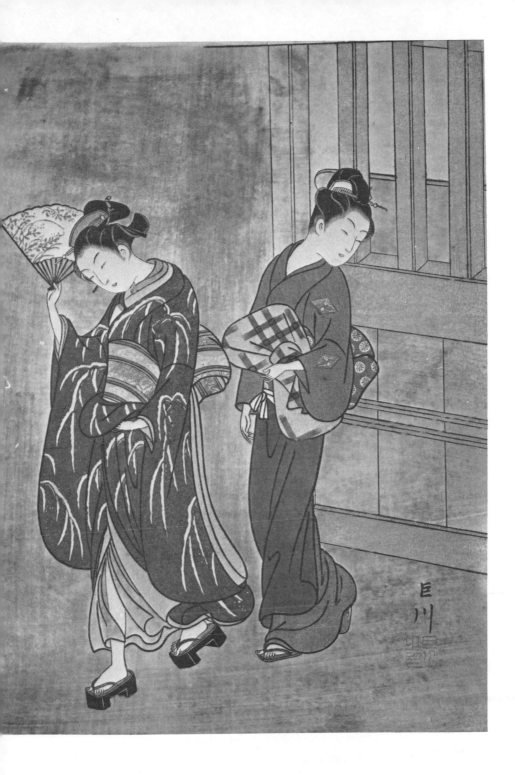

This print is remarkable since its blue sky is so perfectly preserved, for out of a thousand prints using this strange color all but one will have faded to a pleasant buff. The main ukiyo-e colors were:

Tan, a red oxide of lead. Blackens on exposure. (26, 27).

Yellow ochre, a strong color which rarely fades. (27).

Olive, derived from turmeric mixed with other colors. (26, 28).

Beni, a rose-red called in Europe rouge, made from madder or saffron. Fades quickly. (35).

Beni-gara, mixture of red, yellow, black which results in anything from brick-red (41) to the fence opposite, or Harunobu's fine chocolate.

Green, the companion to beni in benizuri-e, made from "first washing of verdigris" (35). Does not fade and dominates most benizuri-e from which beni has vanished.

Airo, very fugitive blue, made from combination of several colors. Used by Buncho for sky opposite, where miraculously it did not fade.

Asa murasaki, a permanent purple which replaced a highly fugitive one. Favored by Toyokuni and with admirable effect.

Prussian blue, imported from Europe about 1820. Used by Hokusai (60) and Hiroshige (61) with pleasing results. Permanent.

Aniline colors, imported from Germany via America, after 1860. Helped kill ukiyo-e.

Location: Art Institute, Chicago.
Size: 10¼ x 7⅝. *Publisher:* Maruya Kohei.
Signed: Ippitsusai Buncho ga. *Date:* 1770c.
Translation: Square seal: To protect the name. *Oval seal:* Maruko, seal of the publisher.
Kabuki: Segawa Kikunojo II, most beautiful woman impersonator in kabuki prior to Nakamura Utaemon VI currently acting in Edo, appears as Tokiwa-gozen, mother of Yoshitsune, who in the natural confusion of kabuki appears as Sagi Musume, the spirit of the snow. Arashi Sangoro II as Yoritomo. *Myoto-giku Izu no Kisewata* (The Story of a Pair of Snow-covered Chrysanthemums That Blossomed in Izu), dance interlude in second act, traditionally called, *Oyama Beni Yuki no Sugao* (The Girl Without Make-up Who Is More Beautiful than Snow Wearing Lipstick). Ichimura Theatre, November 1770.
Technical: Nishiki-e. Airo and beni-gara. Chuban. Prominent gauffrage.
In western art: Paul Revere publishes his hand-colored engraving, "Boston Massacre," 1770.

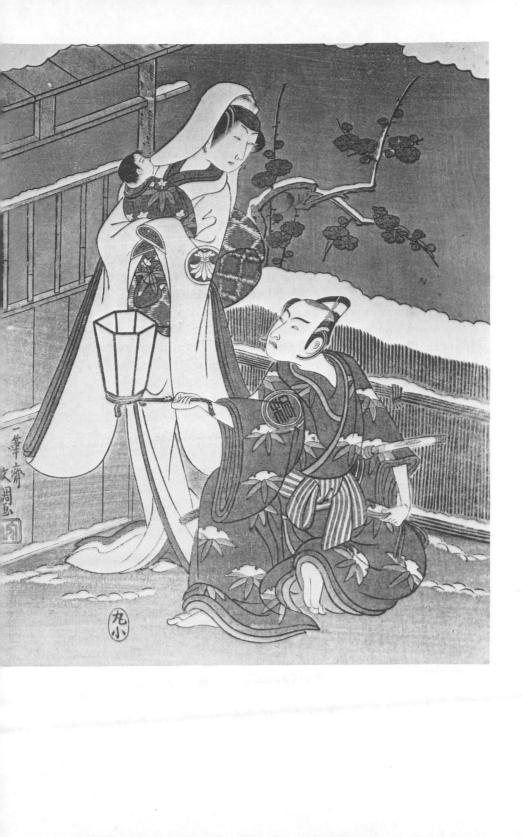

Prints 41 through 46 were all once thought to represent Danjuro V and are fully discussed in Chapter 11. The total number of studies Shunsho made of this actor is unknown but it must exceed sixty. Of them about two dozen show Danjuro in magnificent static poses, and since I am much addicted to these particular prints I had originally selected six quite different Shunshos from the one shown here.

I had chosen Danjuro as Honzo from *Chiushingura*, in which he appears a paragon of manly grace; as Sukeroku with umbrella unfurled in full arrogance; as Soga no Goro with basket hat and flute, one of the purest and simplest designs; as Seigen the mad monk, praised by all critics; as the ghost rising from behind the snowball on which a crow sits, an inspired thing; and a handsome white print in the Metropolitan showing the actor in ceremonial robes, full of honors.

But when I was assembling these flawless prints, Mr. Robert T. Paine, Jr., of the Boston museum pointed out that most of them were already available in other books and, what was more important, that they all showed Danjuro in repose, thus failing to display Shunsho's varied talents. He suggested assembling a pair of panels that exhibited the artist's fuller capacities, and the six prints offered here do that. In them one finds more dynamism than is customary in Shunsho's statelier work, more vigor than in the portraits of women's roles and more powerful color than in some of his widely reproduced prints. Close study of these six will disclose most of Shunsho's virtues: excellent sense of placement, strong design, able portraiture, good color harmonies, and ability to evoke drama.

Location: All three prints in Museum of Fine Arts, Boston. *Also:* 41: New York.
Sizes: 41: 12¼ x 5½. 42: 12 x 5½. 43: 12⅞ x 5⅞.
Publisher: Not known. *Dates:* 41: 1768. 42: 1771. 43: 1776.
Signed: 41: Not signed, but another in pentaptych of which it is the left-hand member signed with tsubo. 42: Signed with tsubo containing the name Hayashi. 43: Shunsho ga.
In western art: John Singleton Copley paints his masterpiece, "The Copley Family," in England, 1776.

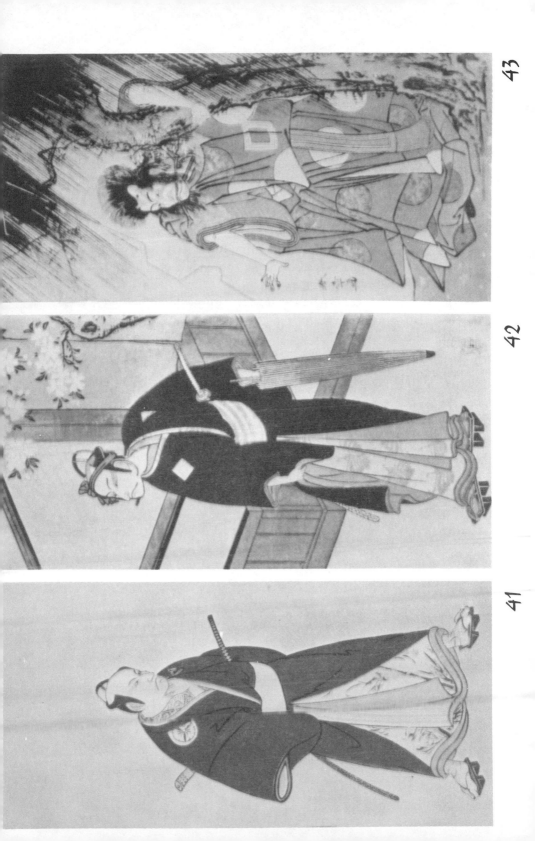

Shunsho's weaknesses are obvious. His drawing is not good, for his basic line wavers (46) and frequently fails to establish any dominant rhythm for the print (44). When applied to details this poor drawing becomes most noticeable. It has been pointed out that Shunsho's feet are especially bad (41, 42, 46) and his shoulders rarely adequate (41, 46). These last of course are trivial complaints and bear no relationship to serious art criticism, for how a man draws feet is unimportant unless he aims to be a chiropodist. But substantial criticisms remain.

Shunsho's backgrounds frequently cause trouble especially when, as in 44, a line—often a hedge—runs through the middle of the print. Mixed architectural backdrops as in 42 are often handled poorly, and one is tempted to generalize that he is happiest with plain drops, as in 41 and 45, but that is not correct, for his greatest prints, like 43 and the Nakazo masterpieces, have complex backgrounds out of which the print logically develops. On the other hand the background of 46 represents a compromise which turned out badly.

Finally there is the criticism that Shunsho's work is monotonous, since he confined himself mainly to actor prints; he utilized the same actors repeatedly; and even though his fecundity was amazing, he did repeat. It is only fair to point out, however, that it is this sweet monotony that many perceptive collectors find most attractive in his work. It is difficult to understand how anyone could weary of his Nakazo prints or his long succession of Danjuro studies.

Location: 44: Museum of Fine Arts, Boston. 45: Art Institute, Chicago. 46: Metropolitan Museum of Art, New York. *Publishers:* Unknown.
Sizes: 44: 12¾ x 5¾. 45: 12¼ x 5⅞. 46: 13 x 6.
Dates: 44: 1784. 45: 1782. 46: 1780 in Boston catalogues; 1788 in Japan; 1790 in New York.
Signed: 44: Shunsho ga. 45: Katsu Shunsho ga. 46: Shunsho ga.
Kabuki: Japanese critics think it likely that the actor in 44 is not Danjuro V but another member of his family, Ichikawa Danzo IV.
In western art: Thomas Bewick publishes his *History of Quadrupeds* establishing end-grain engraving on boxwood as the standard for nineteenth-century book and magazine illustration, 1790.

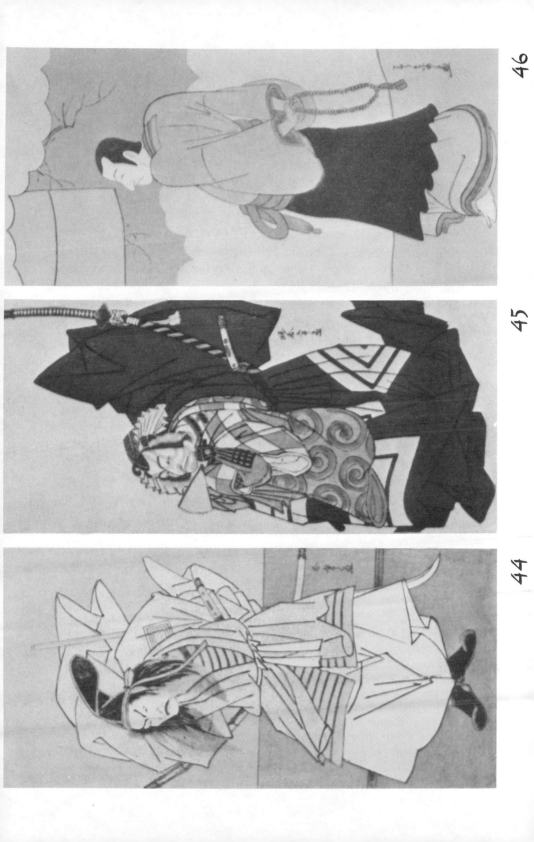

One sees hundreds of hashira-e, grease stained and smoky brown from hanging in homes, before one finds three in such fine condition as these. To the right a gay young man about town and a courtesan inside her cage present a modern analogue to the majestic football scene in *The Tale of Genji* as recited on page 122. The insouciant manner in which the youth kicks the football is typical of ukiyo-e's handling of classic themes.

Another analogue, from the Seventh Act of *Chiushingura*, fills the central panel, where O-Karu on her balcony reads with a mirror the letter held by Yuranosuke, leader of the Forty-seven Ronin, while the villain Kudayu spies beneath the porch.

To the left, in auspicious design, a young courtesan leaves a public bath while a second remains behind the wooden grill. This is one of the most rhythmic and subtle of pillar prints.

The manner in which Koryusai fills all parts of his narrow panel with meaning, the linkage between sections that he arbitrarily contrives and the skill with which he fits people into his procrustean space makes him master of this form. Critics have hailed in turn Harunobu, Kiyonaga, Shunsho and Utamaro as the premier master of this exclusively Japanese problem, but I fail to see how any one of them excels Koryusai. I do admit that his color is often too heavy and that occasionally a Harunobu or Kiyonaga hashira-e achieves a total harmony—in all except design—that Koryusai misses.

Location: All three in Museum of Fine Arts, Boston. *Also:* Chicago has 47. Worcester has a copy of 48 which shows a much different background behind O-Karu's head.
Size: 47: 27 x 4¾. 48: 26¾ x 4¾. 49: 27¼ x 4¾.
Publisher: Unknown. *Signed:* Each signed Koryusai ga.
Date: Judging solely from hair styles, 47: 1772. 48: 1777. 49: 1775.
Translation: Banner left: Jochu-yu (Women's Bath).
Technical: Prints 48 and 49 are known as mitate-e (likening pictures), a word commonly translated as *travesty, analogue, parody* or *modern version.* Prints 18, 53 C and 54 are also mitate-e. Prints 13 and 16 are not.

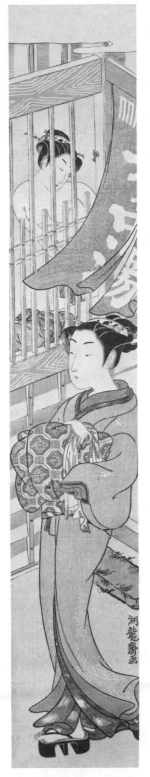

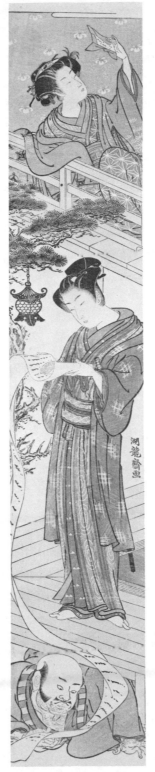

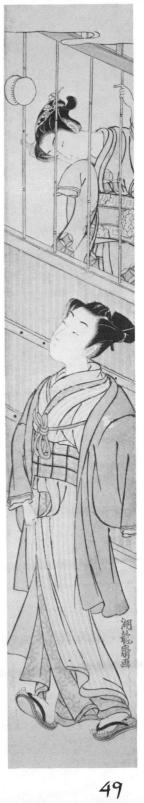

47 48 49

This stately print has been highly praised by many writers who have found both its mood and technical qualities excellent.

Fenollosa: "Greatest of all is his print of three girls at a window. The interior is lighted in warm tones by a Japanese lamp. The scene outside is illuminated in night grays, with the half-full moon entangled in light clouds. The boats in the far harbor show reddish torches. Such a study in three separate sources of light, though without the expedient of cast shadows, is worthy of our modern realistic students. . . . The lines, too, falling from the standing figure and then curling into the two crouching girls upon the floor are more harmonious than Botticelli, more suave and flowing than Greek painting. It is for such work that we must put Kiyonaga . . . into competition with Raphael."

Gookin: "This is perhaps Kiyonaga's finest print."

Binyon: "This wonderful print anticipates by its sense of mystery in simple things and by the beauty of its strange proportions some of the later creations of Utamaro."

Hirano: "The dark outlook through the window in contrast to the soft warm tones of their dresses evokes from the beholder a feeling of sympathetic response."

Metzgar: "There is a print which never fails to stir my soul with its mystic beauty. Perfect in design and exquisite in color, it stands alone in my imagination, alone among all the prints of the world and I do not hesitate to say that I would rather own it than any other I have ever seen."

For a minority report see page 130.

Series title: Minami Juni Ko (Twelve Months in the South). That is, *Twelve Scenes in Shinagawa*, then a suburb just south of Edo. At present only seven prints of the series are known.
Location: Art Institute, Chicago.
Size: 15½ x 10¼. *Date:* 1784. *Signed:* Kiyonaga ga.
Publisher: No prints in this series contain a publisher's mark.
Technical: Nishiki-e. Oban, which was to become the standard size. Probably right-hand sheet of a diptych.

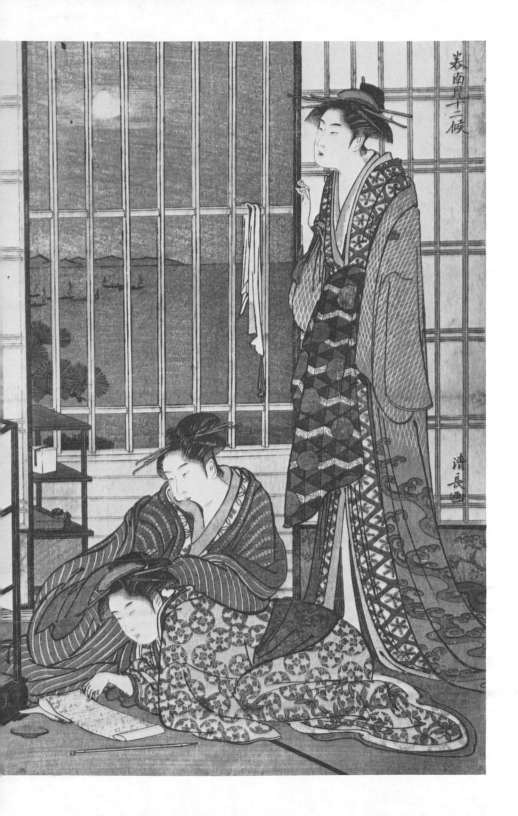

Kiyonaga's series of shosa prints is one of the most distinguished in ukiyo-e. This example is in perfect condition and when contrasted with prints 41–46 shows the significant difference between Shunsho's view of the theatre and Kiyonaga's.

Here three lesser actors depict a highlight in a most popular drama which was constantly being rewritten. Umegawa, kneeling, is a courtesan whose freedom the gallant Chubei has purchased with stolen money. They have fled seeking to escape the police and have accidentally come upon Chubei's father, whose clog is broken. Disregarding her own safety, Umegawa kneels to help the old man.

As in all such Japanese plays, lovers who flee under such circumstances cannot hope to find release from the obligations hanging over them, and Umegawa and her lover are properly executed.

Kiyonaga designed at least thirty-three handsome prints in this form, Shuncho added more and Hokusai ended the series with a hilarious burlesque. The form goes far back in history, at least to 1703. Kiyonobu II and Buncho both designed such shosa prints before Kiyonaga, but he excelled.

Location: Art Institute, Chicago.
Size: 15 x 10. *Date:* 1783. *Signed:* Kiyonaga ga.
Publisher: Eijudo, the only real competitor in taste or success of Tsutaya Jusaburo.
Translation: Upper seal: Eijudo's mark. *Lower seal:* Eijudo, the business name of Nishimuraya Yohachi.
Kabuki: This popular story was constantly being rewritten and in the present version was *Keisei Koibikyaku.* The chanter in the center is Tomimoto Buzendayu, whose music school was famous throughout Edo and whose lovely daughter Toyohina became a distinguished chantress and one of the beauties most often portrayed by Utamaro. The left chanter is Tomimoto Itsukidayu, a disciple of Buzendayu's. Shortly after this print was made the two men quarreled and the disciple left to form the Kiyotomo school of theatrical music, which today dominates kabuki music, the Tomimoto school having died out. Morita Theatre, 1783.
Technical: Nishiki-e. Oban. Shosa with degatari (come out with words) line of musicians at back of stage.

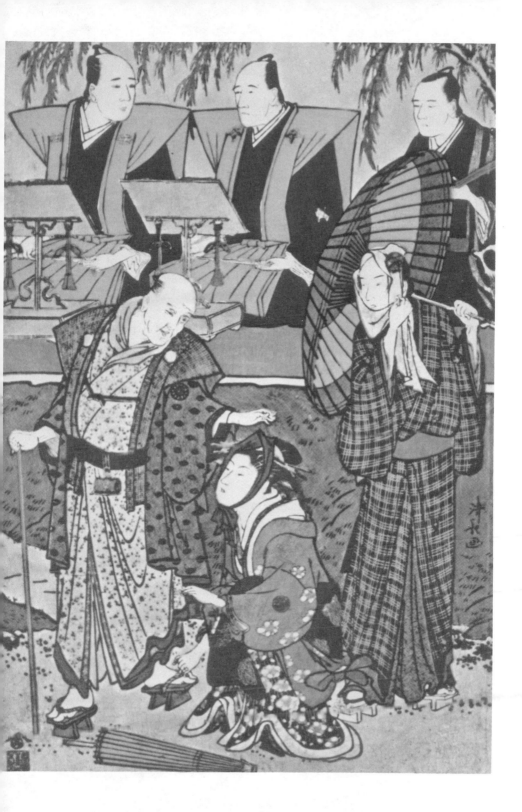

This print is famous in the west under the title "The Strongest and the Most Fair." A more un-Japanese title could hardly be found, for although the champion of champion wrestlers Tanikaze was certainly the strongest man in Edo and O-Kita one of the fairest women, to say so boldly destroys the implications.

The story of Tanikaze is given in page 35, and O-Kita is remembered for the more than twenty exquisite portraits of her by various artists, including Utamaro, who presented her in the series in which print 53 A appeared.

I have seen three prints in this series and suppose there must be four, since each shows a famous wrestler accompanied by a popular beauty, and the wrestler appears by turn in three different corners of the page. This version, with the hulking weight of the wrestler above, is much finer in design than the one in which the mass is used at the bottom of the print to build up a traditional pyramid.

Twelve years later Shunei portrayed monstrous Tanikaze and stole the present portrait line for line with a fidelity that is remarkable. Not quite so successful is the Shuncho print in which Onogawa, the perennial foe of Tanikaze, looms upper right above handsome O-Hisa, another of Utamaro's favored models, who also appears in the series of which print 53 A was a part.

It is interesting to observe that while Japanese culture has consistently held white-skinned races in little regard and although children with part-white blood are held in contempt, the ideal Japanese beauty has always cultivated and treasured very pale skin as proof that the owner did not work in the sun. Noblemen like the one shown in print 57 and gentlewomen like those in print 12 usually traveled under umbrellas, especially in the sun.

Location: Art Institute, Chicago.
Size: 15⅜ x 10¹⁄₁₆. *Publisher:* Tsuruya Kiemon. *Signed:* Shuncho ga. *Date:* 1784? Kondo suggests 1792c. In either case the Shunei copy of Tanikaze so startling in its borrowing of Shuncho's lines came later.
Translation: Chinese characters: Tanikaze (second of that name, 1750–1795). *Hiragana syllables:* Naniwaya O-Kita. *Seal:* Trademark of the publisher.

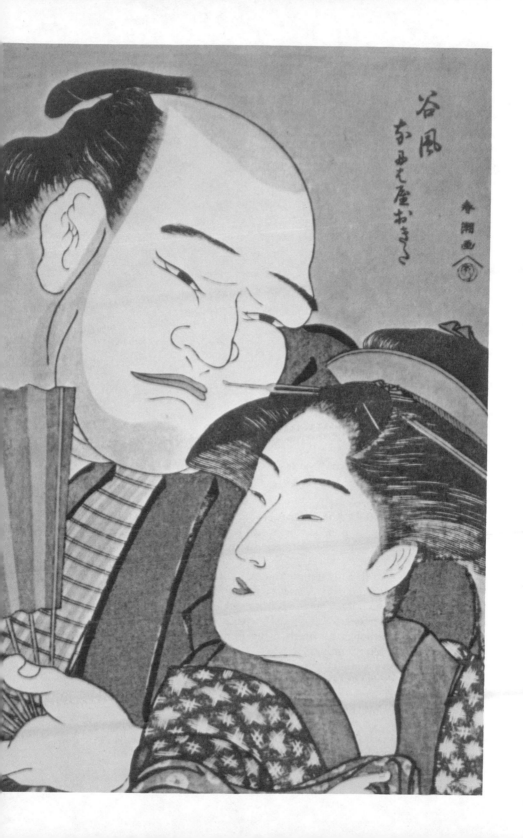

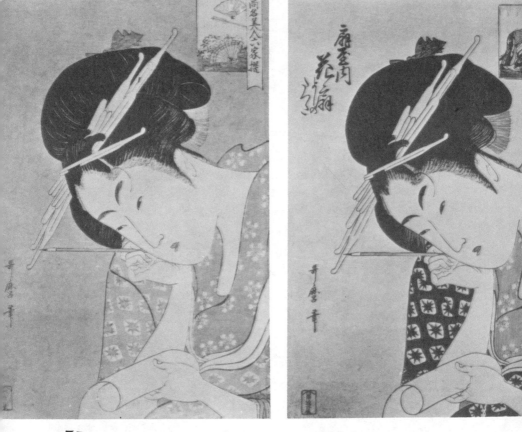

53 a, b, c KITAGAWA UTAMARO

Series title: 53 A & B: *Komei Bijin Rokkasen* (Renowned Beauties from the Six Best Houses), a pun on the word Rokkasen. 53 C: title cartouche recut: *Furyu Rokkasen* (Elegant Six Immortal Poets.) The proper use of Rokkasen.

Location: 53 A & B: Museum of Fine Arts, Boston. 53 C: New York Public Library. Chicago has 53 A and 53 B, the latter trimmed like the Boston copy, but without mica. Did the block crack? Was the mica a late forgery?

Size: 53 A: 15¼ x 10¼. 53 B: 14⅝ x 10, sharply trimmed at top. 53 C: 14⅞ x 10⅛. Although all prints came from one set of blocks, they differ because of variable trimming.

Publisher: Omiya Kenkura. *Signed:* Utamaro hitsu.

Date: Hirano suggests 1794. Japanese exhibition of 1926 proposed 1797. Customary date 1798. 53 B possibly a year later. 53 C probably at least two years later, possibly more.

Translation: 53 C: Ogiya no Uchi Hana-ogi. Yoshino. Tatsuta. The two latter were komuro (young servants) in training with Hana-ogi. *Seal:* Omiya Kenkura's trademark.

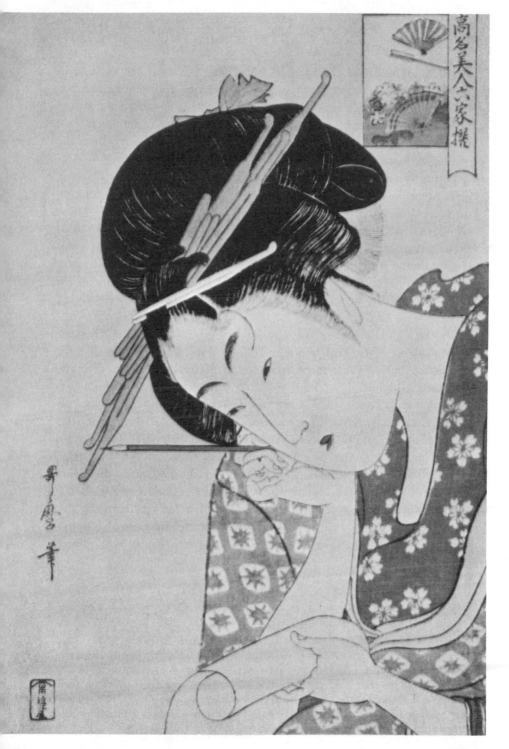

I had never heard of this strange print before I stumbled upon it in Boston. I have discovered nothing about the series from which it comes, but since it is called *Courtesans as the Six Poets* it is reasonable to suppose that there must have been two companion prints. No other ukiyo-e that I have seen so magically catches the curious world in which the great courtesans were held captive.

In the imagination of the men who frequented them, these stately girls came down to earth upon clouds of beauty. They were kept exquisitely gowned, brilliantly covered with the brightest colors. Those who attained top rank were gifted as poets, witty as painters and skilled in conversation. They began their arduous training as infants, spent their girlhood studying the habits and tricks of the leading courtesans, enjoyed a few dazzling years at the apex of Edo life, were kept locked up and constantly under guard, and in their late twenties were kicked out.

To the right is Hana-ogi mentioned earlier. To the left is Kisegawa of Matsubaya (Pine Leaf House). At first it seems perplexing that the distinctive butterfly headdress invented by Hana-ogi is here given to Kisegawa, and one is tempted to guess that some assistant got the names twisted, for of course these were not portraits but idealized advertisements. But the explanation is simpler. The emotional relationship between Hana-ogi and Ono no Komachi is so immediately felt by Japanese —as in print 53 C—that if any contemporary courtesan were to represent Komachi, it would have to be Hana-ogi, who does so in this print. That left her distinctive and artistic headdress free for Kisegawa.

It is difficult to bear in mind that this superb print was in its day collected in much the same way that American children hoard chromolithographs of baseball players or the way G.I.'s in Korea kept colored pin-ups.

Series title: Yukun Rokkasen (Pleasure Ladies as the Six Immortal Poets). *Location:* Museum of Fine Arts, Boston.
Size: 15 x 10. *Publisher:* Iwatoya Kisaburo. *Signed:* Eishi zu. *Date:* 1795. *Translation: Panel left:* Matsubaya Kisegawa. *Panel right:* Ogiya Hana-ogi. *Seal left:* Kiwame (approved). *Seal right:* Trademark of publisher.
Technical: The clouds in this print are borrowed in slightly altered form from old Tosa makimono-e, where they ran laterally along the scrolls to suggest change of scene or passage of time. Here they add to a glorious print a proper antique and historical connotation.

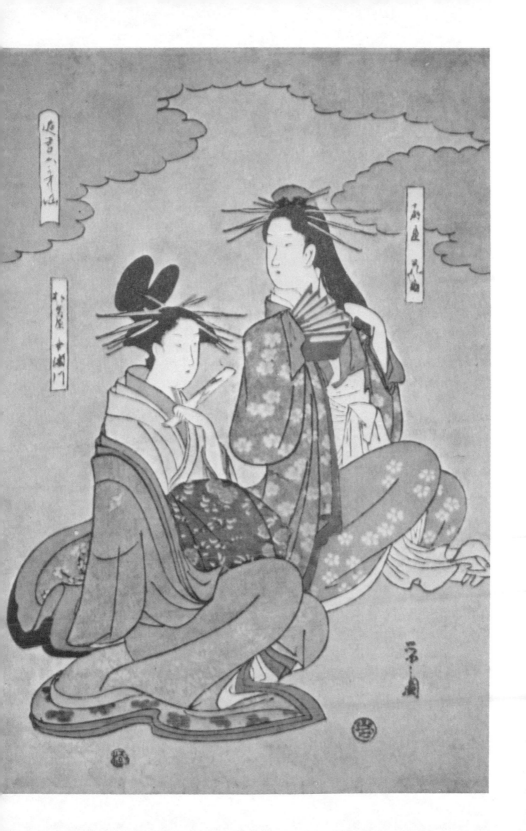

This large print called "Holidaymakers in an Iris Garden Listening to a Cuckoo" is one of the most famous in ukiyo-e. It was done about the time that Kitao Masanobu abandoned art and took up writing instead (56) and critics generally have held there was no great loss, which seems a most prejudiced view.

This is in every way a distinguished print. The spaciousness of its design and the flowing relationships among the five figures bespeak real ability. The handling of nature, too, is evocative, even the leathery and inanimate frog adding to the heavy yet effective treatment. The handling of water is intelligent, while the iris and cuckoo appear pretty much as they reappeared some fourteen years later in the book done with Shigemasa (19).

The large size of this print probably relates in some way to the extraordinary success the artist enjoyed in 1784 with a very big album printed in maximum complexity and brilliant color: *A Mirror Comparing the Handwriting of New and Beautiful Courtesans of the Yoshiwara*, which has been hailed as one of the most gorgeous books ever issued but which only barely escapes the charge of being gauche.

It is difficult to understand why Masanobu quit ukiyo-e. Judging from this finely balanced print, the book of street scenes (19) and the technical brilliance of the big album, a real artist was lost. Possibly the fact that in 1791 Tsutaya Jusaburo set publishing precedent by paying him in cash for books lured him into an easier field, where he could earn a living.

Location: Museum of Fine Arts, Boston. *Also:* Morse collection, currently on exhibition in Hartford.
Size: 15¼ x 21¾. *Publisher:* Not known but almost certainly Tsutaya.
Signed: Masanobu ga. *Date:* 1782 (British). 1784 (Shibui Kiyoshi). 1786(?). Since Masanobu's Yoshiwara book was definitely published in 1784, the time relationship between it and this print is uncertain.
In western art: Jacques Louis David exhibits "Oath of the Horatii," the death warrant of the rococo style, 1786.

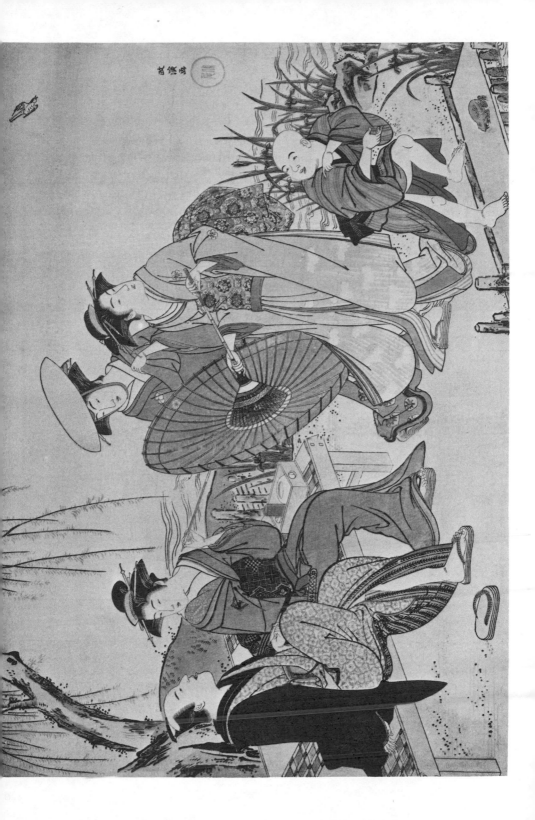

This portrait is generally considered one of the greatest in Tokugawa art, but exactly who designed it is unknown, for although it is clearly signed Eiri, we cannot say which Eiri of several did the print.

It shows Santo Kyoden, the luminous man who was half artist (19, 55), half novelist and all playboy. He exemplified Edo and fortunately several of his little books in which he lampooned the government have recently been translated into English and republished along with their deft drawings in Akimoto Shunkichi's *The Twilight of Yedo*. They show a real wit at work, a kind of newspaper columnist buzzing with gossip, a function Kyoden must have performed as he passed about Edo selling tobacco utensils.

In 1784 he fell in love with a very young courtesan, Rinzan, who became the darling of the Utamaro gang hanging out at Tsutaya's. Kyoden wrote a book about her and started living in the Yoshiwara. In 1790 he married another courtesan, Kikuzono, whom he bought from Hanaogi's house, but she fell ill and his adventure into matrimony ended with him back in the Yoshiwara. In 1791 he married the lovely fourteen-year-old girl Tamanoi who was in training to become a public courtesan and with her he was happy. Shortly after his death, mourned by Edo, Tamanoi died of grief. A contemporary described Kyoden as "that sentimental, weak, beautifully refined man."

When the nineteen-year-old son of a drinking companion died, Kyoden organized a memorial volume, but since his friends had little money it measured only 4½ x 2 inches. His poem: "Never cry. Don't be so sad about your boy's death. This world is no more than a migrant bird in the sky."

Series title: The Flowers of Edo, of which only one other portrait exists, that of Tomimoto Buzendayu (51) father of one of Utamaro's favorite subject, Toyohina.
Location: Metropolitan Museum of Art, New York. *Also:* Boston, Chicago, Honolulu.
Size: 15⅜ x 10¼. *Publisher:* Not known.
Signed: Eiri ga. *Date:* 1794.

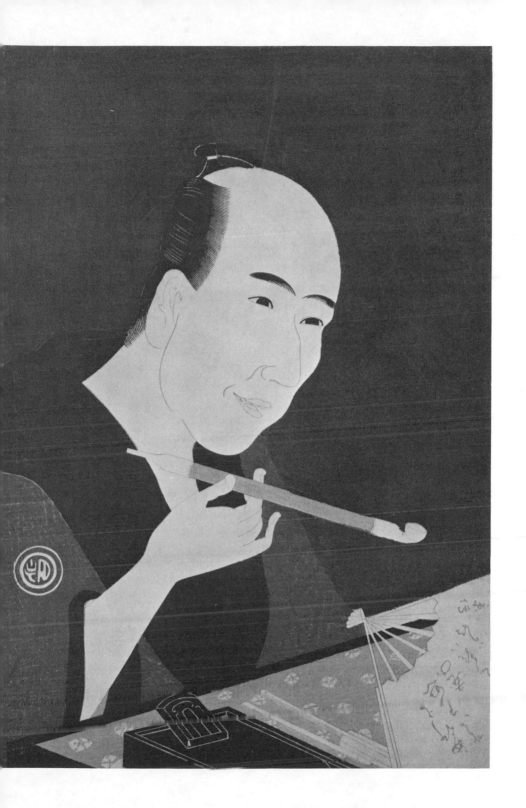

Shunsho was in some respects an ideal teacher. He had many pupils. He taught them much. And as soon as they graduated, they abandoned his ideas. Shuncho, Shunko, Shunzan, Shunjo, Shunden and Shunsen all drifted over into Kiyonaga's orbit. Shunro belatedly developed into mighty Hokusai. Shunei was a special case, for after having produced some prints in approved Shunsho style he branched out into several highly individualistic manners which had little to do with either Shunsho or Kiyonaga.

Three of his prints are highly praised. His portrait in pale blue of sinister Moronao, villain of *Chiushingura*, is properly evil. His massive picture of hulking Tanikaze (whom we have seen in 52) is one of his best wrestling scenes, a group which when overlaid with haphazard oxidization are wonderfully powerful. His masterwork is agreed to be a print in which he competed with Kiyonaga and won. It shows the powerful actors Nakazo and Koshiro as palanquin bearers against a pitch-black sky. This is one of the finest prints I know, but I could find no copy in America. There must be one somewhere and I hope it will soon find its way into a major museum.

The print facing shows Shunei as an important artist, for it was probably he who invented the big-head prints of actors. Here he shows Bando Hikosaburo III as that paragon, Sugawara no Michizane (43). I wish I could explain what the two dots over the eyebrows represent in classic Japanese art, but I have heard so many conflicting guesses that none now makes sense.

Location: Metropolitan Museum of Art, New York. *Date:* 1799.
Size: 15¼ x 10¼. *Publisher:* Uemura Yohei. *Signed:* Shunei ga.
Translation: Circular seal: Kiwame. *Rectangular seal:* Trademark of Uemura Yohei.
Kabuki: In the great kabuki play *Sugawara Denju Tenarai Kagami* (The Lustrous Imparting of Sugawara's Calligraphic Secrets), Sugawara no Michizane is known under his alternative name Kanshojo. Four acts of this noble play are still given almost as separate plays: *Domyoji* (Domyo Temple), which the present print illustrates; *Kuruma-biki* (Stopping the Carriage); *Ga No Iwai* (The Seventieth Birthday); *Terakoya* (The Village School). The school scene is surely one of the world's most powerful dramas. Miyako Theatre, Seventh Month, 1796.
Technical: Headdress slightly embossed, then covered with urushi in the manner of Kiyomasu and Kiyonobu.
In western art: Francisco Goya issues his aquatints, *The Caprices*, 1797.

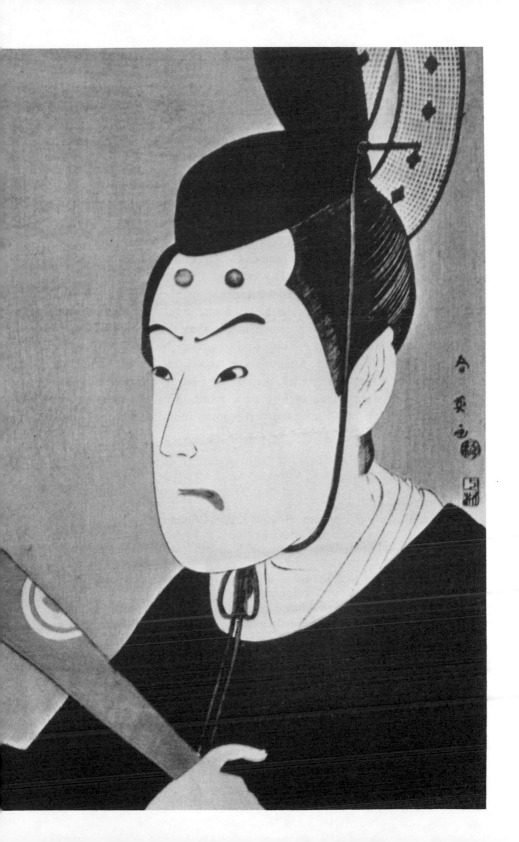

This portrait of Segawa Tomisaburo II illustrates Sharaku's characteristics. Observe the spareness with which line is used. The color scheme is harsh yet effective against a purple mica ground, while the disposition of the figure on paper combines repose with the likelihood that the actor will suddenly move. Eyebrows, eyes and hands are peculiar to Sharaku as are the prim mouth, the narrow sloping shoulders and the pinched face. The signature, its placement and the seal and trademark of Tsutaya are also typical.

This is supposed to be one of Sharaku's most cynical and savage portraits, since Segawa actors were famous for graceful portrayal of women (40). But Segawa Tomisaburo II was an amateur most of his life and when he gained professional status became so overbearing that another Sharaku print of him carries the handwritten note: "Generally called Hateful Tomi." It is probably wrong to say that this print caricatures Tomisaburo. More likely it presents him exactly as he was.

The purple silk over his forehead was necessitated by a Tokugawa law requiring actors to shave off their front hair. Too many wives of noble families were falling in love with actors, who had to be made uglier, but the law failed since married woman found the silken purple cloths even more exciting.

Location: Museum of Fine Arts, Boston. *Also:* Chicago, New York.
Size: 14¾ x 10. *Publisher:* Tsutaya Jusaburo.
Signed: Toshusai Sharaku ga. *Date:* Fifth month (not the same as May) 1794.
Translation: Round seal: Kiwame. *Fuji and ivy:* Tsutaya Jusaburo's trademark.
Kabuki: Hanaayame Bunroku Soga (The Iris Soga of the Bunroku Era) was a popular account of a 1701 vendetta grafted onto the revenge theme of the Soga world, but in order to attract all possible business, elements of *Chiushingura,* the most popular vendetta of all, were added! Miyako (Capital) Theatre, Fifth Month, 1794. The Miyako Theatre was the subterfuge name used by the great Nakamura Theatre when it sought bankruptcy to wipe out accumulated debts.
Technical: Oban. Nishiki-e. Kira-e. Actor print.
In western art: William Blake issues *Songs of Experience* containing among others the relief etching printed as a woodcut and colored by hand to accompany "Tyger, tyger, burning bright," 1794.

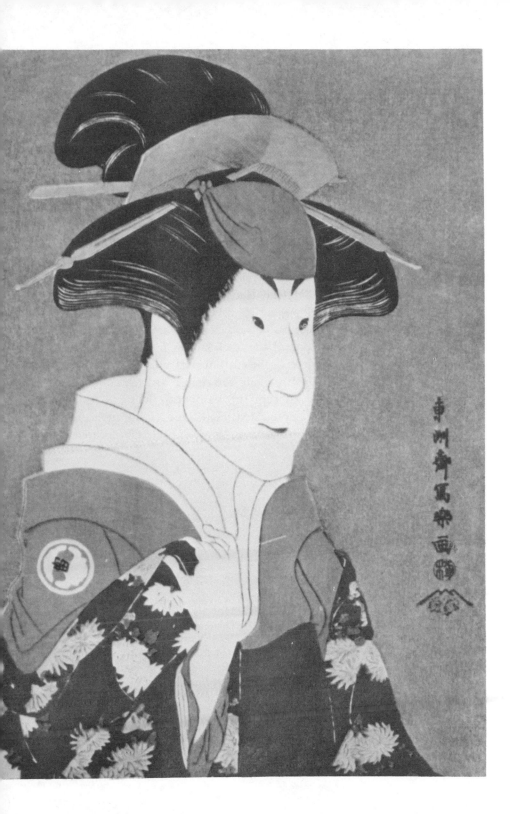

Two ingenious explanations have been offered for the unusual costume shown in this print and in 29 and 45. It was formal garb required at court because, says the first theory, warriors with their legs thus impeded were less apt to engage in brawls. The second reasoning suggests that men at court wore these trailing pants so that they could stand comfortably while creating the illusion that they were respectfully kneeling. As this print shows, the wearer had to hold his pants up with both hands if he wanted to move, a requirement which produces some of the most handsome processions in kabuki.

This strong portrait shows Sakata Hangoro III in the role of the evil daimyo Abe no Mumeto in *Otokoyama O Edo no Ishizue* (Mount Otoko, Foundation Stone of Great Edo), a play which Sharaku illustrated with thirteen known prints plus several now lost. He depicted Hangoro in this present role, his version being in no way superior to Toyokuni's, whose print is one of the least known in his master series discussed on page 185. The blue of the costume was printed with a heavy baren, and the narrow faded strip along the right margin is common in ukiyo-e: it means the print was kept for many years in some book or portfolio from which this edge projected. Had the entire print been exposed to light, the blue would now have almost entirely disappeared.

Series title: Yakusha Butai no Sugata-e (Pictures of Actors on the Stage). *Location:* Museum of Fine Arts, Boston.
Size: 14¾ x 10. *Publisher:* Izumiya Ichibei. *Signed:* Toyokuni ga.
Series date: 1794–1796 (Ledoux); 1795 (Hirano); 1794–1795 (Japanese critics). *This print:* 1794.
Translation: Panel right: Cursive script in panel: Shogatsuya, Hangoro's house name. *Round seal:* Kiwame. *Oblong seal:* Senichi Han, trademark of publisher Izumiya Ichibei. *Two horizontal lines:* The Japanese number two, possibly signifying a second edition.
Kabuki: Since Sakata Hangoro III died in June 1795, and since the above play was produced at the Kiri Theatre in 1794, this little-known print establishes a beginning date for Toyokuni's great series. Kiri was the subterfuge name adopted by the Ichimura Theatre when it wanted to escape debts.

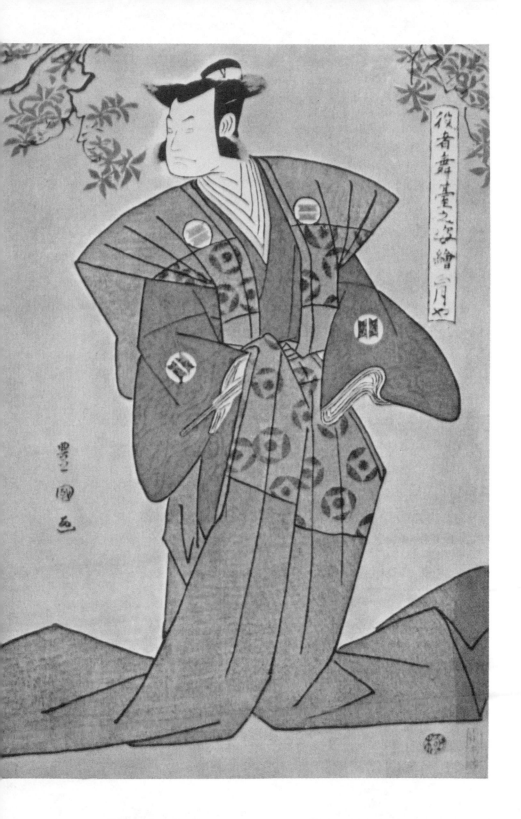

This series depicting the waterfalls of Japan includes several of Hokusai's greatest prints. Each fall is handled individually as if the artist wanted to demonstrate the manifold ways in which water moves. Judgments vary widely as to which print is the chief success of this fine series, but I have never seen any to surpass this.

Its style shows clearly how Hokusai in his old age returned to Chinese motives which he had studied as a young man just out of Shunsho's school. The overhanging crag to the right, although presented in ukiyo-e colors, is strictly Sesshu. The abstract representation of the waterfall is founded on Chinese ideas for the suggestion of natural forces. The figures on the bridge, though easily recognizable as Hokusai's, resemble in placement and function those struggling little men who toil through Chinese art. It seems redundant to say that of course the waterfall of Ono looks absolutely nothing like this picture of it.

No series of Japanese prints appears in American museums for appraisal more often forged than this set of waterfalls; and within the series—all titles of which were cleverly forged probably within the artist's lifetime on paper and in inks that cannot be detected—none was issued in larger printings than this. Most copies avialable today are forgeries. Thus, if critics do not always agree with me that this is the noblest print, the counterfeiters do.

Series title: Shokoku Taki Meguri (Travels Around the Waterfalls of Various Provinces).
Location: Art Institute, Chicago. *Also:* Boston and New York each have two copies, Worcester one.
Size: 15 x 10. *Publisher:* Eijudo. *Signed:* Zen Hokusai Tame ichi fude.
Date: 1827 (de Goncourt). 1830–35 (Fenollosa).
Translation: The Waterfall of Ono no taki on the Kisokaido.
Technical: This Ono is said to be the locality from which Ono no Komachi (Komachi of Ono) came.

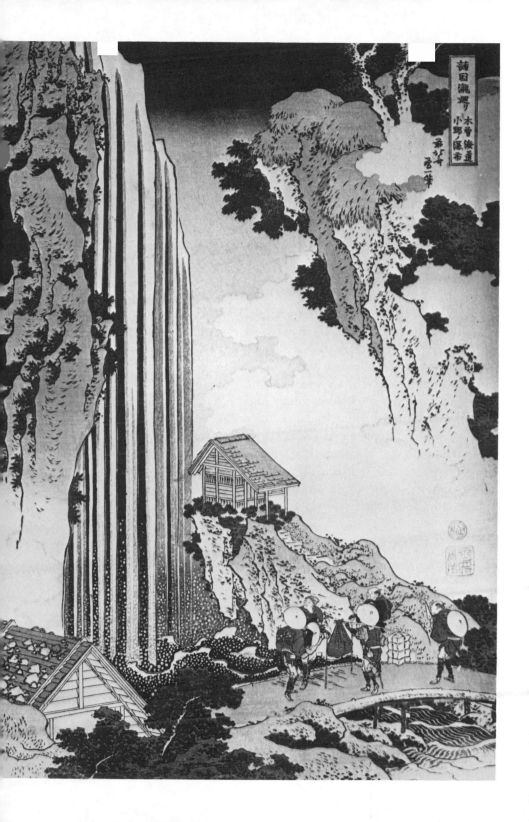

Discussion of this austere, glowing print occurs at page 222. Merely to list all series titled *Eight Views of Lake Biwa* would fill this page many times over, but a few will be cited:

Kiyomasu did an archaic but deeply moving series. "Karasaki Pine" is notable.

Masanobu's series is cluttered with poems but the landscapes are superior, "Seta Bridge" and "Miidera" being especially fine.

Shigenaga composed a virile series, "Evening Sails" being the choice.

Hokusai designed a compact, lively set. "Katata" and "Seta Bridge" are best.

Hiróshige did more than twenty complete sets. The first was finest and is represented here. Some of the hurried later sets were poor.

Ukiyo-e artists also applied the *Eight Views* concept to locations other than Lake Biwa (Hokusai's Ryukyu set is in this form, as are dozens of Hiroshige's views of Edo) but they especially delighted in fanciful applications to middle-class life:

Kiyomitsu did *Eight Views of Youth* (38).

Toyonobu and Choki each did *Eight Views of Chiushingura.*

Koryusai did *Eight Views of Chinese Poems.*

Toyohiro offered *Eight Views among Young Girls.*

Utamaro and Harunobu (39) did *Eight Views of Indoor Life.*

Kiyonaga did fourteen different sets applying the conceits to the Yoshiwara, night life in Shinagawa, gay houses of Fukagawa and the private life of actors.

Series title: Omi Hakkei no Uchi, Hira no Bosetsu (Eight Views of Lake Biwa, Evening Snow at Mount Hira).
Location: Metropolitan Museum of Art, New York, which has two other fine versions. *Also:* Several copies in Boston and Chicago.
Size: 8⅞ x 13³⁄₁₆. *Publisher:* Kawaguchiya Shozo.
Signed: Hiroshige ga. *Date:* 1835c.
Translation: Round seal: Eisendo, firm name of the publisher. *Poem as given in the Phillips Catalogue:* When the snow has ceased falling/The whitened peaks of Hira toward evening/Surpass in beauty the cherry blossoms.
Technical: Hiroshige announced that he intended this series to be a muted study in black, white, gray, blue. The publisher's addition, in later printings, of bright color ruined his intentions.
In western art: Honoré Daumier's savage lithograph, "Ventre Legislatif," 1834.

The deer-and-horse seal on this print, which appears reversed on other Hiroshige work, if taken in Japanese order reads *ba* for horse and *ka* for the second syllable of deer, meaning *baka* or fool, a designation Hiroshige delighted in. The unusual proportions of this print make it a good one to use in a discussion of the most common sizes.

Bai-oban, 18 x 13½ inches. Big and rarely used. Print 55.

Chuban, 10 x 7½. Standard Harunobu size. Print 39.

Hashira-e, 28¾ x 4¾. Pillar print. Prints 47–49.

Hoso-e, 13 x 5⅝. The actor or Shunsho print. Prints 37, 41–46.

Kakemono-e, very roughly 30 x 9. Two sheets pasted together near bottom of print. Print 34.

Naga-oban, 23¾ x 11⅞. Two sheets pasted together near bottom of print. Prints 3, 5, 14, 15 and many other great early works are in this size.

Oban, 15 x 10. The most common size, vertical or horizontal. Prints 54, 63.

Tanzaku, 15 x 5. Used by Hiroshige in his imposing series of bird and flower prints. Print 62 is O-tanzaku, 15 x 6⅝, but such refinements of designation are pedantic.

In reality prints vary a good deal from these theoretical measurements, which are derived from the manner in which certain standard sheets of Japanese paper are cut. Thus a tanzaku is an oban halved.

Location: Museum of Fine Arts, Boston. *Also:* Chicago, New York.
Size: 15 x 7. *Publisher:* Unknown.
Signed: Hiroshige hitsu. *Date:* 1832c. *Seal:* See above.
Translation: Poem: Wind blows over the water, cold grips us and solitude when the wild duck cries.
Technical: Nishiki-e. O-tanzaku. Kacho (Flower and bird).
In western art: John James Audubon, *Birds of America*, 1827–1838.

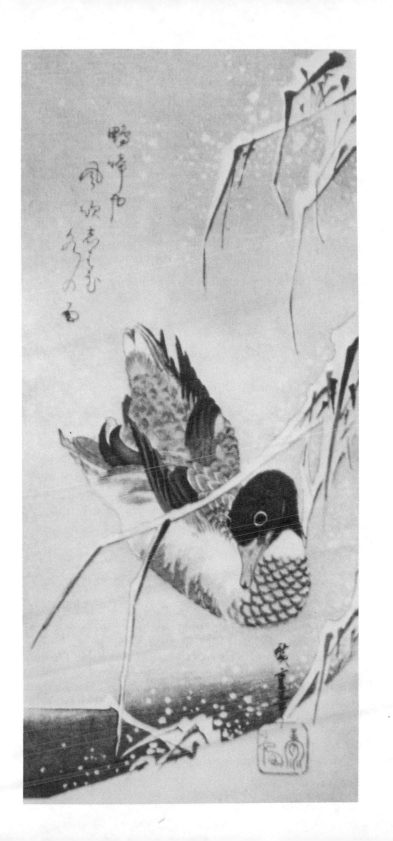

Because no copy of this tragic print was available in America, a modern reproduction by Adachi is used. This permits us to see the key block (63 B) and a print made from it (63 C). On a perfectly flat piece of Shizuoka cherry, cured for two years, a photographic emulsion was laid down, on top of which the original Kuniyoshi print was placed. Exposure of light through the print produced an exact copy, which the engraver then spent two weeks carving, using tools like the ones used by Tsutaya Jusaburo's men. Eighteen key prints were struck off on thin paper and color areas were indicated on these. Thirteen different colors were needed, so five separate color blocks, used front and back, were prepared. Only eight of the ten available sides were carved, but several of these handled two or more colors. Two weeks were spent carving these color blocks.

Printing was done in this order: black (from carbon), yellow (sulphur), red (insect from Russia) and blue (local root). Paper called kizuki from Fukui Prefecture, used also for bank notes, was sized with glue and alum, then dampened to a controlled moisture point, where it was kept for the seven days of printing. Sometimes one color was printed on top of another, as on the horizon below the birds where blue was printed on gray. These blocks yielded 3,000 good copies compared to 800 in the time of Shunsho, 2,000 for Kiyonaga, 3,000 for Hokusai, up to 10,000 for Hiroshige, whose blocks were used till they fell apart, and only about two dozen from the modern katsura wood used by Onchi for print 23. In Utamaro's time, if small heads appeared with intricate hairdress, inlays of harder wood were sometimes inserted, as happened when print 33 was plugged for a new head.

Location: Author. No original copies known in America.
Size: 9%16 x 14%16. *Publisher:* Original: Hishikawa Morobu. Copy: Adachi.
Signed: Ichiyusai Kuniyoshi ga. *Date:* Original: 1826. *Copy:* 1947.
Translation: Yellow cartouche: Artist's signature. *Red cartouche:* Eleventh Act of *Chiushingura.* The Night Attack.
Kabuki: Although this notable print shows events related to the Eleventh Act of *Chiushingura,* it is not actually a kabuki print, since it does not report a particular performance. It is considered a landscape print.
Technical: Nishiki-e. Oban. Uki-e and other elements of western perspective. Sky without key block.
In western art: William Blake issues his engraved *Book of Job,* 1826.

63a

64

Title: Lovers
Location: The James A. Michener Collection, Honolulu Academy of Arts.
Size: 29.9 x 35.1 cm. *Date:* mid-1680s.
Technical: Black-and-white ōban album sheet.
Commentary: Thought to be the frontispiece to a set of twelve erotic prints, the sweeping overall composition of this print is typical of Moronobu's fully developed style.

65

Title: Daikoku, Courtesan and Kamuro
Location: The James A. Michener Collection, Honolulu Academy of Arts.
Size: 37 x 27 cm. *Date:* Ca. 1710.
Technical: Black-and-white horizontal ōban.
Commentary: This album sheet depicting Daikoku, the God of Wealth, is one of twelve parodies dealing with the Seven Gods of Happiness. Such parodies reveal Okumura Masanobu's intelligence, seriousness, and unconventional humor that set him apart from his contemporaries.

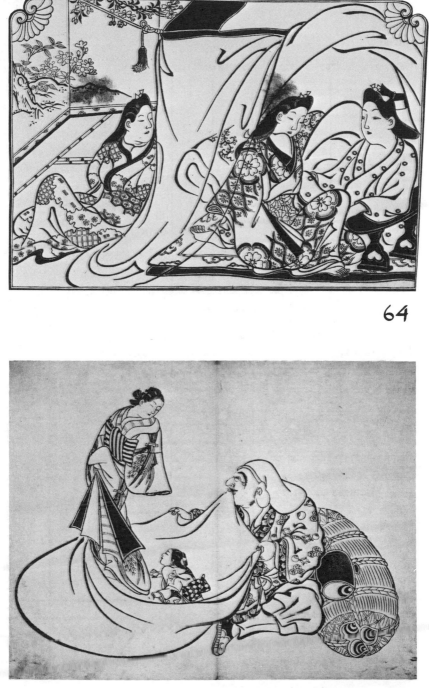

64

65

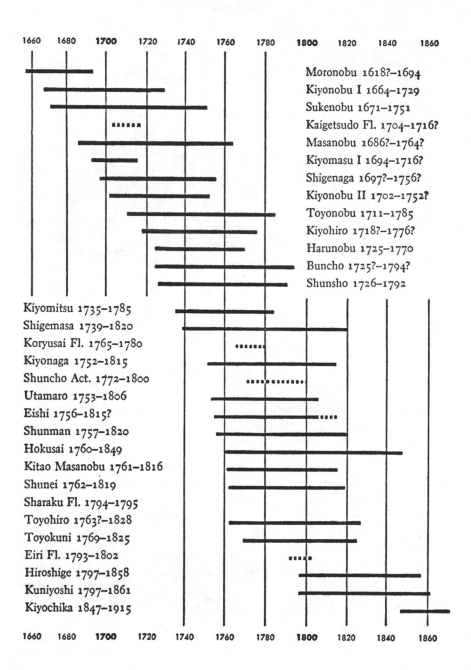

1660 1680 **1700** 1720 1740 1760 1780 **1800** 1820 1840 1860

Moronobu 1618?–1694
Kiyonobu I 1664–1729
Sukenobu 1671–1751
Kaigetsudo Fl. 1704–1716?
Masanobu 1686?–1764?
Kiyomasu I 1694–1716?
Shigenaga 1697?–1756?
Kiyonobu II 1702–1752?
Toyonobu 1711–1785
Kiyohiro 1718?–1776?
Harunobu 1725–1770
Buncho 1725?–1794?
Shunsho 1726–1792

Kiyomitsu 1735–1785
Shigemasa 1739–1820
Koryusai Fl. 1765–1780
Kiyonaga 1752–1815
Shuncho Act. 1772–1800
Utamaro 1753–1806
Eishi 1756–1815?
Shunman 1757–1820
Hokusai 1760–1849
Kitao Masanobu 1761–1816
Shunei 1762–1819
Sharaku Fl. 1794–1795
Toyohiro 1763?–1828
Toyokuni 1769–1825
Eiri Fl. 1793–1802
Hiroshige 1797–1858
Kuniyoshi 1797–1861
Kiyochika 1847–1915

1660 1680 **1700** 1720 1740 1760 1780 **1800** 1820 1840 1860

Buncho

Full name: Ippitsusai Buncho.

Family name: Maroru (Fujikake). Mori (Gookin).

Born: 1725? (Ledoux). *Died:* 1794? (Fujikake).

Pupil of: Ishikawa Kogen, a Kano painter, but soon influenced by Harunobu and possibly by Shunsho.

Comment: All critics sooner or later ponder the problem of who was greater, Shunsho or Buncho. The fact that I allocate six prints to the former and only one to the latter, a full chapter to the former and no text to the latter might seem to indicate that I had resolved the problem overwhelmingly in favor of Shunsho. That is not the case. Binyon says flatly that Buncho is the better artist. Fujikake says he equals Shunsho. I find his tight, angular, sometimes harshly colored prints much to my liking and had either his life or his work provided material for the problems discussed in this book I could happily have chosen Buncho instead of Shunsho. The book he did with Shunsho, *Ehon Butai Ogi* (Picture Book of Stage Fans) 1770, is overpraised; and his paintings on silk are only fair. But some of his actor prints are powerful art. Very popular with collectors are his portraits of Harunobu's favorite models, O-Fuji and O-Sen (6).

Eiri

Flourished: 1793c-1802c.

Pupil of: Eishi.

Comment: The question of who designed this print, clearly signed Eiri, is unusually confused. There seem to be three different artists involved— but these shadowy figures may be only one man—Chokyosai, Rekisentei and Shikusai, all of whom used the art name Eiri, but in differing Chinese characters for the syllables. The author of print 56 has usually been called Rekisentei Eiri. Regardless of what is finally decided, the artist seems to have been a student of Eishi and in addition to his magnificent portrait of Santo Kyoden he seems to have issued nothing of merit except

a partner portrait of Tomimoto Buzendayu (51), the father of one of Utamaro's favorite subjects. It should, however, be pointed out that one major Japanese critic believes the Kyoden portrait to have been done by Eisho, a very able student of Eishi, and the known author of many excellent portraits, but only of women.

Eishi

Full name: Chobunsai Eishi. In Japan often given as Hosoda Eishi.

Family name: Hosoda. *Personal:* Jibukyo, Tokitomi.

Born: 1756. *Died:* 1815. (Early research and Yoshida say 1829.)

Pupil of: Kano Eisen Yoshinobu, a painter of repute and Bunryusai, of whom little is known.

School in which he studied: Kano. But regarding ukiyo-e he was much impressed by Kiyonaga, taking his name Chobunsai from the first character of Torii, which is pronounced Cho in Chinese, adding to it characters from Bunryusai, his painting instructor.

Comment: Eishi's grandfather without question was treasurer to the Tokugawa government, a well paid official of samurai rank. As a young man Eishi is supposed to have served as court painter to Ieharu, the tenth shogun, who gave him the name Eishi. Further details regarding this graceful artist, whose work in subdued color is among the most highly regarded in ukiyo-e, insofar as gentility, poetry and feeling for old and classic themes are concerned, will be found accompanying the two examples of his work. He abandoned print making in 1799 and spent the rest of his life painting.

His major pupils: Eisho, Eisui, Eiri, Eishin, Eijin, Eicho, Eiryu and others. The first is a splendid artist insofar as his big heads are concerned but limited otherwise. Eishi strongly influenced Toyokuni.

Harunobu

PRINTS 6, 39

Full name: Suzuki Harunobu.

Family name: Hozumi. *Personal:* Jihei.

Born: 1725. *Died:* 1770. (Fujikake, Binyon). 1771 (Noguchi).

Pupil of: Nishimura Shigenaga. Strongly influenced by Sukenobu and the Chinese book of painting and instruction *Mustard Seed Garden.* Also by Toyonobu and Kiyomitsu.

Comment: See Chapter 9.

His major pupils: Harushige, known later as Shiba Kokan and many others. Also exerted strong influence on Buncho, Koryusai, Shunsho and particularly Kiyonaga.

Hiratsuka

PRINT 7

Full name: Hiratsuka Un-ichi.

Born: 1895.

Pupil of: Ishii Hakutei for very brief period. Profoundly influenced by ancient Buddhist woodblock prints and by Moronobu. Also directly influenced by the contemporary woodblock artists Tobari Kogan and particularly Yamamoto Kanae, who had studied in France and whose prints have been held by some Japanese critics to resemble the work of Van Gogh.

Comment: See Chapter 24.

His major pupils: Maeda Masao (1904–) and Azechi Umetaro (1904–).

Hiroshige

PRINTS 61, 62, 69, 72

Full name: Ichiryusai Hiroshige.

Family name: Father originally Tanaka but son was adopted into Ando family. *Personal:* Born Tokutaro, took Juemon, then Tokubei. *Professional:* Given by Utagawa Toyohiro in form of Ichiyusai Hiroshige. Changed in 1829, upon Toyohiro's death to Ichiryusai. In later life he used Ryusai. *His poetry name, which became popular in Edo:* Tokaido Utashige, indicating his affection for his Utagawa training. In fact, he sometimes signed his pictures Utagawa Hiroshige.

Born: 1797. *Died:* 1858.

Pupil of: amateur painter Rinsai Okajima. Applied unsuccessfully to Toyokuni for instruction. Accepted at age 13 by Toyohiro, who was himself a pupil of the well known uki-e (bird's-eye picture) and landscape master Utagawa Toyoharu.

Comment: See Chapter 21.

School he founded: He was ambitious to found a school but failed because he had bad luck in his pupils. However, a Hiroshige IV was working as late as 1925.

His major pupils: Morita Chinpei married Hiroshige's adopted daughter Tatsu and took the name Shigenobu, then Hiroshige II. He divorced Tatsu and took name Kisai Ryusho, under which he painted florid designs on tea boxes, which made friends call him "The Tea Box Hiroshige." Tatsu then married Goto Torakichi, who took the art name Shigemasa (but far from the fine artist who did print 19) and later Hiroshige III. In the early twentieth century critics attempted to invent a hypothetical Hiroshige II to whom they attributed all of Hiroshige's poor designs. Some British critics contended that the illusory Hiroshige II (not Shigenobu) was responsible for all vertical landscapes prints, but the idea died for lack of proof that there was such a man and because documentary proof was found that Hiroshige himself did design at least two vertical series, containing some very bad prints. It should be noted that Hiroshige II, III and IV were poor artists.

Hokusai

Full name: Katsushika Hokusai.

Other names: It will probably be instructive to follow at least one ukiyo-e painter through the unbelievable adoption of one name after another. A manuscript by Kuwahara Yojiro is the basis for this list, but it has been added to by the author.

Original surname: probably Kawamura but if so he was adopted early into Nakajima family, hereditary mirror makers to the shogun. *Personal name:* Tokitaro, changed at 14 to Tesuzo. Used Miuraya Hachiemon when he went into self-enforced exile to escape pressure. *Art name:* As pupil of Katsukawa Shunsho he was accorded name Katsukawa Shunro before 1780 but he used the name Zeiwasai 1781 and signed hack-work books Tokitaro or Tetsuzo up to 1785, when he seems to have been expelled from Katsukawa school, taking name Mugura Shunro. 1785 Gunbatei. By 1787 used Hishikawa Sori. Later Tawaraya Sori, Hiakurinsai Sori and in preface to book Katsushika Sori. 1796 Hyakurin Sori. 1797 Hokusai, but some say not before 1799. By 1800 and possibly earlier Kako. 1800 Gwakiojin, Tokimasa, Hokusai Shinsei. 1804 Kintaisha. 1805 Gwakiojin Hokusai, Gakyo Rojin, Kukushin. 1806 Toyo and probably for the first time Katsushika Hokusai. 1808 Manji-hitsu. 1811 Taito. 1812 Raishin. 1814 Tengudo Nettetsu. 1815 Zen Hokusai Taito. 1817 Zen Hokusai Iitsu. By 1820 Tameichi. 1835 Manrojin. Last signature Gwakio Rojin Manji, "The Old Man Mad About Drawing."

Poetry name: 1781 Zeiwasai. 1782 Gyobutsu. 1786 Kakusetsuko. 1793 Hakusanjin Kako. 1794 Kako. 1801 Tokitaro Kako. *Other names:* Kachikawa, Sorobeku for novels plus at least twenty more for various purposes.

Born: 1760. *Died:* 1849. Occasionally 1850 given in error.

Pupil of: Katsukawa Shunsho. Tradition adds Shiba Kokan, the master of Dutch perspective and Harunobu's pupil.

School in which he studied: Katsukawa. Record says he also studied Kano painting, for which he was expelled from Katsukawa school, possibly because Shunko saw a Kano painting of his and tore it up, passionately loyal to the Katsukawa school. In later life Hokusai often said that his

fame was due to Shunko, whose angry action had forced him to develop a style of his own.

Comment: See Chapter 19.

School he founded: Katsushika.

His major pupils: Dozens with names like Hokkei, Hokuba, Hokuda and Hokuju, all of whom showed talent. Strongly influenced Keisai Eisen, Hiroshige's collaborator, and Kiosai. Also taught his gifted daughter Oei; and his son-in-law who lacked talent, Shigenobu, not to be confused with Hiroshige's son-in-law of the same name who had even less.

Kaigetsudo PRINTS 5, 14, 15

Flourished: 1704–1716?

Comment: The tangled problems surrounding the names Anchi, Dohan and Doshin are fully discussed in Chapter 7.

Kitao Masanobu PRINTS 19, 55

Family name: Haida or Iwase. *Personal:* Jintaro or Denzo. *As author:* Santo Kyoden.

Born: 1761. *Died:* 1816.

Pupil of: Kitao Shigemasa.

Comment: The principal facts relating to this artist have been given in connection with the prints above and especially with print 56. Masanobu's earliest work was in kibyoshi-bon written when he was 17. About 1789 he abandoned prints and became so popular as the writer and illustrator of kibyoshi-bon that his publisher, usually Tsutaya Jusaburo, had to hire other artists to do the illustrating. Fujikake says the following were so used: Shigemasa, Utamaro, Kiyonaga and Toyokuni. One of his most popular novelettes he illustrated himself: *Enjiro, the Rake,* in which a snub-nosed loafer becomes obsessed with love stories and decides to become known as Edo's most daring lover. He hires a girl to rush in and threaten suicide if he does not marry her. He hires another to pose as

his wife and weep with grief at his escapades. He hires girls to drag him to the Yoshiwara, men to beat him up for having won their mistresses, a geisha to commit a romantic double suicide with him—in fun only. Finally his father does some hiring too, and robbers break up the suicide and beat the devil out of poor Enjiro. The book was a phenomenal success and it is said strangers would come for miles to peek at Kyoden in his tobacco shop to see if he really had a snub nose. He didn't.

Kiyohiro
PRINTS 37

Full name: Torii Kiyohiro.

Born: 1718? but not confirmed. *Flourished:* 1737–1765. *Died:* 1776?

Pupil of: some unidentified Torii master, probably Kiyomasu II but possibly Kiyonobu II.

Comment: See Chapter 8.

Kiyomasu I
FRONTIS AND PRINTS 3, 28

Full name: Torii Kiyomasu I.

Common name: Shojiro. Possibly the oldest son or brother of Kiyonobu I.

Born: 1694 (often given as 1696). *Died:* 1716?

Pupil of: Torii Kiyonobu I.

Comment: For the tangled theories surrounding Kiyomasu I see Chapter 5.

Kiyomitsu

Full name: Torii Kiyomitsu.

Other names: Kamejiro. Son of Kiyomasu II.

Born: 1735. *Died:* 1785.

Pupil of: Torii Kiyomasu II.

School in which he studied: Torii, of which he became Torii III.

Comment: See Chapter 8.

His major pupils: Kiyonaga, Kiyotsune. Influenced Harunobu and Shige-masa.

Kiyonaga

PRINTS 50, 51, 68

Full name: Torii Kiyonaga.

Family name: Seki or Shirokoya. *Personal:* Ichibee or Shinsuke.

Born: 1752. 1742 frequently cited but certainly wrong. *Died:* 1815.

Pupil of: Torii Kiyomitsu. Influenced by Harunobu, Koryusai, Shunsho.

School in which he studied: Torii, of which he became Torii IV.

Comment: See Chapter 13. It seems likely that he was born in the village of Uraga in Sagami Province as the son of Awaya Jinemon and was promptly adopted into the Seki or Shirokoya family of booksellers and tenement keepers in Edo. His first print appeared at age 15.

His major pupils: Many ineffective artists whose names begin with Kiyo-, including his own son Kiyomasa, who did have talent. His influence on the pupils of other teachers was profound: Shuncho, Shunzan, Shunman, Toyokuni, Eishi, Utamaro and numerous others.

Kiyonobu I

PRINTS 10a, b, 11, 26, 27

Full name: Torii Kiyonobu.

Other names: Shobei.

Born: 1664. *Died:* 1729.

Pupil of: his father, Torii Kiyomoto, the Osaka actor and Edo sign painter. Also deeply influenced by Moronobu and possibly by Kaigetsudo.

Comment: See Chapter 5, to which must be added one of the few facts we know about him: that in 1693 he married.

School he founded: Torii, of which he was Torii I.

His major pupils: Kiyomasu I, Kiyonobu II, Kiyotada, Kiyoshige, Kiyotomo, Kiyoharu, all acceptable artists, plus several others. Influenced Shigenaga and many others.

Kiyonobu II

PRINT 29

Full name: Torii Kiyonobu II.

Other names: Teishiro. Also called Shobei.

Born: 1702. *Died:* 1752 according to tradition, but Binyon cites prints signed by some Kiyonobu as late as 1757 and a book in 1758.

Pupil of: Torii Kiyonobu I.

Comment: For the tangled theories surrounding Kiyonobu II see Chapter 5.

Koryusai

PRINTS 47, 48, 49

Full name: Isoda Koryusai. In Europe generally Koriusai.

Personal name: Masakatsu. Also Shobei. *Earliest art name:* Haruhiro, from Harunobu. *In later life signs himself:* "The Man With no Occupation from Yagenbori."

Flourished: 1765–1780 as print designer. 1780–1788 as painter. Book published by him in 1784.

Pupil of: Nishimura Shigenaga, but modern critics deny this. Certainly directly influenced by Harunobu.

Comment: See Chapter 12.

His major pupils: He influenced Kiyonaga, who continued the series launched by Koryusai, *Fashion Plates: New Designs as Fresh Young Leaves.* Also all succeeding artists through his pioneering the standard-size print, 15 x 10 inches.

Kuniyoshi PRINTS 63a, b, c

Full name: Ichiyusai Kuniyoshi. Often given as Utagawa Kuniyoshi.

Family name: Igusa. *Personal:* Magosaburo. *Studio:* Chooro.

Born: 1797 (most authorities). 1798 (Binyon). *Died:* 1861.

Pupil of: Toyokuni, from whom he received his name.

School in which he studied: Utagawa.

Comment: See Chapter 22.

His major pupils: Yoshitora, Yoshitoshi and many others, most of whose names began with Yoshi-. About 80 percent of the worst aniline-dye prints imported in stacks to the United States were by his pupils.

Masanobu PRINTS 16, 30, 31, 32, 35, 65

Full name: Okumura Masanobu.

Personal name: Gempachi, Shimyo. *Studio:* Hogetsudo, Tanchosai, etc.

Born: 1686 (Fujikake and Yoshida). 1691 (Binyon). *Died:* 1764 (Fujikake). 1768 (Binyon).

Pupil of: Kiyonobu I, say certain chronicles. More likely he was self-taught. Strongly influenced by Sukenobu.

Comment: See Chapter 8.

School he founded: Although his influence was a determinant in ukiyo-e history, he was too strong an individualist to bother to impress his style on many students.

His major pupils: Toshinobu, who was probably his son Masatoshi. Directly influenced Shigenaga and Toyonobu.

Moronobu PRINTS 2, 8, 9, 25, 64

Full name: Hishikawa Moronobu. 1638 Shisei.

Personal name: Kichibei. *As a monk:* Yuchiku.

Born: 1618c (Fujikake). 1625c (Binyon, Ledoux). 1646c (von Seidlitz).

Died: 1694. 1714 early rumor.

Studied: Principles of design with father, an embroiderer. Also self-taught in principles of classic art.

Schools which he studied: Kano, Tosa, ukiyo-e.

Comment: See Chapter 3.

School he founded: Hishikawa.

His major pupils: Moronaga, Moroshige, Moromasa and many others including Morofusa, his son, whose works are often passed off as Moronobu's, as they were in his life time. Whether Shigemasa Jihei, to whom many Moronobus now in the United States may one day be given, was a pupil is unknown at this time. Influenced Kiyonobu I and many subsequent artists, like Hiratsuka.

Onchi PRINT 23

Full name: Onchi Koshiro.

Other names: Onchi is often spelled Onzi on prints (23). The prewar nationalist government promulgated radical new spelling laws whereby Fuji became Huzi and Hiroshige, Hirosige. Onchi, however, derived his spelling from the German, a fact which symbolizes his early influences. His name is really Onji, but he never liked the sound of it.

Born: 1891.

School in which he studied: Tokyo Academy of Fine Arts. Influenced by Yamamoto Kanae (see Hiratsuka's biography). But Onchi specifically modeled his style on Edvard Munch of Norway, Wassily Kandinsky, the Russian-German, and Vincent Van Gogh of Holland.

Comment: See Chapter 24.

His influence: Yamaguchi Gen (1902–); Shinagawa Takumi (1908–); Sekino Jun-ichiro (1914–); Kitaoka Fumio (1918–).

Sharaku

PRINT 58

Full name: Toshusai Sharaku.

Family name: Saito. *Personal:* Jurobei.

Flourished: 1794–1795.

Comment: The mystery surrounding this great artist is discussed in Chapter 17.

Shigemasa

PRINT 19

Full name: Kitao Shigemasa.

Personal name: Tarakichi, later Kyugoro. *Art:* Kitabatake.

Born: 1739. *Died:* 1820.

Pupil of: No known teacher. Apparently self-taught. But influenced by Moronobu, Toyonobu and Kiyomitsu. Later and with somewhat unfortunate results, by Harunobu. Probably worked at some time with Shigenaga.

Comment: In 1755, when only 16, he prepared the art work for the Edo calendar, an important contemporary publication, and did so yearly, with only two misses, until his death. He was highly respected and considered, according to one contemporary account, a better artist than Shunsho, with whom he collaborated on what most critics hail as the finest ukiyo-e color book, *Seiro Bijin Awase Sugata Kagami* (A Mirror Reflecting the Forms of Fair Women of the Green Houses, 1776). He seems to have de-

rived many aspects of his style from Koryusai, especially his manner of depicting women, whom he portrayed in several dozen memorable prints, marked by stolid draftsmanship, excellent placement and strong, somber colors. He probably portrayed Japanese women more completely honestly than any other ukiyo-e artist but men who came later like Kiyonaga, Eishi and Utamaro saw that the resulting art would be better if the women were somewhat elongated. His single prints are almost invariably satisfying.

School he founded: Kitao.

His major pupils: Kitao Masanobu, later Santo Kyoden (56), Shunman, Kitao Masayoshi.

Shigenaga
<div align="right">PRINT 33</div>

Full name: Nishimura Shigenaga.

Other names: Eikwado, Senkwado, Kyakuju, Magosaburo.

Born: 1697? *Died:* 1756 customarily cited but Chicago has a book signed by him and dated 1765.

Pupil of: Torii Kiyonobu I, says old chronicle. Self-taught, say modern critics. In either case, influenced by Kiyonobu, Sukenobu, Masanobu.

Comment: See Chapter 8.

School he founded: Nishimura.

His major pupils: Toyonobu, Harunobu, possibly Koryusai and Shigemasa, Toyoharu and more than twenty others of lesser accomplishment. Probably the foremost teacher in ukiyo-e history.

Shuncho
<div align="right">PRINT 52</div>

Full name: Katsukawa Shuncho.

Active: 1772–1800.

Flourished: 1780–1795. Fujikake says he started issuing prints 1781. *Died:* 1820? (Fujikake).

Pupil of: Katsukawa Shunsho, whose teaching was quite obliterated by the tremendous influence upon Shuncho of Kiyonaga, whose imitator he became.

Comment: Many collectors share a common experience. They start with prints of the great names and spend periods sometimes as long as several years relishing the work of Utamaro, Kiyonaga and Hokusai only to realize belatedly that a very fine artist has been at hand all that time with prints one third as expensive. Shuncho is the stateliest of the ukiyo-e artists, his heavy figures pressing powerfully upon the paper. He did landscapes that cannot be differentiated from Kiyonaga's, several excellent prints copied from the style of 51, some strong, solid actor prints and numerous studies of Utamaro's two favorite models, O-Hisa and O-Kita. His diptych showing princesses getting ready for a football game is excessively praised but is so rarely found in good color as to be in general disappointing.

Shunei

Full name: Katsukawa Shunei. Often given as Shun-ei, Shunyei.

Family name: Isoda. *Personal:* Kiyujiro. Also Kyotokusai. Nicknamed "The Old Man from the Cross Street."

Born: 1762. Old records say 1768. Error commonly seen says 1752. *Died:* 1819.

Pupil of: Katsukawa Shunsho.

Comment: His main vocation was joruri singing, but he did excellent art work at age eleven, published an able illustrated book at fifteen. The general level of his work, characteristics of which are briefly summarized at print 57, is high and he has to his credit a dozen or more prints that any collector would be proud to own. They are all marked by rigid control, strong color relationships and seem to have been produced under the aloof command of a realistic eye.

Shunman

Full name: Kubo Shunman. Also spelled Shumman, which is close to the actual pronunciation.

Family name: Kubota. *Personal:* Yasubei. *As author:* Nandaka Shiran. *To brag of his ability as a left-handed artist:* Shosado and Sashodo.

Born: 1757. *Died:* 1820.

Pupil of: Katori Nabiko (Kajitori Uwohiko) a painter, who gave him the name of Shunman, not connected in any way with the school of Katsu- kawa Shunsho. He later changed the character used for the Shun- in his name to avoid identification with Shunsho's school. His ukiyo-e training he acquired from Kitao Shigemasa. Also influenced by Kiyonaga.

Comment: The special merits of Shunman, which are high, are covered in the note facing his print. Fujikake thinks he surveyed the field of ukiyo-e at his time and concluded that he could not compete with Kiyonaga and Utamaro. Consequently he abandoned the art and made his living writing comic poems, at which he seems to have been highly skilled. He also wrote and illustrated kibyoshi-bon. Almost everyone who owns a good Shunman print prizes it highly, for he did little work but with great distinction. He dabbled with western perspective, unique color harmonies and unusual subject matter and was in all he did a graceful, quiet artist.

Shunsho

Full name: Katsukawa Shunsho.

Family name: Hayashi. *Personal:* Yusuke. *Clan:* Fujiwara. Plus many other names for poetry.

Born: 1726 (almost all critics). 1729 (one Japanese). *Died:* 1792. 1793 (Gookin).

Pupil of: Katsukawa Shunsui, a pupil of Miyagawa Choshun, one of the finest ukiyo-e painters, many of whose works have survived but who de- signed no prints. Studied Kano painting with Ko no Sukoen. Also in- fluenced by Harunobu.

Comment: See Chapter 11.

His major pupils: Shunei, Shunko, Shuncho, Shunzan, Shunsen and many others, including Shunro, later Hokusai. He also influenced Kiyonaga, who copied his actor prints, Toyokuni, Utamaro and possibly Buncho. Fujikake lists thirty-one ukiyo-e artists whose names begin with Shun- and who derive from Shunsho or his immediate pupils.

Sukenobu

PRINTS 4, 12, 13

Full name: Nishikawa Sukenobu.

Family name: Nishikawa. *Personal:* Yusuke or Sakyo. Also Jitokusai, Bunkado, Fuji, Nansei. *For erotic works:* Nishikawa Sukubei.

Born: 1671 (Binyon). 1674 (von Seidlitz). Possibly 1678 (Rumpf).

Died: 1751 (Binyon). 1754 (von Seidlitz).

Pupil of: Kano school artist Kano Eino and Tosa school artist Tosa Mitsusuke, from whom he derived the Suke- in his name.

Comment: See Chapter 6.

School he founded: Nishikawa.

His major pupils: Suketada, his son, and more than a dozen other Kyoto and Osaka artists. Influenced Masanobu directly, Harunobu profoundly and almost all subsequent ukiyo-e artists indirectly. His books provided a gold mine for other men to copy from.

Toyohiro

PRINT 20

Full name: Utagawa Toyohiro.

Family name: Okajima. *Personal:* Tojiro. *Studio:* Ichiryusai. He was not the brother of Toyokuni.

Born: 1763. But 1773 has persisted for many years and seems more likely.
Died: 1828.

Pupil of: Toyoharu and possibly Toyokuni.

School in which he studied: Utagawa.

Comment: A most graceful artist who produced many appealing prints. Critics who do not like the flamboyance of Toyokuni usually praise Toyohiro fulsomely, which seems not to be supported by his works. On the other hand, a few of his works, including two triptychs and a magnificent faded print of a woman with umbrella, now in the Mansfield Collection at the Metropolitan in New York, are flooded with poetic feeling. For a rhapsodic appreciation, written by a man who fell completely under the Toyohiro spell, see Ficke.

His major pupils: Many, most of whom like Hironobu, Hiromasa and Hirochika borrowed from his name. His most illustrious pupil was Hiroshige, who seems to have appreciated long and deeply the sensitive instruction he received at Toyohiro's school.

Toyokuni PRINT 59

Full name: Utagawa Toyokuni.

Family name: Kurahashi. *Personal:* Kumachiki, changed to Kichiemon. *Studio:* Ichiyosai.

Born: 1768 (Ficke). 1769 (all others). *Died:* 1825.

Pupil of: Utagawa Toyoharu, whence his name. Strongly influenced or dominated in turn by Shunsho, Kiyonaga, Choki, Shuncho, Eishi, Utamaro, Shunei, Sharaku, Kunisada.

Comment: See Chapter 18.

School he founded: None, but it was under his command that the Utagawa dominated ukiyo-e for a generation.

His major pupils: Kuniyoshi, Kunimasa, Kunimaru and at least fourteen others similarly named. Also Kunisada (Toyokuni III). Influenced Toyohiro. A good many prints signed Toyokuni are by pupils.

Toyonobu

Full name: Ishikawa Toyonobu.

Other names: Prior to 1730 known as Nishimura Magosaburo. Then till 1738 or possibly 1744 Nishimura Shigenobu, under which name he did many rather tedious prints in the style of Kiyomasu II or a less inspired Shigenaga, from whom the name Shigenobu derived. Also used Meijodo and Shuha. Known in later life as Nukaya Shichibei from the name of an inn which he acquired along with his wife.

Born: 1711. *Died*: 1785.

Pupil of: Nishimura Shigenaga, but strongly influenced by Masanobu and indirectly by Sukenobu.

Comment: See Chapter 8.

Utamaro

Full name: Kitagawa Utamaro, both names deriving from Tsutaya Jusaburo's private names Kitagawa and Karamaru.

Family name: Unknown. *Personal*: Nobuyoshi called Yusuke. Through 1778 his prints are signed Kitagawa or Toriyama. Through 1778 Toyoaki. Also signed Toyakira, Murasaki, Entoku. *Pen names*: Sekiyo, Mokuen, Entaisai, Murasaki-ya. *Poetry names*: Fude no Ayamaru, Shisui Enju.

Burial name: Shuyen Ryokyo.

Born: 1753, not 1754 as occasionally reported. *Died*: 1806.

Pupil of: The Kano painter Sekien Toriyama, who was definitely not his father and in all likelihood not his adopted father either. Earliest prints seem copied from Shunsho; next series strongly influenced by Kiyonaga.

Comment: See Chapter 16.

School he founded: Kitagawa.

His major pupils: Tsukimaro, Kitamaro, Minemaro and many others of no talent whatever, including Baigado, known as Utamaro II, who married the widow of his master, although many contemporaries reported erroneously that Utamaro I was unmarried. Strongly influenced Toyokuni.

The Floating World
Thirty Years Later

*I*n 1957, Richard Lane, who would subsequently collaborate with Michener on *Japanese Prints* (1959), reviewed *The Floating World* for the *Harvard Journal of Asiatic Studies* and made the following comments: "Mr. Michener happily has perpetuated fewer popular fictions about ukiyo-e than one might expect; *The Floating World* is on the whole a valid, if highly personal, account of the flowering and withering of the greatest of the Japanese plebian arts. It is the first integrated history of the genre to appear in some years, and contains a good deal of information not readily available in Western sources . . . it can be recommended as stimulating supplementary reading for any course in Japanese cultural history that deals with the Tokugawa period."

I am happy to report that this assessment still holds and that in some instances our growing knowledge has corroborated many of Michener's theories and personal points of view. At the same time the book is not without need of correction, and while the account that follows is by no means comprehensive, I attempt to deal with a number of issues that will supplement and refine Michener's original text.

The title, *The Floating World*, is in itself a very significant one for Michener to have selected. It refers to the contemporary world of the Edo period and its various pursuits of pleasure, profit, and the fashionable. Michener points to one of the deepest gaps in ukiyo-e studies as it existed in the 1950s with this title, for the key to this fascinating world is the literature, history, customs, and psychology of the Japanese people. The title, therefore, presages much of the scholarship of

the past thirty years made by specialists with a thorough grounding in these areas—many of the same specialists with whom Michener consulted for his own work.

Despite the employment of certain fictional techniques, Michener has produced an account which remains for the most part unbiased and his chapters come to life without being parodies of the facts. One unfortunate exception occurs at the beginning of the book with a fictional account of a daimyo procession passing through the little town of Otsu outside of Kyoto. It is in this town that primitive pictures called Otsu-e were made, and, according to Michener, the true origins of ukiyo-e may be sought here. This popular misconception was not original with Michener and must be classified as a fiction dreamed up by ukiyo-e connoisseurs of many generations ago.

Let it be said that Otsu-e up to the late nineteenth century were folk paintings and did not employ the woodblock medium. Richard Lane refers to a statement about Otsu-e in Hishikawa Moronobu's *Tōkaidō Buken Eizu* dated 1690, noting: "Otsu: they make various Buddhist pictures here." The earliest Otsu paintings are indeed Buddhist as Michener suggests and Moronobu confirms. Late Otsue-e works, as Michener himself suggests, were probably influenced by the more sophisticated prints of Edo and not the reverse as had been earlier suggested. Had Michener considered this point more carefully, he probably would have deleted the chapter all together. Nevertheless, his summary is of interest to the general reader who may have encountered the term Otsu-e in early books on ukiyo-e. Michener's main source of information was *The Peasant Painting of Otsu*, by the noted scholar Yanagi Muneyoshi, which, along with the Fogg Art Museum catalogue *Japanese Peasant Painting from the Village of Otsu* (not noted by Michener), were the only substantial comment in English on the subject available in the 1950s.

While the actual origins of ukiyo-e have yet to be adequately studied, its style can be traced to the genre schools of painting of the late sixteenth and early seventeenth centuries, which in turn can trace their origins back to yamato-e (Japanese style picture) scroll painting of the Fujiwara (897–1185), Kamakura (1185–1333), and Muromachi (1392–1573) periods. Michener also briefly discusses the traditional founder of the ukiyo-e school, Iwasa Matabei (alternate pronounciation, Matahei, 1578–1650), and dismisses this enigmatic artist as having nothing whatsoever to do with ukiyo-e style. In re-

cent years, however, this opinion has been challenged, notably by the eminent scholar of Rimpa and genre painting Nobuo Tsuji. Among the genre paintings to be attributed to this recondite and elusive master of genre art are "The Tale of Princess Joruri Scroll" and the "Lady Tokiwa Scroll," both in the collection of the MOA Art Museum, Atami, Japan. The figures depicted on both scrolls are characterized by voluptuous proportions, with elongated faces and full cheeks. This style can be seen in a number of screen and scroll paintings dealing with aspects of the floating world, such as Okuni kabuki, teahouse extravaganzas, and a trio of scrolls once owned by the seventeenth-century feudal lord of Shimazu, Iehisa, who died in 1638. A basic source of Japanese painting, *Koga Bikō*, lists this triptych as the work of Isawa Matabei. Whether or not this enigmatic master was the "founder" of the ukiyo-e school remains to seen, but if these attributions prove correct, Matabei surely must be judged as an important wellspring for its style. Perhaps the artist Eisen under a pseudonym, writing in the 1830 *Ukiyo-e Ruikō* manuscript, was correct in naming Matabei as an important early master of the ukiyo-e tradition.

In contrast to proto-ukiyo-e and ukiyo-e paintings, prints began to appear in the early 1660s and were the culmination of ideas instigated by a small group of connoisseurs of erotica for multiplying choice examples in limited editions. Initially, most of the broadsheets were unsigned, although some of the many book illustrations of the early period carried the artist's signature and date. Michener's opinion that ukiyo-e was essentially a folk art most certainly needs to be reconsidered in light of the above comments. Indeed, Michener later characterized ukiyo-e as "work produced by individual men who sometimes had great genius and who always had separate personalities." As Richard Lane notes, these are not characteristics that would apply to the folk art tradition.

While Michener's chapter on Otsu-e must ultimately be regarded as a narrative means of drawing in his reader, his work on the land and the people (chapter 2) is successful, although one might argue about whether the bakufu authorities harbored any philosophic hatred of prints, per se, as symbols of the merchant class and their growing power. Here Michener is at his best in capsulizing a very difficult subject area.

The nominal founder of the ukiyo-e school has been considered the Edo book illustrator Hishikawa Moronobu (?–1694), who is the focus of chapter 3, "The Sovereign Line." The main points to be made about Moronobu, which supplement Michener's views, are as follows: The traditional opinion of Moronobu as the sole founder of the ukiyo-e school has been abandoned with the rediscovery of the existence of his contemporary Sugimura Jihei (active 1681–1697?) and the work of Moronobu's anonymous predecessors, whose names are mostly not recorded but whose work, largely book illustrations, can be classified stylistically. At least four hands so far have been determined.

Sugimura Jihei (not discussed by Michener), peer of Hishikawa Moronobu, was active from 1681 to around 1697. Although his name is mentioned in the *Ukiyo-e Ruikō*, it was not until the 1920s that Sugimura's extant prints were separated from the large corpus of unsigned art by Hishikawa Moronobu and his contemporaries. Many of these so-called unsigned prints actually bear a hidden signature worked into the design.

Evidence from contemporaneous sources on the life of Sugimura is scant. The earliest known reference to the artist is in the *Edo Zukan Kompuku*, a directory of Edo artists published in 1689, where he is listed under the heading "Woodblock Artist, Sugimura Jihei Masataka, Tori Abura-chō [his address]." In a second source, the *Yōsha-bako* (The Document File), published in 1841 by the essayist Ryūtei Tanehiko (1783–1843), Sugimura is listed as the illustrator of two books, one dated 1682 and the other 1684, neither of which is believed to be extant today.

Six signed and dated books by Sugimura survive and are the basis for establishing the seventeen-year working period attributed to him. It is from these key books and the several prints bearing his cryptic signature that Sugimura's stylistic individuality has been determined. One of Sugimura's most interesting books, containing a number of literary mitate (among the earliest visual mitate known), suggests the importance of literary allusion in this artist's work. This characteristic is in sharp contrast to the book illustrations of Moronobu, the "pure artist" whose work is practically devoid of such allusion. Moreover, where the greater part of Moronobu's printed work is found in book illustration, Sugimura seems to have concentrated on single sheets, both print and album. In fact, the earliest signed kakemono-e

print is by Sugimura from the late 1680s. There is a certain grandeur and freshness in the compositions of his best work and a clear emphasis on the richness and animation of the kimono. Sugimura was, without question, a very imaginative and original artist whose influence on later ukiyo-e was considerable.

Moronobu was the first known ukiyo-e artist of great stature and the first true genius to emerge. Michener's own collection includes Moronobu's earliest surviving signed and dated work, *Buke Hyakunin Isshu* (One Hundred Warrior Poets) of 1672, a large number of gracefully designed book illustrations from the artist's *Bijin E-zukushi* (Collection of Beautiful Women) of 1683, and a page from his last signed and dated book, *Sugata-e Hyakunin Isshu* (The One Hundred Poets Illustrated) of 1695. Michener's comment in *The Floating World* regarding Moronobu's cluttered backgrounds was, in fact, a reference to a book illustration in *Bijin E-zukushi*. His criticism fails to distinguish the different requirements of book illustration and of purely decorative prints. While Michener chooses Moronobu's *Yoshiwara no Tei* to illustrate Moronobu's achievements, the artist's finest work, in my opinion, is seen in his great shunga album designs of the 1680s. The sweeping overall composition of these sheets is a paradigm of the artist's fully developed style at its best. His large figures have a poetic grandeur when compared with the small figures of his *Yoshiwara no Tei*.

Michener's definition of ukiyo-e as "literally a picture, possibly religious in import, of the evanescent world," has clearly been superceded by more accurate definitions. Asai Ryōi, writing in 1661, defined the term *ukiyo* as "living only for the moment, gazing at the moon, snow, and cherry blossoms and autumn leaves, enjoying wine, women, and song, and just drifting along the current of life like a gourd floating down a river." While this poetic statement of the 1660s surely reflects the *ukiyo* attitude of the day, a number of compounds in which *ukiyo* occurs provides at least three different connotations: fashion, erotic, and genre. Richard Lane formulates a synthetic comprehensive definition based on the multiple uses. His definition seems to be as close as anyone will come to defining this elusive term: "a new style of pictures, very much in vogue, devoted to the depiction of everyday, human life, but particularly of fair women and handsome men engaged in pleasure, or part of the world of pleasure; pictures, as often as not, of an erotic nature."

"The City and the Stage," Michener's next subject, is particularly well done. Setting aside some minor points, the chapter deals with a number of important subjects including the founding of kabuki, such playwrights as Chikamatsu Monzaimon (1653–1725), the great kabuki actors Danjūrō I and II, and an entire range of interesting information about Edo that brings the city to life. Of course, any given topic within this brief chapter could be easily expanded. It is in the area of kabuki that further comment seems needed, since so many of the prints chosen for *The Floating World* deal with the popular stage.

Credit for the beginning of kabuki goes to a female shrine dancer from Izumo named Okuni. Around 1600, the very year of Hideyori's defeat by Ieyasu, she performed a Buddhist ceremonial dance in the dry bed of the Kamo River in Kyoto. With erotic variations all her own, she became an immediate success and quickly attracted a group of students, both men and women, who formed a company. The new theater was little more than a bawdy dance review and quickly earned the somewhat uncomplimentary name, Okuni Kabuki. The term, derived from the verb *kabuku*, "to tilt forward," extended metaphorically in early Edo slang to signify customs or behavior that defied the traditional norm and drew attention. As with the word *ukiyo*, the term was imbued with overtones of the licentious and hedonistic. Rival troupes known as onna kabuki were in fact composed of "easy" women. Adverse effects on public morals were considered so great that finally, in 1629, the shogunate was forced to issue a decree prohibiting all women on the stage. With the prohibition of women, young men of bisexual conduct known as wakashu, were given free rein in a variety of roles including onnagata (female impersonators). These male youths eventually proved as great a source of attraction as the women, so that in 1652 the shogunate again suppressed the theater. After this, actors were compelled to shave off their forelocks to lessen their effeminate charms—but that special distinction proved to make the onnagata even more attractive.

Profound changes in the actual form of the drama itself followed. Officially the newly formed theater was referred to as spoken drama with mime or imitation but was commonly known as yarō-kabuki. The word *yarō* meant "man" or "fellow" with the implication that the new kabuki was now being performed by robust men of adult

age. Eventually, the word *kabuki*, always written in kana syllabic script at this time, would be rendered in Chinese ideographs meaning "song, dance person," but the dates of this change which involved at least two transitional steps is by no means certain.

In any event, skillful acting of both male and female roles became necessary, and scenarios that had previously been nothing more than a type of revue took on an orthodox pattern. Each actor began to specialize in one particular kind of role, and in 1664 the revues were divided into more than one act. These acts were eventually distinguished as historical drama and domestic drama and often included a dance play as one of the acts.

The leading actor of domestic drama during this golden era was Sakata Tōjūrō I (1647–1709), who developed the soft, elegant, and essentially realistic acting style of Kyoto kabuki. Specializing in the so-called leading male roles, his greatest successes usually were in the portrayal of Kyoto merchants and their involvement with life in and around the Shimbara pleasure quarters. His style of acting, known as "soft stuff," was to influence the entire school of Kamigata (Osaka/Kyoto) actors.

Nearly simultaneous with the development of Tōjūrō's elegant approach to acting and the domestic drama was the bombastic and totally unrealistic acting tradition of Ichikawa Danjūrō I and his historical scenarios. This vastly energetic man was a giant on the kabuki stage and was the founder of the ranking dynasty of actors in Edo.

In 1673, young Danjūrō, then only fourteen years old, played the part of Sakata no Kintoki, a warrior in the play *Shitenno Osanadachi* (The Childhood of Four Strong Warriors). It was the first instance of "rough-stuff" acting style that was to be so important to Edo kabuki. His style, which required a tremendous amount of swaggering about as a swashbuckling hero, was based largely on characteristics of the imaginary superhuman Kimpira, as told by street chanters in a narrative called *Kimpira-bushi*, a kind of exaggerated storytelling that was in fashion in Edo around this time. This storytelling dealt with the heroic exploits of this legendary hero and involved the use of elaborate dolls. Although none of these dolls exists today, a number of illustrations survive, many done for military storybooks and attributed to nameless woodblock masters of Kyoto in the 1660s.

Danjūrō's achievements are well described in kabuki record. The exposed portions of his body and face were painted entirely in red

with black lines drawn to delineate and emphasize his features. His large, fierce eyes were accentuated and his eyebrows were painted with bold, upturned strokes to symbolize vitality. All this was borrowed from the Kimpira puppet tradition and would seem to be the crude beginnings of kumadori makeup. Such symbolic makeup was eventually to be distinguished by the use of bold alternating lines drawn in a kind of striped pattern and is still in use today to identify the hero.

Stage successes followed in quick succession, many written by Danjūrō himself under the pen name Mimasu Hyōgo. Not content with the primitive and simple stories that typified early historical drama, his plots took on a greater maturity and complexity. In 1684 he wrote and acted in his first staging of a drama about Saint Narukami, the monk who caused the rain to stop falling throughout Japan. He made extensive revisions to this drama in 1698, and the work eventually became the best of all Genroku era plays. Four years later, in 1688, he produced his first Soga drama, based on the heroics of the legendary Soga brothers and their attempt to revenge their father's murder. This play was the prototype for a long succession of dramas dealing with the Soga theme.

Thus, by the Genroku period, the division in kabuki-style acting was complete: Kamigata-trained actors offered a polished and elegant style of realistic acting and favored the domestic drama while Edo actors specialized in the rough bombastic acting style and the historical scenario. This distinction is important to an understanding of the art of the early Torii masters, the next subject to be tackled by Michener. By the late 1690s, when these artists began to dominate the print world, a definite interrelationship between the ukiyo-e woodblock print and kabuki existed. In fact, many of the memorable performances were recorded in books, albums, and broadsheets by these illustrious masters, apparently under some kind of special arrangement with the theaters of Edo.

"The Dramatic Vision," chapter 5, deals with the theatrical prints and paintings bearing the signatures of the Torii masters, Torii Kiyonobu and Torii Kiyomasu. On the whole, the chapter is brilliantly written, summarizing the major issues surrounding the name succession and the various theories attempting to identify the enigmatic Kiyomasu I. In his review, Richard Lane finds little to criticize, cor-

recting only the signature reading of a 1687 book and some small mistakes in romanization. The chapter proved to be a springboard for my own research into the question of the Torii school. The results of my work were subsequently published in two issues of *Ukiyo-e Art* and most recently in the exhibition catalogue, *The Theatrical Prints of the Torii Masters* (published by the Honolulu Academy of Arts and the Riccar Art Museum, 1977). What follows is a summary of the main points of my research as presented in the *Ukiyo-e Jiten*, published by Ginga-sha in cooperation with the Japan Ukiyo-e Society.

Torii School of Ukiyo-e Print Designers

The tradition of designing theatrical billboards, programs, illustrated books, and prints for the Edo kabuki stage was a monopoly of the Torii school for over half of the eighteenth century. Beginning in the late Genroku period (1688–1703) the Torii family of artists established a standard in the representation of kabuki subject matter that was to influence ukiyo-e for decades to come. Torii Shōbei Kiyonobu I (1664–1729) is traditionally regarded as the founder of the school, but research in recent years has shown that at least two artists using the Torii name preceded him. Torii Kiyomoto, Kiyonobu's father, is designated in the *Torii ga Keifu*, a family record written down in the Meiji era, as an Osaka actor-artist who moved to Edo with his family in 1687. He set up residence in Namba-cho and in 1692 began to design kamban-e (theatrical posters) for one of the three officially licenced kabuki theaters in Edo.

Recent research has also uncovered the artist Torii Kiyotaka. This recondite master, although not listed in the *Torii ga Keifu*, is mentioned in *Fūryū Kagami ga Ike* (1709) as being a teacher of Shōbei Kiyonobu I and the "veteran artist" of the Torii school. Recent speculation suggests that this second artist may have been part of an independent branch of the Torii family at work in Edo before Torii Kiyomoto and his son Torii Kiyonobu I came to Edo from Osaka. The first Torii Kiyomasu, whose identity and relationship to Kiyonobu I is uncertain, may have descended from this Edo branch of the family, for he was fully contemporary with the first Kiyonobu, yet there is no mention of his name in the family records. Kiyonobu, the founder of the Torii school, is regarded as its first titular head. The second titular head of the Torii school is in dispute. Following the death of Kiyonobu I in 1729, a second artist of the school adopted

the name Kiyonobu and it is generally thought that this artist would be given this title. Other sources and a tombstone inscription, however, suggest that the second Kiyomasu, an artist adopted into the Torii Kiyonobu family, received this honor.

The third titular head of the school was Torii Kiyomitsu, the son of Kiyomasu II. Unfortunately, this third great master's own son Kiyohide, who showed great artistic promise from an early age, died in 1772. In order to assure a successor in the Torii school, Kiyomitsu gave his son-in-law, an artist of little talent, the artistic name Kiyohide and devoted a great deal of energy to his artistic education. Following Kiyomitsu's death in 1785, the atelier, represented by Kiyotsugu, Kiyotoki, Kiyokatsu, and Kiyosaka, decided to take Kiyonaga, one of Kiyomitsu's best students, as their teacher. The theater owners, moreover, asked Kiyonaga to take over the position of head of the school despite the fact that Kiyomitsu's son-in-law was actually closer to the succession. It was not until 1787 that Kiyonaga officially became the fourth titular head of the school when Kiyomitsu's daughter, Ei, gave birth to a long awaited male heir, Shonosuke, who was to become known as Kiyomine. This artist eventually became the fifth head of the Torii school when he assumed the name Kiyomitsu II. Kiyomitsu II died in 1868, the year of the Meiji restoration.

Torii (Shōbei) Kiyonobu (1664–1729) was an ukiyo-e painter and printmaker who specialized in illustrations for the Edo kabuki stage from 1697 to around 1727. He was the son of Torii Kiyomoto (1644–1702), a former actor who turned to sign painting for the kabuki theaters. According to the Torii genealogy, Kiyonobu was born in Osaka in 1664. He moved to Edo with his father, Kiyomoto, and settled at Namba-cho. His posthumous name, found on the first of two recorded Torii tombstones, reads "Jōgen-in Seishin Nichiryū Shinshi," with the death date 1729. Traditional founder of the Torii school, his earliest surviving extant woodblock art—two signed illustrated books dated to 1697—reveal the strong influence of Hishikawa Moronobu (d. 1694) and his decadent contemporary Sugimura Jihei (active 1680s–1690s). From 1698 onward, his prints and attributed illustrated books were largely of scenes from plays and actors, no doubt stimulated by the Torii family tradition as painters of kabuki posters. His theatrical depictions were, for the most part, decorative and curvilinear in style, no doubt derived from the more polished and elegant

acting tradition of the Kamigata region. His forms were round and full both in the outlines of his figures and the blunt curvilinear motifs of his costume detail. His brushline was bold and thick like that of poster painting and lacked the calligraphic virtuosity of his enigmatic contemporary Torii Kiyomasu. He only occasionally adopted the bravura style of Kiyomasu, who initially favored the rough acting tradition of Edo. He is said to have also studied under Torii Kiyotaka, the veteran Torii artist of Edo kabuki whose biography and art are unknown.

Kiyonobu's signed masterpieces include two folding albums—*Fūryū Yomo Byōbu*, a book of illustrated actors of the past and present, and *Keisei Ehon*, a book of courtesan portraits, both published in 1700. At least three shunga albums in various states of completeness published between 1700 and 1711 and twenty-five signed single-sheet prints depicting leading actors of the day published from 1698 to 1727 survive. As founder of the Torii school, he is said to have had a large following including Kiyonobu II (active 1720s–ca. 1760), Kiyomasu II (1706–1763), Kiyotada (active 1720s–1740s), Kiyoshige (active late 1720s–early 1760s), and Kiyomoto (ca. 1720s–1740s). A number of other artists were influenced by his persuasive style including Okumura Masanobu (ca. 1686–1764), Nishimura Shigenaga (ca. 1697–1756), Kondō Kiyoharu (active 1704–1720), and Hanegawa Chinchō (1679–1754). The Kaigetsudō school artists (active 1710s) were also directly influenced by his illustrated book *Keisei Ehon* noted above.

Torii Kiyonobu II (active 1725–ca. 1760) was also an ukiyo-e printmaker who specialized in kabuki actor prints. According to one persistent theory, Kiyonobu II is the same artist as Kiyomasu II. A more likely theory suggests that he was a son of Kiyonobu I who upon the father's death in 1729, or retirement in 1727, took his name. His personal name is listed by the scholar Inoue Kazuo as Teishiro and his posthumous name as Chiryuin Hogen. Neither of these names, however, can be confirmed. Inoue suggests that Kiyonobu II died in 1752. If so, we must presume still a third artist utilizing the name Kiyonobu, since prints signed Kiyonobu survive from as late as 1760. The second Kiyonobu is known to have collaborated on a picture book with the second Kiyomasu some time in the mid-1720s, proof that there were two independent artists. He produced a number of single sheet prints of actors and theatrical scenes handpainted

or printed from two blocks. Many of his compositions have been labeled banal and uninteresting, perhaps accounting for the fact that he did not become the second titular head of the school. Illustrated books signed Kiyonobu survive dated 1755, 1757, and 1758 in the colophon.

Torii Kiyomasu I (active 1697–mid 1720s) was an ukiyo-e printmaker specializing in Edo kabuki theatrical prints. Aside from the same surname, no firm genealogical connection has ever been proven between Kiyonobu I and Kiyomasu I. According to one theory, these artists are one and the same person; according to other theories Kiyomasu is a brother or son of Kiyonobu I. Until the discovery of some incontrovertible basic source directly linking Kiyomasu I with a recorded member of the Torii family, any theory must be approached with caution. It is possible that Kiyomasu I and his direct namesake, Kiyomasu II, originally represented an Edo branch of the Torii family distinct from the Kamigata branch headed by Kiyonobu and Kiyomoto. This theory is given support by the recent discovery of the veteran Edo artist Torii Kiyotaka, who possibly headed the Edo school. The absence of either the Kiyotaka or Kiyomasu name in the earliest Torii genealogy devoted to the Kiyonobu lineage, as well as significant differences of a regional character in Kiyonobu and Kiyomasu's primary art styles, offers additional support. Moreover, two separate tombstones—one for Kiyonobu and his lineage and one for Kiyomasu and his family—with different family crests on each, were recorded by Inoue Kazuo in 1923. Since the dates accompanying the Kiyomasu name on the tombstone (1706 to 1763) do not conform to the first Kiyomasu's known period of activity (ca. 1697–ca. 1725), the name is thought to belong to the second Kiyomasu, an artist who married into the Kiyonobu branch of the Torii family in 1724. The identity of the first Kiyomasu remains uncertain.

The first Kiyomasu occasionally signed his name "Torii uji [family] Kiyomasu" suggesting that he held a ranking position in the Edo branch of the Torii school. No signed and dated illustrated books by Kiyomasu I or shunga albums signed or attributed are known to survive. The earliest signed art by Kiyomasu I is a small group of single sheet prints commemorating kabuki performances, dated by record from 1697 to 1704. These prints are all done in the bravura style reserved for the depiction of Edo-school actors. It is thought that Kiyomasu may have invented this heroic form which features the

"wiggling worm line" and "gourd-shaped legs" that were to become two of the hallmarks of Torii art in generations to come. In later years Kiyomasu's style took on a softened more elegant quality. His output was large and along with handcolored single sheets he is known to have designed playbills and votive shrine paintings executed on wood. In addition, a number of unsigned illustrated books dating from 1697 to 1710 contain illustrations recently attributed to Kiyomasu I in collaboration with Kiyonobu I.

Torii (Hanzaburō) Kiyomasu II (1706–1763) was another ukiyo-e printmaker specializing in Edo kabuki theatrical prints. Some critics believe that Kiyomasu II and Kiyonobu II are one and the same person but such a theory does not conform with genealogical evidence or with the art. Inoue Kazuo rightly suggests that Kiyomasu II was adopted by Kiyonobu I upon marrying his eldest daughter in 1724. Kiyomasu II's association with his namesake, the first Kiyomasu, is uncertain, but he may have originally been part of the Edo branch of the Torii school prior to his marital adoption in 1724. His posthumous name found on the second of two Torii tombstones reads "Seigon-in Sōrin Nichiyō" with his birth and death date recorded. He began work in the mid-1720s designing picture books, one in collaboration with Kiyonobu II. His large output also included handcolored prints of actors and in later years, two-color block prints. His work is rather uneven, particularly in the hard lines of these later prints, but his earlier prints are very fine in a quiet, subdued way. He became the second titular head of the Torii school and had many pupils working in the atelier at his death including Torii Kiyohiro (active 1750s–1760s), Torii Kiyoharu (active 1700–1730), Torii Kiyotsune (active 1750s–1770s), Torii Kiyohide (active 1750), and Torii Kiyomitsu (1735–1785) who was to become the third titular head of the school.

It is curious that Michener should entitle chapter 6 on the quiet artist from Kyoto, Nishikawa Sukenobu (1671–1750), with the hedonistic appelation "The Floating World." The text, nevertheless, is engaging and accurate. A mistake occurs with respect to the publishing location of Sukenobu's first edition books. While later editions most assuredly came from Osaka publishers, all of Sukenobu's first edition works emanated from Kyoto.

A minor flaw surrounds one of the many stories and legends that

Michener includes in his lively discussion of Sukenobu's illustrated books. One illustration from *Ehon Yamato Hiji* of 1742 depicts an incident in the life of the classic painter Sesshū, who as a boy was tied to a porch, but drew with his big toe pictures of rats. Michener suggests that these rats were so realistic that his astonished captors set him free. The story as it is illustrated in Sukenobu's book, however, suggests that the rats were so realistic that they came to life and actually gnawed away the ropes.

Sources for a more comprehensive study of Sukenobu are the following: Miyatake Gaikotsu, *Nishi Suke Gafu*, Tokyo, 1911; Mizutani Umihiko, *Kohan Shōsetsu Sōga-shi*; Nakata Katsunosuke, *Ehon no Kenkyū*; the compendium *Nihon Fuzoku Zu-e*; and the master's degree thesis by Maribeth Graybill, "The Illustrated Books of Nishikawa Sukenobu: A Preliminary Catalogue," (University of Michigan, 1975).

The main points in the life of Sukenobu, based on these sources, may be summarized here. A leading Kyoto artist, Sukenobu studied first under Kanō Eino and Tosa Mitsusuke. In 1699 he turned from classical subjects to genre depictions, developing his own style of figures drawing upon the earlier art of Okumura Masanobu in Edo. (Both Michener and Richard Lane suggest Moronobu, but I fail to see the influence.) The Sukenobu style continued with surprisingly little variation. His earliest illustrated books were novels and kabuki texts, many done for the noted Kyoto book publisher Hachimonji-ya. Sixty such books were produced between 1699 and 1745. Another sixty-odd books dealing with life and legends of old Japan were published between 1718 and 1750. Still other illustrated books dealt with kimono designs, often with figure prints as frontispieces. Lane reports some two dozen or more erotic books by Sukenobu survive. They rank among his finest work.

Michener's chapter 7 "The Function of the Symbol" treats the problem of the Kaigetsudō masters with considerable intelligence. While some scholars would argue that the mystery surrounding the thirty-nine surviving prints, variously signed Anchi, Doshin, Doshū, Doshu, and Dohan Kaigetsudō, has been resolved, I tend to agree with Michener that the mystery remains. A review of the problem seems appropriate here.

There is in existence today a body of art, comprising both paint-

ings and woodblock prints, which is attributed to the Kaigetsudō school (variously translated as "Embrace the Moon Studio" or "Yearning for the Moon Studio"). All the prints and most of the paintings of this school take for their subject solitary women who are distinguished equally by their gorgeous attire and by their faces, which are uniformly devoid of expression. Their kimonos dominate the compositions, and the outlines of their majestic figures are made up of bold swirling strokes.

According to the *Kagai Manroku* published in 1825, a Kaigetsudō artist was active in the 1620s but no signed work survives from this period. Kaigetsudō Ando, the traditional founder of the school, was a painter who apparently worked in Edo in the early eighteenth century. What his assocation was, if one there was, with the shadowy Kaigetsudō of the 1620s is unclear. Ando may have been exiled in 1714 because of his involvement in a political scandal and may have returned to Edo at a later time. None of his paintings carries an inscribed date. He designed no prints. Other than the style of his paintings, mention of the political scandal of 1714 is the only documentary basis for determining Ando's working period.

About the other artists who are believed to have been pupils of Ando there is no mention in contemporary records. About nine paintings and twelve prints signed Dohan are extant. These tend to be uneven in artistic merit.

Because the prints of all five artists are stylistically identical and their signatures are nearly indistinguishable, the critics Laurence Binyon and J. J. O'Brien Sexton have proposed that all the artists are one and the same person—perhaps synonymous with Kaigetsudō Ando who used the pseudonyms in the wake of the 1714 political scandal.

An interesting discovery noted by Roger Keyes offers some small support for Binyon and Sexton's proposal. The work of each of the Kaigetsudō print artists is linked to a different publisher with one dubious exception. If Ando's work had been banned and his name could not appear, there might be demand for prints based on his work. Therefore, if publishers issued his designs under a pseudonym, it might make sense that these publishers would use different names. I might add that this would account for small differences in style and signature noted by some scholars.

No satisfactory evidence has been gleaned from the numerous

paintings signed Kaigetsudō. Many of these appear to be forgeries. Until the spurious paintings are persuasively identified and the genuine paintings are placed in an acceptable chronology, the enigma surrounding the school will remain.

At the close of Michener's account, he suggests that Kaigetsudō had created one of the most powerful symbols ever devised: the massive woman drawn in an overpowering black line that conveys a "terrible loneliness and complete satisfaction." Assuming that the date for Kaigetsudō is indeed the early eighteenth century, a possible source for the style could be Kiyonobu's *Keisei Ehon*. A pirated edition of the 1700 classic dated to the sixth month of 1701 and published by Kurihara Choemon offers not only a strong stylistic comparison but nearly identical kimono patterns to some of the Kaigetsudō prints.

Michener also offers an interesting footnote at the close of his chapter on Kaigetsudō: "Found ten prints by Kaigetsudō for one yen, sixty-five sen the lot." He goes on to note "that it has been traditionally stated that these ten prints, now worth around twenty-five thousand dollars [in 1954], sold for seventy cents;" according to Michener, "a more accurate equivalent would be about $2.60."

My own computation would value each print around one hundred dollars based on the recession in progress in 1878. Triptychs at that time cost a common person's monthly wage.

Chapter 8, "The Role of the Inventor," refers primarily to the artist Okumura Masanobu. The chapter, however, also includes his contemporaries Nishimura Shigenaga, Ishikawa Toyonobu, Torii Kiyohiro, and Torii Kiyomitsu. Michener's highly personal account of the flowering and withering of the Japanese print required that a genius be found in the thickets of ukiyo-e, and he chose Okumura Masanobu as his star. No one can doubt Masanobu's importance to the historical study, for his work spans the periods of sumuzuri-e, tan-e and beni-e, as well as benizuri-e up to the threshold of full-color printing. I would argue the question, however, of his status as an "explosive genius." If anything, he was a witty, intelligent opportunist who understood the fashion of the day and was quick to seize upon and improve it. For example his book of courtesans, dated 1701, is in fact loosely based on Kiyonobu's 1700 *Keisei Ehon*. His numerous album leaves, derived from Moronobu, Sugimura, and the Torii masters, add an element of wit and humor that give them a

special Edo flavor; they are hardly innovative. He improved upon the originals by introducing some intelligence which gave them a special mark. Then he began to produce some hosoban and kakemono-e, neither of which he invented, infusing the best of them with the same personality as his album leaves.

Comparing Masanobu's lacquer prints with those of his early contemporary Toshinobu convinces Michener in his later writings of Toshinobu's superior status as a designer. Masanobu called himself the *kongen* of *beni-e* (lacquer print), *hashira-e* (the narrow pillar print), and *uki-e* (the one-point perspective print). Jinn K. Lee of the University of Washington, however, does not render the term *kongen* (which occurs in the publishing data on these prints) as meaning "inventor"; he defines the term as being something close to "outstanding," in reference to Masanobu's publications. Lee fairly convincingly proves, moreover, that Kiyotada (active ca. 1720–1750) and not Masanobu designed the first uki-e. Lee's argument is not conclusive, however, since we are dealing with only a few surviving examples of uki-e. It seems relatively certain that Masanobu coined the term beni-e for his lacquer prints (the more apt title urushi-e is used today), but whether he invented it is another question. As for pillar prints, the suggestion that the prototype could have been the more important half of a split-at-the-join oversize kakemono-e block of the 1740s seems plausible (see Link, *Primitive Ukiyo-e*, p. 112).

It would be ludicrous, of course, to suggest that Masanobu invented color printing. The well-known story of the printer who had studied Chinese prints, collaborating with a Japanese engraver to invent the first registration marks may or may not be true; but there is no proof, in any event, that the two ever worked in Okumura's workshop. Moreover, Masanobu's own limited two-color benizuri-e fall far below the great examples by Ishikawa Toyonobu and Torii Kiyohiro that surivive. His big handcolored kakemono-e of the 1740s are equally clumsy when compared with other artists who ventured to work in the same format. It should be added that the famous self-portrait, an impression of which may be seen at the Art Institute of Chicago, is probably not a depiction of Masanobu but rather just a fine example of a middle-aged painter. Masanobu was in his late teens or early twenties when the picture was made.

The image of Masanobu that emerges is not one who "kicked the art open wide" so that it could exist for another sixty years. Indeed,

Hokusai (1760–1849), Toyokuni (1769–1825), Kunisada (1786–1864), Kuniyoshi (1797–1861), Yoshitoshi (1839–1892), and Utamaro (1754–1806), had far greater part in revitalizing ukiyo-e than did Masanobu. Intellectually, however, Masanobu is certainly more interesting than most of his contemporaries and more important on this account than any historian has so far acknowledged. The above is a subjective rendering of the known facts as they have been confirmed in recent years. Many no doubt will disagree and prefer to follow a more traditional view of Masanobu as the great innovator of the period.

In the present stage of ukiyo-e studies many of the sources need to be re-examined systematically and critically. Biographies involve complex problems that can only be summarized in a text such as this. In many instances, the traditional biographical statements appear to be totally undocumented. In general a reader should be warned against blindly accepting posthumous biographical information.

Sekine Tadanobu indicates (in *Meijin kishinroku*, 1894) that Nishimura Shigenaga (1697–1756) died in his sixties on the twenty-seventh day of the sixth month of 1756, but this statement needs to be confirmed. His art names were Senkadō, Eikadō, and Hyakuju. According to the *Ukiyo-e Ruikō*, he was a landlord in Tōri Abura-chō; later he moved to the Kanda district of Edo, where he managed a bookstore.

Shigenaga worked from the Kyōhō (1716–1736) to the Hōreki (1751–1736) eras, designing many urushi-e and a few benizuri-e. His early work during the Kyōhō era is mostly of kabuki actors done in the pervasive Torii style. He eventually created a new style, however, combining the sensual and more flowing character of the art of Nishikawa Sukenobu and Okumura Masanobu with his own early Torii forms. Many prints are signed "hitsu" or "zu." His students may have included such important artists as Toyonobu and Harunobu.

Ishikawa Toyonobu (1711–1785) is said to be a late name of the artist Nishimura (Magosaburō) Shigenobu, chief pupil of the distinguished artist Nishimura Shigenaga. Toyonobu died in 1785 at the age of seventy-five and was buried at the Shōkaku-ji (temple) in Asakusa, Edo. He became a member of his wife's family around 1747 and, as proprietor of the family's inn at Kodenma-chō, was known as Nukaya Shichirōbei.

It is said that around this time he changed his art name from

Nishimura Shigenobu to Ishikawa Toyonobu. This name change is by no means certain, however, and stylistic differences between prints signed Shigenobu and those signed Toyonobu make it difficult to reach a firm conclusion. The artist signing himself Shigenobu produced many fine designs in the style of his mentor, Shigenaga, while prints signed Toyonobu follow the basic style of Okumura Masanobu, often presaging the gentle mood of Shigemasa and Harunobu. The Michener Collection contains a few choice urushi-e datable to the mid-1740s and a large number of fine benizuri-e, including some fine mitate designs, ranging in date from the mid-1740s to the early 1760s.

Torii Kiyohiro (active 1750s–1760s), most writers have agreed, was one of the gentlest designers of the period of two-color prints. An entry in the *Ukiyo-e Ruikō* states that he died in a measles epidemic that raged through Edo in 1776, but this claim is not confirmed elsewhere. Beyond the *Ukiyo-e Ruikō* statement that his given name was Shichinosuke and that he lived in Sakaichō, nothing else about his life is known. Some writers suggest that Kiyohiro was a pupil of Kiyomitsu, and possibly even Kiyomasu's son, but there seems to be little ground for these speculations.

His prints all seem to have been benizuri-e, with the exception of one unsigned full-color calendar print for 1765. All were published in the 1750s and 1760s. Many of his designs were copied or adopted by Suzuki Harunobu, whose lyricism owes as much to Kiyohiro perhaps, as the earlier artist owed to Toyonobu.

According to the research of Kazuo Inoue, Torii Kiyomitsu (whose personal name was Kamejirō) was the second son of Kiyomasu II. Born in 1735 at Naniwa-chō, Edo, he studied ukiyo-e under his father. He died in 1785 at the age of fifty-one and was buried at Hōjōji in Asakusa. The family line was continued by Torii Kiyonaga, a pupil rather than a blood relative, since Kiyomitsu's only son died at the age of sixteen.

As titular head of the Torii family, Kiyomitsu carried on the duties of producing actor prints, billboards, and playbills for the Edo theaters. In these works he followed the traditional style of the Torii school. He also illustrated books from about 1764 to 1780. Most of his single-sheet prints are two and three color, published from the late 1750s to the early 1770s. In the mid-1760s, however, he began to produce prints in four or more colors, some which may even precede

the full-color calendar prints of 1765. His artistic style is somewhat stiff and prosaic, for Kiyomitsu was no innovator. At his best, however, he produced some satisfying designs. His output was great, and he had many pupils.

Michener's study of Suzuki Harunobu (1725?–1770), who was the first to successfully produce the so-called brocade or full-color print in 1765, can be considerably updated. Aside from a few iconographical mistakes in the description of prints, Michener's account of this poetic artist is well considered. In some instances, though, the transliteration of characters needs to be corrected and I should caution the reader regarding this. For example, on page 92 "Uriame Dohei Den" follows the order of the characters, but the preferred reading, "Ameuri Dohei ga den," is indicated several times in the text by phonetic symbols.

Michener pays considerable attention to the fact that Nishikawa Sukenobu produced 20 to 50 percent of Harunobu's themes and that without the work of this book illustrator it is uncertain what Harunobu would have become. Michener regards Harunobu's contribution chiefly as a remarkable colorist; for Michener, many of Harunobu's subjects verge on the cloyingly sweet. Harunobu was, in fact, the first successful artist to wed the technical accomplishment of full-color printing with a design approach that well suited the medium. He was not, however, the inventor. Michener's own collection includes, for example, the book *Wakana-shu* by the artist Ryūsai which features illustrations made from eight blocks with additional color achieved by overprinting. The work is dated 1756, some eight years before Harunobu's experiments.

At least three major studies on the age of Harunobu have been made over the past thirty years that require discussion here: first, "Tracing Harunobu's Biography," published in 1970 by the noted Japanese scholar Hayashi Yoshikazu; second, a catalogue of woodcuts by Suzuki Harunobu and his followers in the Museum of Fine Arts Boston, entitled *The Harunobu Decade*, published in 1978 and written by the distinguished scholar David Waterhouse; and third, "Shiba Kokan's Days as an Ukiyo-e Artist," by the Japanese scholar Narusei Fujio, published in 1982. The following is a summary of the main conclusions drawn by these scholars, particularly as it relates to Michener's views.

One of the most interesting aspects to the study of Harunobu made

by David Waterhouse is a new theory concerning the early color-printed calendars of 1765 and 1766, utilizing Harunobu's art. As the reader will recall from Michener's account, these calendars were printed privately for groups of connoisseurs in Edo who employed Harunobu either to design the print or to rework a design they had previously sketched out. It is these calendar prints that led directly to the production of full-color prints, a development in which Harunobu was the leading artist. Waterhouse, basing his conclusions on a search of the regulations governing the Japanese calendar in the eighteenth century, uncovered the fact that only fifteen designs for the calendar print were produced between 1724 and 1725, but that in 1765 alone there were probably more than one hundred. Moreover, there was no serious attempt to conceal calendar information as some accounts of the period indicate. Calendars were a government monopoly and the introduction of pictorial calendars occurred well after the official calendars had been promulgated. In other words, the calendar prints were not prepared at the end of the old year for presentation on New Year's Day as has been often stated. Waterhouse has successfully proven that in the year 1765, for example, pictorial calendars were produced within the fifth and eighth months of the year for exchange at parties celebrating the opening of a new observatory. The celebration also accounts for the plethora of calendar printing in that year. The calendar prints were not issued secretly as they were exchanged at events where senior samurai, a privileged group, were present. Waterhouse also subscribes to the opinion that Harunobu was not a man of the streets, but a householder with good connections in samurai society.

Harunobu's biography has received fresh attention by scholars as well. The standard biography would be as follows: Suzuki Harunobu (1725–1770); real family name, Hozumi; familiar name, Jihei; gō (alternate name), Chōeiken or Shikojin; lived at Yonezawa-chō, Ryōgoku, or Shirakabe-chō, Kanda in Edo. Died at the age of forty-six. This information is not contained in the usual biographical compendiums such as the *Ukiyo-e Ruikō* compiled by Ōta Nampo between 1789 and 1800, but in encyclopedias where no data on original sources are provided. Hayashi, in his detailed research, however, discovered that some of this information came from the *Meijin Kishin Roku* (Death Register of the Masters) published in 1894, about 120 years after Harunobu's death. The unreliability of this late record is

confirmed by the fact that its author equates Harunobu with another artist, Isoda Koryūsai (active ca. 1764–1788), and lists his age at death and other information inaccurately. Despite these inaccuracies, the record is still quoted in biographical dictionaries. In truth, there are no historical documents that record definitely that Harunobu died at the age of forty-six, and so the accuracy of the statement remains in doubt.

Suzuki Harushige, who later used the name Shiba Kōkan, mentioned in his *Shumparōhikki* that Harunobu died of a sudden illness in his forties. Hayashi suggests that Harunobu was a heavy drinker and points to the fact that in a three-volume erotic work titled *Tawabure Busa*, published in 1770, Suzuki Harunobu is referred to as *shusuki* which means "to be fond of wine." His heavy drinking, in combination with the demands of publishing a new print every three and one half days between 1765 and 1770, the year of his death, no doubt contributed to his demise. In fact, Hayashi suggests that he possibly died of apoplexy, a frequent disease among heavy drinkers.

Harunobu's death date (i.e., the fifteenth day of the sixth month of 1770) has always been based on the new edition of the *Ukiyo-e Ruikō*, written by Tattasha Shūkin, but Hayashi has discovered that the source for the *Ukiyo-e Ruikō* statement was actually an earlier essay by Ōta Nampo.

Recently, new evidence has come to light that is of considerable interest. A record of the death register for the Nishikawa family of Kyoto (this family includes the famous Kyoto illustrator, Nishikawa Sukenobu), includes under the entry for the fourteenth day of the sixth month of 1770, the name of the deceased, Suzuki Harunobu. The fourteenth rather than the fifteenth day, as stated in the above-mentioned essay by Ōta Nampo, is a small discrepancy indeed. More importantly, when first reported by Hayashi in 1964, he questioned the curious inclusion of Harunobu's posthumous name in a death registry for the Nishikawa family.

Michener, early in his study of Harunobu, notes the mass borrowings of Sukenobu illustrations for Harunobu's designs. These borrowings have since been confirmed and more fully documented in the research of both Richard Lane and David Waterhouse, among others. Michener's own visual perceptiveness in this is also confirmed by Hayashi's suggestion that Harunobu was actually Sukenobu's student in Kyoto before he produced his full-color prints in Edo. This theory

is supported not only by the style of Harunobu's art and the Nishi-kawa death registry, but also in another record by Morishima Chū-ryō, a pupil of Hiraga Gennai. This source states that "Harunobu learned the art of picture drawing from Nishikawa." Hayashi also speculates that since the name Suzuki Harunobu was recorded in the Nishikawa lineage with his artist name, Suzuki might actually be his real name. If so, Harunobu must have been descended from a samu-rai family. Still another edition of the *Ukiyo-e Ruikō* proved fruitful in Hayashi's work when he discovered the fact that Harunobu's other name was Hozumi. The Hozumi-Suzuki clan of Edo was subsequent-ly identified by Hayashi as hatamoto (direct retainers to the shogun). This is reported in the *Kansei Chōshū Shoka Fu* [Genealogies of the samurai families in the kansei period]. Unfortunately, Harunobu's name per se could not be found in the genealogy, but Hayashi be-lieves that he has located the family. The samurai family in question had been disgraced and banished from Edo in 1716.

Hayashi's theory has not met with total approval from the scholar-ly community. Waterhouse, for example, does not accept Hayashi's view, despite the fact that it is clear that Harunobu had good con-nections in samurai society and despite the obvious borrowings of Harunobu from Sukenobu's illustrated books, many uncovered by Waterhouse himself. Indeed, Harunobu wrote of his debt to Suke-nobu in the preface of a book published in 1767.

Waterhouse's main objection to Hayashi's identification is that for the most part, Harunobu shows himself to be an Edo man. His early prints of actors and other subjects are in a completely Edo style. Harunobu's earliest surviving print in benizuri-e, is, in fact, a kabuki scene from a theater in Edo dated to the third month of 1760, featur-ing Ichimura Kamezō I and Bandō Sanpachi in the roles of Soga Gorō and Asahina. The style resembles that of Kiyomitsu. Water-house goes on to demonstrate that the view expressed by Michener and others that Harunobu depicted a timeless, idealized world needs to be modified; a number of prints deal with actual scenes, events, and individuals from contemporary Edo life. Waterhouse reports that Harunobu lived in the Kanda district, not far from where Kyosen and Sake (pen names of well-known hatamoto) lived. It was these samurai who commissioned Harunobu to do the first 1765 calendar prints. Among Harunobu's neighbors was also Hiraga Gennai, whose pupil (mentioned earlier) wrote of Harunobu's student connection

with Nishikawa Sukenobu. It seems to me that Hayashi's discoveries and Waterhouse's views are not necessarily incompatible; there is no reason why Sukenobu could not have spent his early years in Kyoto in training and then returned to the family's former home in Edo, where he studied Edo-style ukiyo-e and then took up the brocade calendar print in 1765, surpassing the style of his earliest studies in Kyoto.

Michener also discusses very briefly the problem of counterfeit prints signed Harunobu, suggesting that a plethora of artists engaged in making Harunobu-style works. In fact, there seems to be only one artist who actually signed his name Harunobu: Shiba Kōkan, or Harushige. The most recent work on Shiba Kōkan's years as an ukiyo-e artist is the research of Narusei Fujio. Narusei quotes the well-known essay *Shumparōhikki*, published in 1811, and written by Shiba Kōkan himself, noting that many of the artist's statements do not reflect the known facts derived from a study of his art. The passage in question translates:

> I aspired to become a great artist. First I studied under Kanō Hisanobu [1676–1731]. But soon I found Japanese paintings are worldly. Then I entered the school of Sōshiseki [1715–1786] who is of Nanpin descent. At that time an ukiyo-e master named Suzuki Harunobu [1725–1779], who had depicted women's life of the times, died suddenly in his mid-forties. Then I created Harunobu's fake compositions and engraved them. However, no one could penetrate they were false prints and the public believed those prints were by Harunobu himself. On the other hand, as I am not Harunobu, I could not consent to be a fake artist any longer. I adopted the name Harushige and designed Japanese beauty, borrowing the technique of Kyūei and Shūnshin, genre painters of China's Ming dynasty. In Natsuzuki Zu, "Picture of Summer Moon," I drew a woman clad in diaphanous clothes through which her bare limbs are shown; and in Fuyuzuki Zu, "Picture of Winter Moon," I depicted a hut surrounded with bamboo thicket and a garden with a stone lantern covered with snow. I used the Chinese method of gradation with thin sumi-ink to draw the snow. In those days a hair style, called *binsashi*, came into vogue, an innovation for women's hair dressings. I designed prints of women sporting this hair style, and those works were highly appreciated by the public. But I was afraid that this kind of painting would smirch my name. So I terminated my ukiyo-e creations.

Narusei suggests that Shiba Kōkan actually became a pupil of Harunobu and that the name Harushige was probably given to him by his

teacher. There are two kinds of pictures bearing Harushige's signature: those with the signature "Harushige ga" and those with the signature "Shōtei Harushige sha." In view of the design techniques and the women's hair dressings, most of the prints signed "Harushige ga" seem to have been produced before and shortly after Harunobu's death, while works signed "Shōtei Harushige sha" were created during the period 1772–1776, when Shiba Kōkan became a pupil of Sōshiseki, a Nagasaki artist.

Prints by Harushige but signed "Harunobu," distinguishable from genuine Harunobu products by the curious rendering of the character "Haru," as well as by small stylistic differences, should not be thought of necessarily as "fake prints" despite Harushige's own pronouncement in the abovementioned essay. Narusei suggests that a publisher had Harushige, as his chief student, design prints for Harunobu's signature for a short period, announcing to the Edo public that they were Harunobu's unpublished pictures. This was not an uncommon situation in Edo publishing. Hiroshige II probably designed all of the books from the set *Edo Miyage* under the same premise. The problem of ghost artists in the atelier is no small one, and the recent discovery of Sakai Hōitsu's letters to Suzuki Kiitsu and Suzuki Reitan, reported by me at the Rimpa lectures of the Japan Society in New York in 1981, supports the opinion that atelier artists did in fact design and produce complete works of art under their master's name. Roger Keyes goes even further than Narusei and suggests that Harushige had a legitimate right to the Harunobu name since a newly discovered painting by Harushige has been uncovered which carries the authentic seal of Harunobu. Perhaps, Harushige was Harunobu II for a short time. Why Shiba Kōkan, alias Harushige, should have chosen to view his life in such a controversial light, therefore, remains a mystery.

Among the best chapters in *The Floating World*, calling for little revision or amplification, is chapter 10, "The Basic Principles of Ukiyo-e." The points that were particularly well made by Michener occur under principles 9, 10, 11, and 12. Michener's equation of the triumph of color with the triumph of the nouveau riche spirit and bourgeois taste, however, needs qualification. Clearly the gaudy aspects of the Japanese print, which occurred from the 1800s onward, has something to do with the nouveau riche taste, particularly the taste of the nouveau riche of outlying districts of Edo. But the

range of color in ukiyo-e that has been so honored by the connoisseur is a direct continuation of the color range and harmonies found in Yamato-e scroll paintings dating back to the twelfth century. One small correction also should be added: the daimyō were not masterless samurai; the appropriate name for this category is rōnin.

The essentials of Katsukawa Shunshō's life (1726–1793) and art may be summarized as follows. He was a leading ukiyo-e painter, print artist, and illustrator who founded an important ukiyo-e school. He studied painting under Shunsui (active 1744–1764) and Sūkoku (1730–1804), not venturing into the print medium until 1767 when he began to develop a more realistic style. His color harmonies reflect the influence of Suzuki Harunobu (1724–1770) and Kitao Shigemasa (1739–1820). And in the field of actor prints, in which he excelled, his work soon overshadowed the Torii school. In fact, Shunsho ranks with Torii Kiyonobu (1664–1729), Torii Kiyomasu (1696–1716), and Toshūsai Sharaku (active 1794–1795) in his influence on kabuki depiction. His later years were spent producing some very fine paintings and he was an important teacher to such notable pupils as Shunjo, Shunko, Shuncho, Shundo, Shun'ei, Shunzan, and Hokusai (alias Shunro).

In chapter 11, entitled "Integrity and the Artist," Michener's love of Shunsho extends only to the artist's portraits of actors on stage. He dismisses most other prints by Shunsho except those in hosoban size as being undistinguished. In truth, Shunsho did some of the best suriving pillar prints, some absolutely spectacular oban prints of ghosts and kabuki actors backstage, and some of the best illustrated books of the period. He was a superb draftsman despite Michener's comment to the contrary, and this can easily be proven by an examination of his paintings. Indeed, Shunsho's masterpiece of the 1780s, "Three Beauties Representing Snow, Moon, and Flower," offers his precise observations of beautiful women in different environments with a delicate but sure line and a brilliant use of color.

Finally, Michener's account of three prints of Danjūrō needs to be reconsidered, for one of the prints (44) is not Danjūrō but another actor of the Ichikawa family, Danzō. Despite these lapses, the chapter does provide the essentials of Shunsho's contribution in the area of kabuki portraiture.

The "Inevitable Prison," chapter 12, refers to the pillar print and the artist Isoda Koryūsai (active ca. 1764–1788), who is responsible for using the format in the 1770s and early 1780s. Koryūsai, whose early name was Suzuki Haruhiro, was a student of Suzuki Harunobu. He was indeed a popularizer of the long pillar print format, but I would not agree with Michener's assessment that Koryūsai produced the best pillar prints. Many are, in fact, cluttered examples when compared to the superb pillar prints of Harunobu, his early teacher. Beyond this point, there is little to add to our understanding of Koryūsai as reported by Michener since new research on this artist is just now being reported by such scholars as Waterhouse.

Michener's chapter 13 on Torii Kiyonaga (1752–1815) entitled "The Complete Artist" is a wonderful condensation of the known facts about this great master and there is little that we might add to the account. Michener's dismissal of earlier distortions of Kiyonaga's art provides a perfect foil for his own glowing treatment of the artist.

For those readers interested in exporing Kiyonaga's noble art further, the most comprehensive works on the subject are as follows: *Kiyonaga: A Study of His Life and Works*, by Chieko Hirano, Cambridge, Massachusetts, 1939; and *Kiyonaga* (in Japanese), by Yoshida Teruji, Tokyo, 1953.

An attempt to outline the history of Japanese painting is undertaken in chapter 14, "Certain Facts Not Widely Known."

Four major artists are selected to represent the various movements in Japanese painting. These artists are Fujiwara Nobuzane (1176–1265), Kanō Eitoku (1543–1590), Sesshu (1420–1506), and Tawaraya Sōtatsu (early seventeenth century). While there are numerous studies appearing in Japanese on all of these artists, there are only a few new works in English that would be helpful to the Western reader. For interesting accounts of Sesshu (an artist for whom Michener has little affection), the best works in English are *Japanese Ink Painting: Shubun to Sesshu* by Tanaka Ichimatsu in the Heibonsha Survey of Japanese Art, 1972, and *Japanese Ink Painting: Early Zen Masterpieces* by Kanazawa Hiroshi, Kodansha International Ltd. and Shibundo, 1979. Kanō Eitoku is discussed by the distinguished scholar Takeda Tsueno in the volume *Kanō Eitoku*, published by Kodansha International Ltd. and Shibundo, 1977. The most current work on

Tawaraya Sotatsu is my own *Exquisite Visions: Rimpa Paintings from Japan*, published by the Honolulu Academy of Arts, 1980. Fujiwara Nobuzane has not received definitive treatment in a Western language to date.

The reason for Michener's choice of artists can be explained as follows. During the Momoyama period (1568–1603) the great Kanō painters wedded Japan's two major painting traditions, the native Yamato-e, with its emphasis on surface color and cursive line (Fujiwara Nobuzane), and the Chinese derived Kanga, with its more rigorous, monochromatic composition and sharply defined, almost calligraphic line (Sesshū), to produce two styles of art. The first, the decorative style, is best exemplified in the work of Kanō Eitoku. The second is the genre style in which people of all classes and walks of life are depicted in loving detail. This last is the direct precursor of ukiyo-e paintings and prints, and the name Iwasa Matabei is often referred to in early studies of this style. The genius, Tawaraya Sōtatsu, in truth, had little to do with this development and was, in fact, part of a Yamato-e revival that paralleled the early genre movement.

In chapter 15, "How It Was Done," Michener opens his discussion by suggesting that Torii Kiyonobu originally drew a line that was three to five times as thick as the one we now see in his prints. This is misleading, for prints duplicated the drawing exactly. What is true is that Kiyonobu's large posters had a much thicker line than that observed in his prints. The suggestion that Harunobu sometimes gave only the vaguest indication of what colors might go well with his designs cannot be proven and is, in fact, unsupported by any surviving document. The consistency of Harunobu's color, would, if anything, suggest that this artist had great control over the final palette selection.

Later on Michener suggests that the great publisher Tsutaya Jusaburō made most of his money from the sale of guide books of the Yoshiwara. This statement is highly questionable. Michener also discusses the first cash fees to novelists, referring to Santo Kyoden's payment from Tsutaya in 1791. Richard Lane has uncovered evidence to suggest that a century earlier Saikaku had recieved similar payment. In fact, while documentary evidence is lacking, it is clear that an author such as Ijima Kiseki (1667–1736) must have received wages from his publisher. Michener attempts to document Tsutaya with an

illustration of him sitting quietly selling his prints. Unfortunately, this is probably not a portrait of Tsutaya at all since the illustration comes from a Hokusai book published two or three years after Tsutaya's death. Michener also suggests that most museums own keyblocks that have been preserved nearly three hundred years. This should be amended to read that many museums have keyblocks dating from the nineteenth century; a few museums purport to have three-hundred-year-old keyblocks.

Chapter 16, "The Popular Symbol," deals with the major artist Kitagawa Utamaro (1754–1806). The chapter is immensely successful. Although Michener dismisses Utamaro's early years when he produced at least twenty illustrated novels (1779–1787) and four important picture books (1786–1787), this does not interfere with the brilliant discussion of Utamaro's single-sheet prints for which the master is best known. Michener attempts to erase the perpetual charges of decadence that have long attended reviews of Utamaro's art. One series, *Kintoku Yamauba*, is inappropriately used as evidence of motherly love. The set has definite erotic overtones.

Michener's chapter on Utamaro also suggests that decline in ukiyo-e (ca. 1805) came because no new ideas reached the art and that the only two authentic talents, Hokusai and Hiroshige, dignified the last years but lacked sufficient force to revive the art. I wonder if Michener would today reconsider this statement in light of the more complete studies of such vital artists as Utagawa Kuniyoshi (1797–1861) and Tsukioka Yoshitoshi (1839–1892) now available.

Chapter 17, "Art's Mystery," deals with Tōshūsai Sharaku (active 1794–1795) and is an account of an artist who has been fictionalized as much by art historians as by Michener. As I have stated repeatedly throughout this review, ukiyo-e biographies are by no means certain, and in truth very little real evidence exists to support them. Why Sharaku should become art's great mystery is a mystery in itself, but the whole tradition is not new to Michener. The real mystery rests with Sharaku's art—the miracle of designing at least 140 masterpieces in the short space of ten months.

The Sharaku legend is deftly treated by Michener, but some of his points need to be qualified by new evidence. The theory, for example, that mica prints were outlawed in late 1794, may never be prov-

en. In fact, mica prints have been dated quite accurately to as late as 1797. The idea that Sharaku prints were actually unpopular is based on one supplement to the *Ukiyo-e Ruikō* and is not substantiated by the surviving art. In 1794 Sharaku designed more prints than perhaps even Utamaro. The suggestion that Sharaku's space allocation, choice of color, and use of line were undistinguished can surely be challenged; Sharaku knew exactly what he was doing and did it superbly well. The psychological content and visual tensions created by color, line, and space make this artist unique.

Finally, the suggestion that Sharaku introduced a very un-Japanese style of portraiture needs to be reconsidered; a long tradition of portraiture existed, dating back to the Kamakura period (1185–1333). Sharaku was part of this tradition which was particularly strong and perpetuated itself in the Kamigata region (Osaka/Kyoto area).

Michener's picture of Utagawa Toyokuni (1769–1825) offers the standard critical judgments that would be made about an unoriginal eclectic artist. There is no question that Toyokuni was fully capable of aping the style of a successful print artist. All of the ukiyo-e artists did so. To dismiss Toyokuni as unoriginal, however, seems somewhat unfair in the light of at least two original contributions. The first, a lengthy series of prints dealing with actors on stage. Many of these prints "ape" Sharaku according to Michener and other authorities, but recent dating of a number of the prints proves conclusively that the set was begun months before Sharaku introduced his probing style. The set has a life and personality of its own, and if Toyokuni did nothing else he would be remembered for this set as creative and original. Other sets such as *The Seven Komachi* introduce techniques and style that are equally personal.

Toyokuni's career after 1800 is envisioned by Michener as one of total decline: his line became objectional; his sense of design collapsed; he turned out thousands of conglomerations of "twisted figures, ugly balances and garish curly-cues." It is true that the year 1800 generally marks a change in public taste in prints. This was the result of an influx of demands from the rural areas for a less sophisticated art. This change however is offset by an increased interest in prints as documents of social change. As Narazaki suggests, "many of the nineteenth-century prints are fascinating illustrations of the influx of European influence; the overtones of social and political satire

became more and more common in them as the days of the Tokugawa shogunate came to an end." Perhaps Toyokuni should be admired for his tenacity and courage to continue to work during the tumultuous changes of the nineteenth century. In truth, not all of his work after 1800 is hackwork. Many examples are of considerable quality.

Michener's treatment of Katsushika Hokusai (1760–1849) in chapter 19, "The Life of the Artist," is well done, presenting many of the anecdotes that surround this colorful figure. It should be noted, however, that in 1817, Hokusai was not an impoverished artist already in his mid-forties and lacking in fame but was fifty-seven years old and famous.

Katsushika Hokusai, with his enormous imagination and diversity, has sometimes been hailed as the greatest of all Japanese print artists. This opinion is not without defense. Hokusai's biography and artistic career are comparatively well documented. He is discussed in the *Ukiyo-e Ruikō* and related sources. Moreover, Muneshige Narazaki has made a thorough study of his career and biography in the monumental *Hokusai Ron* (1944), which remains the best single source on the artist's work.

Michener's own collection on Hokusai is particularly well balanced, providing the historian with a wealth of documentation for reconstructing Hokusai's artistic career. What follows is a summary of his life and career based on a study of the prints themselves and some limited research undertaken at the Ukiyo-e Center. It is offered here as a supplement to Michener's views.

Hokusai lived most of his life in an Edo business district along the Sumida River. He studied the art of woodblock engraving under the printer Honjo Yokozunachō, and this knowledge, which required the mastery of copying an artist's individual line, was to prove very important to his future artistic career. At the age of eighteen, Hokusai became the pupil of Katsukawa Shunshō (the great artist of kabuki who helped to establish a more realistic portrait of the actor), and within one year he was given the name Shunrō in recognition of his talent. The Michener assemblage includes a few choice prints signed Shunrō from the 1780s; especially choice is the middle sheet of a triptych depicting a Chinese festival (70).

From 1778 to around 1788, he experimented in many facets of the

woodblock (e.g., bijin-ga, yakusha-e, kacho-e, uki-e, and distinctive illustrations for novelettes). Hokusai was obviously searching for a style of his own, a quest he pursued throughout his long life, for as he tired of one kind of expression he sought a new and fresh one. It is Hokusai's unique probing quality that provides a wide variety of styles. His great individuality was also to be the source of considerable trouble. It was clearly impossible for young Hokusai to remain slavishly loyal to the style of his mentor, Shunshō, and criticism of Hokusai's artistic experiments was often leveled by his seniors, Shun'ei and Shunkō.

After Shunshō's death in 1792, Hokusai began to produce works jointly with the artist Tsutsumi Tōrin III, who claimed to have derived his style from that of Sesshū (Tōrin often signed his work Sesshū XIII). He experimented widely with prevailing styles: bird-and-flower studies of the Nampin School; literati works of Chinese Ming painting; Japanese pictures of the Sumiyoshi School; and even Kano art. Perhaps because of his enthusiasm for a wide range of styles, Hokusai was finally expelled from the Katsukawa School in 1794.

His names form a vast and confusing study in themselves. It was traditional for artists to take a special artistic name, or gō, and sign their works. Hokusai was unusual among ukiyo-e artists, changing his name nearly a hundred times during the seventy years he was productive. We know him today as Hokusai because this particular name appeared on and off, in various combinations, during a long period from about 1796 to 1833.

In 1795 he assumed the leadership of the so-called Tawaraya School, once headed by Sōri I who died in 1780, and assumed the name Sōri III for a time. But Hokusai's adherence to the Tawaraya tradition of Rimpa painting was hardly exclusive, for among the subjects he depicted at this time were the more purely ukiyo-e series of beautiful women studies popularly known as *Sōri bijin-ga*.

In 1798 Hokusai broke with the Tawaraya family and became an independent artist. For the next thirty years this unsettled master produced prints of power and originality under a bewildering variety of names. A number of these works are represented in the Michener Collection. For example, in the 1830s Hokusai produced a series of at least ten chūban bird-and-flower studies showing a strong influence of Chinese painting. The Michener Collection owns one example, published by Eijudō, in virtually mint condition depicting a bullfinch

and drooping cherry branch set against a stunning blue background. The remainder of the series in the academy unfortunately has been determined to be later recuts and not part of Hokusai's genuine oeuvre.

At the age of sixty-three, all of Hokusai's past efforts crystallized into one creative effort. It was at this time that Hokusai is believed to have begun his most famous series of prints, *Thirty-six Views of Mt. Fuji.* This set, totaling forty-six prints, was the subject of a recent study at the academy's Ukiyo-e Print Center, where it was possible to compare a number of variant prints from different editions, all part of the Michener Collection. The prints were organized according to signature, seal, impression, and color. It was possible to conclude from the study that the earliest prints were probably monochromatic blue and that later impressions had added to them a second color, usually yellow. Moreover, when the ten prints utilizing a black keyblock line were added to the series of thirty-six (all printed with a blue keyblock line) the entire set was reprinted in black outline with additional color variants. This was confirmed by the fact that, save for the additional ten prints, all other black-line prints were late, weak impressions. It should be added that the Michener Collection's Fuji series includes some very fine impressions of the more famous subjects. Indeed, the collection's surrealistic "Aka Fuji" has been hailed as the finest impression of the subject in the world. The lines are clean, the color registry perfect, and the tones subtly modulated. Other important series well represented in the Michener Collection were probably done during the creation of the Fuji prints. They include two fine prints from the three-print series *Snow, Moon, and Flowers (Setsugekka)* published by Eijudō around 1830—the greatest of Hokusai's several interpretations of this classic Japanese trilogy of natural beauties; the entire series and the keyblock proof of one of the more important designs from the splendid series of ten prints entitled *The Poetry of China and Japan: A Living Mirror (Shiika Shashin-kyō)* published by Mori-ya; and a complete set of eight prints from *Eight Views of the Ryūkyūs (Ryūkyū Hakkei)* published by Mariji, probably in 1832. It has recently been discovered that Hokusai, who apparently never visited the Ryūkyūs, took his basic compositions from an illustrated history book entitled *Ryukyu Kokushiryaku.* The only date known for that source book is 1831, thus accounting for the 1832 attribution for the Hokusai series.

Next to the *Thirty-six Views of Mt. Fuji,* the eight-print series,

Tour of the Falls of the Various Provinces (Shokoku Taki Meguri) must be regarded as the boldest and most original of Hokusai's pure landscapes. Indeed, as the Hokusai specialist Peter Morse suggests, "In its unique combination of real and fantastic elements, it may surpass even the 'Fuji' set in its consistently high standard." The Michener assemblage owns seven of the eight prints of this series, all in good condition.

Nonetheless imaginative, even though depicting actual places in Japan, is the eleven-print series *Guide to Famous Bridges of the Various Provinces (Shokoku Meikyo Kiran)*, probably published in 1834 by Eijudō. The Michener Collection has eight pristine prints from this important series.

According to the recent research of Roger Keyes and Peter Morse, a total of eight prints has been recorded from the series *Guide to Famous Places (Shōkei Kiran)*, possibly published in 1835. This exceptionally rare set, in fan print format, is represented by four excellently preserved examples in the collection.

The assemblage also boasts the series *The Hundred Poems Explained by the Nurse*, which represents both Hokusai's last years of life and ability as a humorist, a point missed by Michener in his discussion of this set. The academy has the only complete series known in the world.

Chapter 20, "The Other Books," deals with ukiyo-e erotica, and Michener must be commended for the inclusion of this often taboo subject at a time when it was not fashionable. His account is extremely lively and at times even humorous, but there are some exaggerations. For example, he estimates that about one-half of all prints sold were erotic in nature. Not even one-tenth could be so designated. The fact that so many survive merely indicates that they were preserved with greater care because of their nature and the very limited editions involved.

It should be added that it would be difficult to prove, as Michener suggests, that all of the artists represented in this book (with the exception of Eishi and Sharaku) did shunga. Incidentally, Eishi did some very famous handpainted shunga scrolls. Thorough and documented studies on shunga have been produced by Richard Lane and for those readers interested in exploring the subject, I recommend his writings.

A study of Hiroshige is presented in chapter 21, "The Function of the Eye." Michener admits freely that he is not particularly fond of the art of Hiroshige. It is, therefore, ironic that he should have become custodian of some of Hiroshige's finest surviving prints. Of the 4,533 prints once in the Chandler Collection bought by Michener, nearly 2,700 were by the master of poetic landscapes, Utagawa Hiroshige (1797–1858). As the early American collector Judson Metzgar once remarked, "This is America's finest private collection of Hiroshige. . . ."

Chandler was an inveterate hunter of states and variants and acquired these with a passion that seems peculiar to noted Hiroshige collectors (Happer, Schraubstadter, Matsuki, and Uchida come to mind). Michener himself understood the importance of such variants and states, and this he brilliantly expresses in his essay about Mt. Hira.

Work is in progress on a catalogue raisonné of the Chandler/ Michener Hiroshige holdings with the technical assistance of Roger Keyes. The variants are being carefully recorded both photographically and in verbal description for the benefit of the student and scholar, thus setting a new and important precedent in the ukiyo-e field.

Hiroshige was born in 1797 in Yayosugashi in Edo. His first formal art studies began at the age of fifteen under Utagawa Toyohiro, a man of limited artistic talent, whose personality was retiring but kind. Within one year Hiroshige was given the name Utagawa Hiroshige in recognition of his great abilities. Along with some unofficial training in the Kano school, he also studied the softer styles of Chinese-inspried art of the Nanga and Shijō schools under the painting master Ōoka Umpō. It was only after years of study that Hiroshige was able to synthesize these styles, along with that of the Western landscape artists, to produce something entirely harmonious. His bijin studies proved totally unpopular, lacking the sensuality demanded by Edo patrons. The Michener Collection owns a small number of these early studies.

In 1830 Hiroshige gave up this genre and devoted his entire attention to landscapes and bird-and-flower studies, bringing into play his varied training in these areas. At this time he changed his art name from Utagawa Hiroshige to Ichiyūsai Hiroshige in recognition of his

new style of art. His initial efforts were encouraging, and, despite a lack of polish, many of his more salient characteristics can be observed at this time. For example in his ten-print landscape series, *Tōto Meisho Jūkkei (Ten Views of the Eastern Capital)*, his colors are already melodic and harmonious, and his love of nature and compassion for humanity are clearly in evidence in his sympathetic renderings. The Michener Collection owns one complete set of this important early series.

Two years later, at the age of thirty-five, he changed the characters for his name to Ichiryūsai to indicate still another step in his fast maturing career. At that time (1832), Hiroshige produced his now famous *Tōkaidō Go Jū San Tsugi no Uchi (Fifty-three Stations of Tōkaidō)*. The academy owns two complete sets of the *Tōkaidō*, including a number of duplicate states and variants.

Also in the early 1830s Hiroshige produced some of his finest bird-and-flower pictures. Unpretentious and romantically warm, these prints presage in character all of Hiroshige's best work of the later years. The Honolulu Academy of Arts' Michener Collection boasts over five hundred Hiroshige nature studies, many in a superb state of preservation and some known in only one or two impressions.

Riding on a wave of popularity, Hiroshige went on to produce series after series of landscapes, including *Ōmi Hakkei (Eight Views of Lake Biwa)* and *Naniwa Meishi Zue (Views of Naniwa)*, the latter being one of the few unsuccessful works in Hiroshige's large output. In the late 1830s he completed the *Kisokaidō* series begun by his competitor Eisen. The result was *Kisokaidō Rokujūkyū Tsugi no Uchi*, one of the great landscape collaborations in all of ukiyo-e.

Hiroshige's life was full of misfortune, perhaps accounting for his obvious sensitivity to nature and humanity. His wife died in the same year that the *Kisokaidō* series was released (1839), and just three years later his son decided against following his father's occupation. This son died four years after this irreconcilable act. Hiroshige tried to ease the pain in his life by marrying the daughter of a farmer, but this, too, brought misfortune when it was discovered that his second wife's brother, a priest, was defrocked for illicit relations.

Hokusai died in 1849 when Hiroshige was fifty-two. From then on Hiroshige was the undisputed ukiyo-e landscape artist. At the age of sixty-two he produced two sets of landscapes: *Views of Edo (Edo Meisho)* and *One Hundred Views of Edo (Meisho Edo no Hyakkei)*;

the latter consisted of 119 prints. While he was at the height of his productivity a cholera epidemic broke out in Edo, and according to one source, claimed his life, as well as the lives of twenty-eight thousand fellow citizens.

Among the prints in these interesting last sets is the marvelous "Sudden Shower at Ōhashi," in which travelers are caught by a torrential downpour while crossing a bridge, from *One Hundred Views of Edo*. Not only does this print epitomize Hiroshige's ability for atmospheric effects, but it also offers a perfect illustration of the significance of variant printings. What is thought to be the earliest version, or at least the rarest and most aesthetically pleasing, shows definite shadows on the bridge, while at the top of the print dark clouds are allowed to drift well into the composition. A second state, clearly less pleasing, omits the shadows on the bridge, but includes new blocks for the silhouette in grey of the distant shoreline; some boats along the river's edge have also been added. In the least desirable version, and the one which is most commonly found in collections, neither the shadows on the bridge nor the additional boats along the shore are retained, and the black clouds at the top of the print are treated insensitively with an even gradation overall. Such comparisons underline Michener's pronouncement: 'I cannot stress too strongly the fact that the ten thousandth copy . . . is simply not a Hiroshige, even though struck off from his blocks and in something approximating his colors." Most Hiroshige late variants are anomalies; the poor quality of the virtually thousands of late Hiroshige impressions is ironic proof of how famous an artist Hiroshige really was during and after his lifetime.

Additional Comments

It is entirely possible that many in the English-speaking world would never have become interested in these "little scraps of paper" if it had not been for James A. Michener. When this book was originally published, he was already a noted novelist—a spinner of marvelous tales that enticed the reading public. The title did nothing to dissuade them from that idea, and, in fact, the book begins like a novel. Michener's love of the art form breathed life into what some critics call flat and unprofound renderings. That the account was a popular one does not diminish its importance. A general book on the subject

of ukiyo-e had not been written in decades and interest in the Japanese print had waned from the great days of collecting in the early 1900s. It took a man such as Michener, with his ability to accurately summarize complex issues, to popularize the subject for the average person. It is all the more to his credit that he did so with such affection and enthusiasm for the print and the Japanese artists who produced them. It is hoped that the above comments will give Michener's achievement renewed life and permit future generations of art lovers to join with James Michener in his joy of the art.

A few comments must be made on the text which accompanies the plates. It should be noted that the forty plates originally reproduced in color now appear in black-and-white. As Richard Lane noted in his review of the first edition: "Of the colored illustrations to this volume, the least said the better. The printing is, in general, inferior to that in the comic strips in the *New York Journal-American* . . . the color plates are either out of focus, off-register, or off-color— usually a combination of the three." The new black-and-white plates are, therefore, a welcome addition despite the absence of good color examples to underline one of the important glories of ukiyo-e.

Corrections and comments to a number of the plates follow:

Plate 9, showing an album leaf from *Yoshiwara no Tei*, does not reveal the "essence of ukiyo-e subject," in my opinion; rather it shows the essence of late-seventeenth-century ukiyo-e subject matter.

Plate 12, dealing with Nishikawa Sukenobu's "Ehon Tamakazura," offers the signature translation "Great Japan Painter Yamato-eishi." An alternate meaning might suggest that Nishikawa was a Kyoto or Kamigata artist rather than an Edo artist.

Plate 15, showing a standing figure by Kaigetsudō Dohan, offers the signature reading "Nippon Gigwa." While Michener is to be commended on his general unification of romanizations throughout *The Floating World*, this mistake went unchecked. The reading should be "Giga."

Plate 17, dealing with Kubo Shunman, is an affectionate treatment of this master. It could be added that Shunman designed some fine surimono until his death in 1820.

Plate 21, by Katsushika Hokusai, has already been discussed. The portrait is probably not Tsutaya, the famous publisher.

Plate 27, dealing with a Torii Kiyonobu print, needs further explanation. Yaoya O-shichi did not burn Edo to the ground for love; she

started the fire in order to reach a temple to see her lover, Kichiza. It is clear from the text that she did not intend to spread the fire.

Plate 28, showing a Torii Kiyomasu print that has been severely cropped, offers a tentative identification of the seal; we confirm that the seal is that of the publisher Iga-ya.

Plate 30 offers a classic Masanobu perspective print or uki-e. It has already been noted elsewhere that the earliest surviving perspective print is by Torii Kiyotada, not by Okumura Masanobu. Lee's research also suggests that such perspective prints were not derived directly from Dutch prototypes but were actually based on Italian examples via China.

Plates 31 and 32 offer the split-block theory as the possible origins of hashira-e. This theory has since been given added strength by comparing identical subjects in Michener's own collection with those found at the Museum of Fine Arts Boston—the former a kakemono-e and the latter a hashira-e.

Plate 37, dealing with Torii Kiyohiro's print of "Matsukaze," needs amendment. It was a kabuki drama not a noh drama that inspired the print.

Plate 38, showing a typical benizuri-e of the great master, Torii Kiyomitsu, needs further comment. Benizuri-e, that is, pink and green combination prints, were first introduced by the Chinese; the happy combination was adapted by the Japanese and further refined.

Plate 40 offers an interesting compilation on the colors used in ukiyo-e. Some of Michener's facts need correction. Prussian blue was first introduced in Edo about 1828 not 1820. Aniline colors, imported from the West, were introduced in 1865.

Plate 44, dealing with an Ichikawa actor by Katsukawa Shunsho, has already been noted in the text; the identity of Ichikawa Danjūrō is incorrect. The print depicts Ichikawa Danzō.

Plates 47, 48, and 49 feature Isoda Koryūsai's attempt at designing for the pillar print. All three works testify to my earlier indictment that Koryūsai's art in this format is usually busy and cluttered.

Plate 51, showing a print dealing with a dance sequence from kabuki with musicians in the background, offers the curious statement that Hokusai ended the form with a "hilarious burlesque." The reference is obscure to me. As far as I know, Hokusai did not design anything like this, much less a parody in the 1780s or 1790s.

Plate 52, showing a famous wrestler of the day by Katsukawa

Shuncho, offers a number of alternative dates. 1784 is quite impossible. Based on style, 1792 or 1793 seems more likely. Shuncho probably copied Shun'ei and not the reverse as stated.

Plates 53 a, b, and c is an interesting set of comparisons dealing with various editions of the same bijin subject by Utamaro. It should be noted that mica was not printed from blocks; it was often added by hand to the recut issues and genuine impressions. The publisher is listed as Ōmi-ya Kenkura. This reading is clearly wrong; perhaps it should be rendered Kengoro. Komura should be rendered Kamuro and does not mean servant, as indicated, but young apprentice courtesan. The earliest print in the group, based on the style of signature, would date between 1796 and 1797. As for the later editions, no one knows for certain how much time elapsed.

The most glaring error connected with Plate 57 is the often stated opinion that Katsukawa Shun'ei invented the large head portraits of actors. In the single-sheet format, the large head portrait may be traced back at least fifty years earlier. In fact, a series of fan prints in the Hibiya Library, Tokyo, reported by Adachi, suggests that Torii Kiyomasu II may have actually been the first to work in this form.

Plate 60 depicts a print from Hokusai's famous waterfall series. Michener suggests that most impressions of this work are forgeries. This is statistically not true. Moreover, the so-called forgeries were actually facsimilies published in the Meiji period. They were not intentionally deceptive.

Plate 62, dealing with a bird-and-flower study by Hiroshige, includes the deer and horse seal often read *baka*, or "foolish." The animals also represent the characters *fuku* and *ju*, which mean "happiness" and "longevity" respectively.

Plate 63 a, b, and c show an Adachi Institute facsimile of the famous Kuniyoshi print from *Chūshingura*, Act 9, the block from which the facsimile was made, and a keyblock impression. While this gives Michener an opportunity to illustrate specific points connected with the process of printing, the suggestion that no copy of this tragic print was available in America at the time needs to be qualified. Superb impressions were available in 1953 in the Ainsworth Collection, the Oberlin College Collection, and the Springfield Art Museum, to name only a few. The Michener Collection itself now owns a very fine impression housed at the Honolulu Academy of Arts.

Additional Prints

66

Title: Atama Sori (Shaving the Head)
Location: The James A. Michener Collection, Honolulu Academy of Arts.
Size: 37.9 x 25.6 cm. *Publisher:* Ōmi-ya. *Date:* Late 1790s.
Signature: Utamaro hitsu.
Technical: Ōban, nishiki-e.
Commentary: Michener's perceptive study of Utamaro is perhaps his most successful in *The Floating World.* This affectionate print of the late 1790s reveals Utamaro's concern for mother and child and ranks among the artist's greatest ukiyo-e glories.

67

Title: The Story of the Jewel Theft
Location: The James Michener Collection, Honolulu Academy of Arts.
Size: 52.7 x 32.2 cm. *Publisher:* No mark. *Date:* Ca. late 1670s.
Signature: None.
Technical: Handcolored kakemono-e, left-hand sheet of a diptych.
Commentary: The Worcester Art Museum owns both sheets of this exceedingly rare diptych based on the popular story "Tamatori Monogatari." Both its size and the manner of coloring suggests a date in the late 1670s. Some scholars have cautiously suggested the style of Sugimura Jihei. In any event, the work may very well be the earliest surviving kakemono-e and one of the few known examples of a diptych in this format.

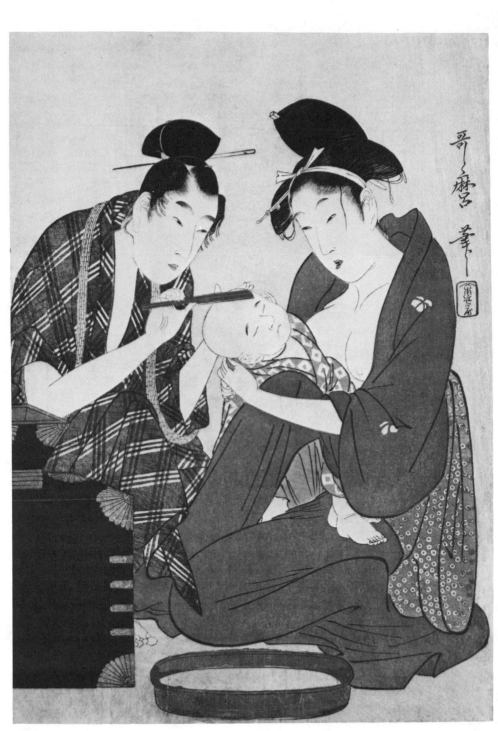

66

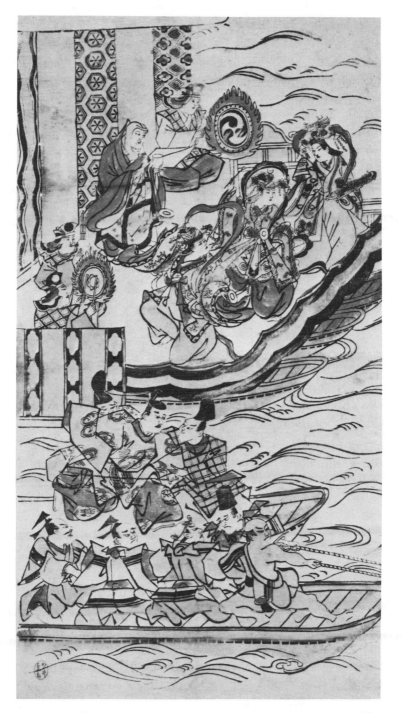

67

68

Title: Minami Jūni Kō Shichigatsu Yoru No Okuri (Twelve Months in the South, the Seventh Month)
Location: The James A. Michener Collection, Honolulu Academy of Arts.
Size: 37.3 x 50.2 cm. *Date:* 1784.
Technical: Ōban, nishiki-e.
Commentary: Michener's favorite Kiyonaga diptych, a form in which the artist excelled, has been hailed by him as a work of "such subtle, yet simple beauty as to epitomize the best of ukiyo-e."

69

Title: Kingyo (Goldfish)
Location: The James A. Michener Collection, Honolulu Academy of Arts.
Size: 33.0 x 11.5 cm. *Date:* Ca. 1832.
Signature: Hiroshige hitsu.
Seal: Hiro.
Technical: Tanzaku, nishiki-e.
Commentary: Hiroshige's bird-and-flower studies are among the more important artistic treasures left by this master, and this print from Michener's own holdings of nearly 500 pristine examples is particularly rare and fine.

70

Title: Karako Asobi (Chinese Matsuri Festival)
Location: The James A. Michener Collection, Honolulu Academy of Arts.
Size: 38.5 x 26.2 cm. *Date:* Mid-1780s.
Signature: Shunrō ga.
Technical: Ōban, nishiki-e, probably middle panel of a triptych.
Commentary: The versatility of Hokusai is well considered by Michener. This Hokusai print, signed with the early name of Shunrō, is proof of Hokusai's ability to design in a variety of styles.

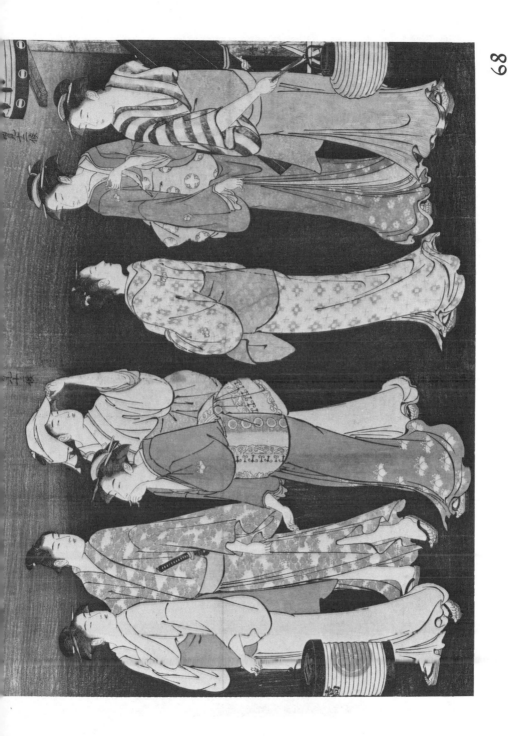

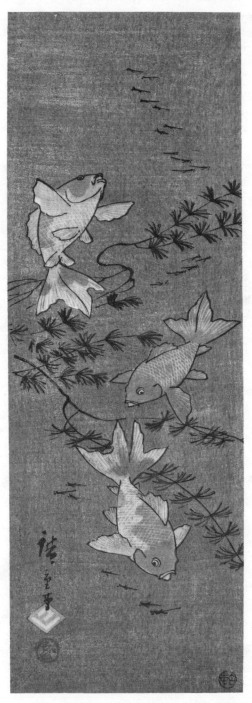

69

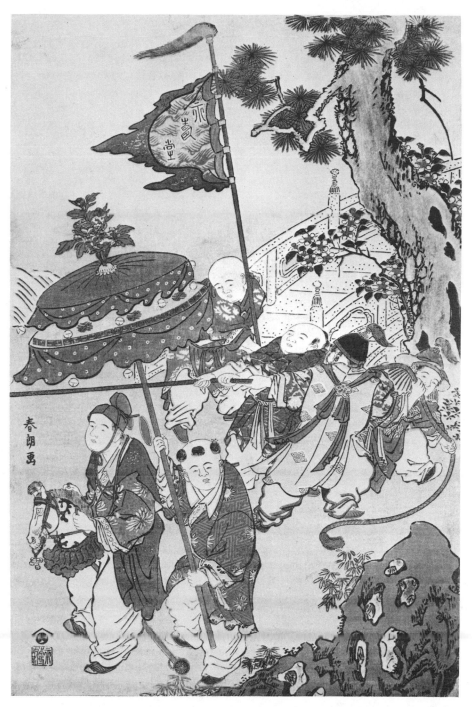

70

71

Title: Hyakunin Isshu Uba Ga Eitoki (One Hundred Poems Explained by the Wet Nurse)
Location: The James A. Michener Collection, Honolulu Academy of Arts.
Size: 25.6 x 38.0 cm. *Publisher:* Eijudō. *Date:* 1835.
Signature: Zen Hokusai Manji.
Technical: Ōban, nishiki-e.
Commentary: Few connoisseurs, including Michener, have really understood this remarkable late series by Hokusai. In 1975 the series of twenty-eight known prints in the James A. Michener Collection was completed with the acquisition of this example. This series is now thought to be the only complete set in the world.

72

Title: Mochizuki (No. 26 in the series)
Series title: Kisokaidō Rokūjukyū Tsugi no Uchi (Sixty-nine Stations on the Kisokaidō).
Location: The James A. Michener Collection, Honolulu Academy of Arts.
Size: 24.5 x 36.7 cm. *Publisher:* Kinjudō. *Date:* Late 1830s.
Signature: Hiroshige ga.
Seal: Ichiryūsai.
Technical: Ōban, nishiki-e.
Commentary: In the late 1830s Hiroshige completed his famed Kisodaidō series begun by his competitor Eisen. The result was one of the great landscape collaborations of ukiyo-e. Most scholars agree that James A. Michener's collection of the Kisokaidō series is virtually unmatched.

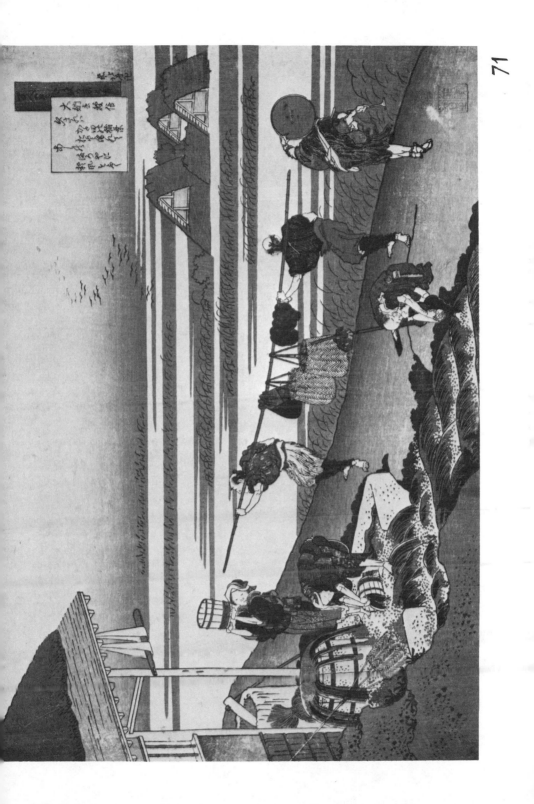

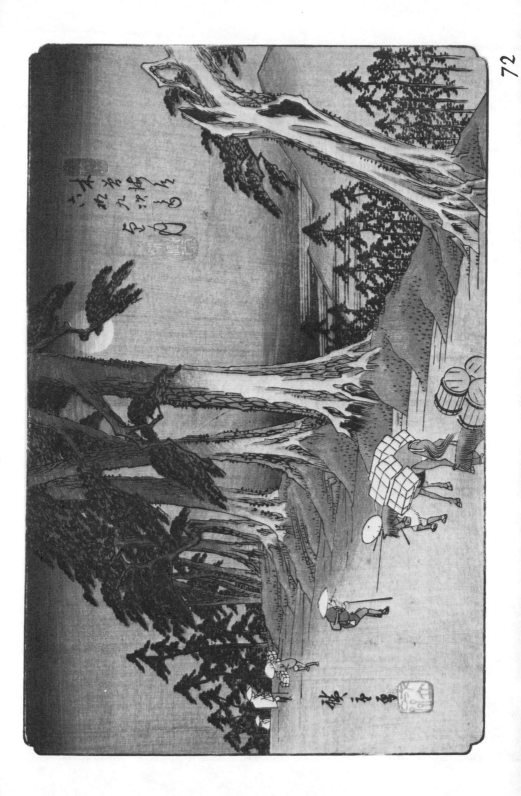

Bibliography

THE literature on ukiyo-e is so limited that it is quite possible for anyone interested in the subject to read literally everything existing in English, French and German. This is no special feat. However, it does permit one to list an impressive bibliography, most of the items consisting of pamphlets sixteen or thirty-two pages in length. In the bibliography that follows I have tried to resist such exhibitionism. The following books, especially those in the first category, are guaranteed not to waste a reader's time but to insure a reasonable background of fact and understanding. They are exciting reading, for they deal largely with ideas.

Throughout the preparation of this book I have had the thoughtful help of Bertha M. Usilton, librarian of the Freer Gallery in Washington.

SEVENTEEN BASIC BOOKS

These books, if read in sequence, would guarantee an understanding of the nature of prints (books 1, 2); the cultural patterns of Japan (books 3–7); the characteristics of oriental art (books 8, 9); the fundamentals of ukiyo-e (books 10–13); the magnificent range of one great collection (book 14); two fine treatises on the beginnings of ukiyo-e (books 15, 16) and a masterful account of one of the culminating artists (book 17). None of the excellent books in Japanese are included in this first basic list, but only because so few western readers can make their way through this most difficult language.

1. Ivins, William M, Jr. *Prints and Visual Communication*. Cambridge: Harvard University Press, 1953. xxv, 190 pp.

 A short, witty, speculative inquiry into why men make prints. Few critics agree with all Ivins' guesses, but everyone learns something.
2. Zigrosser, Carl. *The Book of Fine Prints*. New York: Crown Publishers, 1937. 499 pp.

 Much exaggerated nonsense has been written about ukiyo-e because

the authors were not acquainted with the great prints of the rest of the world. This compact book, with 555 world prints, is an antidote to provincialism.

3. Sansom, George B. *The Western World and Japan*, A Study in the Interaction of European and Asiatic Cultures. New York: Alfred A. Knopf, 1950. xxvii, 504 pp.

 Among scholars this book is held to be so fine that no attempt is made to describe it. An intellectual treat of the first grade.

4. Kokusai Bunka Shinkokai, ed. *Introduction to Classic Japanese Literature*. Tokyo: Kokusai Bunka Shinkokai, 1948. xxi, 443 pp.

 Loving, detailed, flavorful, and occasionally critical summaries of the greatest Japanese books.

5. Shikibu Murasaki. *The Tale of Genji*. Arthur Waley, tr. New York: The Literary Guild, 1935. xvi, 743 pp.

 Twice in the text I have suggested that the very best approach to the Japanese spirit is a patient and savoring reading of this massive novel. That's still sound advice.

6. Jippensha Ikku. *Hizakurige*, A Shank's Mare Tour of the Tokaido. Tokyo: Toa Bungei Sha. xvi, 412 pp.

 This book is a robust, salty, endless joy. The dust of the Tokaido is on every page, waiting to be brushed into life by the reader's passage.

7. Bowers, Faubion. *Japanese Theatre*. New York: Hermitage House, 1952. xxvi, 294 pp.

 One of the foremost works of scholarship dealing with Japanese culture to come out of the occupation. Since so many ukiyo-e prints deal with kabuki, this book provides a solid foundation for one's appreciation.

8. Minamoto Hoshu. *An Illustrated History of Japanese Art*. Tr. from the Japanese by Harold G. Henderson. Kyoto: K. Hoshino, 1935. ix, 265 pp. and 218 plates.

 A series of reproductions of paintings and sculpture, each with an explanatory essay.

9. Warner, Langdon. *The Enduring Art of Japan*. Cambridge: Harvard University Press, 1952. 113 pp., 92 plates.

 Experts agree that for a brief, exalted insight into the artistic philosophy of Japan this book, by the scholar whose pleas are credited with saving the cities of Kyoto and Nara from American bombs, is a masterpiece.

10. Volker, T. *Ukiyo-e Quartet;* Publisher, Designer, Engraver and Printer. Leiden: J. Brill, 1949. 29 pp.

 This very short essay by a Dutch scholar, printed in English, is one of the foundation stones for an understanding of ukiyo-e. It has strongly influenced the basic ideas presented in this present book.

11. Binyon, Laurence and Sexton, J. J. O'Brien. *Japanese Colour Prints*. London: Ernest Benn, Ltd., 1923. lvi, 235 pp. plus 41 plates.

If time permits the reading of only one book on this list, this is it.

12. Rumpf, Fritz. *Meister des Japanischen Farbenholzchnittes*. Berlin: [n.p.], 1924. 141 pp. 18 plates including 70 text figures.

Most people who have not ploughed through this famous and revolutionary book think it is an organized account of ukiyo-e. Actually it is a most vitriolic, hilarious and iconoclastic explosion with very little organization but with a tremendous amount of insight. Proves profanely that all preceding German experts, especially Julius Kurth, were ignorant.

13. Toda Kenji. *Descriptive Catalogue of Japanese and Chinese Illustrated Books in the Ryerson Library of The Art Institute of Chicago*. Chicago: The Art Institute, 1931. xxxii, 466 pp.

An admirable, jam-packed study filled with unusual information.

14. Ledoux, Louis V. *Japanese Prints of the Ledoux Collection*, Volumes I–V. New York: E. Weyhe, 1942–1951. 258 prints plus accompanying text.

The most beautiful catalogue of an ukiyo-e collection ever published, plus an assembly of accurate scholarship.

15. Noguchi Yone. *The Ukiyoye Primitives*. Tokyo: Privately Published, 1933. xiii, 137 pp. plus 93 plates.

Amazing Yone Noguchi, a poet who once worked for Joaquin Miller, has produced in English a dozen or more of the most flamboyant books of art criticism in our time. Connoisseurs of his fantastic style sometimes try to find the longest paragraph with the most incomprehensible meaning. Some gems have been turned up. But this particular book (its sensational English was toned down by a college classmate of mine) is a thoroughly enjoyable work of art criticism.

16. Gunsaulus, Helen C. *The Clarence Buckingham Collection of Japanese Prints, The Primitives*. Portland, Maine: Anthoensen Press, 1955. 284 pp., 531 illustrations, 8 plates in color.

The first massive volume of what will in time be the first great catalogue of a leading American public collection. Each print illustrated and accompanied by a scholarly summary.

17. Hirano Chie. *Kiyonaga; A Study of His Life and Works*. Boston: The Museum of Fine Arts, 1939. 545 pp. plus 146 plates.

A huge work. The opening essays are excellent and full of meat. The concluding chronologies, lists of data and materials on contemporary artists are unmatched in English. The glossary is a skilled summary of Japanese culture.

GENERAL BACKGROUNDS

Akimoto Shunkichi. *The Twilight of Yedo.* Tokyo: Tokyo News Service, 1952. 231 pp.

Especially valuable for its photographic reproductions of four complete kibyoshi-bon.

Chatto, William Andrew. *A Treatise on Wood Engraving,* with Upwards of 400 Illustrations Engraved on Wood by John Jackson. New York: J. W. Bouton, 1839. 749 pp. Original edition.

From the day of its inception this famous old masterpiece was the subject of contention. Still the best account of European wood engraving. Especially good on Thomas Bewick.

De Becker, Joseph Ernest. *The Nightless City,* or, The History of the Yoshiwara Yukwaku. Yokohama: Max Nossler, 1899. xvi, 386 pp.

Unorganized collection of astonishing facts.

Honjo Eijiro. *Economic Theory and History of Japan in the Tokugawa Period.* Tokyo: Maruzen Co. Ltd., 1943. xvi, 350 pp.

Published in English, this book explains some of the extraordinary measures taken by the bakufu to control Japanese life.

Iacovleff, Alexander E., and Elisséeff, Serge. *Le Théatre Japonais (Kabuki).* Paris: Julus Meynial, 1933. 100 pp. and 32 color plates.

A fine account of kabuki with many illustrations of the actors and the characterizations they portray.

Joly, Henry L. *Legend in Japanese Art.* London: John Lane, The Bodley Head, 1908. 453 pp.

A much-loved old classic, fine for checking the fairy-tale iconography of ukiyo-e.

Kaempfer, Engelbert. *The History of Japan.* London, 1728. 2 vols. with plates, maps.

This account of a voyage to Japan in 1673, written by E. Kaempfer and translated from the original manuscript by J. G. Scheuchzer, is one of the early books which gives an account of the ancient state and government of that empire.

Kincaid, Zoë. *Kabuki, the Popular Stage of Japan.* London: Macmillan and Co., Ltd., 1925. xvi, 385 pp. plus 49 plates.

A classic and deeply moving account of the Japanese theatre.

Kokuritsu Hakubutsukan. *Pageant of Japanese Art,* v. 1–6. Tokyo: Toto Bunka Co. Ltd., 1952. 6 vols. Profusely illustrated. Edited by the staff members of the Tokyo National Museum. Volumes I and II. Painting. III. Sculpture. IV. Ceramics and Metalwork. V. Lacquer and Textiles. VI. Architecture and Gardens.

Miyamori Asataro. *Tales From Old Japanese Dramas*. New York: G. P. Putnam's Sons, 1915. 403 pp.

Extended English synopses of a few leading kabuki plays.

Mueller, Hans Alexander. *How I Make Woodcuts and Wood Engravings*. New York: American Artists Group, 1945. 97 pp.

Useful as a point of comparison with Japanese methods.

Redesdale, Algernon Bertram Freeman-Mitford, Lord. *Tales of Old Japan*; with illustrations drawn and cut on wood by Japanese artists. London and New York: Macmillan, 1891. xii, 383 pp. and 31 plates.

A minor employee of a British mission to Japan filled his after-hours with translating classic Japanese stories into exquisite English. It is the footnotes, however, some up to thirty pages long, that are most appreciated. His account of harakiri is terrifying.

Sadler, Arthur L. *The Maker of Modern Japan*; The Life of Tokugawa Ieyasu. London: George Allen and Unwin, 1937. 429 pp.

Although Ieyasu died long before Moronobu started his ukiyo-e publishing, this notable biography is an excellent introduction to Tokugawa Japan. Brilliantly written.

Sagara Tokuzo. *Japanese Fine Arts*. Tokyo: Japan Travel Bureau, 1949. 249 pp.

This inexpensive handbook crams a lot of information in between some excellent color plates.

Sirén, Osvald. *A History of Early Chinese Painting*. London: The Medici Society, 1933. 2 vols. 226 plates.

——————. *A History of Later Chinese Painting*. London: The Medici Society, 1938. 2 vols. 242 plates.

The first history begins with the Han and stops at the Yuan dynasty. The later history continues to the end of the Chien Lung reign, ca. 1796.

Tatekawa Emba. *Kabuki Nendai Ki*. (Chronological records of Kabuki plays). Tokyo, 1905. 10 vols. with hundreds of illustrations.

An excellent account from which to check ukiyo-e data.

Toda Kenji. *Japanese Scroll Painting*. Chicago: The University of Chicago Press, 1935. ix, 167 pp. 19 plates.

The plates in full color give some idea of the great makimono.

Tschichold, Jan. *Hu Cheng-yen: A Chinese Wood-engraver and Picture-Printer*. With sixteen facsimiles from sheets in the *Ten Bamboo Hall*. New York: The Beechhurst Press, 1952. 16 pp.

Pages from one of the great art books of the orient.

——————. *Chinese Color-Prints from the Painting Manual of the Mustard Seed Garden*. London: George Allen and Unwin Ltd., 1952. 17 pp. plus 16 plates.

Pages from the book which influenced Harunobu and Hokusai.

Wells, Wilfrid H. *Perspective in Early Chinece Painting*. London: Edward
Goldston, 1935. 64 pp.

Involved, scholarly analysis which helps explain why oriental pictures
look the way they do.

SOLID STUDIES

Many of these could with profit be moved into the first group of seventeen
basic studies, and anyone venturing upon serious work on ukiyo-e will come
to use these books pretty much as dictionaries.

Binyon, Laurence. *A Catalogue of the Japanese and Chinese Woodcuts in
the . . . British Museum*. London: British Museum, 1916. 605 pp. plus
129 plates.

So far as text, and especially translations of Japanese poems, is con-
cerned, this big catalogue is still the most thorough ever attempted on
a major public collection.

Ficke, Arthur Davison. *Chats on Japanese Prints*. London: T. Fisher Unwin,
Ltd., 1915. 456 pp. and 56 illustrations.

Probably the most influential and poetic book on ukiyo-e ever pub-
lished outside of Japan.

Fujikake Shizuya. *Ukiyo-e No Kenkyu*. (Study on Ukiyo-e.) Tokyo: Yuzan-
kaku, 1943. 3 vols., 516 plates.

A thorough study of ukiyo-e by one of the deans of ukiyo-e research
which includes biographies of the artists, discussions of their works, and
the social and cultural background of this period.

Ledoux, Louis V. *Japanese Prints in the Occident*. Tokyo: Kokusai Bunka
Shinkokai, 1941, 69 pp.

An admirable and moving essay reporting one man's love of an art.
Also includes twenty good reproductions of Torii prints in America.

Narazaki Muneshige and Kondo Ichitaro. *Critical History of Japanese Land-
scape Woodprints*. Tokyo. 268 pp. and 159 plates.

In Japanese. It should be translated, for it provides an admirable
antidote to the commonly held belief that ukiyo-e landscape started
with Hokusai and Hiroshige.

Shibui Kiyoshi. *Estampes Erotiques Primitives du Japon*. Tokyo, 1926. Two
volumes. 120 plates.

This world-famous publication has been a standard bit of research
for so many years that when I met Shibui I expected to see an elderly
man. He is about my own age, having issued his masterwork when just
out of college.

Takahashi Seiichiro. *Ukiyo-e Nihyakugoju-nen.* (Two hundred and fifty years of Ukiyo-e.) Tokyo, 1939. 89 plates.

Takahashi has for many years been a leading professor of economics and an ukiyo-e expert on the side. His ideas have influenced my thinking.

Yanagi Muneyoshi. *The Peasant Painting of Otsu, Japan.* In Eastern Art, Vol. II, pp. 5–36 incl. 17 plates,

A perceptive essay with thirty-nine reproductions, some in color, providing the only substantial comment in English on Otsu-e.

Yoshida Hiroshi. *Japanese Wood-block Printing.* Tokyo: Sanseido Co. Ltd., 1939. 136 pp.

Few American G.I.'s returned from Japan without at least one Yoshida print. His blocks have been used more assiduously than any since Hiroshige's. Here he explains how he works.

Yoshida Teruji. *Ukiyo-e Jiten.* (Dictionary of Ukiyo-e.) Vol. I. Tokyo Hokko Shobo, 1944.

An excellent dictionary of ukiyo-e material, including artists, technical terms, subjects, books, periodicals, etc.

BOOKS ON INDIVIDUAL ARTISTS

In general, monographs on individual ukiyo-e artists, whether compiled in Japan or elsewhere, are apt to be disappointing. Great scholarship has not yet attended to this field, possibly because biographical materials available for study are so spare.

Adachi Toyohisa, ed. *Sharaku:* A Complete Collection. Tokyo: Meiji-Shobo, 1952. Text to accompany Volume I by Yoshida Teruji. 77 pp.

This book, when completed, will cost about $500 and will reproduce in the almost absolute-facsimile method described in connection with print 63 A each known Sharaku print. English text available.

Ficke, Arthur Davison. *The Prints of the Kwaigetsudo.* New York: *The Arts*, Vol. IV, No. 2. August 1923. pp. 95-111 incl. 22 plates.

A short classic essay describing each of the then known Kaigetsudo masterpieces. The name is spelled in the old manner.

Goncourt, Edmond de. *Hokusai.* Paris 1896.

A poetic evocation of the master who influenced French artists so strongly, partly because of the salesmanship of this book. Research, provided by Hayashi, was not strong.

———————. *Outamaro.* Le Peintre des Maisons Vertes. Paris: Bibliothèque-Charpentier, 1891. 265 pp.

The impact of this trail-blazing work was considerable. Hayashi did the basic research, which is now outmoded.

Gookin, Frederick William. *Katsukawa Shunsho*, 1726–1793; A Master Artist of Old Japan. Chicago: Art Institute. Mimeographed copy, 1931. 280 pp. and 300 plates.

This book is one of the regrettable tragedies of ukiyo-e. Gookin's brilliant appreciation of Shunsho is among the finest and most perceptive writing ever done on an ukiyo-e artist. The author died without its being published because a painful number of the ukiyo-e prints upon which he based his conclusions were found to be wrongly identified and wrongly dated. Today's scholarship would permit, with relatively little editorial revision, a correction of the manuscript and would make it a major contribution to the study of ukiyo-e.

Henderson, Harold G., and Ledoux, Louis V. *The Surviving Works of Sharaku*. New York: E. Weyhe in behalf of the Society for Japanese Studies, 1939. 337 pp. incl. 104 plates.

Around the world this patient and loving work is regarded as proof of what American scholarship can accomplish. Curiously, Catalogue Number 16, which represents the most consistently mis-identified print in history, is again wrongly identified. It's Ebizo III, not IV, and shows Danjuro V in one of his last noble roles.

Holmes, C. J. *Hokusai*. New York: Longmans, Green and Co., 1901. viii, 48 pp. and 20 plates.

Working almost from instinct, Holmes provides what is still a sage guess as to the character of Hokusai and the value of his work.

Inoue Wayu, comp. *Ukiyo-e Shiden*. (Biographies of masters of the Ukiyo-e school.) Tokyo: Watanabe Hangaten, 1931. 266 pp. and 38 plates.

Iwanami Shoten, Tokyo. *Sharaku*. (Collection of works of Sharaku.) Tokyo, 1953. 64 pp.

Kurth, Julius. *Suzuki Harunobu*. Munich: R. Piper and Co., 1923. 121 pp.

This is one of the books Fritz Rumpf blasts. Nevertheless, it contains the basic Harunobu material.

——————. *Sharaku*. Munich: R. Piper and Co., 1922. 215 pp.

This has been largely superseded by Rumpf, Henderson and the new Adachi. Still the best source for the old moralizing theories regarding Sharaku.

Shibui Kiyoshi. *Utamaro*. (His life and works.) Tokyo: Asoka Shobo, 1952. 144 pp. plus 14 plates.

Anything Shibui does merits careful attention.

Strange, Edward F. *The Colour-Prints of Hiroshige*. London: Cassell and Co., Ltd., [no date]. 205 pp.

A pleasant work. Contains long excerpts from the diaries and considerable praise for Hiroshige's fan prints, an opinion most difficult to share.

Succo, Friedrich. *Katsukawa Shunsho*. Dresden: C. F. Schulz and Co., 1922. 143 pp. plus 45 plates.

Harshly criticized by American critics on publication—because of its German provincialism which overlooked the best Shunsho prints in both France and America—this book now is valued for its researches into Shunsho's life.

COLLECTIONS OF PRINTS
IN BOOKS CURRENTLY AVAILABLE

More than most other arts, ukiyo-e can be enjoyed in reproduction. It is possible to use book pages of almost the size of the original prints. The list that follows includes only publications which can be bought today, some at very reasonable prices.

Blunt, Wilfrid. *Japanese Colour Prints From Harunobu to Utamaro*. London: Faber and Faber, Ltd., 1952. 24 pp.

Ten superb color plates.

Boller, Willy. *Masterpieces of the Japanese Color Woodcut*. Boston: Boston Book and Art Shop, [no date]. 174 pp.

Expensive, but gives a fine view of an almost unknown European collection. Actual size, many in color.

Fujikake Shizuya. *Japanese Wood-Block Prints*. Tokyo: Japan Travel Bureau, 1953. 219 pp.

A short guidebook, valuable for its excellent reproductions, many in color, of modern artists.

Fujikake Shizuya. *Mokuhan Ukiyo-e Taika Gashu*. (Collection of pictures by the masters of Ukiyo-e block printing). Tokyo, 1915. Japanese text with 67 plates.

Color woodblock prints of the greatest artists arc handsomely reproduced in this folio volume.

Gunsaulus, Helen C., ed. *Japanese Prints by Early Masters*. Chicago: The Art Institute of Chicago, 1946. 16 pp.

Black-and-white photographs of some of Chicago's great early prints that would not necessarily profit from color reproduction.

Hakone Art Museum. *A Story of Ukiyo-e*. Hakone, Japan: Hokane Art Museum, 1953. 32 pp.

Excellent small reproductions of some famous prints and paintings ot the ukiyo-e school.

Hillier, J. *Japanese Masters of the Colour Print*. London: Phaidon Press, 1954. 140 pp.

Big, good reproductions, some in color. Introductory text.

Metropolitan Museum of Art Miniatures. *Japanese Prints in the Metropolitan*.
New York: Book-of-the-Month Club, Inc., 1952. 32 pp.

Interesting and beautifully reproduced small copies of two dozen
masterpieces, many of which are talked about in this book.

Onchi Koshiro. *Nihon no gendai hanga*. (Contemporary Japanese block
printing.) Tokyo: Sogen-sha, 1953. 85 pp., 163 plates.

Contains fine, small plates of many avant-garde moderns.

Priest, Alan. *Japanese Prints from the Henry L. Phillips Collection*. New
York: The Metropolitan Museum of Art, 1947. 22 pp. plus 52 plates.

A good catalogue of a small collection which contains some prints
in superb condition.

Ruffy, Arthur W. *Japanese Colour-Prints*. London: His Majesty's Stationery
Office, 1952. 24 pp. plus 111 plates.

The forerunner of this long-lived publication appeared as early as
1904 and stressed, unfortunately, the Utagawa school. The present ver-
sion is well rounded and constitutes an excellent value.

Shibui Kiyoshi. *Shoki Hanga*. (The Kiyoshi Shibui primitives.) Tokyo:
Asoka Shoba, 1954. 146 pp. and 42 plates.

A very good buy and one of the best introductions to ukiyo-e.

Ukiyo-e Taisei. Tokyo, 1930–31. 12 volumes. 5004 prints.

Although the prints are apt to be small and useful only for reference,
each volume contains a few in color, a few more in adequate size.

Ukiyo-e Taika Shushei. Tokyo, 1931–32. 20 volumes. 1238 prints. Plus a sup-
plement in six volumes, 1933.

A beautiful publication, calculated to provide the viewer—for there
is little text and all in Japanese—with the best possible appreciation
of the richness of ukiyo-e. The bookshops of Tokyo can usually lay
their hands on this or the preceding series, but they may need a couple
of months for searching.

LARGE COLLECTIONS OF PRINTS
AVAILABLE ONLY IN LIBRARIES

Fujikake Shizuya. *Ukiyoye Hanga Seisui*. Selected Gems of Ukiyoye Prints
in the Matsuki Collection. Kyoto, 1925. 3 vols. 192 plates.

Contains many unusual prints, not too well reproduced.

Gookin, Frederick William. *Descriptive Catalogue of Japanese Colour-
Prints, The Collection of Alexander G. Mosle*. Leipsig, 1927. 58 pp.
plus 8 plates.

Notable for companion portfolio which reproduced excellently the
Kyosen set of which print 39 is a part.

Kawaura Kenichi. *Album of Old Japanese Prints of the Ukiyo-e School.* Reproduced from the collection of Kawaura Kenichi. Tokyo, 1919. 425 prints.

An interesting, well-rounded selection.

Kawaura Kenichi. *Descriptive and Historical Album of Old Japanese Prints of the Ukiyo-e School.* Tokyo: Yoshizawa Shoten, 1918. 10 pp. and 120 plates.

The title-page and text in Japanese but each print has manuscript annotations in English.

Nihon Fuzoku Zue. (Complete picture collection of the social life, customs, scenery, arts and crafts of Japan.) Compiled by Kurokawa Shinto. Tokyo, 1914-15. 12 vols. profusely illustrated.

Noted ehon or picture books dealing with Japanese life are reproduced in black and white about actual size. Valuable for collector, student or designer.

Tajima Shiichi, ed. *Masterpieces Selected from the Ukiyoye School.* Tokyo: Shimbi Shoin, 1906-1909. 5 vols. of folio size reproductions.

Superb reproductions, with perhaps too much emphasis on painting.

Matsukata Kojiro. *Catalogue of Ukiyo-ye Prints in the Collection of Mr. K. Matsukata.* Osaka, 1925. 101 plates.

Beautifully printed selection from the chief masterpieces of the Vever-Matsukata collection described in Chapter 23.

Vignier, M., and Inada Hogitaro. *Estampes Japonaises.* Paris: Ateliers photo-mécaniques D. A. Longuet, 1909. 29 pp. plus 64 plates.

This great five-volume work is in a class by itself. Reproducing as it does the outstanding treasures of a series of exhibitions held in Paris 1904–1914, it established the groundwork for all subsequent research. It remains a splendid job of reproduction, a good job of identifying the major facts of ukiyo-e.

INTERESTING READING

Brown, Louise Norton. *Block Printing and Book Illustration in Japan.* London: G. Routledge & Sons Ltd.; New York: E. P. Dutton & Co., 1924. xii, 261 pp. and 43 plates.

One of the classics, but now largely superseded by the more accurate Toda catalogue.

Haar, Francis. *Japanese Theatre in Highlight;* A Pictorial Commentary. Tokyo: Tuttle, 1952. 177 pp.

A beautiful book providing an excellent visual introduction to noh, bunraku, kabuki.

Hamilton, Charles E. *Kamisuki Choki;* A Handy Guide to Papermaking. Berkeley: The Books Arts Club, University of California, 1948. 78 pp.

Handsomely reproduced copy of a famous old Japanese text with pictures on how to make good paper. Text translated into English.

Metzgar, Judson D. *Adventure in Japanese Prints.* Los Angeles: Grabhorn Press for Dawson's Book Shop, [no date]. 117 pp.

Pleasant conversation on what it was like to live in Chicago area when the great collections were being assembled.

Schraubstadter, Carl William. *Care and Repair of Japanese Prints.* Cornwall-on-Hudson, N. Y.: Idlewild Press, 1948. 117 pp.

The best of its kind on the conservation and preservation of prints.

von Seidlitz, Waldmar. *A History of Japanese Colour-Prints.* London: William Heinemann, 1920. First edition 1910. xvi, 207 pp.

One of the most important early books. Opinionated, sometimes in error but often with flashes of deep insight.

Shimbi Shoin, Tokyo. *Process of wood-cut printing explained.* Tokyo, 1916. 4 pp. and 40 plates.

Of the many little volumes showing graphically how various blocks combine to produce one color print, this version is best.

Stewart, Basil. *Subjects Portrayed in Japanese Colour-Prints.* London: Kegan Paul, Trench, Trubner and Co., Ltd., 1922. xvi, 382 pp.

Interesting review of certain iconographic and kabuki problems, but the majority of prints illustrated are boring.

Wettergren, Erik. *Japanska Träsnitt ur Martin Manssons Samling.* Stockholm: Nationalmuseum, 1948. 46 pp. and 32 plates. (Nationalmusei utställningskatalog, nr. 143).

A neat corrective to the old fable that ukiyo-e first reached Europe as wrapping paper for chinaware.

Index and Glossary

(Note: figures in parentheses refer to plate numbers)

T

U